The Newberry
125

MERCVR TRISM... CADMVS

...MPLAI RES DV SIEVR DE BEAVLIE...

...monstrees fidellement toutes sortes de lettres et...

...nces, Chancelleries et autres & service...

...uec Sue methodique Instruction d'icelles

63 - An attempt
sing of one of the
black & red draped
placards. This one
read: "Bin Rosa - the
voss, she is, she will
be again." All these
things had to be
taken secretly as
it was forbidden
to take pictures.

64 - Ben, Dr.
Hölmann and
Georg Gros, the
artist, in our room
June, 1919.

65 - A time of
Ben.

66 - Se
of the sa
by alo
the ad
Sign.

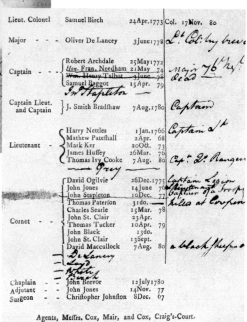

Rank	Name	Date	Notes
Lieut. Colonel	Samuel Birch	24 Apr. 1773	Col. 17 Nov. 80
Major	Oliver De Lancey	3 June 1778	Lt. Col. by brev
Captain	Robert Archdale	25 May 1772	
	Hon. Fran. Needham	21 May 74	Major 76
	Wm. Henry Talbot	3 June 78	dead
	Samuel Baggot	15 Apr. 79	
	Jn. Stapleton		
Captain Lieut. and Captain	J. Smith Bradshaw	7 Aug. 1780	Captain
Lieutenant	Harry Nettles	1 Jan. 1766	Captain Lt
	Mathew Pateshall	2 Apr. 68	
	Mark Ker	20 Oct. 73	
	James Hussey	26 Mar. 76	Capt. Dr. Rangers
	Thomas Ivy Cooke	7 Aug. 80	
	Grey		
Cornet	David Ogilvie	26 Dec. 1775	Captain Legion
	John Jones	14 June 76	Lieutenant of a Troop
	John Stapleton	10 Dec. 77	Captain of a Troop
	Thomas Paterson	31 do.	killed at Cowpens
	Charles Searle	15 Mar. 78	
	John St. Clair	23 Apr.	
	Thomas Tucker	10 Apr. 79	
	John Black	13 do.	
	John St. Clair	13 Sept.	
	David Maccullock	7 Aug. 80	a black sheep
	DeLancey		
	Loyd		
	White		
	Bush		
Chaplain	John Beevor	12 July 1780	
Adjutant	John Jones	14 Nov. 77	
Surgeon	Christopher Johnston	8 Dec. 67	

Agents, Messrs. Cox, Mair, and Cox, Craig's-Court.

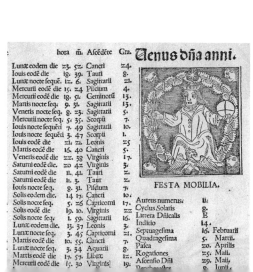

	hora	m.	Ascedéte	Gra.

Venus dña anni.

Lunæ eodem die	23.	52.	Cancri	24.
Iouis eodé die	18.	39.	Tauri	8.
Lunæ nocte sequé.	12.	6.	Sagittarii	21.
Mercurii eodé die	15.	24.	Picium	4.
Mercurii eodé die	18.	51.	Geminorū	13.
Martis nocte seq.	9.	31.	Sagittarii	13.
Veneris nocte seq.	8.	23.	Sagittarii	5.
Mercurii nocte seq.	5.	35.	Scorpii	7.
Iouis nocte sequéti	7.	49.	Sagittarii	10.
Iouis nocte sequéti	3.	47.	Scorpii	1.
Iouis eodé die	21.	21.	Leonis	25.
Martis eodé die	16.	40.	Cancri	5.
Veneris eodé die	22.	58.	Virginis	17.
Saturni eodé die	20.	42.	Virginis	3.
Saturni eodé die	11.	41.	Tauri	2.
Saturni eodé die	11.	5.	Tauri	2.
Iouis nocte seq.	8.	31.	Pisciū	7.
Solis eodem die	14.	17.	Cancri	10.
Solis nocte seq.	5.	26.	Capricorni	17.
Solis eodé die	19.	10.	Virginis	22.
Solis nocte seq.	1.	59.	Sagittarii	16.
Lunæ eodem die	13.	37.	Leonis	3.
Lunæ nocte seq.	3.	45.	Capricorni	21.
Martis eodé die	10.	55.	Cancri	7.
Lunæ nocte seq.	3.	34.	Aquarii	8.
Martis eodé die	17.	57.	Libræ	12.
Mercurii eodé die	15.	30.	Virginis	19.

FESTA MOBILIA.

Aureus numerus	11.
Cyclus Solaris	8.
Littera Dñicalis	E
Inditio	14.
Septuagesima	16. Februarii
Quadragesima	5. Martii
Pasca	20. Aprilis
Rogationes	28. Maii
Ascensio Dñi	29. Maii

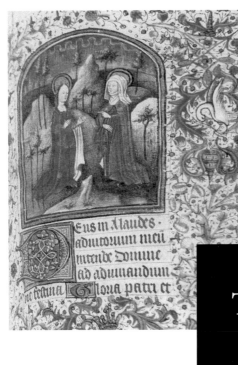

The Newberry

125

·

Stories of
Our Collection

Introduction by David Spadafora

Published by the Newberry Library
Distributed by the University of Chicago Press

The Newberry Library

expresses its appreciation to

Richard and Mary L. Gray

for making possible

the publication of this book.

The Newberry 125, Stories of Our Collection
was published in celebration of the library's 125th anniversary and in conjunction
with an exhibition held September 6 – December 31, 2012.

ISBN 978-0-911028-27-0

Credits:

Published by:
The Newberry Library
60 West Walton Street
Chicago, Illinois 60610
www.newberry.org

Distributed to the trade by:
University of Chicago Press
1427 East 60th Street
Chicago, Illinois 60637
www.press.uchicago.edu

Produced by The Coventry Group LLC, Chicago
Design and typography by Hal Kugeler Ltd., Chicago
Color separations by Prographics, Rockford, Illinois
Printed by Graphicom, Verona, Italy

Note to the reader
Names of the authors/creators of the books, maps, and manuscripts
follow the Library of Congress authority form.
Titles in italics are given as they appear on the item.
Titles in Roman have been supplied by the author of the entry.
Unless otherwise noted, all items are printed.
Bound items were measured closed.
In all cases, height precedes width precedes depth.

Illustration on p. 4: see no. 67

Illustration on p. 8: Henry Ives Cobb,
Rendering of the Newberry Library from the southwest (detail; c. 1892).
NL Archives.

Illustration on p. 212: see no. 114

Illustration on p. 220: see no. 13

Contents

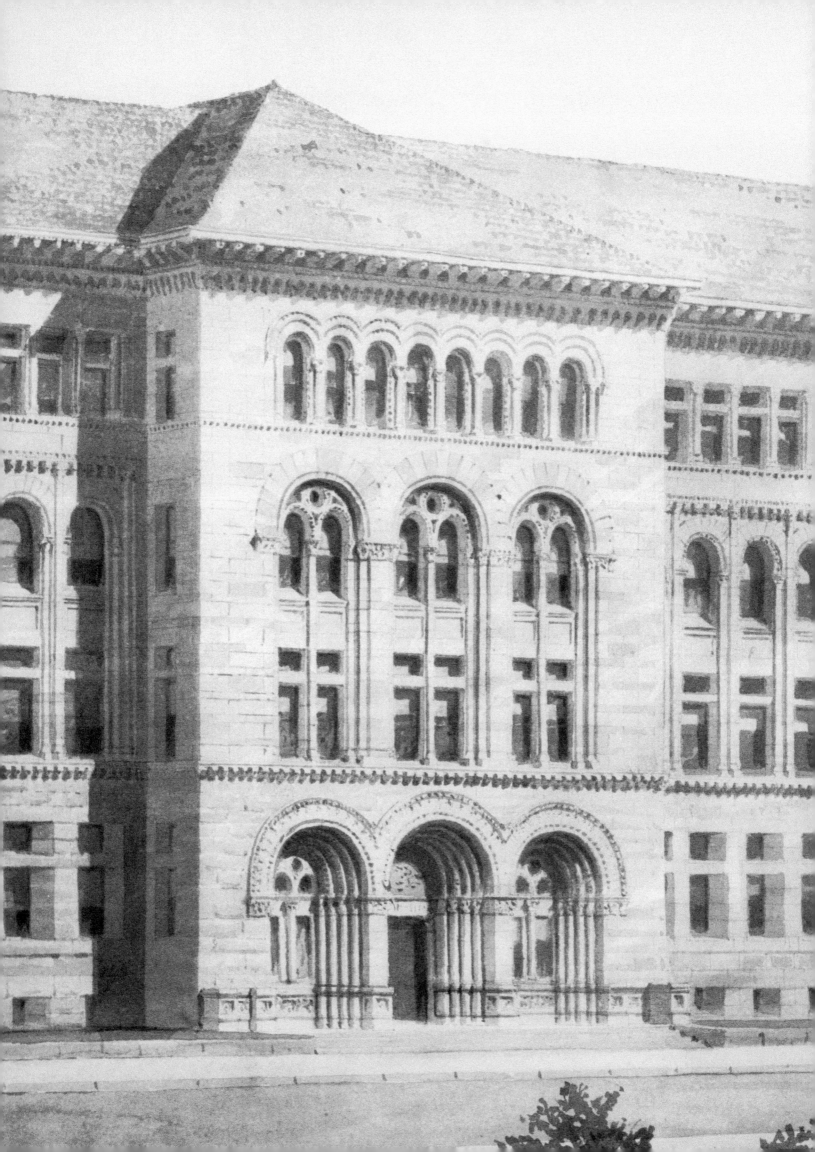

The Newberry Idea

David Spadafora, *President and Librarian*

The genre of the "elevator speech" does not suit the Newberry Library, even in the great city of skyscrapers. To be sure, we can accurately say that, 125 years after its founding, the Newberry remains an independent research library in Chicago that is free and open to the public; that it has a collection of some 1.5 million books, 15,000 linear feet of manuscripts, half a million maps, 200,000 pieces of sheet music, and many other items; that some 100 staff work in its main building, opened in 1893, and its attached 1982 stack building; that it operates four research centers and offers a wide range of programs for scholars, graduate students, undergraduates, teachers, genealogists, and other serious readers. But by then we have reached the seventieth floor without revealing anything substantial about the Newberry's uniqueness. Try as we might, the essence of the Newberry is not susceptible of sound bytes. To do the library justice requires greater nuance and more leisure.

Our chosen genre for telling the Newberry's story is the essay. This volume consists primarily of a series of illustrated essays about 125 items in the Newberry's collection, written mostly by staff members but also by others who have been directly involved in the institution. Together with this introduction, the essays exemplify and illuminate what the Newberry has, how and why such materials have come to us, what we have been doing about and with them since the library's founding in 1887, and why they matter to us and our community. Through description and analysis of representative materials, the essays aim at bringing the Newberry to life across its 125 years. An essay, as we are reminded in an account of Montaigne's originating work for the genre (see no. 97), is of course not a comprehensive treatise but instead a relatively brief attempt to present a point of view. Collectively, these 125 essays function more like individual microhistories than like a formal institutional history. They are indicative and suggestive, perspectival but not definitive.

But the essays do testify to the Newberry's overall story, from its beginning to the present. They bear witness to the people—from trustees to donors to staff to readers—who have shaped the institution and marked it with a special character: eager to serve, rich in collections, lean and resourceful in every other way, collaboratively minded, deeply committed to research and education, and slightly odd. They reflect the institution's ethos as a remarkably diverse place held together by passionate curiosity and seriousness of purpose in assembling, preserving, making available, and using a remarkable cultural treasure.

And in their way, the essays reveal from varying angles the most fundamental thing about the Newberry: its very idea, formulated initially by Walter L. Newberry and under development ever since.

1. The Founding Generation

As early as 1841, Newberry (1804–1868) urged the creation of a great library in Chicago. A will designed with his friend Mark Skinner specified that, as a contingency, half of his estate would go to establish such an institution. After the contingency came into effect, the estate could realize Newberry's library, which he had hoped would "go on increasing until it becomes the pride and boast of our city."[1] Eliphalet W. Blatchford (1846–1914) and his fellow Newberry estate trustee William H. Bradley (1816–1892), encouraged by other civic worthies, quickly focused the basic idea. Taking into account the existence of the Chicago Public Library (CPL) since 1876, they decided that the new library would concentrate on reference or, as we would say today, research and reference. By July 1, 1887, the idea was

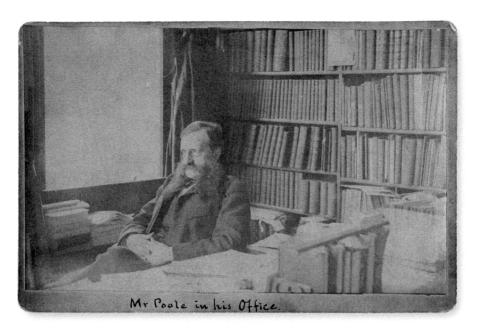

William Frederick Poole in his office at the Newberry Library (c. 1890).
NL Archives, 15/01/01, Box 2.

announced to the world, and on September 6 of that year its realization commenced when the Newberry Library opened its doors at 90 LaSalle Street, near the southwest corner of LaSalle and Washington.

William Frederick Poole, the founding librarian (1887–1894), knew that the Newberry was coming, having as early as September 29, 1877, arranged for gifts of a new Bible from Oxford University Press and the catalog of the Liverpool Public Library for the Newberry's eventual collection.[2] As head of the CPL, he must have had a hand in the decision to make the Newberry a research library. His commitment to building the collection and extending the reach of the CPL into the community had quickly placed it second in circulation among all American libraries. Naturally, Poole had no intention of replicating at the Newberry what he had already accomplished south of the Chicago River and before that in Cincinnati. Instead, he took on his new assignment precisely because it involved something different, something he understood well: the support of research and reference needs. Having cut his librarian's teeth on meeting those needs during his undergraduate days at Yale College, he went on to create in *Poole's Index* the premier reference guide to periodicals, and he was himself a well-regarded historian who understood research from the inside. No one at the time could have been more familiar than he with the combined value of original sources and secondary literature (see no. 32).

Collecting Begins
Poole began buying catalogs and other bibliographic materials as soon as funds were available, in early August

1887, but the trustees long remained involved in overseeing acquisitions. As Poole wrote, the "rule is that I report to the Trustees, and they authorize or not the purchase, usually, however, confirming my recommendations."[3] Fortunately, he and they appear to have agreed upon purposes. As he put it, the new library was intended to provide not for the "general average of readers" but instead "for the wants of scholars, scientific students, professional men, who want to get below the surface, and inquire into the origin and history of ideas and progress of events, who read and seek for books in many languages."[4] The trustees' annual report for 1888 confirmed this approach: faculty from professional and higher-educational institutions throughout the region, when consulted, had expressed interest in the "establishment in this central position of a large reference library having means to procure books, often expensive, which are needed by scholars for original and thorough investigation."[5]

In the early years, the acquired materials ranged widely, as the institution strove to identify and serve the needs of potential users. For instance, Poole made it a point to ask Catholic clergy to recommend books.[6] Meanwhile, the trustees enthusiastically observed in an early annual report that their purchase of books and periodicals on technical and scientific subjects responded to the "phenomenal increase in our city and its suburbs of extensive manufacturing enterprises," which had brought to the Chicago area large numbers of mechanics, engineers, and scientists.[7]

Beyond responding to the perceived needs of users, the Newberry also began to establish a research agenda of its own by seeking the advice of friendly experts and then buying or receiving as gifts large block collections. For instance, George P. Upton (1834–1919), *Chicago Tribune* reporter and self-taught music expert, provided guidance that led quickly to the purchase of Count Pio Resse's magnificent music library of some 750 famous titles and great rarities, especially in Italian and on music history and theory (see no. 107). Two years later came Upton's own large music library, rich in secondary materials, and a collection of English and American psalmody. With this foundation in place, Upton could later help the Newberry acquire as a gift the library of Chicago Symphony Orchestra conductor Theodore Thomas (see no. 112).

Another instance of collecting *en bloc* involved medicine. The Newberry established a Medical Department in 1890 and immediately purchased the medical collection of the CPL. These materials were joined in 1893 by the most notable surgery collection in the United States, and then in 1897 by an extraordinary physiology collection of 10,000 titles. By then the Newberry had established a special annex to support physician and medical-student research and interaction. A decade later, the Newberry Medical Department held 28,000 volumes and 16,000 pamphlets.

The House That Poole Built
The construction of a permanent site for the rapidly growing collection, at 60 West Walton Place, chosen in part for convenient access to public transportation, was finished in the fall of 1893. Poole's vision of a collection of vast breadth, with an ultimate goal of perhaps four million volumes, had begun to rankle the trustees, who insisted on frugality in purchases. Similarly, his views on the design of the new building raised the hackles of its architect, the young Henry Ives Cobb (1859–1931). In the end, Cobb placed his imprint on the Spanish Romanesque exterior, while Poole won the struggle over the building's interior arrangements.[8]

Poole wanted the interior divided into a series of small-to-medium-size spaces that would house subject-based collections in close proximity to staff possessing relevant expertise. His decentralized approach contrasted sharply with the then rapidly developing use of consolidated bookstacks, from which materials were served up to cathedral-size reading rooms where substantial groups of readers pursued their research heterogeneously. Poole worried about the wasted space and heat associated with large reading rooms, as well as about the preservation problems created by multilevel bookstack buildings whose higher reaches bathed books in hot, humid summer air. More troublesome still, even if the needs of readers in a public lending library could be well served by large reading rooms, Poole thought that the more sophisticated users of a research library required something different: a stream of items from the same subject area, the ready availability of informed attendants, and consultation both with library professionals and, as the medical annex demonstrated, with one another.[9]

In 1895 the new building's first floor housed the departments of Medicine and Bibliography. On the second were History (with biography and genealogy, geography and travels, and archeology and customs sub-departments), Philosophy (religion, sociology, and education), and Arts and Letters (literature, music, and language), as well as a Main Reading Room for current periodicals and general reference work. The Science Department resided on the third floor, along with public documents and bound newspapers. For the general public, a "museum" on the first floor showcased a permanent exhibition of special treasures, most of which were drawn from the magnificent 2,500-volume collection purchased in 1891 from Cincinnatian Henry Probasco (see no. 119). Having advised Probasco on acquisitions, Poole knew at firsthand that his collection was notable for incunabula, Grolier bindings, important Bibles, and Shakespeare folios, which would have a powerful impact in turning the Newberry toward acquiring rarities.

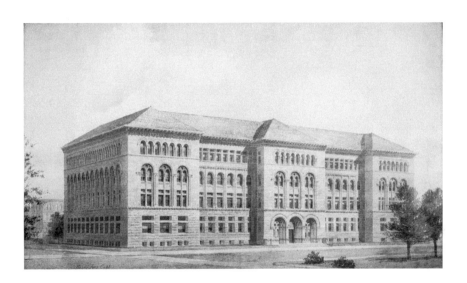

Henry Ives Cobb,
Rendering of the Newberry Library from the southwest (c. 1892).
NL Archives.

By the time of Poole's death in 1894, the Newberry idea involved a focus on serious readers who wanted to go "below the surface" of things, wide breadth of collections, an acquisition strategy often informed by outside experts but executed by an authoritative leader wrestling with a small board of trustees, organization of space and staffing based on subject, and the presence of some carefully acquired rare books. The "museum" and the operation of university extension courses in nearby facilities such as Unity Church meant that the Newberry saw itself from the start as an enterprise with both research and educational commitments: its serious readers included but were not limited to scholars.

First Adjustments

Poole's department-based collection structure continued under his successor, John V. Cheney (1894–1909), despite some physical relocations in 1902–1903. Even before Cheney arrived, however, an enormously important change in collecting loomed on the horizon, owing to the founding of another new Chicago institution, the John Crerar Library for science, technology, and medicine. As early as 1890, the Newberry's trustees, anticipating the impending establishment of the Crerar, were thinking about a collaborative rather than a competitive approach to collecting in the city. With Blatchford on both libraries' boards, cooperation was almost inevitable. It became a reality on June 24, 1896, when the Newberry's trustees agreed that natural science and the "useful arts" should be assigned to the Crerar, as part of the division of fields among the two public "reference" institutions and the CPL, the city's lending library.[10] Thousands of volumes and pamphlets went to the Crerar that very year. A decade later, the Medical Department, so carefully and successfully created, was also transferred.[11] The Newberry idea had shifted to concentration on the humanities and social sciences, as they were becoming known.

By 1914, reflecting more than a quarter-century of collecting and the impact of the three-institution "co-operative arrangement" with its policy of "non-duplication,"[12] the Newberry formally announced to the public the "principal fields of knowledge and branches of learning" under its auspices. These began with bibliography and the history of printing. Religion and theology were described as being "especially rich." History featured American, British, and Continental materials, with genealogy (see no. 53) and the magnificent Edward E. Ayer Collection of early American history and American Indian materials, which arrived

Clement W. Andrews, John Vance Cheney,
and Frederick H. Hild,
"Report," in Minutes
of the Board of Trustees (1896).
NL Archives, 02/01/21,
Box 3, Folder 1.

in 1911, meriting special mention. In literature the emphasis fell on early-modern English rarities and on original texts and English translations of classical and Continental European works, and also on the historical linguistics and philology of the 16,000-volume Louis-Lucien Bonaparte collection (see no. 121). In the fine arts, special attention was paid to music, and in education the focus was both historical and methodological. Philosophy, psychology and ethics, political science, geography, and biography were mentioned without details. In each of these divisions, the library declared, it "possesses many treasures, books of interest and value for all time."[13]

At this point in its development, beyond preserving a cultural heritage, the Newberry continued both to welcome "all classes of readers from the most learned investigator to the boy or girl seeking information for school use," and to aver that a "majority of the books are, naturally, mainly intended for the use of professional scholars," or at least for "serious and qualified students" rather than for "pupils and untrained readers." The institution's programs for reaching these readers beyond the departmental reading rooms had changed, like the collection itself. Gone were the university extension courses. As for the "museum," it had become an "Exhibition Room" with a large number of permanently shelved rare books[14] and a succession of displays by means of which "rare or beautiful books, manuscripts, or prints may always be seen by visitors." With these displays, the library contended, the "contents of the institution are constantly being brought to the attention of the public in an education[al] way."[15] In just a single decade, starting in 1909, the Newberry held twenty-six distinct exhibitions.[16] The Newberry idea had found a seemingly comfortable resting place, with serious

readers pursuing a steadily growing collection of books in the humanities and the social sciences, some of which were special enough to attract a wider audience.[17]

2. Developing Distinctiveness

Beginning in the 1910s, the presence of Bughouse Square at its front door and the Dill Pickle Club (see no. 42) less than two blocks away assured the Newberry of a lively neighborhood of social and political radicals, bohemians, and writers. By contrast, the Cobb building's granite darkened quickly as a result of pollution, giving the library an austere, even forbidding demeanor. External appearances did not deter readers, however. From the start of one world war to the start of the next, as many as 70,000 people or more came each year to the Newberry, with its six-days-a-week, thirteen-hours-a-day access. As the century advanced, the readership diversified into something unique, and the parallel development of the staff who served that readership marked the institution with a set of identifiably Newberry characteristics.

Readership
The Newberry's commitment to being free and open to the public encouraged members of the general public who wanted to use the materials housed at 60 West Walton. A few, like Jack Jones (see no. 42) and Studs Terkel (1912–2008), prepared in part for their Bughouse Square soapbox speeches by reading at the Newberry. The acquisition of genealogical sources, as well as the preparation of research tools for their use starting in 1896, soon meant the presence in the library of a substantial body of readers who were pursuing their families' histories. For a century, the exploration of genealogy and its ally, local history, have had a highly visible presence at the Newberry. The development of the John M. Wing Foundation on the History of Printing, beginning in the later 1910s, together with the somewhat later presentation of printing- and calligraphy-related exhibitions, has drawn a substantial group of readers from Chicago's vibrant and influential design community.

But at the center of the readership has always stood the scholar, and especially the scholar with an academic affiliation. Poole maintained the Newberry's independence as a provider of university extension courses, resisting University of Chicago president William Rainey Harper's desire to lead such

a program for the entire Chicago area, but he was pleased to see Harper write that his "professors are beginning to lean upon you [i.e., the Newberry] more and more heavily."[18] Even so, it was not until the fifth librarian, Stanley Pargellis (1942–1962), that the Newberry initiated institutional programs explicitly aimed at attracting professional scholars—including those not connected to universities or colleges—who wanted to conduct research and write books and articles. The first fellowship was approved by the trustees in December 1942.[19]

Pargellis had bigger plans than this single research fellowship. He wanted a program that would "attract to the Newberry a group of scholars who will stimulate one another and . . . attract others. . . ."[20] "For years," he wrote, the Newberry, like other research libraries, "has been content . . . to acquire books and make them available to the public." This "passive . . . policy" would no longer do. "We wish to see continually around this Library people doing serious and readable writing of all sorts," which would lead to the "somewhat distant goal of creating here a center of

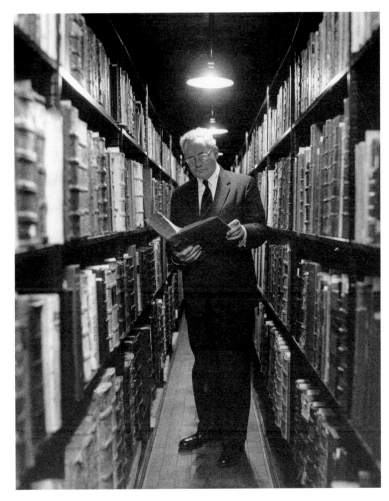

Stanley Pargellis in the Newberry Library stacks (c. 1950s). NL Archives, 15/01/01, Box 2.

humanistic interests."[21] Early in his tenure, then, Pargellis was intent upon refining the Newberry idea in a fashion that has endured ever since—turning the institution into a center for the humanities whose programs stimulate active use of the collection and foster a community of scholars.

In 1944 the Rockefeller Foundation made a grant of $25,000 to the Newberry providing three years of fellowship support for "study which would culminate in books about the Midwestern area."[22] It followed up with even more money, and the Newberry's fellowship program took off, for a few years. When the Rockefeller funding ceased, Pargellis was reduced to offering one long-term fellowship per year, often to distinguished writers such as Malcolm Cowley (see no. 16). In the first years of Pargellis's successor, Lawrence W. Towner (1962–1986), the modest funding available tended to be spread out among a larger group of recipients of "grants-in-aid," the precursors of the short-term fellows of today.

Towner worked with his fellow independent-research-library leaders toward the creation of the National Endowment for the Humanities (NEH) in 1965, and then to obtain from it substantial grants that made possible a large program of residential fellowships. In 1971 the Andrew W. Mellon Foundation provided additional generous support for long-term fellowships. Concurrently, several individual donors established endowments to support residential fellowships. In recent decades, therefore, the Newberry has hosted eight to ten long-term and some forty short-term fellows each year. Their range of interests extends far beyond the initial emphasis by Pargellis on Midwest culture, and their output of articles and books has been enormous. Between 2000 and 2011, the 125 long-term fellows authored at least 121 books,[23] and many of them have been recognized with awards from disciplinary societies and even with MacArthur Foundation fellowships.

The fellows have been complemented since the mid-1960s by a substantial contingent of scholars-in-residence, drawn from Chicago metropolitan-area universities and colleges and from the region's community of independent humanities-oriented researchers, journalists, and other writers. Spending "research days" at the Newberry and, in retirement, preparing the articles and books that teaching or other professional duties delayed, has become a way of life for this large body of readers.

In 1962, when the then-young Associated Colleges of the Midwest (ACM) was creating its first programs for undergraduates from the region's liberal-arts schools, Professor John J. Murray of Coe College encouraged the Newberry to think about hosting a humanities seminar. Within three years, Towner and the ACM had a full-semester program up and running; it has brought hundreds of Midwest liberal-arts students to Chicago for advanced study in the humanities, including undergraduates from the Great Lakes

Colleges Association. In 1997, inspired by the seminar's success, the Newberry initiated a similar, but non-residential, program for undergraduates from the University of Illinois at Chicago, and DePaul, Loyola, and Roosevelt universities. This Newberry Library Undergraduate Seminar (NLUS) is taught by interdisciplinary teams, sometimes including the Newberry's own staff, and its students produce major research papers. The ACM and NLUS students have made the undergraduate community at the Newberry a lively and important one and a strikingly unusual commodity at an independent research library.

Despite the increase in the Newberry's academic-affiliated readers, the total number of in-person reader visits has declined appreciably since the beginning of World War II, from about 64,000 to about 19,000 per year. This surely relates to the same broad social changes that brought about a long-term, per capita decrease in American public-library usage until about 2000, and the more recent drop in physical visits to academic libraries. In the Newberry's case, it is also accounted for by the availability online of key genealogy resources and the Newberry's catalog itself, which has made it possible to check our holdings without making an in-person visit to consult the old card catalog. But the diversity of the Newberry's readership has remained a fact across the past 125 years and constitutes one of the institution's most distinctive characteristics. Genealogists, undergraduates, graduate students, local professors and independent scholars, fellows from throughout the country and well beyond, members of the public with significant intellectual curiosity—all have contributed to the community of serious readers that Blatchford and Poole first imagined and that they and successors like Pargellis and Towner realized. Rarely among American research libraries has such a collection been brought to life by such a wide array of readers.

Professional Activities and Collection Control
As the Newberry's readership diversified in the 1910s and after, so its staff grew and became even more professional, pushing the institution to develop in several important directions. In the early years, the librarian and the small board of trustees dominated the institution. Things changed appreciably in the era of the third and fourth librarians, William N. C. Carleton (1909–1919) and George B. Utley (1920–1942), with lasting consequences.

The professionalization of large libraries after World War I was necessitated in the Newberry's case in part by growing readership, leading to the establishment of the Public Service Department, which oversaw the circulation of materials in the building and provided reference services to patrons. Across many decades, this department, today known as Reader Services, has earned the Newberry an international reputation for supporting reader needs with knowledgeable, friendly, and prompt service. In 2007 a

professionally designed survey found that, among other things, 89.2 percent of first-time users and 86 percent of repeat users of the Newberry were very satisfied with their experience—remarkably high numbers.[24] The institution's goal has not deviated from the principle articulated to the staff in 1919: "To give the public a skilled, intelligent, and understanding service throughout the hours during which the Library is open; to see that no serious student leaves the Library without having had placed at his disposal or called to his attention the full resources of the institution on the subject of his study or inquiry."[25] The sustaining of a service-oriented professional culture is a longtime, distinctive feature of the institution, recognized in 2008 by the Newberry's receipt of the National Medal for Distinguished Library Service.

In the early decades, the need for good service promoted growth in staffing, but so did the collection's expansion. Of 160,000 items acquired between 1887 and 1893, only 58,590 were fully cataloged during that period, and the backlog had reached 100,000 items by 1909.[26] Carleton's and Utley's diligent attention to the problem resulted in a meaningful reduction in the backlog by 1930. At that point, the Catalog and Classification departments had a staff of sixteen, seven of whom had at least a bachelor's degree. Even so, staff expansion and professionalization could not fully resolve the cataloging backlog, as proved true in so many other research libraries.

The Newberry has long been acknowledged in library circles for the quality of its cataloging, especially of rare books, and for its creation of a stand-alone map catalog, a unique tool for research in the history of cartography. Nonetheless, financial deficiencies made the Newberry slow to computerize its card catalog. Its conversion to an online catalog, in 2004–2008, was possible only because of major gifts from foundations and individuals. Together with the Newberry's participation in the Illinois-wide Consortium of Academic and Research Libraries online catalog, this project has brought collection materials to the notice of hundreds of thousands of readers who would not otherwise know about them—keeping the library free and making it even more "open" than before.

Meanwhile, a tradition of scholarly curatorship was growing up which would strongly shape the collection through patterns and emphases that quickly evolved into

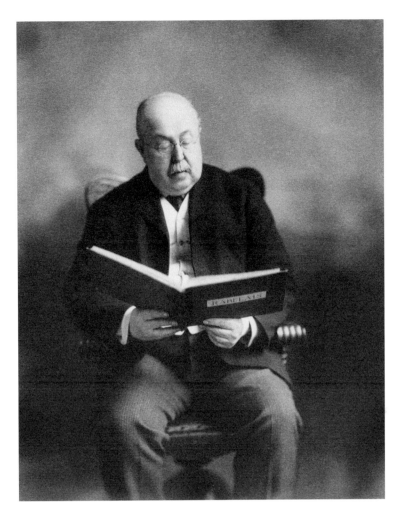

John M. Wing reading Rabelais
(Chicago, 1905). NL Archives, 15/01/01.

enduring norms. After the Poole era, the curve of the collection continued to rise, from 120,000 books in 1894 to 192,000 in 1908, then to 365,000 in 1916 and 465,000 in 1930. Throughout this period, the trustees still exercised final jurisdiction by means of a Book Committee that saw the titles and prices for everything acquired. In reality, however, day-to-day operations shifted toward staff control, and the framing of acquisition policy came to depend on staff expertise. The development of the Wing Foundation illuminates this process.

Having decided in 1900 to give his collection of history and travel literature and illustrated books to the Newberry, the Chicago journalist and publisher John M. Wing (1844–1917) deposited his extra-illustrated books in 1913, and five years later the rest of the collection arrived, with a bequest for its support and expansion. Carleton advised the board to create a process for implementing Wing's intentions, and the resulting special committee—consisting of two trustees, the librarian, and a University of Chicago professor—established

Pierce Butler,
"Books Printed in the Fifteenth Century Arranged Alphabetically by the Author…
Recommended for Purchase by the John M. Wing Foundation of the Newberry Library" (1926).
Vault Case Wing MS Z 313083.C4368.

a series of principles in January 1919. The Wing collection would emphasize bibliography and the history of printing, defined so as to exclude writing and paleography. The collection-building process would avoid the "fetich [*sic*] of bibliographical completeness . . . , and quality not quantity be made the guiding rule." At the outset, special attention would be paid to establishing a "representative collection of the books printed by the pioneers of the art during the first century of its history, viz.: 1450–1550."[27]

The application of these principles fell to L. Pierce Butler (1884–1953), a medieval-church historian and Episcopal clergyman who had been serving as head of the Newberry's Order Department. It was Butler who settled on the Wing Foundation's goal of collecting "such things as will instruct, correct, and inspire the makers and users of books in the higher aspects of typographic art," or, as he also put it, in "the humanities of typography."[28] It was he who, notwithstanding his own deep interest in acquiring the work of more recent printers such as that of William Morris's Kelmscott Press, soon homed in on the first fifty or "cradle" years of printing, surveying in 1919 the existing 280 incunable titles so as to prepare the way for buying more of them once the Wing funds were available. It was Butler who sought both "typical material illustrating all

possible phases in the development of printing" from 1450 to 1500 and "books which contained those texts that were most significant of the intellectual interests and methods of scholarship current in that period."[29] And it was Butler whose five European buying trips between 1922 and 1930 enabled the Newberry to make great strides in realizing these goals (see no. 56). By 1933 the Newberry had increased its incunable holdings to 1,613 titles, acquiring important books at affordable, postwar prices while avoiding duplication with the collections of the Crerar and the University of Chicago libraries.[30] Wing's personal collecting and generosity made the foundation possible and the board's principles shaped the parameters for its development, but Butler gave that development its special and enduring character.

Butler's three successors as Wing Custodian—Ernst Detterer (1932–1947), James M. Wells (1951–1984), and Paul F. Gehl (since 1987)—have shown how a curator can put his or her imprimatur on a specific collection. Each has taken the Wing Foundation in a slightly new direction. Detterer, for example, bought relatively few incunables, because their prices had skyrocketed, and instead initiated new emphases on sixteenth-century books and fine modern printing. Likewise, and very significantly, he removed Butler's restrictions on writing and branched out into calligraphy (see no. 61).

In adjusting the library's collecting to take account of market forces and the availability of externally assembled collections as well as to emphasize their own special interests and knowledge, Newberry curators such as Detterer have played the leading part in developing the collection, especially its rare materials. They have also balanced acquisition by purchase with acquisition by gift, an important element in the evolution not only of the collection but also of the very idea of the Newberry. And what is true about the successive leaders of the Wing Foundation is also true of those who have guided the development of the Edward E. Ayer, Everett D. Graff, and other great individual collections.

Staff Culture, Scholarship, and Exhibitions

Butler exemplifies another prominent characteristic of the Newberry: the strong, scholarly bibliographic and curatorial culture of its staff. Despite going on to become a leader of the new School of Library Science at the University of Chicago, he was in fact not trained as a professional librarian, unlike most heads of the institution until Pargellis. At the Newberry, however, his late-medieval historical expertise provided him with the opportunity to pursue a range of important bibliographical and scholarly projects, in addition to buying books, and throughout his career he produced a substantial body of scholarship.

Many of the curators who followed Butler have produced works of even greater scholarly achievement. Most notable of all is Hans Baron, a German emigré who found a congenial home at the Newberry as chief bibliographer of European history (1949–1965). While bringing to the library an amazing array of early-modern materials—books, pamphlets, and manuscripts (such as no. 92)—he simultaneously completed *The Crisis of the Early Italian Renaissance* (1955), a major examination of civic humanism, and other notable books and articles. Since Baron's time, a stream of important studies on medieval and early-modern topics have come from Newberry curators and other staff, including David Buisseret, Paul Gehl, Robert Karrow, Mary Beth Rose, Paul Saenger, John Tedeschi, and Carla Zecher. Directors of the McNickle Center for American Indian and Indigenous Studies (see below), especially Frederick Hoxie and Francis Jennings, have frequently produced influential scholarship in their discipline. Paul Banks, a leader of the modern paper-conservation movement, wrote a string of important articles and short books in that field. The Newberry staff as a whole have become increasingly productive as scholars. In 2006–2011 alone, they published four books, edited nine books or catalogs, published thirteen refereed articles and twenty-one other articles or book chapters, and made 160 professional presentations. The staff's commitment to research and writing matches that of the library's readers, enhancing the institution's overall reputation and influencing the world of humanities scholarship.

Butler modeled staff activity in two other notable ways. First, he produced successive checklists of fifteenth-century printed books, which aided the Newberry and other American libraries in developing their incunable collections. His experience as a young researcher persuaded him that it was critically important for scholarship to uphold high bibliographical standards.[31] He set just such a standard for the production of bibliography, establishing a model for subsequent staff. Checklists, bibliographies, and catalogs have streamed from Newberry curators and professional librarians across the decades. Among the most influential in drawing readers

Newberry Library Staff Photograph (May 28, 1928).
NL Archives, 15/01/02, Box 1, Folder 2.

to the Newberry have been Ruth Chapman Butler's crucial checklists for Ayer Collection manuscript and linguistic works (1937 and 1941, respectively), Virgil Heltzel's heavily used *Check List of Courtesy Books in the Newberry Library* (1942), Colton Storm's massive *Catalogue of the Everett D. Graff Collection of Americana* (1968), and Saenger's *Catalogue of the Pre-1500 Western Manuscript Books at the Newberry Library* (1989).

Among Pierce Butler's other projects were exhibitions on incunabula and early editions of Virgil. For more than a century, the Newberry's curators and librarians have industriously shown the treasures housed here in order to stimulate the collection's use and to contribute educationally to the community. Most often the works on display have come exclusively from the Newberry's own collection, as in our current Spotlight Series. But partnerships with individual collectors and other organizations have frequently resulted in important shows at the Newberry and elsewhere, from the annual exhibitions of fine printing undertaken with the Society of Typographic Arts in the 1920s and '30s to the Chicago-wide Festival of Maps in 2008 and the Library of Congress Abraham Lincoln bicentennial show in 2009.

Expanding public awareness of such topics as fine commercial printing and book design has been one important outcome of this longstanding program, following up on the early commitment to education through exhibitions. Another result of exhibition activity has been the staff's own deepening knowledge of the collection. Without the many hundreds of exhibitions hosted by the Newberry since 1909, much of the collection would have remained *terra incognita* to the staff, as well as to readers.

3. Advanced Studies and Lifelong Learning

Pargellis's 1943 statement of policy placed service as a humanities research and reference library for the "Chicago metropolitan area" first among the Newberry's functions. In going on to reject "passive" collection building and envisioning the Newberry also as a "center of humanistic interests," he had what he called the "serious scholar" squarely in mind. Like Poole before him, however, Pargellis strongly emphasized the need for the institution to provide "certain kinds of educational activity." The Newberry, he said, should both support the work of the professional scholar and writer *and* provide substantial educational opportunities for the interested general public. He wanted the library to "come to occupy an active and significant place in the community," by featuring and supporting lecture series, concerts based on the music collection, and adult classes on these kinds of topics.[32]

The Newberry has pursued this goal with increasing vigor across the past seven decades.

An Intellectual Intersection
The fellowships program was only the first of Pargellis's concepts for building at the Newberry a "center of humanistic interests." In September 1950, a blue-ribbon committee of university deans and librarians, with several library trustees in attendance, recommended that the Newberry "should become more than before a national institution, a scholar's Library in so far as full development of our special fields is concerned." The increased publication of catalogs, the writing of scholarly essays about the library's holdings, and the hosting of academic conferences would provide the means for this change.[33] A series of such conferences commenced the very next year, on American studies and then on Renaissance and American Indian studies. Additional conference subject areas in the mid-1950s included English history (Pargellis's field), university history, Hispanic-American studies, and French history. The American and Renaissance studies conferences continued annually for many years, helping to establish the Newberry as an institution with serious scholarly ambitions.

This latest refinement of the Newberry idea, now with an emphasis on providing leadership for the humanities as a whole, advanced much further in the Towner era. At the core of Towner's vision was the establishment of ongoing centers for research and allied educational programs in "emerging areas of scholarship in which the Newberry's collections are particularly strong."[34] His approach rested in large measure on an interest in promoting effective use of the collection,[35] as became clear with the founding of the first center.

In 1966 Towner worked with Chicago book and map dealer Kenneth Nebenzahl (who eventually became a trustee) to create a lecture series in the history of cartography, in memory of the Nebenzahls' son. Towner and Nebenzahl arranged for R. A. Skelton, longtime superintendent of the Map Room in the British Museum, to deliver the inaugural lectures. His visit gave him the chance to look carefully at the Newberry's map and atlas collection and to develop a report on these holdings, which from an early stage included manuscript maps and many important atlases.[36] Skelton's report concluded that in the existing collection was "already available a large proportion of the materials needed for studying the general history of cartography."[37] These materials, Skelton asserted, deserved careful attention and greater development, which, if realized, would equip the Newberry "to serve as a regional center … for the history of geography and cartography." It would

thereby provide "a broad base for the sustenance of research projects" in a field that would otherwise continue to lack "systematic and continuous support."[38]

Using these arguments, Towner persuaded the president of the board of trustees, Hermon Dunlap Smith (1900–1983; see no. 82), to establish a very substantial endowment to help support a research center and provide funds for map and cartographic-book purchases. From the time of David Woodward's appointment as its founding director in 1971, the Hermon Dunlap Smith Center for the History of Cartography has tended not only to scholarly needs, publishing newsletters and the ongoing Nebenzahl lectures (in

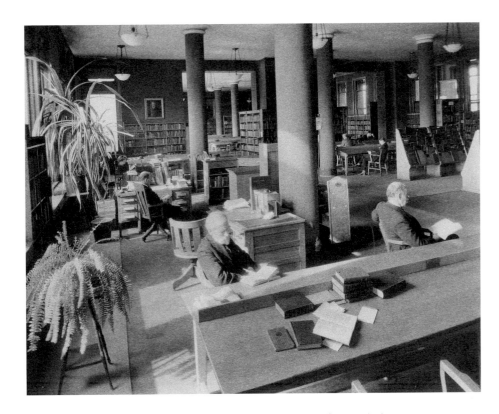

Newberry General Reading Room (1920). NL Archives, 15/01/03.

a series that now numbers fifteen volumes), but also to the interests of lay people through courses in map-making and sponsorship of the Chicago Map Society. The dozens of Smith Center programs across the last forty years include the creation of online resources to bring historically significant map documents into school classrooms.

Each of the Newberry's three other centers also grew out of a great institutional strength, as Towner intended. The Center for the History of the American Indian (established in 1971), now called the McNickle Center for American Indian and Indigenous Studies, was a perfect fit for an institution that has held since 1911 the magnificent, ever-growing collection named for Edward E. Ayer, a trustee from 1892 until his death in 1927 (see no. 30). Ayer's is surely the single most important collection given to the Newberry and arguably the most important such collection anywhere related to the native peoples of the Americas (see no. 17). The Center for Family and Community History (also founded in 1971), later renamed the Dr. William L. Scholl Center for American History and Culture, developed because of the Newberry's fine collections of American history and literature and genealogical materials, with their special emphasis on the Old Northwest and the modern Midwest. Chronologically the last of the centers to be founded, the Renaissance Center (1979) actually has the longest pre-history, going back to the

inauguration of the annual conferences on the field in 1951. In this case, the library's late-medieval and early-modern manuscripts, incunables and other holdings in the book arts, sixteenth- and seventeenth-century works in Western European vernaculars, and special gatherings of genres such as emblem books and courtesy literature (see nos. 95, 99) all made the institution a natural site for such a center.

The wide variety of programs promoted by each center includes in particular graduate-student research opportunities and conferences held in recent years under the auspices of university consortia created by the McNickle and Renaissance centers. Other important initiatives supporting advanced training for graduate students have ranged from the Summer Institutes for Quantitative History (1973–1982) to the longstanding summer paleographical training programs in early-modern vernaculars (since 1980) conducted during recent years in concert with other libraries. The centers have hosted and sponsored scores of ongoing seminars for scholars from the Midwest, as well as summer seminars for college and high-school teachers.

In short, each center has served as a communication node for a set of disciplines, bringing scholars in touch with one another and with new intellectual problems and approaches, and facilitating their acquisition of new skills. The widespread appearance of field-based centers

at universities since the 1970s testifies to the Newberry's impact on scholarship. It is not too much to say, for instance, that no single institution anywhere has played a more profound part in the development of the history of cartography and American Indian Studies than has the Newberry. A principal consideration in explaining the centers' effects is their habitual practice of bringing scholars from across the academy into ongoing engagement on a neutral terrain, where the quality of ideas matters more than the participants' official rank or institutional affiliation.

The centers have exerted influence in another major way: they have drawn attention to the collection itself. Scholars who come to the Newberry for a conference, training session, or other program have inevitably found themselves drawn to the reading rooms, where time and again they have come upon things that they did not know about before and suddenly realized they needed to read. Often they have explored in depth items of which the Newberry staff were previously unaware, knew only slightly, or did not know were connected with important materials elsewhere. This two-way traffic has surely made the intellectual intersection that is the Newberry productively busy.

Projects and Publications
Pargellis understood that a center of humanistic interests would need its name burnished by sponsored publications that went beyond bibliographic works, however important these might be. He began by establishing the *Newberry*

Library Bulletin in 1944, as suggested to him by his predecessor, Utley. It was intended to tell the institution's story and articulate its theory of scholarship. This periodical shed light on the Newberry and its history, but it had less impact than subsequent publishing projects.

The first of these involved the distinguished Chicago bookdealer Wright Howes (1882–1978), a collecting and travel partner of Graff and a Newberry Fellow who, in 1954, with support from the library, published *U.S.IANA*, a bibliography of significant and scarce works of Americana. This undertaking obviously related to the ongoing series of bibliographical works that describe the Newberry's collection, but *U.S.IANA* ventured farther afield and became a standard reference work for collecting Americana beyond the Newberry itself.

The Newberry in Towner's era experienced a vast extension of such projects, in connection with his vision of the Newberry as, in part, "a Research and Development Center."[39] In some ways, the most notable is a complete, standard edition of the works of Herman Melville (fifteen volumes, 1968 to date), undertaken in conjunction with Northwestern University and its press. Beginning in 1966, the Newberry attempted to acquire all editions, variants, and translations of Melville's works, as well as all scholarship written about them. These materials were used by the external editors of *The Writings of Herman Melville* in establishing for each work a text that was as close to Melville's intention as possible (see no. 70).

Four map-based projects ran alongside Melville's *Writings*, each a perfect fit with the Smith Center's mission. The first was the *Atlas of Early American History*, another collaborative effort, which began at the Institute of Early American History and Culture in 1969 and relocated the next year to the Newberry, where it received not only housing but substantial fundraising and staff support, including the help of ACM students. Under the editorship of Lester Cappon (1911–1981), it appeared in 1976, as a co-imprint of the library and the institute. Among its staff were Helen Hornbeck Tanner (1916–2011) and Adele Hast, the editor and associate editor, respectively, of the *Atlas of Great Lakes Indian History* (1987). This project was undertaken in conjunction with the Newberry's American Indian Center. Like the early American atlas, it had major funding from the NEH, as did a third

Lawrence W. Towner (third from right) speaking with President Ronald Reagan, in the company of National Endowment for the Humanities Chairman William J. Bennett (far left) and independent institution librarians Edwin Wolff II, Louis Tucker, and Vartan Gregorian (Washington, D. C., December 8, 1982). NL Archives, 15/01/01, Box 2.

initiative, the American county boundaries project, under the editorship of John Long, also an alumnus of the early American history atlas. Its earlier, four-volume version appeared in 1984, and a second, *Atlas of Historical County Boundaries*, reached nineteen printed volumes before its completion online in 2010. Other large team-based Newberry projects ranged from Robert Karrow's training program for the cataloging of Midwest maps in the 1970s to the *Encyclopedia of Chicago*, coedited by James Grossman in the 1990s and 2000s in partnership with the Chicago History Museum.

Over time, the publishing and project dimensions of the Newberry idea have taken on a largely American cast because of the collection's American strengths and the availability of grant money. But not all such endeavors have been American. In the late 1960s and '70s, projects included the preparation of scholarly editions in conjunction with the Renaissance English Text Society, and, under the auspices of the Smith Center, five volumes with the Society for the History of Discoveries. Similar publications were prepared for the *Corpus Reformatorum Italicorum*, an initiative that helped to pave the way for the establishment of the Renaissance Center.

In these varied ways, since the 1960s the externally funded project has become a crucial part of the Newberry. Along with the fellowship programs and the research centers, and to some extent in conjunction with them, these initiatives have helped to realize Towner's ambition to build an institution that is "not only a library in the traditional sense" but also "a Center for Advanced Studies."[40]

Programs for the Public and for Teachers
And what of Towner's desire also to create at the Newberry "a Center for Non-traditional Education"? This goal was consonant with another element of the 1950 blue-ribbon committee's prescription for the institution. The Newberry, it said, should not only become a research institution with national scope but also, as "a local institution," "expand its services to the community." The committee believed that this would mean more lectures, exhibitions, and concert series, and even what were termed "classes to encourage self-education."[41] The disappearance of the university extension courses favored by Poole had been followed by decades of quiescence in public education. The re-emergence of public programming began with six concerts featuring early, baroque, and classical music, presented to large audiences in 1946 and 1948. These outreach events were not sustained, however, and a regular program of music with a strong educational component involving pre-concert lectures did not resume until 1982, with the beginning of the Newberry Consort under the leadership of Mary Springfels. Pargellis did try other approaches to public education: one was to allow

the Society of Typographic Arts to set up a workshop in the Newberry's basement, where the society conducted courses. Another, when *Poetry* magazine was on the brink of disappearing in the 1950s, was to bring that operation to the Newberry, where it remained for half a century, promoting modern poetry to a large audience.

From the 1970s, the research centers themselves have performed public educational functions. Nowhere was this more true than in the cases of the McNickle Center, which established and has maintained close relations with the American Indian community in Chicago, or the Scholl Center, which originated the Chicago Metro History Education Center, whose History Fair annually engages 15,000 Chicago-area students. Surely one of the most important community resource offerings of the Newberry has been its genealogical expertise, which its staff have made available through regularly scheduled sessions for beginners and more advanced inquirers. These sessions have often been held at libraries throughout the Chicago area.

"Classes to encourage self-education" began in earnest only in the late 1970s and grew into a major adult-education program once the Cobb building was renovated in the mid-1980s. The Newberry's seminar-style offerings range from history and literature to current Chicago topics to creative writing and book arts. Some courses have attained legendary status and been fully enrolled every time they have been offered. Today it is common for 1,500 adults to enroll each year.

Adult education played a central role in the increased level of public outreach initiated by Charles T. Cullen, Towner's successor as president (1986–2005). During the Cullen era, the Newberry also expanded the scale of its exhibitions, which now utilized more exhibition space and drew significantly larger audiences to shows of sophisticated design, such as the one marking the Elizabeth I quadricentennial in 2003. Even when they included borrowed material, these exhibitions remained focused on the institution's strengths and were intended to help promote the collection's use.

Collection use has also figured notably in the Newberry's relatively recent reinvolvement with secondary education. Professional-development seminars for Chicago and suburban teachers promote their own learning in order to advance that of their students. Usually led by area university faculty, these sessions focus on acquainting teachers with the latest scholarly thinking related to the history and literature taught to high-school students. A key element of the Newberry's teacher programs has been to familiarize participants with original source material, typically the institution's own.

In short, the evolution of the Newberry idea toward being simultaneously a national scholarly and a local educational resource, articulated in 1950, was realized within half a century.

Supporting the Newberry Idea

Institute for advanced study, local educational resource, scholarly sanctuary, public library: the Newberry idea has made the institution a capacious enterprise. But the cost of that capaciousness has been high in two respects.

First, there is inherent tension in a mission that emphasizes both the scholarly community and the educated public. The problem of collecting for two different audiences was clear to Poole and his trustees, and it was very much on the minds of those wrestling with collection development in 1930.[42] It has only grown as the specialization of scholarship and the alternatives to library-based reading have accelerated. Today the staff resources needed to serve scholars and the public simultaneously are often not identical, in reference assistance and many other activities. Organizational structures have sometimes underscored rather than reduced this kind of tension. The longtime separation of the staff into divisions of Library Services, Collection Development, and Research and Education established a set of assumptions—only partially accurate—that building a collection, maintaining that collection and serving readers who use it, and running scholarly and educational programs are distinct activities.

Second, the financial cost of developing and operating the collection and myriad programs eventually became too great even for the Newberry's large initial endowment. Throughout the Pargellis era, operating costs and income were at least balanced, and often there were surpluses. The Newberry's endowment in these years tended to consist of approximately fifty percent stocks (more than twice as much common as preferred), twenty-five percent bonds, and twenty-five percent income-yielding mortgages held. Even so, trouble was brewing for the long run, because the building needed expansion in order to accommodate the growing collection, and future growth in book purchases would demand more income than the existing endowment could provide.

In the 1960s, income grew by only 3.7 percent per year overall, but expenditures increased by 7.9 percent annually. By 1970, therefore, the Newberry, so well managed financially for so many decades, was in deficit, even before the great national inflation and the library's much-needed big building projects of the following two decades. The purchase in 1964 of the Louis H. Silver Collection (see nos. 58, 101) for $2.7 million contributed significantly to this situation, and the sale of duplicate material from that collection did not replenish the endowment funds used for the purchase.[43]

Thus commenced a long-term challenge to arrange for the financial support of the Newberry. It might reasonably be argued that the trustees' decision in 1892–1893 to leave the Cobb building half completed[44] signals the founding generation's determination to preserve capital for acquisitions and operations, so that the Newberry might remain freely available to the public. By contrast, the stack building construction and thorough Cobb building renovation projects of the 1980s, which were so essential to care for the collection and provide space for programs, augmented the institution's availability but unfortunately worsened the recently developed budgetary deficit with a heavy load of debt service.

The Newberry adopted several ongoing solutions to its financial problems. One was to curtail expenditures. On several occasions since the 1970s, the library has dramatically cut spending, most recently during the financial and economic crisis of 2008–2009. Consequently, though never an institution given to excess, it has long been a very lean enterprise. Its staff members have borne much of the burden, through very modest salaries, slow compensation growth, and heavy workloads. Fortunately, their exceptional dedication and efficiency have kept the institution's leanness from interfering with service to its users.

Another solution was to initiate a professional fundraising program, with an annual appeal for unrestricted giving that could be used to offset inadequate endowment funds. The development of the Associates Council in the 1960s marked the beginning of these efforts (see no. 49), which eventually included special fundraising events such as the celebrated Book Fair and a special holiday gift sale. None of these ventures could have succeeded without the involvement of hundreds of dedicated volunteers. By contrast, large-scale campaigns to help create or augment endowments and fund positions as well as to pay for capital and other projects, such as the conversion of the card catalog to an online, digital format, have depended on the work of a professional development staff in conjunction with the trustees. Individual and foundation giving have made an enormous difference to the institution's capacity not only to survive but also to thrive as an independent institution, when a number of other free-standing libraries have had to move under the wing of a sheltering university.

For programmatic support, the Newberry turned to grant funding, most of it achieved competitively. In addition to the aforementioned grant from the Mellon Foundation, nearly $7 million came to the Newberry from the NEH in competitive grants for fellowships and research projects initiated during the 1970s. Towner and his close colleague Richard H. Brown, the Newberry's academic vice president, learned how to develop solid, attractive research projects and write the kinds of persuasive proposals needed to secure grants for them.

These grants proved altogether crucial. Among other things, they have made, and continue to make, the research centers possible, since none is as yet fully endowed. Grants have kept the centers at the cutting edge of their fields, readily responsive to potential good ideas generated by

Newberry staff, interested outside scholars, and granting agencies themselves. The downside of obtaining grants is the large amount of time staff must devote to writing proposals, but the benefits of this kind of funding to scholarship, teaching, and education generally have proved enormous.

4. A Story of Collection Stories

"The library is the heart of the university," asserts many a neglected university building inscription. At the Newberry, even considering the crucial roles played now and in the past by people and programs, the collection is indeed the heart of the library. The collection has determined what our programs are, and for decades its development has been largely determined by our existing strengths. Today we describe these as American Indian and indigenous studies; American history and culture; Chicago and the Midwest; genealogy and family history; the history of the book, printing, and the book arts; maps, travel, and exploration; the medieval, Renaissance, and early-modern world; music and dance; and religion. It was not always thus.

Collection-building after 1896 focused on the humanities. By 1930 the Newberry defined this term as a "field" that in a general way embraced the "two great subjects of History and Literature."[45] At present we might speak more specifically of language and literature, history, philosophy, the history of the fine and performing arts, and some aspects of anthropological, political, religious, and sociological studies. We might add, and our predecessors might agree, that the humanities pay profound attention to humankind's pursuit of meaning, and that the academic disciplines ranged under the term "humanities" tend to pose certain kinds of questions connected with familial, social, cultural, and moral existence, both at specific times and across time. Such interests and questions tend to be involved with language rather than with numbers, and therefore language itself and the linguistic and technological forms of communication that it makes possible are also vital to the humanities.

So defined, the humanities still constitute an enormous swath of human intellectual and cultural endeavor, and naturally, then, the Newberry has had to decide which aspects the collection should emphasize. To a substantial extent, the decision has been made in terms of geography and period. Although the library once housed a substantial amount of material from and about the Middle East, and as late as 1908–1910 purchased 21,403 volumes from East Asia,[46] for many years its geographical focus has been on Western Europe and the Americas. Its chronological emphasis falls on the period from the later Middle Ages to the nineteenth century in Europe and Latin America and to the late twentieth century in the Midwest and Chicago.[47]

The Newberry also decided to concentrate more on primary sources, and especially original source material, rather than on secondary works. The 1930 statement about the collection's development called these sources "the fundamental documentary material which is the basis for original and creative work," including sources "coming out of the past as are contemporary with the events or conditions investigated."[48] This emphasis on primary sources took into account the presence in the Chicago area of other great research libraries with superb collections of their own, including secondary materials needed by students and faculty, such as doctoral dissertations. The policy's repeated endorsement in recent decades has been based on the increased use of interlibrary loan arrangements, and especially the Newberry's membership in the Illinois academic and research library consortium (CARLI), which has freed time and money for the acquisition of unique or rare materials.[49] Institutional strength in the history of the book, epitomized by the Wing Foundation, has increased our emphasis on primary sources in their original or at least early states. Of course, all along collecting has meant buying definitive scholarly editions of primary source material and secondary literature—monographs, periodicals, and other serials—that have special bearing on Newberry strengths. But scarce dollars have gone to original sources first and to everything else afterward.

Again and again, the Newberry has declared a commitment to concentrating on its strengths. "If the Library possesses a strong collection in a certain restricted area, that fact warrants repeated additions to the collection and suggests special efforts to increase its usefulness," said the anonymous author of the 1930 statement of policy.[50] Pargellis likewise insisted on the "strengthening of the holdings in those subjects in which the Library is already strong or well started."[51] Not that building on strength always meant resisting innovation. The 1930 statement was soon followed, as we have seen, by Detterer's acquisitions of previously proscribed materials in calligraphy, now a famous part of the collection. Pargellis himself argued for adding the archives of important Midwest businesses, on the grounds that future American historians would surely consider the century after the Civil War to have been marked above all by the development of business (see no. 35). Today the Newberry considers Midwest business archives to be a central collection asset, along with the papers of Midwest journalists and other authors, clubs, and societies. In short, the list of collection strengths has evolved, because, as Wing Foundation custodian James M. Wells wrote in 1972, the Newberry "has constantly refined its collecting programs . . . , sometimes in response to changing needs or circumstances and sometimes as a result of an unexpected gift or bequest."[52]

The collection's strongest features, built and refined across 125 years, provide the categories in this book for telling the collection's story, and through it the story of the Newberry as a whole. The particular stories of 125 individual items shed useful light on our collection strengths; these narratives and categories together give meaning to the entire institutional enterprise. The examples we have selected could have been arrayed differently, of course. We might have presented them by format type: printed books, manuscripts, maps, music, pamphlets, prints, ephemera. The Newberry is well known for each of these formats, and they are all represented here. Indeed, formats count for a great deal in a collection like ours. As Skelton wrote, with the Newberry in mind, the "study of content and the study of form or construction are inseparable, and each reinforces the other."[53] But notwithstanding the concentration in the 1920s and '30s on incunables as the very first exemplars of a particular format, curators and others charged with collecting here have long crossed format boundaries in their daily quest to understand and augment the collection.

We could have described our 125 items, or at least many of them, in terms of their association with great named collections and archives at the Newberry, such as the Ayer Collection concerned with the native peoples of North and South America, the Barzel Collection of dance, the Baskes Collection of books with maps, the Bonaparte Collection of philological and linguistic books, the Chicago, Burlington & Quincy Railroad Archive, the Driscoll Collection of sheet music, the Graff Collection of Western Americana, the Greenlee Collection of Brazilian and Portuguese materials, the Novacco Collection of Italian printed maps, the Ruggles Collection of American and English books and manuscripts, the Silver Collection of early-modern first editions, and the Wing Foundation collection on the history of printing, bindings, calligraphy, and other book arts. Indeed, for many years the named-collection approach was central to the Newberry's self-identity. "An uncommon collection of uncommon collections" was how Towner described the library—emphasizing its "special collections" and great collectors—and the phrase stuck.[54]

Unfortunately, the concept of a collection of special collections obscures as much as it reveals. For one thing, the Newberry's "general" collection is chock-a-block with original sources of great importance and rarity. For another, vast quantities of Newberry materials cross over between and among the concentrations that characterize individual special collections. With his deep experience at the British Museum, Skelton quickly understood this essential fact about the Newberry: "The usefulness of a special collection or department within a library is enriched by its juxtaposition with others. Thus maps illustrating the history of America or of the Middle West may also be

interesting to the student of printing history or of graphic art. . . ."[55] In fact, collecting at the Newberry has developed more and more so as to attempt to acquire things that fit with the emphases of multiple "special collections," and that represent not one but several subject categories and collection strengths. One of the lessons of the selection process for this book is just how many of our original sources are difficult to pigeonhole—a fact worth relishing rather than a problem in taxonomy.

These 125 items might have been divided up according to language. An important characteristic of the Newberry is, after all, that we have a collection of primary sources strikingly rich not only in English and Latin but in Continental European vernaculars, particularly French, Italian, Spanish, Portuguese, and German. It would also have been interesting to display these materials by dates of accession, which range from 1889 to 2009. The largest single number came in 1911, the year that most of the Ayer Collection arrived, which illustrates that collector's extraordinary accomplishment and the enduring remarkable relevance his books have had for the collection as a whole. That forty-eight of the 125 objects featured here have come during the past thirty years and twenty-one in just the past decade suggests not just curatorial familiarity with recent arrivals but how active the Newberry has remained in building its collection, despite budgetary challenges since the 1970s.[56]

Finally, we could have created subject categories meant to challenge standard ways of thinking about the collection. (We actually did this in the exhibition organized to coincide with the publication of this book.) Such a category is "arts and letters," a term more familiarly found in the organizational nomenclature of some universities than in the labeling common to research libraries. In the Newberry's case, it calls attention to the fact that, although we are not a museum, we have materials that are not only literary but also appropriate for inclusion in an art museum. Among our 125 items, this category is expansive enough to hold groupings in typography, fine bindings, calligraphy, artists' books, early music, visual arts, Renaissance literary pathbreakers, and modernism. Another large category that captures many of our 125 Newberry collection examples might be labeled "politics and commerce," words that today hang together somewhat uneasily but that fit a large portion of the Newberry's holdings. Here our offerings fall into subcategories such as advocacy, encounters, building nations, and commercial culture. "Families" represents still another prominent grouping, considering the word in its classical Latin meaning of "household" as well as in the more recent, narrower definition. An enduring part of the Newberry's collection and program for more than a century, the history of the family emerges through genealogical inquiry and the materials that support it, and

in myriad other ways. This portion of our 125 objects can be divided among such subcategories as birth families, constructed families, families apart, and families brought together through research.

In the end, our approach to presenting our selections grows out of a longstanding concern at the Newberry with the use of materials. That is, we have sorted them into a set of categories that serve fields of study today and in all likelihood for years to come. Doing so keeps us true to the perennial Newberry conviction that the collection lives when used, and that we must think of it in terms of its usage. (For a recent example of such use, see no. 104.) Many of our 125 items could easily appear in two or even more categories. This fact simply confirms our conviction that we should acquire items that serve multiple-use purposes, especially in an era when scholarship is drifting away from old disciplinary moorings (examples acquired relatively recently include nos. 18, 52, 108).

Here arises a difficult problem in librarianship. Should readers' recent, current, and anticipated needs drive collecting, or should curators employ their own creativity to assemble collections that readers will find irresistible, thereby shaping usage? The Newberry's overall history suggests that curatorial initiative and responsiveness have figured in our collection development. The individual narratives that follow provide substantiating details of both kinds of activity, and they also show how curators often collaborate to acquire just the right thing (see no. 75).

Likewise, the stories offer insight into the balance between purchase and gift in the Newberry's collection building. Currently, no statistics exist to document with anything like precision what this balance has been during the past century and a quarter. In the case of the library's 1962–1963 exhibition "Treasures of the Newberry Library," purchased items outnumbered gifts by almost five to one. In the present book, the ratio is closer to one-to-one, which, the staff generally agree, reflects the relationship between purchase and gift among important original sources added in the last generation.

To put the matter another way, the powerful curatorial impact on the building of this collection exemplified by Butler does not diminish in any way the vastly important effect of donors and outside experts. Where would the Newberry be but for Mssrs. Ayer and Wing and their passionate, generous successors? Without their collections and their funding to maintain and extend them, the Newberry would not exist. And if this is true of individual donors, it is also the case with regard to institutional donors. Within the last three decades, Chicago seminaries and colleges have given the Newberry rich collections of religious materials (see nos. 120, 124), which have complemented perfectly a strength that dates back to its very first book, a Bible, but that was forgotten for some years.[57] Similarly, how much do we owe also to those, from Upton in the 1880s and 1890s to Skelton in 1966, to the Chicago-area professors of today, who have lent their expertise by advising us on how to move forward—in some instances, such as Howard Mayer Brown, with his deep knowledge of and commitment to music, actually giving us wonderful collections or financial support or both. Their valuable assistance appears repeatedly in the stories that follow.

Whether insiders or outsiders, people who come to 60 West Walton often end up using the word "surprising" to describe our holdings. Those who have collected for the Newberry, both staff and donors, have assembled material that one would simply not expect to be at the Newberry or in Chicago at all. The combination of collection breadth and depth can be startling to readers, who often express amazement at what they uncover with the help of the catalog and reference staff. Surprise goes hand in hand with curiosity to make the Newberry a place alive with intellectual energy.

Taken together, these 125 individual stories reveal the Newberry's beating heart at work-and-play. Collecting often is a form of play, in the sense that Johan Huizinga had in mind when he described the central role of *homo ludens*, playing man, in the building of civilization. Although some play can turn out to be intensely serious, it always involves fun, and whatever stumbling blocks collectors, curators, and librarians might encounter along the way, they most surely experience fun and even joy in creating their own collections or in shaping those of an institution. Likewise, said Huizinga, play not only involves rules but actually brings order out of the chaos of life, and surely, too, the building of a collection is an ordering exercise of a very sophisticated and sometimes elegant kind.[58]

As a set of actions over time, collection development responds to the powerfully important but tremendously difficult question for a research library or a museum: what portion of the entire cultural legacy shall we bring together and preserve? The Newberry answers that question uniquely. There is nothing else like our evolving collection; there is nothing else like what Walter Newberry's idea has become.

1 "Inaugural Address of Walter L. Newberry, Esq., President of the Young Men's Association" (Feb. 10, 1841), *Chicago Daily American*, Feb. 20, 1841, 2:3.

2 Accession Catalog of the Newberry Library, Newberry Library (NL) Archives, 12/04/51, vol. 1.

3 Poole to F. C. Wurtele (Québec Literary and Historical Society), Jan. 4 [188]8, Newberry Library Archives, 03/01/02/02, Poole Letterpress Copybooks, Box 2, Folder 5, f. 24 (out of alphabetical order).

4 Poole to H. C. Potter, July 27, [188]8, NL Archives, 03/01/02/02, Poole Letterpress Copybooks, Box 2, Folder 5, f. 41 (out of numerical order).

5 *Proceedings of The Newberry Library for the Year ending January 5, 1889* (Chicago, 1889), 3.

6 Poole to Rev. Joseph P. Roles (St. Mary's Church, Chicago), Mar. 30, [188]8, NL Archives, 03/01/02/02, Poole Letterpress Copybooks, Box 2, Folder 5, f. 32.

7 *Proceedings of The Newberry Library for the Year ending January 5, 1892* (Chicago, 1892), 4.

8 Only half of the southern half of the building as planned by Cobb and Poole was constructed by 1893; the northern addition was never begun.

9 The architectural battle and its underpinnings are most fully related by Houghton Wetherold, "The Architectural History of the Newberry Library," *Newberry Library Bulletin* 6 (Nov. 1962), 3–23 (see esp. 6–8). The article and a vast amount of original source material completely undercut the claims that the Newberry was designed to be a "gentleman's library" with "cozy nooks" for reading, as if it were a "gentleman's estate." See for example Donald L. Miller, *City of the Century: The Epic of Chicago and the Making of America* (New York, 1996), 404–5. Curiously, Miller cited the Wetherold article (613n.).

10 Clement W. Andrews, John Vance Cheney, and Frederick H. Hild, "Report," in Minutes of the Board of Trustees, June 24, 1896, NL Archives, 02/01/21, Box 3, Folder 1.

11 Interestingly, before the middle of the twentieth century the Newberry was buying books from the Crerar. See for example, "A List of Books Added to the Library During June 15–30 [1950]," Book Lists, Nov. 1949 – Oct. 1950, NL Archives, 02/02/02.

12 By a further agreement, in 1948 the Chicago Historical Society and the Newberry extended the principle of non-duplication in acquisitions.

13 *The Newberry Library* (Chicago, [1914]), 5–9.

14 Newberry Library, "Books Shelved in the Exhibition Room," typescript (1927), NL Archives, 09/01/61, Box 1, Folder 1a.

15 *The Newberry Library*, (note 13), 10, 6.

16 *Exhibitions of Literary, Artistic, and Historical Material Held at the Newberry Library, 1909–1918* (Chicago, 1918).

17 The Newberry continued, however, to encourage both high-school students and their teachers to make use of the collection for supplementary reading in their courses, preparation for assigned debate topics, and research for essays and compositions. See W. N. C. Carlton, "The Newberry Library," *Educational Bi-Monthly* (Apr. 1910), 298.

18 William Rainey Harper to William Frederick Poole, July 20, 1892, and Nov. 11, 1892, in Poole Correspondence, NL Archives, 03/01/01/01.

19 Minutes of the Board of Trustees, Dec. 7, 1942, NL Archives, 02/01/30. Remarkably, its recipient, the folklorist and Celtic specialist A. C. L. Brown, of Northwestern University, was a member of the Board of Trustees. He resigned from the board in order to take up the fellowship.

20 [Stanley Pargellis], "General Statement of Library Policy," approved by the board of trustees on Oct. 4, 1943: see Minutes of the board of trustees, NL Archives, 02/01/30.

21 Pargellis to David H. Stevens, Jan. 17, 1944, Stanley Pargellis Papers, Administrative Subject File, NL Archives, 03/05/03, Box 3, Folder 91.

22 Pargellis to John Marshall, Mar. 16, 1944, and Norma S. Thompson to Pargellis, Apr. 6, 1944, in ibid.

23 "Works published by Newberry Scholars-in-Residence, NEH Fellows, and Other Fellows between 2000 and 2011," in Minutes of the Board of Trustees, Oct. 13, 2011, NL Archives, unprocessed.

24 "Newberry Library User Profile and Satisfaction Study: A Benchmark Study" (June 2007), 4, NL Archives, unprocessed.

25 Newberry Library, *Service Regulations* (Chicago, 1919), 3–4.

26 W. N. C. Carlton, *Special Report to the Board of Trustees* (Chicago, 1911), 2–3.

27 Minutes of the Board of Trustees, May 5, 1919, vol. I, 30–31, 34–35, 38–39; and "Report on Policy to be Followed in Inaugurating and Developing the John M. Wing Foundation" (Jan. 27, 1919), 4, 8–10, NL Archives, 02/01/30.

28 Pierce Butler, "A Typographical Library: The John M. Wing Foundation of the Newberry Library," *Papers of the Bibliographical Society of America* 15, 2 (1921), 83–84, 78.

29 Pierce Butler, comp., *A Check List of Fifteenth Century Books in the Newberry Library and in Other Libraries of Chicago* (Chicago, 1933), xvi.

30 Joel L. Samuels, "The John M. Wing Foundation on the History of Printing," Ph.D. diss., University of Chicago (1973), 28–29.

31 Pierce Butler, "Bibliography and Scholarship," *Papers of the Bibliographical Society of America* 16, 1 (1922), 53–63.

32 "General Statement of Library Policy," Minutes of the Board of Trustees, Oct. 4, 1943, NL Archives, 02/01/30.

33 "Report on a meeting of a Special Library Policy Committee," Sept. 23–25, 1950, in Minutes of the Board of Trustees, Oct. 9, 1950, NL Archives, 02/01/30.

34 Lawrence W. Towner, *An Uncommon Collection of Uncommon Collections: The Newberry Library*, 2nd edn. (Chicago, 1976), 37. This booklet was first published in 1970 and appeared in four distinct versions, with a total of eight printings, across sixteen years.

35 E-mail communication from Richard Brown to the author, Apr. 18, 2012.

36 Clara A. Smith, comp., *List of Manuscript Maps in the Edward E. Ayer Collection* (Chicago, 1927); University of Chicago Libraries Documents Section, *Atlases in Libraries of Chicago: A Bibliography and Union Check List* (Chicago, 1936).

37 R. A. Skelton, "First Report: The Map Collections of the Newberry Library," Nov. 3, 1966, 2, NL Archives, 07/07.

38 Idem, "Second Report: A Center for the History of Cartography," Nov. 4, 1966, 2–3, NL Archives, 07/07.

39 Towner (note 34), 31.

40 Ibid.; 3rd edn., 32.

41 "Report on a meeting of a Special Library Policy Committee" (note 33).

42 Outlines of a General Policy of Library Development (Chicago, 1930), 8-9.

43 Jed I. Bergman with William G. Bowen and Thomas I. Nygren, Managing Change in the Nonprofit Sector: Lessons from the Evolution of Five Independent Research Libraries (San Francisco, 1996), 52–55.

44 See note 8.

45 Outlines of a General Policy of Library Development (note 42), 6.

46 Berthold Laufer, Descriptive Account of the Collection of Chinese, Tibetan, Mongol, and Japanese Books in the Newberry Library (Chicago, 1913), 1.

47 It was formerly described as later medieval to Romantic Era in Europe and in Latin America, and to World War I in the United States; Towner (note 34), 1985 edn., 15.

48 Outlines of a General Policy of Library Development (note 42), 8.

49 See the approach suggested in Paul Saenger, "Collecting in the Second Century," Humanities' Mirror: Reading at the Newberry Library 1887–1987 (Chicago, 1987), esp. 46.

50 Outlines of a General Policy of Library Development (note 42), 9. It seems likely that Pierce Butler wrote or had a significant hand in writing this document.

51 "General Statement of Library Policy" (note 32).

52 James M. Wells, "The Present Collecting Policy of the Newberry Library" Feb. 14, 1972, ed. Joel L. Samuels (July 21, 1983), 1.

53 Skelton (note 37), 1.

54 Towner (note 34), 1st edn. (1970), 19.

55 Skelton (note 37), 1.

56 This pattern applied as well to the 1962–63 exhibition that marked the library's seventy-fifth anniversary, "Treasures of the Newberry Library," which drew approximately half of its sixty-five items from the past three decades: calculation made from accession dates given (for almost all items) in Treasures of the Newberry Library: An Exhibition to Celebrate the Renovation of the Library Building (Chicago: [1962]).

57 For instance, Towner described the "general collection" as "a great research collection in the humanities, chiefly in history, literature, music, and philosophy"; Towner (note 34), 1985 edn., 15. His was an era when religious studies were in the doldrums in the United States.

58 J.[ohan] Huizinga, Homo Ludens: A Study of the Play-Element in Culture, trans. R. F. C. Hull (Boston, 1955), 5, 3.

American History
and Culture

FROM THE MOMENT in 1609 when Henry Hudson sailed up the river that now bears his name, the Dutch claimed the Hudson Valley as New Netherland. Settlement followed, and by mid-century there were some 2,000 Dutch in the colony. However, bad governance by the West India Company and two years of intermittent warfare with the indigenous Lenape people left the colony in a sorry state. In 1649 Adriaen van der Donck (c. 1618–c. 1655), the author of this book, submitted a document called "Remonstrance of New Netherland" to the States General in Holland. The "Remonstrance," supported by a popular petition, urged drastic reform of the colony's affairs and its removal from the control of the West India Company.

In the Netherlands, van der Donck lobbied for reform while continuing to seek more colonists. He commissioned a map of the colony by the cartographers Jan Jansson (1588–1664) and Claes Jansz. Visscher (1587–1652), and oversaw a large increase in the number of emigrants. In 1655 he published the first edition of his *Beschryvinge van Nieuw-Nederlant* (Description of New Netherland), and the following year this second edition, augmented by illustrations, a reduced copy of the Jansson-Visscher map, and

Adriaen van der Donck

Beschryvinge van Nieuw-Nederlant

Amsterdam: Evert Nieuwenhof, 1656
Book
7⅝ x 6¼ in. (book)
12⅜ × 7½ in. (map)
Gift of Rudy L. Ruggles, 1985
Vault Ruggles 430 no.1

a document called "Conditions for Emigration." This consists of thirty-five articles that guaranteed to prospective emigrants a certain level of support from both the city of Amsterdam and the trading company, including trade protections, tax relief, and free passage for mechanics and farmers who could prove their ability to make a living in North America. In 1656 alone, seventy Dutch households and 300 Waldensian exiles from Piedmont emigrated to New Netherland, and by 1660, largely thanks to van der Donck's efforts, the European population had increased to some 10,000.

The view of the small settlement of New Amsterdam at the bottom of the map depicts the town as it looked in 1648. So neglected was the colony then that the original drawing (recently discovered in the Albertina, Vienna) shows only two working vanes on the windmill, but van der Donck added two more to present a more prosperous image. In the foreground is the little wharf at Schreyer's Hook (now part of Battery Park). The tall, cranelike structure is actually a fire-basket, which facilitated nighttime landings. The largest structures are three storehouses, the fort, a church, and, at the far right, the city tavern, converted in 1653 to city hall. Scholars have been able to identify most of the buildings indicated, including a number of private homes.

The Indian presence in the area depicted at the top of the map is strongly evident. Five Mohawk villages are indicated along "Marquaa Kill" (today's Mohawk River), including "Assareawe." This is probably Ossernenon, where in 1656, the year this book was published, Kateri Tekakwitha was born. An early convert to Catholicism, she was beatified in 1980 and is scheduled to achieve sainthood in October 2012. Van der Donck's book includes valuable enthographic information about the native peoples, including this description of an Iroquois long house:

> Often there are sixteen or eighteen families in a house, fewer or more, according as the houses are large or small. The door is in the middle, and the people on either side. Everyone knows his place and how far his space extends. If they have room for pot and kettle and whatever else they have, and a place to sleep, they desire no more. This means that often one hundred or one hundred and fifty or more lodge in one house. R.W.K.

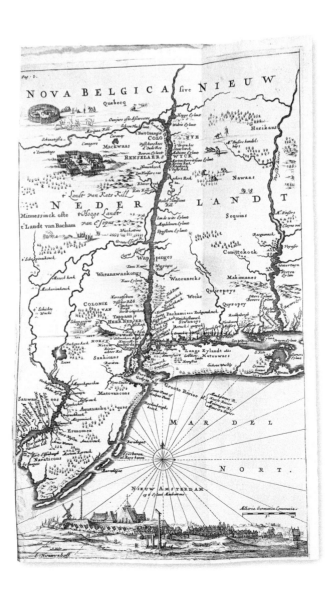

Mary White Rowlandson

A True History of the Captivity & Restoration of Mrs. Mary Rowlandson

London, 1682
Book
7½ × 5⅝ in.
Gift of Rudy L. Ruggles, 1985
Vault Ruggles 303

THE FULL TITLE of this book—the first New England captivity narrative—occupies nearly the entire title page (illustrated below). As can be seen in the opposite illustration, the story begins: "On the tenth of *February*, 1675, came the *Indians* with great numbers upon *Lancaster* [Massachusetts]." Mary White Rowlandson and her children were abducted during King Philip's War (1675–1678; see no. 21) and spent almost four months among the Indians before being ransomed. This tale was written in a highly dramatic tone ("Thus were we butchered by those merciless Heathen") and was extremely popular. Over the past three centuries, Rowlandson's account has become one of the most famous American frontier narratives, a classic of early New England, and a model for the Indian captivity genre.

The Rowlandson captivity was printed four times in its first year—three times in New England and once in London—and went through some fifteen editions by 1800. It helped to establish the Indian captivity narrative as an American genre with widespread appeal. Because early examples tended to be published as pamphlets, most were read to tatters, which is why early editions of the Rowlandson captivity are quite rare and often show signs of heavy use. This copy, the first English edition, comes from the Rudy L. Ruggles Collection, donated to the Newberry in 1985. Like another copy of the London edition found in the Newberry's Edward E. Ayer Collection, it shows the effects of many readings; it lacks the appended sermon of Mary's husband, Reverend Joseph Rowlandson, which is listed on the title page.

Rowlandson's and other captivity narratives of early New England became the prototype for innumerable stories of white pioneer settlers who were captured, tortured, killed, or sometimes redeemed and released, which was interpreted as a demonstration of God's wisdom and mercy. By the late eighteenth century, however, overtly religious themes became less central to these stories. For instance, after the Boston Massacre (1770), newly added prefaces to Rowlandson's tale turned the story of a woman captured by Indians into a political metaphor: the struggle of the American colonies (Mary Rowlandson) against Great Britain (Indian captors). And as the genre became a mainstay of the book trade, the desire for climactic drama and gory sensationalism outweighed concerns for historical accuracy. Not surprisingly, many captivity narratives are more fictional than factual.

The Newberry has been home to one of the world's finest collections of captivity narratives since the donation of the collection of Edward E. Ayer in 1911 (see no. 17). The following year, the custodian of the Ayer

A TRUE HISTORY OF THE Captivity & Restoration OF Mrs. *MARY ROWLANDSON*, A Minister's Wife in *New-England*.

Wherein is set forth, The Cruel and Inhumane Usage she underwent amongst the *Heathens*, for Eleven Weeks time: And her Deliverance from them.

Written by her own Hand, for her Private *Use*: And now made Publick at the earnest Desire of some Friends, for the Benefit of the Afflicted.

Whereunto is annexed,

A Sermon of *the Possibility of God's Forsaking a People that have been near and dear to him.*

Preached by Mr. *Joseph Rowlandson*, Husband to the said Mrs. *Rowlandson*: It being his Last Sermon.

Printed first at *New-England*: And Re-printed at *London*, and sold by *Joseph Poole*, at the *Blue Bowl* in the *Long-Walk*, by *Christ-Church* Hospital. 1682.

Collection, Clara Smith, published *Narratives of Captivity Among the Indians of North America* and another supplement to that list of books and manuscripts in 1928, both of which publicized the collection and have become touchstones for generations of book dealers, librarians, and collectors of this material, who make such references as "Ayer 76," "Ayer Supp. 54," or "Not in Ayer" (the latter indicating a true rarity).

With the acquisition of the Frank C. Deering Collection of Indian Captivities in 1967 and the gift of Rudy L. Ruggles in 1985, the Newberry has continued to expand its world-class holdings. Two recent acquisitions demonstrate this ongoing development. In 2006 the Newberry added a unique Colonial–era survival story, "On the deliverance of Hugh Gibson, a captive with the Indians, 2 years & 10 months." In this 1770 letter to the editor of an unidentified Baltimore-area paper, the author crafted a poem to commemorate the liberation of his friend from captivity. Gibson was fourteen years old and living near Fort Robinson,

Pennsylvania, when his home was attacked by Delaware Indians in July 1756. Gibson's mother was killed, and he was taken prisoner. After almost three years in captivity, he escaped to Fort Pitt in April 1759. Like the original Rowlandson narrative, this eight-stanza poem contains strong religious overtones and, as the following portion indicates, high drama:

> Their warlike shouts, their dreadful screams;
> My doleful Days, and nightly dreams,
> My memory still retains:
> Amazement, dread, and horror filled
> My Soul: the vital blood stood chilled
> And swelled the purple veins.

In 2006 the library purchased a scarce Civil War–era almanac, *The Magnetic Almanac for 1865*, which demonstrates the lasting flexibility of the captivity account. For the most part, *The Magnetic Almanac* functions like a typical almanac—with discussions of tides and astrology—but it also includes an elaborate advertising pitch. In the fanciful "Rescue of Tula," a Dr. Cunard saves an Aztec princess from the Navajos and is rewarded with the secret to Mountain Herbal pills that "will purify and cleanse as sure as the sun will rise to-morrow." These two recent acquisitions not only reflect the variety within the genre—ranging from accounts about real events to outright fantasies—but also demonstrate the continuing efforts to deepen the Newberry's outstanding collection of a fascinating subcategory of American literature, the Indian captivity narrative. J. B.

A Narrative of the Captivity and Restoration of Mrs. *Mary Rowlandson.*

ON the tenth of *February*, 1675. came the *Indians* with great numbers upon *Lancaster*. Their first coming was about Sunrising. Hearing the noise of some Guns, we looked out; several Houses were burning, and the Smoke ascending to Heaven. There were five Persons taken in one House, the Father, and the Mother, and a sucking Child they knock'd on the head; the other two they took, and carried away alive. There were two others, who being out of their Garrison upon some occasion, were set upon; one was knock'd on the head, the other escaped. Another there was who running along was shot and wounded, and fell down; he begged of them his Life, promising them Money (as they told me); but they would not hearken to him, but knock'd him on the head, stripped him naked, and split open his Bowels. Another seeing many of the *Indians* about his Barn, ventured and went out, but was quickly shot down. There were three others belonging to the same Garrison who were killed. The *Indians* getting up upon the Roof of the Barn, had advantage to shoot down upon them over their Fortification. Thus these murtherous Wretches went on, burning and destroying before them.

At length they came and beset our own House, and quickly it was the dolefullest day that ever mine eyes saw. The House stood upon the edge of a Hill; some of the *Indians* got behind the Hill, others into the Barn, and others behind any thing that would shelter them: from all which Places they shot against the House, so that the Bullets seemed to fly like Hail: and quickly they wounded one Man among us, then another, and then a third. About two Hours (according to my observation in that amazing time) they had been about the House, before they could prevail to fire it, (which they did with Flax and Hemp which they brought out of the Barn, and there being no Defence about the House, only two Flankers, at two opposite Corners, and one of them not finished.) They fired it once, and one ventured out and quenched it; but they quickly fired it again, and that took. Now is that dreadful Hour come, that I have often heard of, (in the time of the War, as it was the Case of others) but now mine Eyes see it. Some in our House were fighting for their Lives, others wallowing in their Blood; the House on fire over our Heads, and the bloody Heathen ready to knock us on the Head if we stirred out. Now might we hear Mothers and Children crying out for themselves, and one another, *Lord, what shall we do!* Then I took my Children (and one of my Sisters, hers) to go forth and leave the House:

3

Fur-Trade Contract between François Francoeur and Four Voyagers for Transport of Goods and Purchase of Beaver Pelts in Michilimackinac and Chicago

Ville-Marie, Quebec, 1692
Manuscript
12½ × 7⅝ in.
Ruggles Fund, 2001
Vault Ruggles 419

THIS EARLY fur-trade contract, drawn up in Ville-Marie, Quebec, in 1692, contains one of the earliest manuscript references to Chicago; a former owner of the manuscript underlined the place name in the phrase "au lieu de Chicagou" (in the place Chicago) halfway down the left side of the first page. One of a limited number of legitimate trade contracts that survives from the early years of New France, it underscores the growing importance of the Illinois region to the fur trade by the end of the seventeenth century.

The document established an agreement between François Francoeur dit Lavallée—represented here by his wife, Marie Magdelaine St.-Jean, who was permitted to conduct the couple's joint business affairs while he was in Illinois ("aux Illinois")—and four voyagers (Simon Guillory, Jean-Baptiste Jarry, Louis Roy, and Simon Roy) to travel by canoe to the Jesuit mission and French army post established along what became known as the Chicago River.

The agreement provides an interesting lens into the economy of New France and how tightly it was regulated. It states that each of the men would receive 500 *livres* in beaver pelts, plus food, to embark on an expedition to "Chicagou" via the Straits of Mackinac (Michilimackinac) in their own two canoes to transport merchandise and then make the return trip with beaver pelts. It permits the four voyagers (*hyvernants*) to use one of the canoes to trade 300 *livres* of merchandise each for personal profit at each of the trading centers. Amendments to the agreement are noted with a sophisticated method of footnotes,

In the 1670s, France made a series of attempts to regulate the fur trade by issuing annual licenses. But because only a few dozen permits were granted each year, the only way for an independent voyager who had not received a permit to participate in the lucrative business was to obtain a subcontract. This is why Guillory, Jarry, and the Roys entered into an agreement with Francoeur. Fur-trade contracts played an instrumental role in the developing economy of North America and took on more than just legal significance. They could actually be exchanged for goods and circulated as currency. As Laurence M. Lande, author of the definitive bibliography of Canadiana and also one of the former owners of the manuscript, stated: "The economic existence of Canada itself at first depended upon the beaver trade, and the beginnings of paper money on this continent evolved from the beaver note."

The Newberry purchased this contract in 2001 from Martayan Lan Rare Books of New York City to complement the library's deep print, cartographic, and manuscript holdings on the economy of New France. It predates any other Newberry manuscript mention of "Chicagou" by more than twenty-five years; the next earliest document is Antoine de Cadillac's manuscript transcription of 1718, which describes the French settlement at Michilimackinac, discusses the customs and traditions of the neighboring Indian tribes, and mentions the "Miamis of Chicagou." The Francoeur agreement is a wonderful survival that in two short pages demonstrates the increasing presence of the fur trade in Illinois at the dawn of the eighteenth century and offers a unique glimpse into the early history "in the place Chicago." J. B.

starting with a single caret and adding a small circle to each subsequent annotation (the insertions are labeled ^o to ^ooo). Considering the possibility that such contracts could fall prey to fraudulent emendations, each footnote is carefully initialed by two or three of the parties involved, and the document is signed by St.-Jean and Guillory; the notary, Maugue (with flourish); and two witnesses.

4

A List of All the Officers of the Army: viz. the General and Field Officers; the Officers of the Several Troops, Regiments, Independent Companies, and Garrisons

[London]: War-Office, 1781
Book
8 ½ x 5 ½ in.
Ruggles Fund, 2004
Vault Ruggles 438

IN 2004 THE NEWBERRY'S bibliographer of Americana, John Brady, noticed that Helen R. Kahn & Associates of Montreal was offering for sale a heavily annotated copy of *A List of All the Officers of the Army* (1781), which it had obtained at a Christie's auction in May 2000. Brady was very familiar with a related volume in the library's Rudy L. Ruggles Collection, *The Narrative of Lieutenant-General Sir Henry Clinton Relative to . . . His Conduct in North America,* 7th ed. (1785), bound with the *Answer of Lord Charles Cornwallis* (1738–1805) to the attempt by Clinton (1730–1795) to exonerate himself from responsibility for British military failure in North America, and with Clinton's rejoinder to Cornwallis. The volume is filled with marginal notes by Clinton himself, and Brady thought that the book being offered for sale might make an exceptionally good fit for the library because it contains annotations by its original owner, General Alexander Leslie (1731–1794), who played a notable part in the events over which Clinton and Cornwallis quarreled. So Brady arranged for the book's purchase.

The top of the title page bears Leslie's autograph. On many pages in the first half of the volume, he inserted marginal notes in ink, providing information about hundreds of British officers who served in the American Revolutionary War. Frequently, he placed next to officers' names the words "dead" or "killed," and in the case of the latter he sometimes indicated the relevant battle. Some of these deaths in action took place in early September 1781 at the Battle of Eutaw Springs. Notations on the deaths of senior generals from natural causes mostly date to 1782 and allow us to establish that Leslie did not complete his annotations before March of that year.

Leslie served in the 64th Regiment beginning in 1758, and, according to his own annotations, he eventually joined the 63rd. The *List* indicates that he was promoted to colonel on June 24, 1762, and to major general on May 25, 1772. From 1775 to 1777, he saw action first in New England and then in New York and New Jersey. Thereafter, he served for several years in New York before being assigned by Clinton in 1780 to support Cornwallis with a diversion in the Chesapeake Bay area. Cornwallis sent him on to Charleston, South Carolina, a move that later became fodder for the Cornwallis-Clinton quarrel. No sooner did Leslie reach Charleston than he was ordered to link up with Cornwallis's force. Leslie and his troops arrived too late to participate in the Battle of Cowpens, but two months later they saw fierce action in the Battle of Guilford Courthouse. After a stint in New York for his health in mid-1781, he returned to Charleston to command British forces there but could not get his troops north fast enough to help Cornwallis avoid the outcome at Yorktown. From that point on, he oversaw the entire southern theater of the war, remaining in Charleston until British troops were evacuated in late 1782.

The Historical Manuscripts Commission's Report on American Manuscripts in the Royal Institution (1907) includes letters to and from Leslie in 1781 and 1782 that allow us to observe a very senior British commander managing a lost cause in its final months. Leslie's copy of *A List of All the Officers* enables us not only to learn details about other officers but also to imagine him sitting at a table in what he called Charles Town, in ill health and desperately wanting to be back across the Atlantic, sadly reminding himself of who among his comrades would not ever be going home. D. S.

TO SUPPORT THE ABOLITION of slavery, the American Anti-Slavery Society issued four publications soon after its 1833 founding: a newspaper, *Human Rights*; two magazines for adults, *Anti-Slavery Record* and *Emancipator*; and a sixteen-page, monthly children's magazine, *The Slave's Friend*. Lewis Tappan, a founder of the society, edited the latter from the organization's New York offices from its first issue in 1836 to its last, only two years later.

Each issue of *The Slave's Friend* includes short stories, poems, and wood engravings—all designed to show the terrible conditions of slavery in the United States. The magazine portrays slaveholders as cruel and evil, while slaves are noble but abused. Time and again, in melodramatic and sentimental tales, the magazine's writers drew on Christian piety to excoriate the nation for the sin and shame of slavery. Editors of *The Slave's Friend* imagined children as political actors, calling on them to save their pennies, and those of their parents, for the abolitionists' cause. An 1837 issue of *The Slave's Friend* asks readers to form their own juvenile anti-slavery societies.

The small-format publication cost one cent per issue, though few were sold. Instead, the society distributed the magazine through the mail free of charge. Most readers were children from Northern states; few issues made it to the South, because postmasters there were reluctant to allow delivery of abolitionist propaganda.

The cover of issue number 5, shown below at right, depicts a Christian gentleman teaching black children. The scriptural reference, a common feature of the magazine, reads: "The lips of the wise disperse knowledge" (Proverbs 15:7). The same engraving and reference appeared on the cover of numerous issues. The opening of issue number 2, below left, shows a chained black man praying on one knee over the caption: "O my great massa in heaven, Pity me, and bless my children." Opposite is the "Child's Creed," intended to teach youngsters that God is the father of all children, free or slave, and "that God loves a colored child as well as he does a white child." Readers likely were expected to recite the portion of the creed that states, "I believe that it is right to be kind to the poor slaves, to pray for them, and to try to persuade slaveholders to give them their liberty: that it is right to say that slavery is a dreadful sin, and that it is very wicked to buy and sell men, women, and children."

The Newberry purchased multiple issues of *The Slave's Friend* in 1999. The periodical complements a number of collection strengths, including abolitionist materials and children's literature. The issues at the Newberry are particularly notable because they include their covers as issued. D. G.

5

The Slave's Friend

New York: R. G. Williams
for American Anti-Slavery Society,
volume 1, numbers 2 and 5, [1836]
Periodical
4 × 2¾ in.
Ruggles Fund, 1999
Vault Ruggles 455

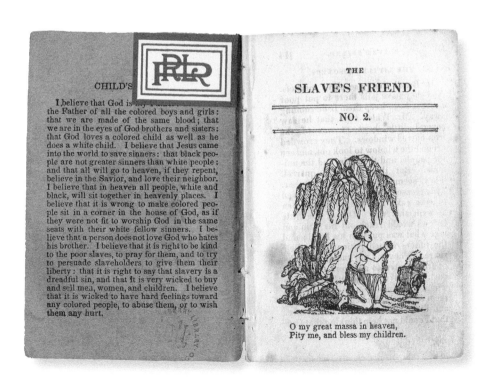

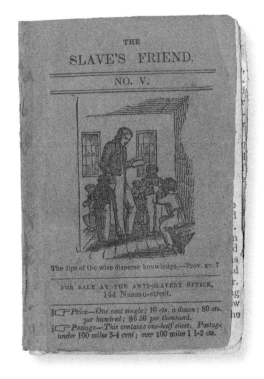

6

Thomas Jefferson
Memorandums for Mr. Short

Paris, c. September 16, 1788
Manuscript
7¼ × 9⅛ in.
Gift of Mr. and Mrs. Walter Goldstein, 1986
Vault Mi

A BOOK OWNED by Thomas Jefferson (1743–1826), or a document from his hand, is a proud part of any research library's collection. Thanks mainly to generous collectors like Herbert B. Strauss, Rudy L. Ruggles, and Mr. and Mrs. Walter Goldstein, the Newberry is fortunate to have a few dozen such items, ranging from Jefferson's annotated copy of the *Federalist Papers* and a very rare copy of his second inaugural address printed on silk, to the interesting and revealing memorandum featured here, donated by the Goldsteins in 1986.

William Short (1759–1849) traveled from Virginia to Paris in 1786 to serve as Jefferson's private secretary during his remaining time as the United States' minister to France. For a number of years, the future secretary of state and president had regarded Short as a protégé, indeed referring to him as his "adoptive son." Delighted to have him in Paris, Jefferson encouraged Short's interest in going to sights that he had visited on his travels through southern France and Italy. Short made plans to tour Italy beginning in the fall of 1788. Undoubtedly, Jefferson gave this undated manuscript to Short just prior to his departure in mid-September, and Short packed it in his trunk for use when he reached Italy, where he planned to stay for several months.

In addition to brief advice on where not to stay on his way to Italy and where to find a wonderful white wine south of Lyon (the current price of which Jefferson wished to know), Jefferson had several favors he hoped Short

could grant during his visits to various cities. He asked his secretary to buy in Venice a copy of the Accademia della Crusca dictionary (1621), but he later wrote to say that a Paris bookseller had obtained a copy for him. Recalling his enjoyment of Italian macaroni, he described a machine for making it and asked Short to procure a small iron mold through which the pasta was pressed so that he could use it to make a similar machine at Monticello. He even made a sketch of the mold, seen here, to ensure that Short bought exactly what he needed. Jefferson asked Short to buy on his return trip six dozen bottles of a wine he had enjoyed in Avignon. While in Nîmes, Short was to purchase a vase shaped like a duck (a version of which Jefferson had bought there but lost), as well as to call upon Étienne Scipion d'Arnal, a mechanical engineer, to give him Jefferson's notes on how Americans installed a millstone in a grist mill. Other than at the beginning of the journey—when he was unable to access the memorandum because it was in his stowed luggage and therefore missed the opportunity to taste the Hermitage wine Jefferson recommended as he traveled south of Lyon—Short was able to follow every recommendation and satisfy every request before returning to Paris.

It was common practice for travelers to keep accounts of their sightseeing journeys and to fulfill requests from friends along the way. The Newberry's list of favors and recommendations reveals Jefferson's wide-ranging and detailed interest in almost everything. Jefferson's memorandum gives the reader days' worth of following leads in other sources that contain the full exchange of letters between him and Short during the journey, letters that not only reveal the statesman's catholic interests but also provide engaging descriptions of travel in that part of the world in the eighteenth century. The memorandum is a wonderful example of Jefferson's active mind and his voracious appetite for learning. C. T. C.

Supplement to the Independent Chronicle

Boston: Powars & Willis, January 31, 1788
Broadside
14¼ × 8¾ in.
Ruggles Fund, 2006
Vault Ruggles 452

LIKE THE NEWBERRY'S holdings of Colonial- and Civil War-era newspapers, its extensive collection of Chicago examples—including a number of rare, labor-leaning German-language newspapers—has been mined by historical and genealogical researchers since the start of the twentieth century. During the past fifty years, these sources have been complemented by a diverse array of materials that reveal the changing nature of how news has been told, received, and absorbed by the public. Two rare early American newspaper special-issue broadsides, both recent acquisitions (see also no. 8), provide an interesting perspective into how the public learned about the latest news.

The Supplement to the Independent Chronicle is a two-sided broadsheet, printed in Boston, communicating a gripping account of a natural disaster, as well as important details about the new United States Constitution. More than half of the broadside is dedicated to news from Kingston, Jamaica, describing "a most-violent HURRICANE, which happened on the Bay of Honduras, on the 2nd day of September last." Thus it was months after the storm, which destroyed the settlement of Belize, that Bostonians first learned about it. The final columns of the broadside relate to more local concerns and the significant steps taken to establish the "general principles for forming a Constitution." This section contains a letter from Massachusetts delegate Elbridge Gerry (1744–1814) to the vice president of the Convention of Massachusetts, William Cushing (1732–1810), and praises the Federal Convention's attempt to balance the proportional representation in the House of Representatives with equal representation in the Senate for small states.

Although the *Independent Chronicle* is represented in the Newberry's Colonial newspaper holdings, this broadside was unrecorded before coming to the library in 2006. It was purchased from Howard Mott Rare Books, Sheffield, Massachusetts, to complement the outstanding material for the study of the Constitution and American law in the Rudy L. Ruggles Collection. J. B.

MAD-RIVER COURANT—Extra. (President's Message—Concluded.) is an early rural Ohio newspaper's broadside that contains the final portion of President James Monroe's message to Congress on December 2, 1823. The broadside reprints the key portion of the president's new doctrine regarding European involvement in the Western Hemisphere. The primary objective of this policy was to ensure that the newly independent colonies of South and Central America "were not to be considered as subjects for future colonization by any European powers," and that the Americas and Europe would have different spheres of influence. *Mad-River Courant* was published in Urbana, west of Columbus, from 1820 to 1832. While extant single issues of this newspaper are quite scarce, as one might expect, this single-sided extra-edition broadside is even more so; like no. 7, it was unrecorded before 2004, when the Newberry purchased it from Robert Rubin Books, of Brookline, Massachusetts. While the broadside is most likely from late 1823 or 1824, it is undated. If one imagines it posted in a public place to be read (and read aloud to those who could not read themselves), the omission of a date underscores the fact that this piece of "breaking news" was not tied to a particular date, but rather was to be understood as a defining and lasting moment in United States history. J. B.

8

Mad-River Courant Extra. (President's Message— Concluded.)

Urbana, Ohio: Evan Banes, Jr.,
c. late 1823/1824
Broadside
12⅝ × 9¾ in.
Ruggles Fund, 2004
Vault Ruggles 451

Joseph Whitehouse

Joseph Whitehouse, Journal Commencing at River Dubois; Voyage from Saint Louis . . . across the Continent . . .

May 14, 1804–November 6, 1805
Manuscript
7 × 8¼ in.
Gift of Edward E. Ayer, 1911
Vault Ayer MS 978

AMONG THE NEWBERRY'S treasures is a multitude of documents relating to the most important journey in United States history: the transcontinental voyage, from 1804 to 1806, led by Captain Meriwether Lewis (1774–1809) and Captain William Clark (1770–1838). In the Edward E. Ayer and Everett D. Graff collections, one can find a comprehensive gathering of printed material on the Lewis and Clark Expedition (also called the Corps of Discovery Expedition), among which are unique objects that have enthralled American-history scholars and enthusiasts. For instance, the library's multiple copies of the first authorized account of the expedition, Nicholas Biddle's *History of the Expedition under the Command of Captains Lewis and Clark* (1814), includes the copy Thomas Jefferson gave to William Clark. The Jefferson presentation copy is in its original binding and includes the ownership marks of both Jefferson and Clark. The late Newberry trustee Gerald F. Fitzgerald donated one of the few manuscript maps associated with the expedition: a reduced copy of Clark's 1811 manuscript map (now at Yale University), likely prepared by George Shannon, a private in the Corps of Discovery who worked in Philadelphia with Biddle. However, the most treasured items in the Lewis and Clark holdings are several important manuscripts that continue to stimulate debate.

In his last communication from Fort Mandan (in present-day North Dakota), on April 7, 1805, Lewis wrote to Jefferson, "We have encouraged our men to keep journals."

Because of this fortuitous decision, the history of the expedition was not only recorded by the two captains, but also by four other members of the party: Charles Floyd, Patrick Gass, John Ordway, and Joseph Whitehouse.

Joseph Whitehouse (c. 1775–c. 1860) was born in Fairfax County, Virginia, and moved with his family to Kentucky in 1784. He enlisted in the U.S. Army as a private in 1798 for a standard five-year term and re-enlisted in 1803. Later that year, he was transferred to the Lewis and Clark Expedition. While on the historic journey, Whitehouse kept a journal consisting of extensive field notes covering the period May 14, 1804, to November 6, 1805. The animal-skin-bound manuscript, now known as the Whitehouse Journal, begins at the official start of the journey west: "hard Showers of rain. this being the day appointed by Capt. Clark to Set out . . . we got in readiness . . . the party consisting of three Sergeants and 38 men who manned the Batteaux and perogues. we fired our Swivel [a cannon] on the bow hoisted Sail and Set out in high Spirits for the western Expedition. we entered the mouth of the Missourie haveing a fair wind."

After the Corps of Discovery's return to St. Louis, Whitehouse was discharged from the military. In the fall of 1806, he had a copyist prepare a different version of his journal, extending the period covered to April 6, 1806, with the intent of having it published. This new and expanded text includes an introductory preface and begins:

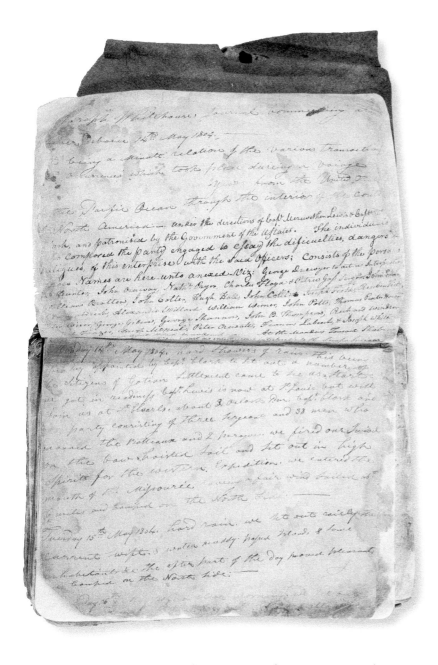

On his deathbed, Whitehouse gave his original journal to his confessor, an Italian priest named Di Vivaldi. The provenance of both Whitehouse manuscript journals is somewhat murky, since they passed through multiple owners. The original journal resurfaced in 1903, when Dodd, Mead & Co. purchased it for Reuben Gold Thwaites (1853–1913), who was editing the publisher's centennial edition of the original Lewis and Clark journals. This monumental, eight-volume work, known as the Thwaites Edition, includes a transcription of the first Whitehouse journal. Thwaites later sold the Whitehouse manuscript to Newberry trustee Edward E. Ayer, who then gave it to the library with his outstanding collection. In 1966 the second Whitehouse journal—also known as the "paraphrased version"—was discovered in a Philadelphia bookshop by University of Illinois geology professor George White. Because the Newberry already owned the original journal, White's colleague Donald Jackson, a noted Lewis and Clark scholar, notified James Wells, then custodian of the library's John M. Wing Foundation on the History of Printing, who promptly purchased the manuscript diary.

The "paraphrased version" of the Whitehouse journal was first published in Gary Moultan's seminal work *The Journals of the Lewis & Clark Expedition* (1997). Despite the best efforts of Jackson, Moultan, and others, the identity of the writer of this version of the Whitehouse journal is unknown. Because it includes nearly six months of additional material and fills gaps in the original journal, it is of great interest, but because whole sections echo contemporary published sources, it continues to stimulate vigorous debate. How involved was Whitehouse in the crafting of this manuscript? What publications were consulted? Did the copyist take liberties when creating the narrative? Many suspect that the famous account by Alexander MacKenzie (1764–1820), published in 1801, of his 1793 journey across Canada to the Pacific was copied outright in the preface; others believe that the newly extended Whitehouse entries were modeled on Gass and Ordway's accounts. While many questions remain unanswered, one thing is certain: future generations will come to the Newberry to attempt to unravel these mysteries and to relive the Corps of Discovery's epic journey. J. B.

From Saint Louis, in the Territory of Louisiana and on the River Mississippi across the Continent of North America, by way of the River Mesouri, to the Pacific or Western Ocean; in the Years, 1803, 4, 5 & 1806, under the directions of Captain Merriweather Lewis, and Captain William Clark, and patronised by the Government of the United States, with a description of the Countries through which they passed; taken from actual survey. Illustrated with Maps, with an account of the Latitude of the most noted places on the Mesouri and Columbia Rivers, by Joseph Whitehouse.

Whitehouse later reenlisted and served on the western frontier and in the War of 1812; he deserted in 1817. The remainder of his life is obscure.

10

Washington Hall; Levi F. Hall

Letters to Jemima Hall

Florida, Missouri,
June 18, 1836; July 22, 1836
Manuscripts
11⅞ × 7⅜ in.; 12¼ × 7¾ in.
Gifts of Mrs. W. F. Schweitzer, 1950
Midwest MS Rodgers, Box 1,
Folder 15

NOT MUCH IS KNOWN about Washington Hall, the African American slave author of three 1836 letters to his wife, Jemima Hall. Hall's owner was Levi F. Hall, a large landowner near Florida, Missouri, who had ten slaves in 1840 and probably produced cash crops like hemp and tobacco. When Levi Hall died in 1841, his son took over the farm and continued to own slaves. Whether Washington Hall was among them is not known.

The outlines of Jemima Hall's life are clearer. Born in Virginia, she was about twelve years old in 1822 when she was purchased for $300 by the Davidson family and given as a wedding present to Mary Davidson Rodgers. That same year, Jemima moved with Mary and her husband, Aleri Rodgers, to Missouri, where she eventually married Washington Hall. Jemima likely was given her freedom in 1836, when she accompanied the Rodgers family to their new home in Warren County, Illinois. She lived with them until her death in 1875.

Washington Hall's correspondence and that of his master make plain the cruel realities of human bondage. In his poignant and affectionate letters to Jemima, written soon after her departure for Illinois, Washington was unable to do more than plead with her to come back to him and urge her not to let her former owners persuade her to stay with them. Levi Hall's stern letter spells out the ground rules for Jemima's return to Washington. He informed her that, on condition of "correct deportment," he would "make you and Washington as happy as circumstances will admit, but not to free him, nor do I think your freedom will much better *your* condition." If Jemima were to rejoin her husband, it seems she had to agree to be free in name only. She went on without him.

Correspondence from African American slaves is quite rare, and letters addressed to family members especially so. Writing was not a common form of expression among this mostly illiterate population. When it does survive, it provides an immediate and tantalizing glimpse into the lives, thoughts, and feelings of the enslaved. In addition to their almost overwhelming emotional content, the Hall letters offer clues about friendships, slave-master relationships, literacy, and religious belief that are difficult to tease out from other sources. M. B.

11

Andrew Rodgers
Oregon Trail Journal

May 29–October 1845
Manuscript
12¼ × 8 in.
Gift of Mrs. W. F. Schweitzer, 1950
Midwest MS Rodgers, Box 2, Folder 108

the missionary Dr. Marcus Whitman, who engaged him to teach school at his station on the Walla Walla River. Two years later, in November 1847, Rodgers was preparing to become a minister and missionary to the Indians when he was killed by the Cayuse in what became known as the Whitman Massacre.

Rodgers began his journal the day his party left Iowa. From start to finish, he was conscious of his role as advance man for family and friends, and he dutifully recorded road conditions, mileage, the availability of water and pasture, and other details that would assist future travelers. In the first days of the journey up the Platte River, Rodgers also found time to write in great detail about his experiences. He devoted several pages to the group's only encounter with American Indians, about 300 hungry Pawnees, some of whom protected the wagon train from others who wished to steal food, clothing, and livestock. He witnessed the shooting of several buffalo and commented on the behavior of men away from the constraints of civilization, noting that to kill "merely for the sake of saying that one has killed so many buffalo is rather too savage." He also opined that whoever had proposed to build a transcontinental railroad across a treeless plain must be a "dupe or a knave."

At the Newberry, Rodgers's activities may be studied within the context of his family, the activities of other nineteenth-century Americans, and very strong collections relating to westward expansion and Native Americans. Like several other previously unknown overland journals and letters, the Rodgers volume was uncovered by archivists during a recent National Endowment for the Humanities grant project to arrange and describe the library's family manuscript collections centered on Chicago and the Midwest. M. B.

THIS HANDWRITTEN JOURNAL, a page of which is reproduced here, is part of the multigenerational papers of the Rodgers family, originally of Rockbridge, Virginia, who in the 1820s pioneered in Missouri, later settled in Illinois (Warren County), and then dispersed across the continent to Kansas, Iowa, New Mexico, California, and Oregon. Like other family collections in the library's Midwest Manuscript Collection, the Rodgers Family Papers reveal both the close emotional ties and remarkable mobility of nineteenth-century American families.

Andrew Rodgers traveled overland in 1845 to Oregon with his younger brother Alexander. Joining a party of about 200 men and forty wagons, the brothers embarked on May 29 from Council Bluffs, Iowa, and reached their destination in early October. At The Dalles, Andrew met

12

The United States at One View

New York: H. Phelps, 1847
Broadside
29⅞ × 22 in.
Strauss Memorial Fund, 2007
Case Oversize E166 .U557 1847

The United States at One View presents a patriotic portrait of an expanding nation through statistics, charts, lists, and symbols. Humphrey Phelps (1799–1875), an entrepreneurial New York editor and publisher of popular maps, travelers' guides, atlases, and gazetteers, synthesized data readily available in these genres to compile the broadside. Displayed most likely in post offices, banks, schools, and taverns, the sheet would have reached a wider audience than most books or maps of the period. Acquired in 2007, it complements other popular publications by Phelps in the Newberry, as well as the library's deep collections of cartographic materials, guidebooks, and printed ephemera.

Phelps conveyed his message through the design as well as the content of the broadsheet. At the base, descriptions of Oregon and Texas fill a green swath hinting at landscape; these recent territorial acquisitions made the growing nation continental in scope. The graphics just above also emphasize the country's vastness through suggestively arranged geographic data: a blue chart of river lengths extends laterally, a list of mountain heights reaches skyward (accompanied by a hot-air balloon), and a table of distances between major towns and cities reads in multiple directions: horizontally, vertically, and diagonally. Near the top, lists of city populations and transportation networks (railroads, canals, steamboat routes) highlight the nation's increasing urbanization and the links between economic centers.

The visual and ideological linchpin of the sheet—and implicitly, the country—is the representation of money in the center. At the left, images of Continental bills, the national paper currency issued during the American Revolution, framed by war data, set the historical stage. At the right is a much larger image of a United States Treasury bill. Such bills were not currency, but short-term, interest-bearing certificates through which the government could borrow funds from its citizens. By featuring this bond, the broadside proclaims that the U. S. was, literally and figuratively, banking on its people. Much as the Continentals helped finance the Revolution, the bonds also helped support the nation's antebellum expansion, facilitating recent territorial acquisitions, growth of major cities, and construction of a continental transportation network. More important, the Treasury bills represented a national monetary system, in contrast to the primary forms of exchange during this period, coin and paper bills issued by state banks. The Treasury bills foreshadow the development of standardized paper currency that would expedite the creation of national markets and further economic development. Conspicuously downplayed in the scheme (relegated to a small table in the middle of the second row from the bottom) are physical commodities, the output of the nation's farms and workshops. The broadside thus presents the U. S. not as a nation of producers, but as a commercial republic, where instruments of exchange—transportation, markets, money—are central.

The form of the broadside itself neatly recapitulates this message. It too is a means of exchange, of information. By producing the sheet, Phelps expanded his own market share of the publishing trade. Like the Treasury bill, the lithograph is made of paper, boasts finely engraved symbols and borders, and is crowned by the national eagle. Replete with decoration as well as data, *The United States at One View* reminds viewers that Americans also need art to ensure the continued development of their national culture. D. D.

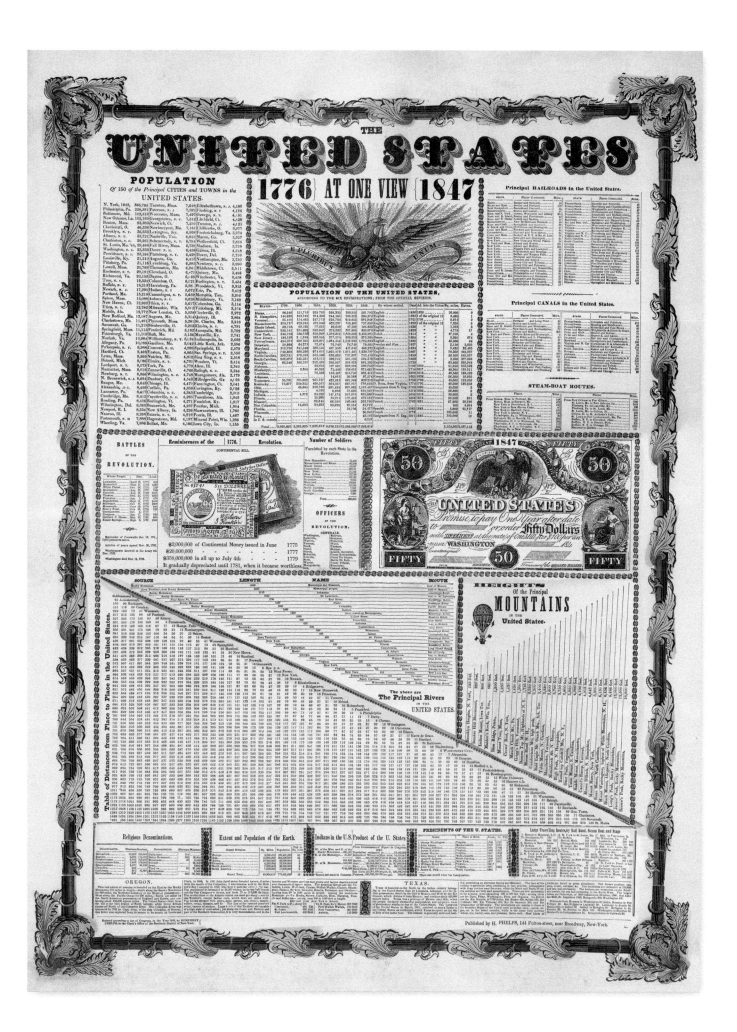

13

Lyman Spencer

Carte-de-Visite Portrait; Letter to Emma Spencer

Indianapolis, 1865; Munfordville, Kentucky, December 17, 1863
Photograph; manuscript
4 × 2⅜ in.; 7⅞ × 10¼ in.
Gifts of Percy H. Sloan, 1950
Midwest MS Spencer, Box 14, Folder 657;
Box 6, Folder 324

THE SON of noted nineteenth-century calligrapher and handwriting expert Platt Rodgers Spencer, Lyman Potter Spencer (1840–1915) devoted his career to developing and promoting the Spencerian writing method pioneered by his father. During the Civil War, he served as a quartermaster's sergeant in the 2nd Ohio Artillery Regiment and was stationed in Munfordville, Kentucky, and Cleveland, Tennessee. That the younger Spencer was also a talented penman and artist is obvious in this 1863 letter to his much-younger sister, Emma. His charming and intricate drawing of a soldier in casual attire (see p. 220) and illustrated description of the types of tents used by the army surely brought camp existence to life for loved ones back home.

Spencer's letters are part of an ever-growing collection at the Newberry of Civil War soldiers' letters and diaries (see no. 15). Over the past thirty years, this area of the Newberry's holdings has flourished as successive waves of Civil War manuscripts have been rediscovered and have entered the public sphere. Today there are more than sixty separate Civil War manuscript collections at the Newberry, relating primarily to Illinois and the Midwest. Since opening in 1887, the library has also intensively collected print materials from the perspectives of the North and the South. The Newberry's wide and diverse gathering of regimental histories, newspapers, periodicals, pamphlets, and maps, along with the manuscripts, makes the library one of the finest Civil War collections in the Midwest.

Letters such as those from Spencer reveal firsthand accounts of that most critical time in our national history. The writers understood the importance of the events in which they participated and recorded their experiences in thousands of letters and diaries that generations of descendants often saved. Beyond battle and event reportage, these surviving primary sources offer an extraordinary window into the lives of ordinary people whose beliefs, attitudes, and experiences are not usually part of the historical record.

Soldiers' photographs often figure in Civil War–era manuscript collections. Having one's photograph taken became a possibility for many just as the conflict began, thanks to new, inexpensive processes and the spread of commercial studios even to small towns. A uniformed Spencer sat for this carte-de-visite image at Swain Brothers Photographers in Indianapolis. Presumably, like so many fellow soldiers, he sent it home.

Lyman Spencer's war letters and photographs are part of the Platt Rodgers Spencer Papers, a collection important for a number of subject strengths at the Newberry, including family history, books and printing, art and design, and women's history. M. B.

are two officers. The one pointing with his hand is giving an order; The one with his hand touching his hat is giving the military salute. Of the tents beyond those, shaped like this △ are called Sibley Tents; those like this △ Wall Tents. There are three other kinds of tents in which the soldiers live, viz. Shelter, Bell, and Hospital Tents. The Shelter tents are the smallest of all tents, and the Hospital the largest. One cannot stand up in a Shelter tent they are so very low. They are sometimes called "Dog Tents"; because scarcely large enough to furnish decent accommodations for a dog. Here are representations of the three tents just named. The Hospital tent differs little from the Wall Tent save in size.

Shelter tent Hospital Tent Bell Tent.

I do not stay in a tent; but in the best office save one in Munfordville. The wood-work is all grained and there are five cases for books and papers, in it, extending to the floor, and all with window doors.

When I come home at the end of the war I shall find the girl I left little Emma grown up to be big Emma — a young woman

I hope to find also that you have grown in goodness. — Not that I think little Emma is now a bad girl, but because none are so good but that they can and ought to become better.

Kiss Father and Felicia and Nellie for me. Write again my Dear little Sister to
Your Aff. Bro
Lyman.

14

Ferdinand Vandeveer
Hayden (author)
Thomas Moran (illustrator)

The Grand Canyon Yellowstone, from
*The Yellowstone National
Park, and the Mountain
Regions of Portions of Idaho,
Nevada, Colorado, and Utah*

Boston: L. Prang and Company, 1876
Book
22 × 18¾ in.
Gift of Everett D. Graff, 1964
Vault Oversize Graff 1830

THE LAW establishing Yellowstone as the United States' first national park (1872) declares that the area would be preserved "for the benefit and enjoyment of the people" and that all "timber, mineral deposits, natural curiosities, or wonders" would be kept "in their natural condition." The founding of Yellowstone set the precedent for all of the national parks that followed. The idea of reserving lands from the public domain for use as parks and preserving their natural beauty was a distinctly American idea that has helped conserve natural spaces the world over. The story of how the park came into being involves scientists, mapmakers, artists, and photographers who were brought together by Dr. Ferdinand Vandeveer Hayden (1829–1887).

Hayden was a pioneer geologist of the West who, between 1853 and 1860, explored the territories that are now part of Kansas, Nebraska, North and South Dakota, Montana, Idaho, Utah, Wyoming, and Colorado. From 1867 to 1878, Hayden worked for the Department of the Interior, where he directed an ambitious series of geologic and natural-history surveys that helped to popularize the nation's natural wonders and beauty. The Newberry has a great many of Hayden's printed reports, guides, and atlases describing the American West.

Hayden's most influential survey took place in 1871, when he and thirty-four men explored the Yellowstone region. Realizing that written reports could be disputed back East, Hayden wanted a photographer and an artist on the expedition to better capture the scale and grandeur of the scenery they encountered. Remarkable images by William Henry Jackson, a pioneer photographer of the West, and stunning paintings by Thomas Moran helped to publicize Yellowstone. Largely because of the visual proof the expedition provided of Yellowstone's incredible lakes, canyons, and waterfalls, Congress acted quickly, and on March 1, 1872, President Ulysses S. Grant signed the law to preserve the region.

After returning from the expedition, Moran (1837–1926) painted a large (7 × 12 feet) canvas entitled *The Grand Canyon of the Yellowstone.* Just a few months after Congress established the park, the work became the first landscape to hang in the Capitol (today it is in the Department of the Interior). In 1876 Moran's watercolors were published in Louis Prang's stunning portfolio of chromolithographs *The Yellowstone National Park.* Prang (1824–1909) engaged Hayden to authenticate the scientific accuracy of the images and to write the accompanying commentary. The preface states that "the sketches can be relied upon as exceedingly correct renderings of their subjects," and the introduction describes "a tract of country more remarkable for the wonderful phenomena of nature than any other region on the globe."

The Yellowstone National Park was the first time Moran's work was published in color. Heralded as a superb technical achievement, it remains a monument of American bookmaking. Complete sets of this deluxe publication are of considerable rarity, and, because of the brilliance of the plates, are highly desirable. The volume is a highpoint in the Newberry's rich assemblage of books with illustrations and artwork often reproduced in plates. These broad plate-book holdings not only demonstrate printing technologies over the centuries, but also remind us of the outstanding artwork that can be found between the covers of such publications.

Hayden's striking *Yellowstone National Park* is part of the Everett D. Graff Collection of Western Americana, which came to the Newberry in 1964 (see no. 20). This beautiful portfolio relates to a number of other strengths in the library concerning the exploration, surveying, mapping, photography, artwork, promotion, and preservation of the West. For instance, the Edward E. Ayer Collection contains nearly 500 of Jackson's photochrome prints. J. B.

THE GRAND CAÑON, YELLOWSTONE.

15

Hiram Scofield
Civil War Diary

1863
Manuscript
6⅞ × 3¼ in.
Ruggles Fund with the assistance
of Robert Wedgeworth, 2002
Vault Ruggles 426

SOLDIERS' DIARIES constitute a significant portion of the Newberry's Civil War collections. Featured here are pages from one of forty-four pocket diaries in the papers of Iowan Hiram Scofield (1830–1906). In addition to these, which cover the years 1857 to 1906, the Scofield holdings include some letters and miscellaneous items.

Born in New York, Scofield moved west in the early 1850s as a young lawyer and by 1857 had opened an office in Washington, Iowa. After the first shots of the war were exchanged at the battle of Fort Sumter, South Carolina, in April 1861, Scofield enlisted in the Union Army as a private and was assigned to Company H of the 2nd Iowa Infantry. His 1862 diary documents his rise through the ranks, the daily life of an officer, the weather, his health, and his reading and relaxation activities.

The Newberry was especially interested in acquiring Scofield's diaries because, from 1863 to 1866, he commanded the 8th Louisiana Regiment Infantry (African Descent) of Colored Troops (later renamed the 47th U.S. Colored Regiment Infantry). The diaries from this time provide a fascinating account of an African American regiment from the perspective of a white commander. While stationed at Vicksburg, Mississippi, in 1863, Scofield wrote of his first days with the Colored Troops:

- May 3: "a meeting with my Regiment—I made a little talk to them which was well received."
- May 4: "boats unloaded and the families sent down to Plantation. Dr. Thornton has been examining the men preparatory to being mustered in. The muster rolls are being made and I fear I shall lack a few men."
- May 24: "2 boys buried today, a good deal of sickness."
- May 25: "Had our first Battalion drill today—the Regiment did remarkably well."

- June 25: "Today the rebels appeared in still larger numbers burning plantations and running off the Negroes."
- Dec. 2: "received some bad—very bad—mush today which we made a fuss about."

Scofield's diaries detail the daily activities of his regiment in 1864 and 1865, when it played a major role in the capture of Fort Blakely, Alabama, and the fall of Mobile. On April 9, 1865, the day Robert E. Lee surrendered to Ulysses S. Grant at Appomattox, Scofield and his troops overwhelmed the defenses of Fort Blakely. He noted in his diary, "Quiet until afternoon when the skirmishes advanced without any direct orders + and engagement was begun which resulted by mistake in the capture of Blakely—Soldiers never did better than the Colored Soldiers today." It is clear that Scofield had a great deal of respect and empathy for the often-maligned Colored Troops.

Since the Scofield diaries entered the Newberry, staff have learned that after the war Scofield assembled one of the largest private libraries in Iowa, with more than 20,000 volumes. One title from this library had entered the Newberry in 1957, forty-five years before the diaries: J. A. B. Besson's presentation copy of *History of Eufaula, Alabama: The Bluff City of the Chattahoochee* (1875), an interesting local history that includes an "H. Scofield, Private Library" bookplate. Thus, not only do Scofield's diaries offer an extraordinary perspective on the Civil War, but they also provide a unique glimpse into the life of a voracious nineteenth-century American reader and book collector. J. B.

INTERPRETING THE MEANING of Jack Kerouac's entertaining one-word message—"BOO!"—to his editor, Malcolm Cowley, is possible because their correspondence is preserved in the Malcolm Cowley Papers at the Newberry. By April 1956, Kerouac (1922–1969) had been working with Cowley (1898–1989) for nearly three years to get *On the Road* into print. For Kerouac the process of finding a publisher had begun before he located Cowley at Viking Press. A respected author, critic, and mentor, Cowley was determined to publish this great rambling ode to the Beat Generation. Finalizing the manuscript seemed now to only be a matter of changing a few characters' names to avoid possible charges of libel.

In the months before Kerouac sent his "Boo!" postcard, the interchange between author and editor reveals a writer anxious to get the job done. In a letter of February 10, 1956, Kerouac complained about Cowley's editing pace: "I had no idea you were going to bring my manuscript to the coast with you, for work. If so, I'd have waited. As it is, I hurried home for Xmas." On March 16, not having received a response to his February letter, Kerouac wrote again to Cowley, informing him that he would visit Stanford University (where Cowley was lecturing) to prepare *On the Road* for publication. On March 21, Cowley wrote that he would be leaving California before Kerouac got there, noting, "Some sort of malign fate is keeping us from getting together." Frustrated by the delays, Kerouac sent his one-word message before Cowley's letter finally reached him in California.

Fortunately, Kerouac did not have to wait much longer. The following year, Viking published *On the Road*, which the *New York Times* hailed as "the most beautifully executed, the clearest and most important utterance" of Kerouac's generation. Cowley, already noted for his work with the major literary figures of his time (Ernest Hemingway, William Faulkner, and F. Scott Fitzgerald), moved on to editing the writing of a new generation of important younger authors, including Ken Kesey and Tillie Olsen.

The Malcolm Cowley Papers are a keystone of the Newberry's Midwest Manuscript Collection. In 1954, at the behest of Newberry librarian Stanley Pargellis (1898–1968), Cowley became a Newberry Fellow, writing on a monthly stipend and advising the library on the acquisition of twentieth-century Americana. That same year, he gave the first batch of his papers to the library, and periodically from then on donated or made his papers available for purchase. M. B. AND A. T.

16

Jack Kerouac
Note and Postcard to Malcolm Cowley

Mill Valley, California,
April 19, 1956; April 18, 1956
Manuscript; postcard
6¼ × 6 in.; 3¼ × 5½ in.
Malcolm Cowley, 1969
Midwest MS Cowley, Box 35,
Folder 2099

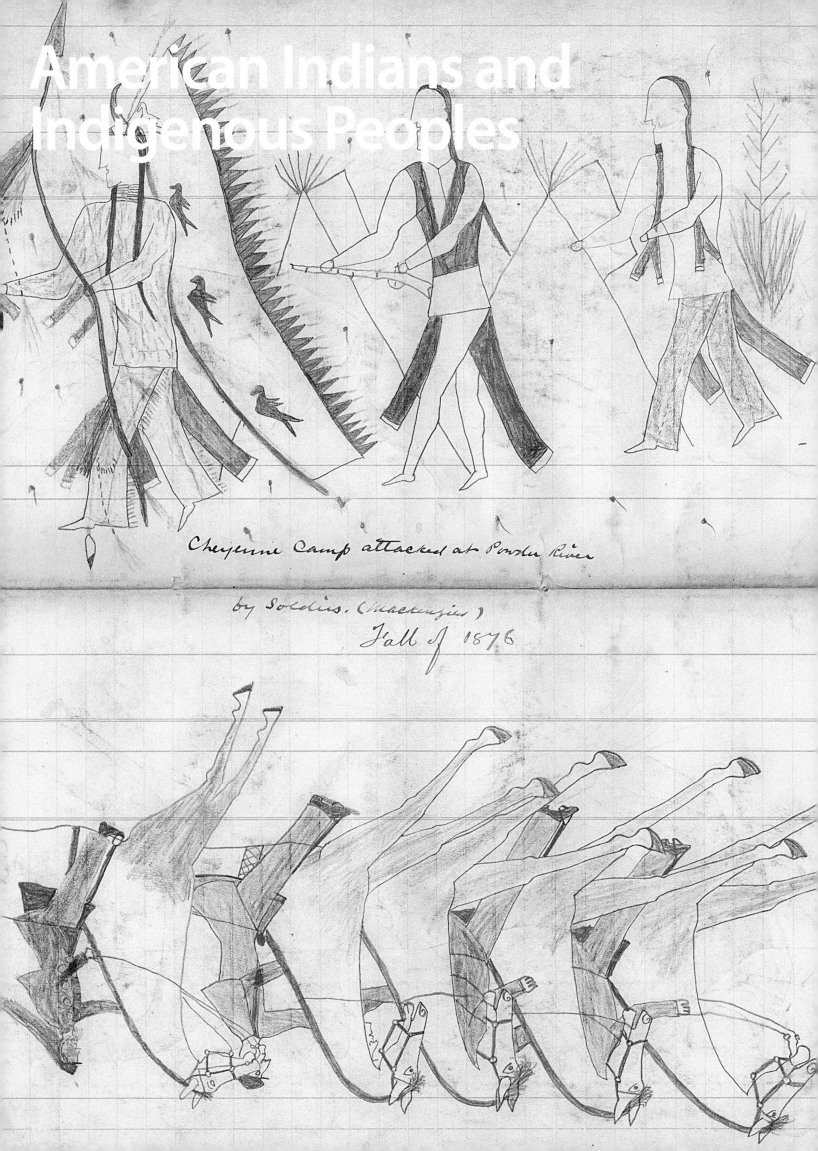

Cheyenne Camp attacked at Powder River
by Soldiers. (Mackenzies)
Fall of 1876

A MANUSCRIPT of religious commentaries from the sixteenth-century Franciscan friar Bernardino de Sahagún (1499–1590) may at first seem like an unlikely gift from Edward E. Ayer (1841–1927), famous for his extensive collection of materials relating to American Indians. Between 1892 and 1911, the Chicago business magnate donated to the library 100,000 items, including books, thousands of manuscript pages, and hundreds of drawings, paintings, and photographs about Native Americans. Ayer had a broad perspective on indigenous cultures, one that went beyond national borders. His interest in collecting materials relating to the history of the indigenous peoples of the Americas was sparked by William H. Prescott's *History of the Conquest of Mexico* (1843), which he read while serving the Union cause during the Civil War. Ayer was in California, where he had gone to seek his fortune, when the Civil War broke out. He marched with Union troops into Arizona and occupied a mining camp near the Mexican border. The remote camp had a small collection of books, among them Prescott's account of the conquest. It was a revelation. Ayer wrote that he never knew history could be so interesting; it made him a lifelong student of history. It should therefore not be surprising that Ayer later sought out materials dating from Mexico's early colonial period, beginning with the Spanish conquest in 1521.

This manuscript was written forty years after the fall of Tenochtitlán, when Spain was preoccupied with converting the Nahuatl-speaking natives of central Mexico to the Roman Catholic faith. The document's author was born in Sahagún, Spain; after being educated in the humanist tradition at the Universidad de Salamanca, he joined the Franciscan Order around 1527. His obvious intellectual ability and deep faith caught the attention of his superiors, who encouraged him to become a missionary in New Spain (Mexico). In 1529 Sahagún began what would be a sixty-one-year career in Mexico. His close work with indigenous peoples allowed him to produce some of the most important surviving documents concerned with native cultures before and after the Spanish arrived. For this reason, he has been characterized as a missionary, ethnographer, linguist, and historian.

The manuscript collected by Ayer is a bilingual text of the "Addicion*es*," additions written by Sahagún to supplement the *Postilla*, or scriptural commentaries used in missionary work among the Aztecs, the name of the Nahua culture that ruled central Mexico before the Spanish conquest. The primary concern of these additions is the three Christian virtues of faith, hope, and charity. Charity receives the longest consideration, as Sahagún attempted to explain the concept of "loving one's enemies" to a people known for dominating and often enslaving their enemies. Beyond these virtues, the text describes the Christian schema of the afterlife—both the joys of heaven and the horrors of hell.

Not all of Sahagún's writings are so focused on Christian doctrine. His most famous text associated with the Aztecs is the so-called *Florentine Codex,* a work of some 2,400 pages with more than 2,000 images created by native artisans under his direction and now housed in the Biblioteca Medicea Laurenziana, Florence, Italy. This monumental undertaking began sometime in 1545, when Sahagún decided to record all he could about a vast range of subjects concerning the Aztecs. His research continued up until the time of his death. The codex is the reason that some consider Sahagún the first ethnohistorian. For Ayer all such accounts and related documents were part of the indigenous history of the Americas. S. M. S.

17

Bernardino de Sahagún

Siguense veynte y seis addiciones desta Postilla

Mexico, 1560–79
Manuscript
12 × 8⅝ in.
Gift of Edward E. Ayer, 1911
Vault Ayer MS 1486

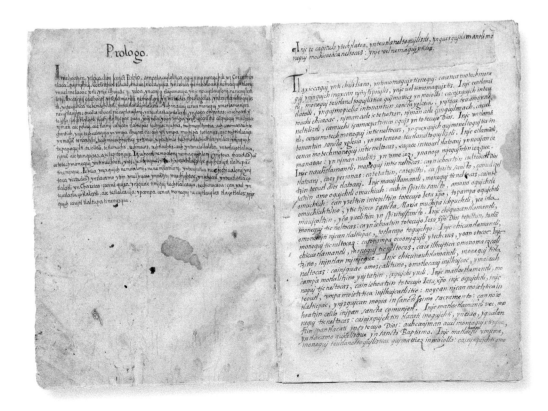

18

Map of the Lands in Tultepec and Jaltocán Regions Adjacent to the Hacienda de Santa Inés

Mexico, 1569
Manuscript
12 × 17 in.
Ayer Fund, 1988
Vault Ayer 1801 map 1

AFTER THE SPANISH conquest of Mexico, one of the continuing contests between the natives and the settlers was over land ownership and use. This 1569 legal document conveys something of the highly developed bureaucratic and legal system that typified Spanish colonial administration of its vast empire. This single sheet of European paper is backed with indigenous *amatl*, a paper derived from the fibers of the bark of trees native to Central America. Use of *amatl* dates back to pre-Hispanic times; it continues to be made in some regions of Mexico today. Here the *amatl* sheet served to strengthen the document, which records the terms resolving a dispute between the native farmers of Tultepec and a Spanish rancher named Juan Antonio Covarrubias.

Conflicts over land became commonplace with the introduction to Mexico of large domesticated animals. Life in traditional agrarian communities was disrupted by Spanish demands for grazing lands to support herds of cattle and sheep. Other animals, such as hogs and goats, were also allowed to range freely and thus could damage or destroy crops. The Spanish, vastly outnumbered in these newly conquered territories, turned to their legal system as a means of avoiding violent discord and meting out justice. The document uses both official legal language, rendered here in a flowing sixteenth-century secretarial hand, and a visual depiction of the settlement of the suit brought by the farmers against the rancher: livestock were restricted to the section outlined in red and dotted with boundary markers (*mojones*); the area outside the red outlines was designated for cultivated fields. Santa María Nativitas, Tultepec's largest church, represents the town, and smaller churches mark subsidiary villages. The small buildings are indigenous dwellings, and the large structure at the upper left is Covarrubias's estate. This sheet provides a visually compelling look at life in the early colonial period of New Spain.

The Newberry's collections relating to Mexican history are particularly rich, extending from the Spanish conquest and Mexican independence to the revolution of 1910. Indigenous Mexico is a key component of all these eras and is represented in documents such as the one featured here and in the library's many histories, missionary accounts, and anthropological and linguistic studies. S. M. S.

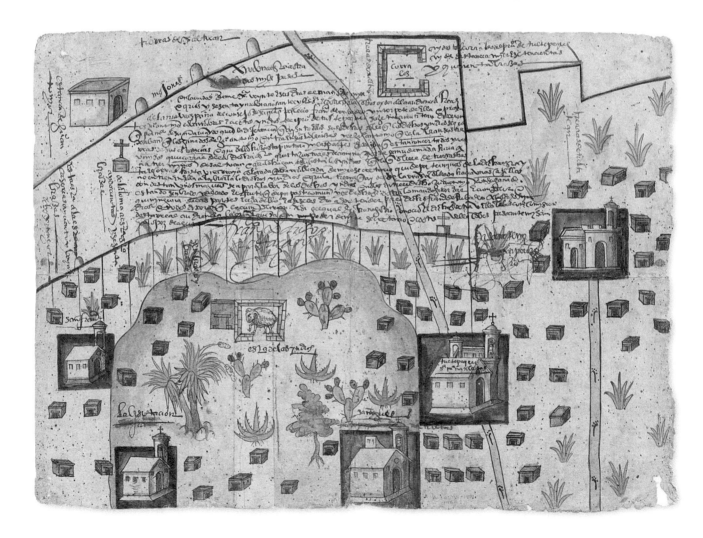

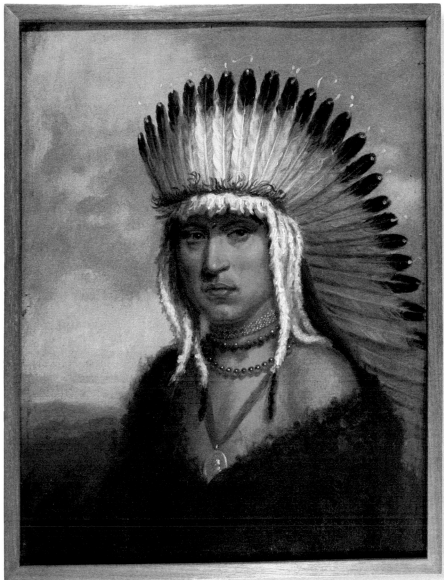

Charles Bird King

Petalesharro

Washington, D.C., c. 1822
Painting
17⅜ × 13¼ in.
Gift of Edward E. Ayer, 1911
Ayer Art King

THE AMERICAN INDIAN portraits by Charles Bird King (1785–1862) may be familiar to viewers even if they have not seen his original paintings. The reason for this relates to an interesting chapter in American art history. King, born in Rhode Island not long after the end of the Revolutionary War, became one of the most successful portrait painters in the early republic. After his initial training with the American portraitist Edward Savage, King spent several years in London studying with Benjamin West. When he returned to the United States, he settled in Washington, D.C. King was ambitious and soon found important clients among the equally ambitious political luminaries of antebellum America, such as John C. Calhoun, Henry Clay, and Daniel Webster. His growing reputation brought him to the attention of Thomas McKenney (1785–1859), who served as superintendent of Indian Trade and later of Indian Affairs in the War Office. McKenney asked King to commemorate members of the various Indian delegations that visited Washington in a series of individual portraits. The artist eventually produced 145 such paintings between

1822 and 1842. Many of these were transformed into lithograph copies that appeared in the three-volume *History of the Indian Tribes of North America*, edited by McKenney and James Hall and published between 1837 and 1844. In 1858, 139 portraits by King were transferred to the Smithsonian Castle, where they were hung in the second-floor art gallery. While the volumes published by McKenney and Hall were very popular, the Smithsonian's Indian portrait gallery became a must-see for visitors to the capital. Unfortunately, in 1865 a fire swept through the building, destroying all but a few paintings.

The Newberry is extremely fortunate to have not only the complete set of McKenney and Hall's history but this original portrait by King as well. Certain Indian portraits were especially popular, and King produced multiple copies of them for his clients. This was the case with the likeness of the Skidi Pawnee chief Petalesharro (c. 1797 – c. 1832), who was famous for having rescued a young female Commanche prisoner from ritual sacrifice by his own tribesmen in 1817. Local missionaries sent an account of his act of heroism back East. Petalesharro's action conformed to romantic notions of the "noble savage" and was widely celebrated in poetry and prose. Here he wears the medal he received from representatives of a Washington girls' school. Its inscription reads, "The Bravest of the Braves." King capitalized on Petalesharro's celebrity and painted five portraits of the handsome young chief when he visited Washington with a Pawnee delegation in 1821. One of those portraits was destroyed in the 1865 Smithsonian fire, but the other four have survived and can be found in the collections of the Gilcrease Museum (Tulsa, Oklahoma), the Tuscaloosa (Alabama) Museum of Art, the White House, and the Newberry. s. m. s.

WILLIAM CLARK and Meriwether Lewis cocaptained an expedition to explore the Louisiana Territory from the Mississippi to the Pacific, a region that was transferred from France to the United States just two months before the expedition began (1804–1806; see no. 9). Lewis recruited Clark (1770–1838) in part because he was an experienced soldier, having served under General Anthony Wayne in the 1794–1795 war with the native people of the Ohio River Country (the Old Northwest). The prinicipal cartographer for the Louisiana Territory journey, Clark drew one hundred maps that contributed greatly to geographical knowledge of western North America.

After the Lewis and Clark Expedition ended, Clark was appointed governor of the Missouri Territory and ex officio superintendent of Indian Affairs. He was also active in the Indian trade, working as an agent for the Missouri Fur Company. In 1822, the year after Missouri became a state, Clark became the first superintendent of Indian Affairs for the St. Louis superintendency, serving until his death. In this capacity, he directed the work of several Indian agents at bureaus along the Mississippi and Missouri rivers, met with representatives of Indian nations and negotiated treaties with them, and distributed provisions to the Indians as prescribed by treaties. Clark also was host to artists and important travelers from the eastern United States and Europe, including George Catlin and Prince Maximilian of Wied-Neuwied (see no. 23).

Clark kept this 1825–1828 account of the expenses of his superintendency. His records show that he paid the salaries of Indian agents, bought supplies for his office, and purchased Indian goods and provisions, including chiefs' coats, blue cloth, and calico shirts. He also listed the expenditures for his personal household, his children's schooling, and real-estate taxes on land he owned in the St. Louis area.

The cover of the account book contains an intriguing piece of information for historians. Here Clark listed the names of and information about the members of the Lewis and Clark Expedition. The interpreter Toussaint Charbonneau and his Shoshone wife, Sacagawea, are included, along with their child. Next to Sacagawea's name, Clark wrote the word "dead." He took an interest in the Charbonneau family after the expedition and in 1813 adopted Sacagawea's children. Most scholars consider Clark's notation to be supporting evidence that Sacagawea died in 1812 at Fort Mandan, and, because of this and other primary documents, reject an alternate theory that she died on the Wind River Reservation in 1884.

Clark's account book came to the Newberry from Everett D. Graff (1885–1964), who joined the library's board of trustees in 1948. Graff was a collector of Western Americana who amassed more than 10,000 books, maps, broadsides, and manuscripts over the course of forty years. Donated to the Newberry in 1964, the Edward D. Graff Collection of Western Americana is a signal contribution to the scholarship and bibliography of the American West. L. F.

A SON OF THE FOREST.

CHAPTER I.

WILLIAM APES, the author of the following narrative is a native of the American soil, and a descendant of one of the principal chiefs of the Pequod Tribe, so well known in that part of American history called King Philip's Wars. This tribe inhabited a part of Connecticut, and lived in comparative peace on the river Thames, in the town of Groton or Pacatonic, and was commanded by King Philip. As the story of King Philip is perhaps generally known, it will be sufficient for our purpose to say that he was overcome by treachery. Betrayed to their avowed enemies, the nation was completely routed and the way thereby opened for the whites to possess themselves of the goodly heritage occupied by this once peaceable and happy tribe. But this was not the only act of injustice which this op-

21

William Apes

A Son of the Forest

New York: The Author, 1829
Book
6 × 3⅞ in.
Gift of Edward E. Ayer, 1911
Ayer 251 .P4571 A6 1829

WILLIAM APES (1798–1839), sometimes written Apess, was an American Indian intellectual, author, and political activist in the early years of the republic. His autobiography, *A Son of the Forest* (1829), the first published by an American Indian, recounts his early struggles in life and his attempts to connect with the Indian communities of southern New England. He was the child of a mixed-race Pequot family from Massachusetts whose early life reads like a bleak tale by Charles Dickens. Apes's parents separated when he was just three years old, and he was placed in the custody of his grandparents in Connecticut. They beat him so often that the state indentured him to a white family with the understanding that he would be housed and educated in exchange for his labor. Apes's indenture was sold at least twice before he ran away to join the United States Army at age fifteen. After fighting in the War of 1812, he spent several idyllic months with Mohawk Indians on the northern shore of Lake Ontario, which helped him renew his sense of connection to his own native community. He then returned to southern New England.

For Apes, raised largely among whites but decidedly as an outsider, his status as an Indian was both alien and alienating. Like many others on the margins of American society during that time, he found inspiration in the Methodist camp meetings of the Second Great Awakening. Apes became an itinerant preacher among the Wampanoag and Pequot communities of Massachusetts and Connecticut, respectively. He also began reading American history and realized that the Indian perspective was never represented. In late January 1836, Apes delivered his antidote to that problem at the Odeon in Boston in the form of a speech, "Eulogy for King Philip," aimed at a white audience. The Indian King Philip, or Metacom as he was known to his people, led an army of native warriors into armed conflict with settlers in the bloodiest war in early New England history (1675–1678) and was one of the period's most vilified figures, but Apes presented him as equal in stature to George Washington. This provocative talk epitomizes Apes's desire to stand up for the Indians of New England and represent their aspirations and concerns.

While living in Mashpee, Massachusetts, among the Wampanoag community, Apes was both a spiritual leader and activist. He also participated in Indians' efforts to elect their own selectmen, an initiative that Boston newspapers dubbed the "Mashpee Revolt." He was arrested for disturbing the peace and sentenced to one month in jail. When the citizens of Mashpee won this fight, Apes wrote the *Indian Nullification of the Unconstitutional Laws of Massachusetts* (1835). In the 1830s, he published five important works on Indian rights, spirituality, and history, all of which are in the Newberry. S. M. S.

ᏣᎳᎩ (GWY) — PROTECTION — ᏧᎳᏂᎢᎦ

CHEROKEE PHOENIX.

VOL. I.　　　　NEW ECHOTA, THURSDAY MARCH 6, 1828.　　　　NO. 3.

EDITED BY ELIAS BOUDINOTT.

PRINTED WEEKLY BY

ISAAC H. HARRIS,
FOR THE CHEROKEE NATION.

At $2 50 if paid in advance, $3 in six months, or $3 50 if paid at the end of the year.

To subscribers who can read only the Cherokee language the price will be $2 00 in advance, or $2,50 to be paid within the year.

Every subscription will be considered as continued unless subscribers give notice to the contrary before the commencement of a new year.

The Phoenix will be printed on a Super-Royal sheet, with type entirely new procured for the purpose. Any person procuring six subscribers, and becoming responsible for the payment, shall receive a seventh gratis.

Advertisements will be inserted at seventy-five cents per square for the first insertion, and thirty-seven and a half cents for each continuance; longer ones in proportion.

☞ All letters addressed to the Editor, post paid, will receive due attention.

LAKE OF ARDENT SPIRITS.

Mr. Editor—In recently turning over the pages of a Magazine printed in the year 1815, my attention was attracted by a calculation of the amount of ardent spirits consumed in the United States in the year 1810. This amount is stated at 33,365,529 gallons. The estimate appears to have been made on well founded grounds. After making his statement the writer adds the following mathematical calculations.

The quantity which the year 1828 will consume would doubtless fill a lake one half-a-mile still.

Now 33,365,529 gallons, is 298,532 hogsheads, (at more than 134 gallons the hogshead,) which supposing one team to carry two hogsheads, would load 124,466 waggons. These, allowing only three rods for each team, would reach more than 1,166 miles, or nearly the whole length of the United States, from north to south! The number of hogsheads necessary to contain the liquor, must, upon a moderate computation, cost 600,000 dollars, and would, if placed so as to touch each other, reach more than 178 miles, exceeding by 45, the whole length of Massachusetts Proper, on the northern line. Or, to present the subject in another light, the quantity of ardent distilled spirits, which is annually drunk in the United States, is sufficient to fill a canal 42 miles long, 10 feet wide, and 2 feet deep; affording convenient navigation, for boats of several tons burthen! The same quantity if brought together, would form a pond more than 68 rods long, 40 rods broad, and six feet deep, covering an area of 17 acres.

HOW TO READ SCRIPTURE.

The simple and unprejudiced study of the Bible is the death of religious extravagance. Many read it under a particular bias of mind. They read books, written by others, under the same views. Their preaching & conversation run in the same channel. If they could awaken themselves from this state, and come to read the whole Scripture for every thing which they could find there, they would start as from a dream—amazed at the humble, meek, forbearing, holy, heavenly character of the simple religion of the Scriptures, to which, in a greater or less degree, their eyes had been blinded.—Cecil.

A man may find much amusement in the Bible—variety of prudential instruction—abundance of sublimity in poetry; but, if he stops there, he stops short of its great end; for, the testimony of Jesus is the spirit of prophecy. The grand secret in the study of the Scriptures, is, to discover Jesus Christ therein, the way, the truth, and the life.—Id.

[CONCLUDED.]

CONSTITUTION OF THE CHEROKEE NATION,

Formed by a Convention of Delegates from the several Districts, at New Echota, July 1827.

ARTICLE VI.

Sec. 1. Whereas the ministers of the Gospel are, by their profession, dedicated to the service of God—and the care of souls, and ought not to be diverted from the great duty of their functions; therefore, no minister of the Gospel, or public preacher, of any religious persuasion, whilst he continues in the exercises of his pastoral functions, shall be eligible to the office of Principal Chief, or a Seat in either house of the General Council.

Sec. 2. No person who denies the being of a God, or a future state of rewards & punishments, shall hold any office in the civil department of this Nation.

Sec. 3. The free exercise of religious worship, and serving God without distinction, shall forever be allowed within this Nation: Provided, That this liberty of conscience shall not be so construed as to excuse acts of licentiousness or justify practices inconsistent with the peace or safety of this Nation.

Sec. 4. Whenever the General Council shall determine the expediency of appointing delegates, or other public Agents, for the purpose of transacting business with the Government of the United States; the Principal Chief shall have power to recommend, and by the advice and consent of the Committee, shall appoint and commission such delegates or Public Agents accordingly, and, on all matters of interest touching the rights of the citizens of this Nation, which may require the attention of the United States Government, the Principal Chief shall keep up a friendly correspondence with that Government, through the medium of its proper officers.

Sec. 5. All commissions shall be in the name and by the authority of the Cherokee Nation, and be sealed with the Seal of the Nation, and be signed by the Principal Chief.

The Principal Chief shall make use of his private seal until a National seal shall be provided.

Sec. 6. A sheriff shall be elected in each District by the qualified electors thereof, who shall hold his office for the term of two years, unless sooner removed. Should a vacancy occur subsequent to an election, it shall be filled by the Principal Chief as in other cases, and the person so appointed shall continue in office until the next General election, when such vacancy shall be filled by the qualified electors. The Sheriff then elected shall continue in office for two years.

Sec. 7. There shall be a Marshall, appointed by a joint vote of both houses of the General Council for the term of four years, whose compensation and duties shall be regulated by law, & whose jurisdiction shall extend over the Cherokee Nation.

Sec. 8. No person shall for the same offence be twice put in jeopardy of life, or limb, nor shall any persons property be taken or applied to public use without his consent; Provided, That nothing in this clause shall be so construed as to impair the right and power of the General Council to lay and collect Taxes. All courts shall be open, and every person for an injury done him in his property, person or reputation, shall have remedy by due course of law.

Sec. 9. The right of trial by jury shall remain inviolate.

Sec. 10. Religion morality and knowledge being necessary to good Government, the preservation of liberty, and the happiness of mankind, Schools and the means of education shall forever be encouraged in this Nation.

Sec. 11. The appointment of all officers, not otherwise directed by this Constitution, shall be vested in the legislature.

Sec. 12. All laws in force in this Nation, at the passing of this Constitution,

shall so continue until altered or repealed by the legislature, except where they are temporary, in which case they shall expire at the times respectively limited for their duration; if not continued by act of the legislature.

Sec. 13. The General Council may at any time propose such amendments to this Constitution as two thirds of each house shall deem expedient; and the Principal Chief shall issue a proclamation, directing all the civil officers of the several Districts to promulgate the same as extensively as possible within their respective Districts, at least nine months previous to the next General election; and if at the first session of the General Council after such General election, two thirds of each house shall, by yeas and nays, ratify such proposed amendments they shall be valid to all intents and purposes, as parts of this Constitution; Provided, That such proposed amendments shall be read on three several days, in each house, as well when the same are proposed, as when they are finally ratified.

Done in Convention at New Echota, this twenty-sixth day of July, in the year of our Lord one thousand eight hundred and twenty seven; in testimony whereof, we have each of us, hereunto subscribed our names.

Delegates of Chickamauga District.
JNO. ROSS, *President of Convention,*
JOHN BALDRIDGE, his x mark.

Delegates of Chattooga District.
GEORGE LOWREY,
JNO. BROWN,
EDWARD GUNTER.

Delegates of Coosawatee District.
JOHN MARTIN,
JOSEPH VANN,
KELECHULEE, his x mark.

Delegates of Amohee District.
LEWIS ROSS,
THOMAS FOREMAN,
HAIR CONRAD, his x mark.

Delegates of Hickory District.
JAMES DANIEL,
JOHN DUNCAN.

Delegates of Etowah District.
JOSEPH VANN,
THOS. PETITT, his x mark,
JOHN BEAMER, his x mark,

Delegates of Taquoe District.
OOCLENOTA, his x mark,
WM. BOLING, his x mark,

Delegates of Aquohee District.
JOHN TIMSON,
SITUWAKEE, his x mark.
RICHARD WALKER, his x mark.
A. M'COY, *Secretary of Convention.*

REPORT

Of a joint Committee in the Legislature of Georgia, on the Cherokee Lands.

From this gloomy and almost hopeless prospect, we turn our attention to the second branch of our enquiry, and trust that we shall be able to establish in the State of Georgia a legal and perfect title to the lands in question, and that we have the right, by any means in our power to possess ourselves of them.

In the examination of this important and interesting question, we are necessarily carried back to the earliest history of this country. When the continent of America was first discovered, it was possessed and owned by various tribes of savages: and the discoverers asserted successfully the right of occupying such parts as each discovered, and thereby established their supreme command over it, asserting their claim both to domain and to empire. By demand we mean that, by virtue of which a nation may use the country for the supply of its necessities; may dispose of it as it thinks proper, and derive from it any advantage it is capable of yielding." And by "empire" we mean the "right of sovereign command; by which, the nation directs and regulates at its pleasure, every thing that passes in the country." Precisely in this way, and no other, did Spain, France, England, Holland and Portugal obtain sovereignty over the portions of this country discovered by each. It may

... contended with much plausibility, that there is in these claims more of force than of justice; but they are claims which have been recognised and admitted by the whole civilized world, and it is unquestionably true that under such circumstances force becomes right. This kind of title is not only good and valid agreeable to the laws of Nations, but is perfectly consistent with justice. The earth was certainly made for the benefit, comfort and subsistence of man, and should be so used as to accommodate the greatest possible number of human beings. It was therefore perfectly in accordance with the design of nature, that the densely populated countries of Europe, should possess themselves of the immense forests in America, which were used only as hunting grounds, and employ them in promoting the comforts and providing for the subsistence of their overflowing population. Acting no doubt upon these principles, Great Britain occupied and colonized the province of Georgia, the limits of which anterior to the revolutionary war, were defined and made to extend from the Atlantic coast to the Mississippi, and from the 31st to the 35th degrees of north latitude. The whole of this territory was made to form a provincial government, thus exercising the highest and most unequivocal act of sovereignty. In this exercise, both of domain and empire on the part of Great Britain, certain portions of territory

THE *CHEROKEE PHOENIX*, a dual-language newspaper founded in 1828, was the first American Indian newspaper printed in the United States. News items appeared in both the Cherokee and English languages, with the former written using the syllabary created by the Cherokee intellectual Sequoya (c. 1770–1843) in 1821. But beyond being a landmark in Native American culture, the *Phoenix* represents the difficult path that so many native nations had to negotiate in order to express their collective desire to endure as indigenous civilizations.

The pressure on Indian communities to accept Euro-American religious and cultural norms was tremendous. On the other hand, the more organic process of acculturation allowed individual peoples to accept and reject aspects of other cultures, both native and non-native, as they saw fit. Just as European settlers adopted certain Indian practices for living in the North American environment, many Indians embraced tools such as the gun or the printing press as they had horses and grazing animals. The Cherokee found themselves surrounded by land-hungry settlers and decided to adopt certain aspects of Euro-American society as a means of presenting themselves as a stable and autonomous nation. In many cases, this meant converting to Christianity or taking up farming on a European model, but it also meant organizing their traditional homeland in a way that was more recognizable to a nation-state.

To this end, New Echota (in present-day Georgia) was founded as the capital of the Cherokee Nation in 1825. It was there that a printing press was established and the type for the syllabary specially cast by a missionary, Samuel Worcester (1798–1859). The general council of the Cherokee Nation selected Elias Boudinot (1802–1839), a Christian convert with a New England education, as first editor of the *Phoenix*. In the paper, Boudinot included news from beyond the Cherokee Nation, items that had a direct effect on his people, such as the United States Supreme Court rulings on Cherokee efforts to resist the annexation of and expulsion from their lands. Some Cherokee viewed the U.S. relocation plan as the best option to retain their identity as a nation, even if it meant living in exile. When Boudinot adopted this pro-removal position, the council forced him out of the editorship.

Ultimately, the Cherokee, Creek, Choctaw, Seminole, and other Indian nations had to leave their homelands in the Southeast, following what came to be known as the Trail of Tears to Oklahoma—an infamous moment in American history. But the creation of the syllabary and the founding of the *Phoenix* served as models for dozens of other indigenous peoples throughout what was becoming the United States. Native American journalism and activism have gone hand-in-hand over the years, from the *Phoenix* to the political magazine *Wassaja*, founded by Carlos Montezuma in 1916 (see no. 30), and the Mohawk activist periodical *Akwesasne Notes*, established in the Red Power movement of the late 1960s. The Newberry's collection of these important documents of American Indian political culture provides an Indian perspective on the turbulent history of the last two centuries in North America. S. M. S.

Elias Boudinot (editor)

Cherokee Phoenix

New Echota, Georgia, volume 1, number 3, March 6, 1828
Newspaper
20⅞ × 13½ in.
Ayer Fund, 1946
Ayer 1 .C45

Karl Bodmer

Guerrier Moenitarri, Fort Clark River 1833–34

1833/1834
Painting
13¼ × 9 in.
Gift of Edward E. Ayer, 1911
Vault Oversize Ayer Art Bodmer,
No. 36

ONE MIGHT NOT necessarily expect an expedition along the Upper Missouri River in the 1830s, undertaken by an aristocratic German naturalist and a young Swiss artist, to end at all well, let alone produce some of the finest extant images of the indigenous communities of the region. Yet that was the result. In 1832 Prince Maximilian of Wied-Neuwied (1782–1867) organized an expedition to North America, having successfully explored the inner regions of Brazil several years before. In his employ were the relatively unknown Swiss painter Karl Bodmer (1809–1893), as well as a huntsman and a taxidermist. The prince planned to follow the route up the Upper Missouri River that had been explored two decades earlier by Meriwether Lewis and William Clark (see nos. 9, 20). This would take his expedition through the traditional homelands of the Omaha, Sioux, Mandan, Hidatsa, and Assiniboin peoples, among others. Maximilian's party journeyed west from Boston all the way to Fort McKenzie (in present-day central Montana) and back, a distance of more than 2,000 miles in each direction.

Though most famous for his depictions of American Indians, which would be popularized in high-quality color aquatints produced in Paris upon his return to Europe, Bodmer was also a skilled draftsman whose depictions of the fauna and landscape of the regions through which he traveled provide an invaluable visual record of the time. Bodmer also had to learn about the various beliefs that indigenous peoples held concerning personal images and representation. Many were hesitant to pose for him, fearing that the image would allow the artist to retain some type of power over them. In the case of Ahschüpsa Masihichsi (dates unknown), the Hidatsa warrior portrayed here, we are told that he would not be content until he produced his own likeness of Bodmer and kept it as a type of insurance against harm.

Bodmer came to regret his part in the expedition because of later disagreements with his patron over plans to publicize their journey. Maximilian wished the account to come out in deluxe editions with illustrations of the highest quality, but the demands this project put on Bodmer and the years absorbed in production took a heavy toll on him. Though the finished result was a product of tremendous beauty and of great fidelity to the original watercolors, the protracted process and limited editions of the work meant that Bodmer realized almost no profit from his labors. European interest in Indians was largely for the sensational and romantic rather than for ethnographic fidelity. Entrepreneurs such as Buffalo Bill Cody captured the imagination of a broad public and reaped the benefits of exploiting Indians. Like his near-contemporary George Catlin, Bodmer never achieved either the fame or wealth he had hoped to gain from his portraits of American Indians. He barely managed to earn a living as an illustrator of magazines in later life and died in impoverished obscurity in his adopted city of Paris. Bodmer became a watchword for someone with a brilliant career that failed. A half-century after his death, he was rediscovered and his reputation restored, largely on the strength of his original watercolors—like the dozens found in the Newberry—and placed among the first rank of artists of the American West. s. m. s.

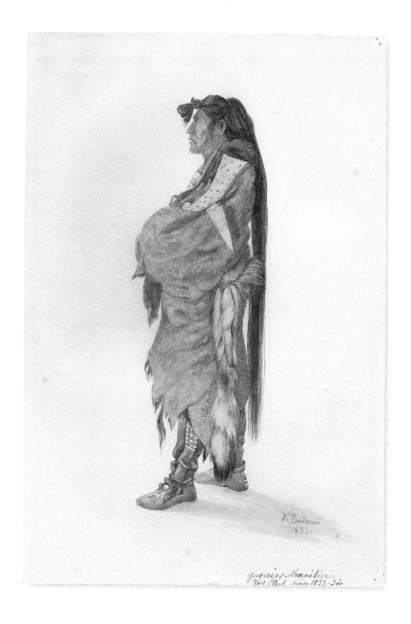

CHIEFS FROM THE PENATEKA, or Southern Comanches, and several divisions of Caddos and Wichitas and some smaller groups signed (put their mark on) a treaty with the Confederate States on August 12, 1861, at Wichita Agency on the Washita River in the Indian Territory. These tribes, as well as small groups of Tonkawas, Shawnees, and Delawares affiliated with them, had been at the agency for only two years. They had moved there from two reserves in Texas, where, because of their efforts to remain on friendly terms with Texans, they had faced threats and attacks from hostile Northern Comanches and Kiowas. Texans who viewed all Indians as enemies also attacked them. In Washita River country, the Caddos (including the Ca-do-Ha-da-cho division) and Wichitas (including the Wich-i-ta and Hue-co divisions) intended to resume their traditional farming practices. In exchange, their warriors, as well as the more nomadic Comanches, had to help the soldiers at nearby Fort Cobb protect Wichita Agency from hostile Indians.

Treaty with the Pen-e-tegh-ca Band of the Né-ŭm, Wich-i-tas, Ca-do-Ha-da-chos, Hue-cos, etc.

Wichita Agency (Indian Territory), August 12, 1861
Manuscript
12 × 7½ in.
Gift of Edward E. Ayer, 1911
Vault Ayer MS 438

At the outbreak of the Civil War in the spring of 1861, the United States withdrew troops from the agency, leaving the Indians there more vulnerable. Albert Pike (1809–1891), commissioner of the Confederate States to the Indian nations west of Arkansas and south of Kansas, arrived in August to work out a peace treaty that offered a new and welcome source of protection to agency residents. The Confederacy sought to retain the loyalty of slaveholding Indians of the Indian Territory (including Creeks and Seminoles), so Pike was ordered to negotiate not only with these tribes but also with Wichita Agency Indians whose raids for stock threatened the interests of the Creeks and Seminoles east of the agency. Creek and Seminole chiefs arrived with Pike to counsel with the Indians at Wichita Agency.

The treaty of August 12, 1861, contains many of the same kinds of provisions as an 1853 agreement between these tribes and the U.S. The tribes obtained the protection of the Confederate States in return for ending raids against Texas and the tribes allied with the Confederacy. Also, the Confederacy promised to furnish the tribes at Wichita Agency with rations, provisions, and other kinds of assistance. In addition, the Indians were granted other commitments they had unsuccessfully asked of the U.S. If it so requested, each tribe was guaranteed its own reservation, where members could follow their own cultural traditions, and such reservations could be occupied "as long as grass shall grow and the water run." The tribes retained the right to hunt off their reserve, and the Confederacy promised an agent-in-residence and an interpreter for each language spoken. A list of the provisions promised to the tribes is appended to the treaty. The Confederate States ratified the treaty in December 1861 but could not protect the agency Indians from attack. That winter most of the Indians fled Wichita Agency for Kansas, which was under Union control. L. F.

25

Scenes from the Black Horse Ledger

North Cheyenne Territory, c. 1874/1879
Manuscript
12¾ × 7⅞ in.
Gift of Edward E. Ayer, 1911
Vault Oversize Ayer MS 3227

CHEYENNE LEDGER drawings capture the essence of these peoples' warrior life with a spirit, power, and beauty that written accounts cannot convey. Bravery is the preeminent mark of Cheyenne manhood, with victory over enemies signifying proof of possessing that virtue and the supernatural power that assures it. Thus, the portrayal of brave deeds is the primary focus of Cheyenne warrior art, which was originally painted on hide, carved in wood, and incised on rock walls as pictographs. Later, such subjects would be depicted on paper and cloth.

In the 1860s, the lined pages of ledger books became favored places on which to show warrior valor and life. Occasionally obtained through capture, but more frequently from United States soldiers, traders, agency employees, and missionaries, these account books were compact and portable. Moreover, colored pencils, watercolors, ink, and crayons—which Cheyenne artists used—became more available at this time.

The earliest-known Cheyenne ledger art, created by the Southern Cheyenne, dates to the 1860s. That of the Northern Cheyenne, however, dates to the 1870s, during their most intense warfare over possession of their lands with U.S. soldiers and settlers. The Newberry possesses a splendid example, known as the Black Horse Ledger. Created sometime between c. 1874 and 1879, it contains 124 drawings, probably the work of nine warrior-artists—fighting men who were also artistically gifted. While the other visual depictions of American Indians featured in this book demonstrate the inevitable subjectivity of the white artists who created them, the drawings in the Black Horse Ledger are important examples of American Indian self-representation. All four traditional Cheyenne warrior societies—the Kit Foxes, Elkhorn Scrapers, Dog Soldiers, and Crazy Dogs—are portrayed here in sweeping images of courage in combat.

The original Cheyenne owner of these drawings remains unknown. The sole warrior in the ledger to be identified by a name glyph is Black Horse. A Northern Cheyenne, probably a So'taa'e, he carries a holy Grasshopper shield, which was believed to derive its supernatural power from Esevone, the Sacred Buffalo Hat, one of the two Great Covenants of the Cheyennes.

In the earliest Northern Cheyenne ledgers, victories over enemy tribes are found more frequently than those over soldiers and settlers. This is true of the Black Horse Ledger. Two of the battles with enemy tribes seen here are so notable that depictions of them appear in other Cheyenne ledgers as well. The first portrays the death of a great warrior wearing a single-horned war bonnet and armed with a club bearing the face of a Maiyun, a powerful spirit. Both convey forceful supernatural protection. This warrior triumphs in two scenes but is killed by a Crow in a third, a catastrophe so great that it is portrayed in at least two other Cheyenne ledgers. The second great event is the defeat and death of a Shoshoni chief carrying a yellow shield, indicating that he is imbued with the immense power of the sun. His death was considered so great a triumph that it is depicted in at least five other Cheyenne ledgers.

The heavy warfare between the Northern Cheyenne and the U.S. culminated in the battles at Rosebud and Little Big Horn in June 1876 and Belly Butte in January 1877. The intensity of the conflict is reflected in the library's ledger, in which battles with white soldiers and civilians appear almost as frequently as those with enemy tribesmen.

The uniqueness of the Black Horse Ledger is that, before it passed to a white owner, a Cheyenne artist altered drawings of Cheyenne battles with whites to make the latter look like Indians. Handwritten captions were added in a white hand. One states, ". . . an attempt has been made to alter the appearance of the white men . . . after it was decided to dispose of the book to white people, with the idea that white people would be offended at the sight." In no other extant Cheyenne ledger known to this writer has any similar alteration been made.

The battles with U.S. soldiers portrayed in the Newberry's ledger occurred in the North, with the exception of two that took place in the South. The earliest is a Cheyenne attack on the wagon escort commanded by Major Lyman of the 5th Infantry, which took place on the Washita River in Indian Territory in September 1874. The second illustrates Cheyennes running off horses captured from Fort Dodge, Kansas. Fighting scenes include victories of single warriors in the battles of Rosebud and Little Big Horn. The finest images illustrate Cheyenne resistance to Ronald Mackenzie's attack on the great village in the Big Horn Mountains in November 1876. In one, reproduced here, a line of Mackenzie's cavalry charges into the Cheyenne village. Facing the soldiers are three warriors on foot. The sacred bow lance and single-horn war bonnet of their leader signal his great bravery and the supernatural forces safeguarding him. Confronting the enemy's bullets, the Cheyennes'

spiritual powers prevailed, for all those carrying bow lances survived, according to Cheyenne oral history.

The Newberry's ledger also includes scenes of warrior life when not in battle: a war party arriving home, warrior-society parades, and men wearing the distinctive regalia of their particular society. The small number of courting scenes (only seven) in this ledger establish it as one of the oldest; a higher concentration of such scenes is typical of later, reservation-era ledger art. Only one animal, other than horses, is portrayed. It is a bull elk, believed to be the source of potent love medicine. Thus its appearance near the courting scenes is significant.

The Black Horse Ledger, created to honor Northern Cheyenne warrior bravery, is one of the finest examples of Plains Indian artistry, providing a vibrant, spiritually expressive overview of Cheyenne warrior life during the final years of Northern Cheyenne freedom. P. J. P.

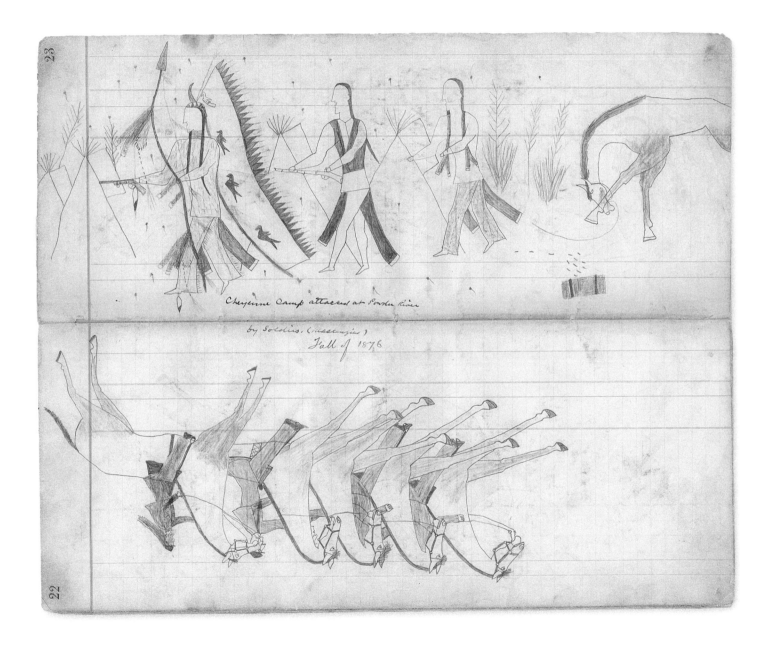

Cheyenne Camp attacked at Powder River by Soldiers. (Mackenzie) Fall of 1876

26

Simon Pokagon
The Red Man's Greeting

Hartford, Michigan: C. H. Engle, 1893
Book
3½ × 5 in.
Gift of Edward E. Ayer, 1911
Ayer 251 .P651 P7 1893

AN AUTHOR and advocate for Native Americans, Simon Pokagon (1830–1899) was a member of the Pokagon band of Potawatomi Indians and a son of his tribe's patriarch, Leopold Pokagon. Pokagon was born near what later became the small village of Bertrand in southwestern Michigan. After receiving a formal education, he returned to his tribe in 1850, marrying and settling into community life. After the deaths of his two brothers, he was elected leader of his community.

Pokagon sold the booklet *The Red Man's Greeting*, clad in birch bark, on the Midway Plaisance during the 1893 World's Columbian Exposition, which garnered him much publicity. Originally titling it *The Red Man's Rebuke*, he wrote it to reproach the exposition's organizers for ignoring the original inhabitants of the region while celebrating the "progress" of the non-native residents of Chicago. When Pokagon was invited to speak on "Chicago Day" at the fair, he renamed the booklet, giving it the title that the copy in the Newberry carries.

In *Burbank among the Indians* (1944), the artist Elbridge Ayer Burbank, who devoted his career to making portraits of American Indians (see no. 27), provided rare evidence of a meeting with Pokagon.

When I went to paint his portrait, I drove over to his farm where I found him planting seed in the old way by walking and casting the seed on the ground. I told him of my errand, that I wished to paint his portrait . . . in his Indian clothes. He said he had no Indian clothes. So I painted him as he was dressed when I met him, in his working clothes. . . . He made me a present of a little book printed on birch bark and entitled, "The Plea of the Red Man" [*sic*]. It was beautifully written.

That portrait by Burbank is also in the Edward E. Ayer Collection at the Newberry. A local Chicago paper of the day noted: "[O]n sale at the American Indian village on the Midway is a little booklet with its leaves and cover made of birch bark. It was written by Simon Pokagon. Its title is 'The Red Man's Greeting.' . . . No one can read it without realizing the other side of the Indian Question."

In 1893 few demanded respect for Native American peoples and cultures. The "question" most often debated, condensed into the "Indian problem," was whether Indians were capable of civilization, progress, and assimilation, or were simply a lost cause. Given that these were the only alternatives under discussion, Pokagon advocated for the education and improvement of his people in lieu of abandonment. He was able to bridge the worlds of the Indian and non-Indian in Chicago and elsewhere like few others.

Pokagon's use of an iconic material of American Indians (birch bark) to make his book conveys a sense of native persistence. The Pokagon Potawatomi never passively accepted the new world forced upon them. Through a combination of written and spoken word, Pokagon reminded natives and non-natives alike that American Indians wished to participate in the social, political, and cultural melting pot of America. *The Red Man's Greeting* serves as a testimonial to this goal and is an example of the attempts by its author to provide opportunities for the Pokagon Potawatomi to do much more than withdraw from their non-indigenous neighbors in Chicago or hide in plain sight. J. L.

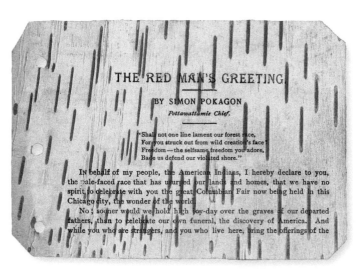

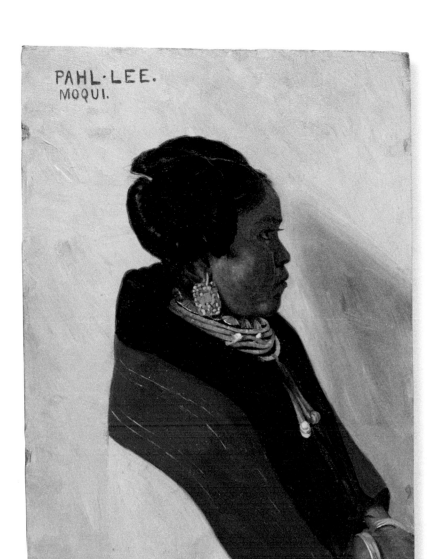

PAHL·LEE.
MOQUI.

E. A. BURBANK
KEAMS CANON
1898 ARIZ

27

Elbridge Ayer Burbank
Pahl-Lee. Moqui

1898
Painting
8½ × 6½ in.
Gift of Edward E. Ayer, 1911
Vault oversize Ayer Art Burbank, No. 60

ELBRIDGE AYER BURBANK (1858–1949) was the nephew of one of the Newberry's greatest benefactors, Edward E. Ayer. Born in Harvard, Illinois, Burbank showed artistic talent as a boy and after grammar school attended the recently founded Chicago Academy of Design (a forerunner of the School of the Art Institute of Chicago), from which he graduated in 1874. In his twenties, he worked as an illustrator for *Northwest Magazine* and traveled through Montana, Idaho, and Washington. Ayer then financed a six-year residency (1886–1892) in Munich, where Burbank studied painting.

Upon Burbank's return to the United States, his uncle proposed another venture, this time in the American Southwest. Ayer, like many contemporary enthusiasts of American Indian cultures, was motivated to collect in part by what we now refer to as "salvage ethnography." By 1890 most believed that the extinction of Native Americans was inevitable. This led to a scramble among collectors and ethnographers to find and preserve whatever could be saved of the remaining tribal peoples. Ayer wanted his nephew to travel to Indian Territory and create a visual record of the Indians living there. Ayer was especially keen for his nephew to paint portraits of Geronimo, then the most famous Indian living in North America. In 1898 Burbank went to meet the Apache chief at Fort Sill, Oklahoma, where he was being held in U.S. custody. Their meeting would prove to be a turning point in the artist's career. Though there are many photographs of Geronimo, Burbank was the only painter for whom the legendary Indian leader sat. Burbank used the opportunity to paint several portraits of him and draw a variety of studies in conté crayon. The Newberry owns two fine portraits by him of Geronimo, one full-face and the other in profile.

After leaving Oklahoma, Burbank traveled to Ganado, Arizona, where he met Juan Lorenzo Hubbell, who operated the famous trading post that bears his name. Burbank flourished in the Southwest and traveled through it extensively, visiting dozens of Indian communities during the next twenty years. One of the communities with which he developed good relations was the Hopi people (also known as the Moqui). In his autobiography, Burbank wrote, "To me the most interesting of all the Pueblo Indians were the Hopis." In the several months he spent with them, the artist produced dozens of sketches and portraits. The image featured here is that of a young Hopi woman known as Pahl-Lee. Her unmarried status is denoted by the traditional squash-blossom braids she wears. Though Burbank has been justly celebrated for his ability to convey character, he also devoted much attention to recording details of clothing and jewelry, as the present work demonstrates. By the end of his long career, the artist had painted or drawn more than 1,200 portraits of Indians from 125 native nations. The main repositories of Burbank's works are the Butler Institute of Art in Youngstown, Ohio; the Smithsonian in Washington, D.C.; and the Newberry. S. M. S.

28

**Zitkala-Ša (author)
Angel De Cora (illustrator)**

Old Indian Legends

Boston: Ginn & Company, 1901
Book
7⅜ × 5 in.
Ayer Fund, 1922
Ayer 324 .Z8 1901

THIS COLLECTION of traditional Sioux legends, recounted by Zitkala-Ša (aka Gertrude Bonnin; 1876–1938) and illustrated by Hinook Mahiwi Kalisaka (aka Angel De Cora; 1871–1919), represents a true cultural artifact of the Progressive era. The years between roughly 1890 and the early 1920s have been thus characterized because of the introduction of social reforms and political activism they witnessed across a wide spectrum of American life. Advocates for women's suffrage, the regulation of industry, and unionization made their voices heard. American Indians participated in the Progressive movements as well.

The Indian Wars of the 1870s and '80s concluded tragically with the massacre at Wounded Knee in December

into white society. The damage of separating these children from their families and native cultures can still be felt in Indian communities today. Zitkala-Ša was enrolled at the Quaker-run White's Manual Labor Institute in Indiana; De Cora went to the Burnham Classical School for Girls in Massachusetts. Zitkala-Ša became an author, educator, and activist; De Cora became a painter and illustrator.

Zitkala-Ša and De Cora met when they were both teaching at the Carlisle Indian Industrial School, in Pennsylvania. It was founded by United States Army colonel Richard Henry Pratt, who became known for his motto "Kill the Indian, save the man." Even though the school's faculty included some Native Americans, its forced assimilation policies served as an infamous model for other such Indian boarding schools throughout the country. The Carlisle School alone marked the lives of the 12,000 students (and their families) who attended it from 1879 to its closure in 1918. De Cora taught graphic and visual arts, and Zitkala-Ša taught music and coached the debate team. Zitkala-Ša, who had previously published stories and essays in *Harper's* and *Atlantic Monthly*, collaborated on her first book, *Indian Legends*, with De Cora. Published in 1901, it is a collection of traditional Sioux myths. Zitkala-Ša selected stories from the speakers of the three main dialects of the Sioux nation—Lakota, Nakota, and Dakota— and rendered them in English for white readers and English-speaking Indians in order to give them a sense of traditional Sioux culture. She believed these tales would appeal as much to the "blue-eyed little patriot" as to the "black-haired aborigine," a notion in keeping with

This was a sign of gratitude used when words failed to interpret strong emotion
(See page 89)

OLD INDIAN LEGENDS

RETOLD BY
ZITKALA-ŠA

WITH ILLUSTRATIONS
BY
ANGEL DE CORA
(Hinook - Mahiwi - Kilinaka)

BOSTON, U.S.A., AND LONDON
GINN & COMPANY, PUBLISHERS
The Athenæum Press
1901

1890. In subsequent decades, Indians struggled to understand the place of their cultures in the United States. Zitkala-Ša was born into the Dakota tribe on the Yankton reservation in South Dakota in 1876 and given the Anglo name Gertrude Bonnin. Hinook Mahiwi Kalisaka, who used the Anglo name Angel De Cora, was born at Winnebago Agency in northern Nebraska in 1871. Both girls were sent far from home to Indian boarding schools, which became one of the key means of assimilating native children

her Progressive-era politics. De Cora's illustrations offer views of a timeless past. However, for another book, Francis La Flesche's *The Middle Five: Indian Schoolboys of the Omaha Tribe* (1900), the artist drew directly on her own experiences of residential school life. Zitkala-Ša joined the Society of American Indians and later became a founding member of the National Council of American Indians, advocating for the rights of native peoples to the end of her life. S. M. S.

PERHAPS EDWARD E. AYER'S focus on collecting materials concerning indigenous cultures and the Spanish empire in the Western hemisphere sparked his interest in the native peoples in the Far East. When Ayer learned of Admiral George Dewey's victory at Manila Bay during the Spanish-American War in 1898, he began purchasing a large number of publications and manuscripts from the Campañia General de Tabacos de Filipinas. These materials chronicle the history of the indigenous peoples of the Philippines from the early Spanish exploration of the islands in 1564 to the Philippine Revolution of 1899. The bamboo manuscript of the Hanunuo Mangyan, an ethnic group living in Mindoro, Philippines, stands out among the Newberry's extensive ethnographic collection of linguistic items, printed works, and other manuscripts relating to the region.

Illustrated here is a bamboo roll that records songs, or *ambahan,* created by the Hanunuo Mangyan to serve practical purposes in their community. The songs—devoted to themes such as courtship, kinship, nature, food, hunting, and funeral and social customs, and often freely rhymed—were incised on the bamboo using sharp-pointed metal tools. They are written in Mangyan syllabic, or *babayin,* script, a pre-Spanish writing system of Indic origin. On this example, writing starts at the bottom and terminates at the top. Spanish missionaries did not teach the natives Castilian but learned their languages instead. The numerous bilingual dictionaries in many languages and dialects that Ayer collected demonstrate the linguistic research missionaries did in order to translate Christian teachings into almost all Filipino languages (Hanunuo Mangyan is one of many dialects in the Philippines).

This bamboo manuscript fits well within the Newberry's collection of primary sources in a variety of formats. This literary work, reflecting its maker's own culture, also complements the library's holdings of early printed writings of ecclesiastics documenting the Spanish colonial period. A pamphlet on the Tagbanua alphabet written in 1914 by Norberto Romuáldez (1875–1941) accompanies the bamboo manuscript. It features proposals to alter the indigenous writing system, such as writing from left to right and employing a capital letter instead of a sign to indicate the beginning of a passage; using orthographic signs like periods and commas to make for easier reading; adopting Arabic numerals for counting; and adding a dash to a character and joining characters to create the sounds of the Spanish letters *h, c, z, n,* and *f.* By the end of the nineteenth century, most Filipinos had adopted the Roman alphabet and had replaced the syllabic script. However, owing to their relative isolation, the Hanunuo Mangyans have managed to preserve *babayin* to the present day. Thus, this bamboo manuscript helps perpetuate a pre-Spanish writing system that has survived three colonial occupations. The manuscript also demonstrates the depth of the Filipiniana collection and the unusual items one finds at the Newberry. J. C.

29

Songs in the Hanunuo Mangyan Dialect and Texts in Tagbanua

Mindoro, Philippines, 1904/1905
Manuscript
20 × 1⅜ in.
Gift of Edward E. Ayer, 1911
Vault Oversize Ayer MS 1726

30

Wassaja, Freedom's Signal for the Indians

Chicago: Carlos Montezuma,
volume 1, number 1,
April 1916
Periodical
9⅛ × 6⅛ in.
Gift of Edward E. Ayer, 1918
Ayer 1 .W27

WHILE BORN a generation apart and into vastly different circumstances, the book collector who purchased this inaugural issue of *Wassaja* and the Native American physician who produced it shared many qualities and interests. Both were Chicagoans who had come to the city from obscure backgrounds and had risen to prominence—Edward E. Ayer as a timber merchant and businessman, and Carlos Montezuma (c. 1866–1923) as a physician and reformer—in the early twentieth century. Both shared a nostalgic affection for the Southwest. Ayer traveled there as a young soldier during the Civil War and returned many times. Montezuma was born in central Arizona to a Yavapai Indian family, but was taken from them by Tohono O'odham raiders while still a child. He did not re-establish contact with his Yavapai relatives until he reached middle age. Both men were deeply interested in the lives and future of the nation's indigenous peoples. By 1916, the year Montezuma launched his newsletter, Ayer was a Newberry trustee and the nation's preeminent collector of books and manuscripts documenting the history of Native Americans. He was also a member of the United States Board of Indian Commissioners, a group of "experts" who advised the Bureau of Indian Affairs. It is not surprising that Ayer wanted Montezuma's newsletter as part of the Newberry's rapidly growing holdings on Native American life.

As suggested by the masthead of the newsletter's first issue, which shows an Indian crushed by a tree trunk labeled "Indian Bureau," Montezuma published *Wassaja* because he believed the Bureau of Indian Affairs—the government agency assigned to supervise reservations and Native American schools and manage the assets of the nation's tribes—had become hopelessly oppressive. By 1916 policies designed a generation earlier to end communal landownership and destroy the Indians' traditional culture had created a situation in which some Indians were given title to tracts of land and ordered to fend for themselves, while others were declared "incompetent" and therefore subject to the permanent authority of a government agent. The "competent" Indians, with little experience in the market place and no political influence, became easy targets for unscrupulous loan sharks and land speculators, while their "incompetent" relatives watched their restricted estates (and the resources associated with them) being routinely leased to outsiders. The cattlemen and energy magnates who secured these leases often colluded with the government officials charged with protecting the tribes' interests. According to Montezuma, the government office that often claimed to be the Indians' ally was in fact coldly indifferent to the needs of communities caught in the brutal transition from a traditional to a modern existence.

Montezuma was also angry at his fellow Native Americans. The Chicago physician was a self-made man—he had graduated from the University of Illinois and Chicago Medical College and built a successful practice on the city's South Side—and he expected other Indians to follow his example. He had no patience with tribal leaders who refused to adapt to the industrial society forming around them. Montezuma at first supported the establishment in 1911 of the Society of American Indians, but he quickly soured on the reform group when its leaders (many of them well-educated personal friends and colleagues) seemed unwilling to confront the authoritarian bureaucrats at the Indian Bureau. By the fall of 1915, the Yavapai physician had had it: he delivered a blistering attack on the government agency at the society's annual meeting and called on the membership to join him in demanding the bureau's immediate abolition. When his audience failed to respond, Montezuma decided to create an independent newsletter to publicize his views. He edited *Wassaja* until his death in 1923. F. E. H.

WASSAJA

FREEDOM'S SIGNAL FOR THE INDIANS

Vol. 1., No. 1. April, 1916.

INTRODUCTION

The WAR WHOOP having been abandoned on account of outside pressure which was brought to bear, WASSAJA is taking its place. The name has been changed in the belief that the former name was not correctly understood.

The intent of the WAR WHOOP has been in the mind of the present editor for many years, and he believes that the time has now arrived to present the real conditions, for the public, and for those in power to consider and be in position to remedy the appalling slavery and handicap of the Indian race.

This monthly signal rays is to be published only so long as the Indian Bureau exists. Its sole purpose is Freedom for the Indians throughout the abolisment of the Indian Bureau.

It is supported by subscriptions and by private contributions from Redmen and everybody who has heart interest in the cause.

Its object is not to form a society, but to free the Indians by exposing the actual conditions of their imprisonment. If you want to help out on the expenses of printing and mailing, subscription is fifty cents a year.

We need your help if you are with us in this vital purpose.

ARROW POINTS.

Had the Indian been treated as a man, without discrimination, in the beginning of the pale-face invasion, today there would be no Indian Bureau and the word "Indian" would be only an obsolete name.

The Indian problem is a problem because the country has taken it and nursed it as a problem; otherwise it is not a problem at all.

What ye sow ye also reap. The Indian Bureau has sown, and it has brought forth nothing but pangs of sorrow and ruination to the Indian race.

It pays to make producers and wage-earners out of Indians rather than idlers and paupers. The Indian Bureau mill turns out the latter.

It does not cost much to feed and clothe the Indians, but the Indian

A QUICK GLANCE at this early map of Chicago shows what the soldiers of Fort Dearborn and boatmen of the Great Lakes already knew: Chicago's so-called "harbour," where the Chicago River flowed into Lake Michigan, was a miserable facility. Just how problematic it was can be seen by examining the narrow mouth of the river (bottom center), whose shallow opening only small boats could squeeze through. Adding to the difficulty were the bends—one particularly sharp—that had to be negotiated in either direction. And constantly getting in the way of navigation was the "Beach of sand and gravel" (right), forever growing, eroding, and otherwise changing shape. Improving the harbor became a high priority, especially with the recently begun construction of the Illinois & Michigan Canal, intended to provide a waterway between Lake Michigan at Chicago and the Mississippi River.

This almost certainly is a copy on tracing paper, made no later than 1858, of an 1830 manuscript map now in the National Archives, Washington, D.C. Drawn by Frederick Harrison, Jr. (dates unknown), assistant United States civil engineer, the original map is based on survey data from six years earlier. So this is what the course of the easternmost part of the Chicago River looked like in 1824. The map shows a plan for damming the mouth and cutting through the sandbar with two long piers (center right), a project that would be funded by Congress in 1833 and completed in 1837.

The Newberry's copy of this map was introduced as evidence in a closely watched trial in federal court in Chicago in 1858, in which George C. Bates (c. 1815–1886) sued the Illinois Central Railroad for usurping his property rights. Bates argued that the shifting landscape of the harbor—"his" former sandbar was now under water—should not invalidate his earlier title. The penciled measurements (upper right) were used by John A. Wills, Bates's attorney, to locate his client's ownership claim before the erosion of the sandbar, but to no avail. Bates lost the case. The Newberry also holds the transcript of the trial, from which comes the evidence that the original 1830 map actually depicts the harbor as it looked in 1824.

The cabin marked "Mr Bailey" (top center) had been built in 1790 by Jean-Baptiste Point du Sable, Chicago's first non-native settlor. It was sold in 1800 to John Lalime, who was to become the Indian translator at Fort Dearborn. The first fort, erected in 1803, across the river from du Sable's cabin, was destroyed in the Fort Dearborn Massacre on August 15, 1812. The replacement fort, erected in 1816, is shown on this map. By this time, the cabin belonged to John Kinzie, one of Chicago's most prominent early settlers. Later Jonathan Nash Bailey, a sutler (provider to soldiers) at Fort Dearborn, rented the cabin from Kinzie's estate.

Bailey was Chicago's first postmaster, and the cabin became Chicago's first post office.

The house marked "Doct Wolcott" (far left) belonged to Kinzie's son-in-law, Alexander Wolcott, Jr., Chicago's first private physician. Wolcott died in 1830. In 1836 his widow married George Bates, the man whose lawsuit prompted the creation of the Newberry's map in the first place.

The court documents of Bates's attorney, Wills, including this one, were part of the bequest of Everett D. Graff (see no. 20). E. C. H.

31

Frederick Harrison, Jr.

Map of the mouth Chicago River Illinois with the plan of the proposed piers for improving the Harbour

Chicago, c. 1855 (after 1830 original)
Manuscript
15 × 19¹¹⁄₁₆ in.
Bequest of Everett D. Graff
Vault Drawer Graff 1800

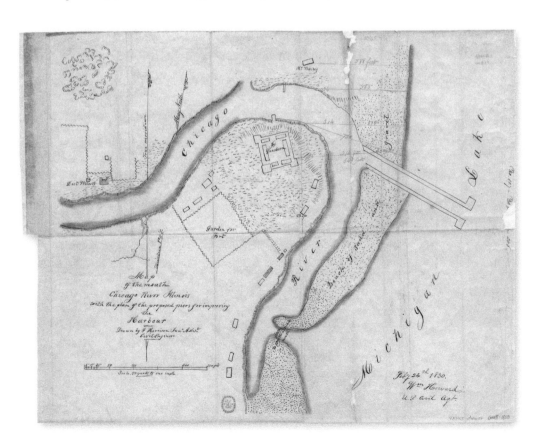

32

John S. Wright

Farmers!
Write for Your Paper!

Chicago: Jas. J. Langdon, 1852
Broadside
18½ × 24⅛ in.
Gift of Harold Byron Smith, Sr., 1996
Case Broadside 69

BY THE TIME the Newberry opened its doors across from Washington Square Park, Chicago had grown into a vibrant center of journalism, with more than twenty daily newspapers and hundreds of other periodical publications. The library was poised to capitalize on this dynamic printing culture not only because of its location, but also because of its staff expertise. The Newberry's first librarian, William F. Poole (1821–1894), was not only a preeminent librarian-historian but also the creator of the first and only systematic article-level index to nineteenth-century periodicals, *Poole's Index to Periodical Literature,* which remains a core resource for researching the nineteenth century. No one was better positioned than Poole to collect periodicals (the journals, magazines, and papers that were the information super-highway of the time) comprehensively; as a consequence, today the Newberry has a vast collection of American and British periodicals.

This stunning broadside, *Farmers! Write for Your Paper!,* is a rare imprint from pre-Fire Chicago that came to the Newberry in 1996 with Harold B. Smith's donation of Chicago history materials. It advertises the journal *The Prairie Farmer: A Weekly Journal, Devoted to Western Agriculture, Horticulture, Mechanics, and Education.* First published in 1841 in Chicago by the Union Agricultural Society, *The Prairie Farmer* was the brainchild of leading Chicago booster John S. Wright (1815–1874). Wright hoped the journal would encourage regional agriculture and ensure Chicago's place as the leading commercial center of the Midwest. Unlike more specialized trade journals that tracked a particular industry, *The Prairie Farmer* had an impact on an entire sector of the marketplace and encouraged the symbiotic relationship between Chicago and the West.

This large, red-and-black broadside, which includes a variety of typefaces and illustrations of fruits, plants, insects, farm animals, and technology, was printed by Jason J. Langdon (c. 1830–c. 1870). Langdon was an early Chicago printer who had a typographical-supply business out of which grew the *Rounds' Printers' Cabinet,* the second journal in the United States (and the first in the Old Northwest) dedicated to the typographic arts. The broadside holds the key to the success of Wright's vision. By enlisting "over 400 of the best practical Farmers and Mechanics in the West" to "write for your paper," Wright secured a steady stream of up-to-date and accurate content. And by giving premiums to people who submitted text and also to those who accumulated the largest list of subscribers for their respective towns, Wright engaged entire communities. Because it was also widely distributed via "cheap postage" to locations "over 1000 and not exceeding 2000" miles away, *The Prairie Farmer* became one of the most influential agricultural journals by encouraging scientific farming practices, symbolized here by the detailed illustrations of agricultural tools, equipment, technology, and buildings.

The popularity of *The Prairie Farmer* extended beyond the farming community because, while the journal included articles on agriculture, horticulture, and raising stock, it also provided general news, a children's column, and sections that dealt with education, health, and household issues. It became a major mouthpiece of the Grange movement of the 1870s and the New Deal in the 1930s. In 1950, nearly a century after this broadside was printed on Lake Street, *The Prairie Farmer* reached a peak of 370,000 subscribers; to this day, it remains a leading voice of the farmer. J. B.

VOL. XII. FARMERS! WRITE FOR YOUR PAPER! **1852.**

NEW VOLUME! TERMS REDUCED!!

PRAIRIE FARMER,

DEVOTED TO

Western Agriculture, Horticulture,

MECHANICS AND EDUCATION.

Published on the first of every Month, at Chicago, Ill., by

WRIGHT & HAVEN.

ENLARGED TO 48 VERY LARGE OCTAVO PAGES,

Stitched and trimmed, making a volume of *Over Five Hundred Pages.* It is the largest and cheapest paper in the whole country.

EDITED BY

JOHN S. WRIGHT, J. AMBROSE WIGHT AND LUTHER HAVEN,

Assisted by over 400 of the best practical Farmers and Mechanics in the West.

TERMS.

One Dollar per Annum in Advance;

6 Copies for $5; 13 Copies for $10.

When sent to one Address,

28 Copies for $20; 45 for $30; 67 for $40; and 100 for $50, or

ONLY FIFTY CENTS EACH.

GREAT PREMIUMS.

The price is cheap enough, especially at the reduced club rates; yet we offer still further inducements: The Subscribers at the Post-Office in *each* Western State, which sends us the largest list of subscribers to this volume, relatively according to the population of the town, as reported by the U. S. census of 1850, shall have the

VOLUME FOR 1853 FREE OF CHARGE.

And the Post Office sending us the *next largest* list *relatively*, in each Western State, shall have it at HALF THE PRICE, paid this year.

Advertisements must be paid for in advance For terms see Paper.

At these reduced rates, together with the cheap postage, every Farmer ought to take it. *Back Volumes*—A few complete sets or single volumes can be had, bound or unbound, POSTAGE *per Quarter on the Prairie Farmer.*—Within Cook County, *free*; within 50 miles of Chicago, 1 1-4 cents; over 50 and not exceeding 300, 2 1-2 cents; over 300 and not exceeding 1000, 3 3-4 cents; over 1000 and not exceeding 2000, 5 cents,

"THAT GATE."

JAS. J. LANGDON, GENERAL JOB PRINTER, (2d and 3d stories,) 161 LAKE STREET, CHICAGO.

33

Burlington & Missouri Railroad Company

25 Miles Staging Saved!
Great Through Route
Burlington & Missouri River
Rail Road!

Burlington, Iowa, 1858
Broadside
21⅝ × 17¼ in.
Gift of the Burlington Northern Railroad
Company, 1975
CB&Q

THIS PROMOTIONAL poster was created by the burgeoning Burlington & Missouri River Railroad and is one of the oldest pieces in the Newberry's massive collection of Chicago, Burlington & Quincy Railroad Company (CB&Q) records. Dated October 1858, the poster advertises the expansion of the road from Burlington to Fairfield, Iowa, making it the major route in southern Iowa and connecting it to lines from Michigan and Illinois.

Located along an established Indian trail in southern Iowa, the Burlington & Missouri River Railroad originated in Burlington, Iowa. While the road was incorporated in name in 1852, it took more time to secure land

grants and financial backing before construction could begin. Investors from the East who would eventually form the CB&Q were at that time involved in expanding the Michigan Central system through Illinois and looking further west, to Iowa and beyond. The Burlington & Missouri River Railroad looked like a promising means to extend their reach from Chicago to the Missouri River. In 1853 the investors pledged their financial support to the fledgling railroad, and construction ensued in the spring of 1855. The next few years saw financial setbacks and the Panic of 1857, and construction on the road ground to a halt temporarily. With additional help from the CB&Q, construction resumed in April 1858. The road reached Fairfield, Iowa, on August 1 of that year, as commemorated by this poster.

Railroad collections such as those of the CB&Q, the Illinois Central, and Pullman Company constitute some of the most important and frequently consulted resources at the Newberry. The records of the CB&Q occupy approximately 2,760 linear feet of storage and contain correspondence; personnel, land, and financial records; and advertising materials and photographs. Diverse users, from business historians to genealogists, utilize the collection daily. L. J.

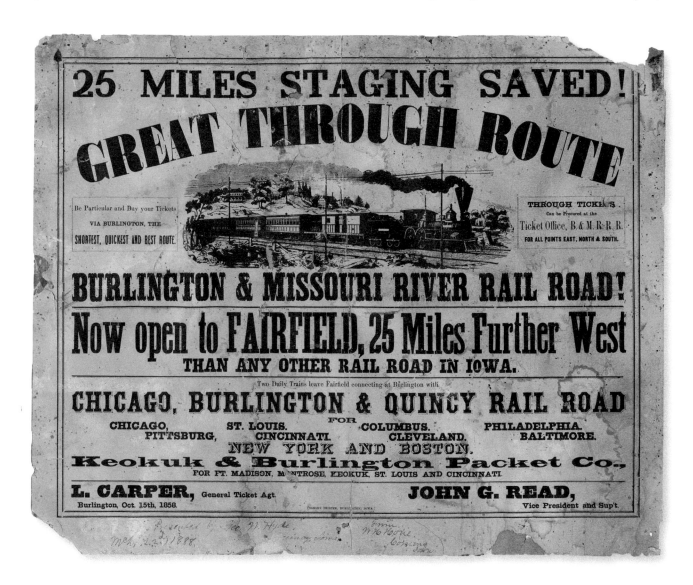

IN JULY 1893, sixteen-year-old Jane Elliott Sever (1876–1956) journeyed from Massachusetts to Chicago to visit the World's Columbian Exposition, staying with friends in the 600-room Women's Dormitory at Ellis Avenue and 53rd Street. Her delightfully descriptive letters to her mother and aunt allow us to experience the wonders of the fair through a young woman's eyes: the dazzling colors, vast grounds, monumental architecture, and convergence of cultures. We also sense the excitement and energy of youth, coupled with the thrill of a once-in-a-lifetime adventure to a fantastical, unimaginable place.

This double-sided letter, written to Jane's aunt Kate Elliott Sever (1827–1899) on July 26, conveys a charming sense of wonder at the sight of the fairgrounds at night: "I think I like it almost better in the evening than in the daytime, it seems more unreal, more fairy-like." Essential to Sever's impression of the nocturnal Dream City is the presence of electric lights, still a novelty at the time, which illuminated the Grand Basin fountains in "a pure shimmering white, then changing to rose, then a pale green, then blue, yellow, then green, rose and white together, making a most wonderful sight." She described the tiny lights outlining the buildings and circling the edges of the Grand Basin, again invoking the mythical fairy's environment to illustrate the sight before her.

"You could never imagine how wonderful the Fair is," Jane wrote her aunt, transporting her there with a textual sketch of the spectacular Peristyle, its white columns and dramatic arch rising against the deep blue backdrop of Lake Michigan on a bright summer day, and the foreground of gondolas gliding in the Grand Basin past golden statues. The Peristyle was the eastern portal to the fair, through which visitors traveling by boat passed, affording a dramatic first impression of the exposition's buildings. In Jane Sever's eyes, in this place of boundless beautiful sights, the Peristyle was the most beautiful.

Donated by her son Noel S. O'Reilly in 1989, Jane Elliott Sever's correspondence is associated with a collection of letters written from the fair by her brother, Francis Webber Sever, whose trip to Chicago was funded by Kate Elliott Sever (who most likely financed her niece's journey as well). In exchange, he promised to write his aunt about his adventures there. The O'Reilly materials complement a large assemblage of diaries, correspondence, reminiscences, ephemera, and other fair-related primary source materials in the Modern Manuscript Collections. K. K.

34

Jane Elliott Sever

Letter from the Woman's Dormitory at the World's Columbian Exposition

Chicago, 1893
Manuscript
6⅞ × 9 in.
Gift of Noel S. O'Reilly, 1989
Midwest MS 4

35

Duane Doty

A Classification of Workmen at Pullman

Chicago, 1890
Manuscript
10½ × 7¼ in.
Gift of the Pullman Company, 1969
Pullman 09/00/03, Box 1, Folder 20

THE DECADE-OLD and rapidly expanding Pullman's Palace Car Company had outgrown its Detroit manufacturing facility when George M. Pullman (1831–1897) determined in the late 1870s to locate a new factory just south of Chicago and to erect a company town run on business principles that would provide housing for his workers in a clean, decent, and safe environment. Pullman's experiment in social engineering was widely hailed, but was also criticized as paternalistic and un-American. Just fourteen years after the town opened for business, the 1894 Pullman strike forever tarnished the vision that a company could or should control every aspect of its workers' lives as employer, landlord, and social and moral arbiter.

Duane Doty (dates unknown), an early and ardent supporter of the Pullman town experiment, came to George Pullman's attention in 1879. By this time, the University of Michigan engineering graduate had been an army officer and war correspondent, newspaper editor, and superintendent of schools in Detroit and Chicago. Hired as the town of Pullman's first agent in 1881, he served for two years before resigning to become the community's civil engineer and statistician. Doty was a prominent figure in the model town. He used the statistics he gathered to write laudatory articles and served as tour guide to important visitors. He also was active in town affairs, promoting worker education and participating in many organizations.

Shown here is "A Classification of Workmen at Pullman," which Doty compiled in 1890 for Mr. Pullman. Meshing statistical compilation and opinion, he categorized workers employed in the town by industry, nativity, and type. He reflected the prejudices of the day in his analyses of

Types	Nativity, or Born in.		Whole Number of Operatives in Pullman	Remarks
American,	United States		1738	Good and versatile workmen and of superior executive ability.
Scandinavian,	Sweden	967.		Good workmen, good citizens, frugal industrious and as a rule religious.
	Norway	108.	1137	
	Denmark	62		
British,	England	372.		Intelligent industrious, progressive and desirable citizens
	Scotland	80.		
	Wales	27	685	
	Canada	306		
German,	Germany	581	620	Industrious good citizens
	Austria	39		
Holland Dutch,	Holland		557	Better at labor here than as mechanics. Our best laborers
Irish,	Ireland	318	318	Never a desirable element here. We may have been unfortunate in our allotment. They control all politics here as elsewhere in Chicago.
French,	France	23		Good workmen and good citizens
	Belgium	9	56	
	Switzerland	24		
	All others	112	112	
			5223	

the "Types" prevalent at Pullman, viewing favorably all northern Europeans except the Irish, whom he declared were "never a desirable element," controlling "all the politics here as elsewhere in Chicago." African Americans are notably absent from the report. While almost all Pullman porters were African American and many were based in Chicago, they and their families did not live in Pullman and jobs in the town were not open to them.

The Doty report is part of the Pullman Company Archives, comprising more than 2,500 linear feet of records documenting the one hundred-plus-year history of the company. Among the collection's many strengths are the personnel records of individual porters, conductors, and shop and yard workers. Frequently containing dates and places of birth and names of next of kin, these records are especially significant for African American genealogical research. There are also scrapbooks containing a comprehensive record of the nineteenth-century town and the 1894 strike, as well as excellent documentation of the company's relations with unions, including the Brotherhood of Sleeping Car Porters.

Thanks to the efforts of its fifth librarian, Stanley Pargellis, the Newberry is a significant repository of railroad history. In addition to the Pullman Company Archives, it holds the records of two other Chicago-based railroads, the Illinois Central and the Chicago, Burlington & Quincy. Pargellis advocated the acquisition of records of midwestern enterprises that contained materials for social and intellectual history, as well as business history. He believed that the important role of corporations in American life could be assessed only if business records were freely available for research. The Newberry's railroad collections are heavily used by genealogists, railroad buffs, local historians, and students and teachers at all levels and in many disciplines. M. B.

36

Pure Milk Campaign Notices from Chicago Commons Scrapbook

Chicago, 1902
Broadsides
9 × 6 in. (each)
Gifts of Lea Demarest Taylor
and Katharine Taylor, 1951
Midwest MS Taylor, Box 58 Folder 2473

THESE PAGES are from a once-tattered and brittle scrapbook that has been conserved and that constitutes part of a major Newberry collection on Chicago and United States history. The scrapbook is one of several that document the initiative known as the social-settlement movement and that reflect the work of one of its major leaders, Graham Taylor (1851–1938). The most well-known American settlement leader is another Chicagoan, Jane Addams, of Hull-House. But as influential and talented as Addams was, she could not have developed the settlement movement by herself into the national and international reform phenomenon that it became in the early twentieth century. Although nearly forgotten today, Taylor founded a settlement house; articulated some of the settlement movement's essential principles; established a journal that would eventually become *The Survey*, the movement's major publication; and wrote a weekly column for the *Chicago Daily News* for more than thirty-five years.

Like Addams, Taylor observed the growing economic inequality in American society caused by the swift expansion of industrialization and unbridled capitalism in the period after the Civil War. To address the resulting social problems, Addams opened Hull-House in 1889 on Chicago's densely populated West Side. Meanwhile, Taylor, a Congregational minister, took a teaching position at the Chicago Theological Seminary in 1892 and two years later opened the Chicago Commons in another crowded immigrant neighborhood on the city's Northwest Side. He lived at the Commons with his wife and children, a controversial decision at the time. Taylor and his settlement colleagues aimed to improve living and working conditions of urban working people and immigrants who had fled political or religious oppression in Europe and sought economic opportunities in the United States. Settlement leaders were also determined to change middle- and upper-class assumptions about the causes of poverty and the status of immigrants in American society. One of Taylor's contributions was to apply to the settlement

movement Social Gospel ideas, a set of theological and practical responses by Christians to the challenges posed by industrialization and capitalism to American society.

By the turn of the twentieth century, Chicago's Northwest Side was home to a mixture mainly of Italians and Poles, with smaller groups of Irish, Germans, Russian Jews, and others. Some residents did not speak English, and most were mystified as to why a middle-class family with a few seminary students in tow had moved into the neighborhood. The Commons established many programs and services. It ran a kindergarten and a day-care center, mothers' meetings, and other programs (including musical entertainment) and clubs.

During brutally hot summers, food and milk spoiled quickly, and infants and small children were most vulnerable to death from spoiled milk. Although impossible to measure precisely, infant-mortality rates remained high in the city in the first decade of the twentieth century. To combat the problem, Commons residents collaborated with colleagues at the Northwestern University Settlement, Hull-House, and other similar institutions in the city to offer inexpensive, pasteurized milk to families with young children.

The Graham Taylor Papers are one of the Newberry's most requested collections. Newberry staff member Lloyd Lewis (1891–1949) solicited Taylor's papers from the minister's daughter and successor at the Chicago Commons, Lea Demarest Taylor, in 1946. Lewis, who had recently acquired the papers of Victor Lawson, editor of the *Chicago Daily News* and Taylor's long-time friend and colleague, understood the significance of Taylor's contributions to Progressive-era history and the value of his collection to the Newberry as a whole. R. E. B.

Latte Puro pei Bambini.

Il vostro dottore vi informerà che il latte che ordinariamente comprate è un nutrimento pericoloso per i vostri bambini durante la stagione estiva.

Il così detto *Pasteurized Milk* (Latte sterilizzato) è assolutamente il migliore preventivo contro le diarree infettive, che di estate attaccano i bambini.

Il *Pasteurized Milk* costa:

Una bottiglia di 8 oncie 2c.

Due bottiglie di 8 oncie 3c.

Per i bambini sotto alla età di nove mesi il latte deve essere preparato appositamente:

Formula No. 1 per bambini sotto ai 3 mesi 2c. la bottiglina.

Formula No. 2 per bambini da 3 a 6 mesi 3c. la bottiglina.

Formula No. 3 per bambini da 6 a 9 mesi 4c. la bottiglina.

Voi potete comprare il *Pasteurized Milk* ed il latte modificato ai seguenti indirizzi:

HULL-HOUSE, 335 S. Halsted St.

NORTHWESTERN UNIVERSITY SETTLEMENT, Augusta & Noble Sts.

CHICAGO COMMONS, Grand Ave & Morgan Street.

CENTRAL BUREAU OF ASSOCIATED CHARITIES, 1500 Wabash Ave.

GADS HILL SETTLEMENT, 22nd & Robey Sts.

THE T206 SERIES of baseball cards, known informally as the "White Border" set, was enclosed by the American Tobacco Company in cigarette and loose tobacco packs from 1909 to 1911. Each card features a color lithographic portrait of a major- or minor-league player surrounded by a white border. On the versos are advertisements for company brands, including Sweet Caporal, Piedmont, and Sovereign. The cards have long been popular with collectors due to their rarity and the quality of the lithographs.

An avid Chicago White Sox fan, American realist writer and *Studs Lonigan* author James T. Farrell (1904–1979) collected forty-six cards of the series—mainly those featuring Sox players, but also their in-town rivals, the Chicago Cubs. Growing up on the city's South Side, Farrell was a high-school varsity baseball player who dreamed of a major-league career. He incorporated his encyclopedic knowledge of and passion for the sport into his writings, including two books and several short stories entirely about baseball. Because of the importance of the game to Farrell, his collection of T206 cards adds an important dimension to the small but growing nucleus of his writings and correspondence at the Newberry. The cards are a 2007 gift of Cleo Paturis, Farrell's longtime companion.

Included in the Farrell Collection are the cards of a number of players who participated in the 1906 crosstown World Series, in which the Sox defeated the heavily favored Cubs. Pitching two wins with the assistance of ace defensive catcher Billy Sullivan, the Sox's Ed Walsh led his team to a surprise four-games-to-two series victory. The 1906 contest was the first World Series for the Cubs' famous infield trio of Joe Tinker (lower right), Johnny Evers, and Frank Chance, who were immortalized as the "Tinker to Evers to Chance" double-play combination in the wildly popular poem "Baseball's Sad Lexicon," by New York newspaper columnist Franklin Pierce Adams.

Arnold "Chick" Gandil's card is also in the collection. Recruited by the White Sox in 1909, he made his major-league debut with the team in 1910. After a disastrous batting season, Gandil was sold in 1911 to Montreal. He later played in the majors with the Washington Senators and Cleveland Indians before returning to the White Sox in 1917. Gandil is known as the ringleader of the infamous 1919 Black Sox scandal, in which eight Sox players allegedly threw the World Series to the Cincinnati Reds. M. B.

BORN INTO a wealthy shipping family in Park Ridge, Illinois, John Alden Carpenter (1876–1951) studied music composition at Harvard with John Knowles Paine. He also studied in Europe with Edward Elgar and then in Chicago with Bernard Ziehn. Supported by a position in his family's business, he composed a number of pieces in which he attempted to reflect an American sensibility. In 1915 Carpenter's first large orchestral work, *Adventures in a Perambulator*—created for the Chicago Symphony Orchestra and its conductor Frederick Stock—was well received.

Composed in 1921, Carpenter's ballet, *Krazy Kat, A Jazz Pantomime*, inspired by the comic strip *Krazy Kat*, by George Herriman (1880–1944), was applauded by critics and praised by publisher William Randolph Hearst, whose newspaper the *New York Evening Journal* had introduced the cartoon in 1913. In 1917 Herriman presented Carpenter's twelve-year old daughter, Genevieve, with a signed ink drawing of the Kat. Four years later, the composer approached Herriman about collaborating on a ballet. The work, infused with jazz-inspired rhythms (characteristic of his style), was a turning point for traditional concert music. In subtitling the ballet *A Jazz Pantomime*, Carpenter became the first concert-music composer to use the word *jazz* in a title.

Both the printed musical score and the ink drawing are part of the John Alden Carpenter Papers, given to the Newberry by Carpenter's daughter, Genevieve (Mrs. Patrick Hill) in 1977. Within the score itself are illustrations by Herriman and program notes by Carpenter, in which he remarked that, ". . . Krazy Kat is the world's greatest optimist, Don Quixote and Parsifal rolled into one."

The John Alden Carpenter Papers at the Newberry form part of a very strong collection of primary sources relating to music and dance in Chicago and the Midwest. They may be researched at the library together with the records of the Arts Club (see no. 46), a highly important venue in Chicago for the avant-garde that Carpenter's wife, the former Rue Winterbotham, cofounded and led for years. J. M. D.

38

John Alden Carpenter; George Herriman

"Krazy Kat," A Jazz Pantomime; Krazy Kat Cartoon

New York: G. Schirmer, Inc., 1922; New York, 1917
Score; drawing
11⅞ × 9⅛ in.; 6½ × 5⅛ in.
Gifts of Mrs. Patrick Hill, 1977
Midwest MS Carpenter, Box 2, Folders 114 and 123

39

May Walden

Explanation of Eugene Debs Campaign Novelty Drinking Cup; Debs Campaign Drinking Cup

Chicago, 1912
Manuscript; cup
8 × 5 in.; 3½ × 2½ × 1¾ in.
Gift of May Walden, 1959
Midwest MS Walden, Box 6, Folder 168b

MAY WALDEN (1865–1960), a Socialist Party organizer and activist based in Chicago, shrewdly capitalized on a number of current political issues when she turned this portable drinking cup into a 1912 presidential-campaign novelty for Eugene V. Debs, the Socialist candidate for United States president. Printed on the reverse side of this intriguing example of printed ephemera is the slogan "A Clean Cup for Clean Politics." Debs ran for president five times between 1900 and 1920, the last time from federal prison, where he was incarcerated for his antiwar sentiments. In 1912, however, the Socialist Party reached its high watermark, with Debs, its presidential candidate, receiving nearly one million votes. Reformers also enjoyed an unusual level of political influence that year. Jane Addams seconded Theodore Roosevelt's nomination for president on the Progressive Party ticket, the first time a social reformer and a woman had been recognized as a political kingmaker, despite the fact that most women did not yet have the right to vote.

A wide spectrum of progressive reforms and reformers heightened concern about public hygiene and cleanliness, which became a major topic of the 1912 election season. Between 1900 and 1920—the Progressive era—reformers approached public health and hygiene from a variety of perspectives and motives. Some drew upon new developments in public health and sanitary science, others on religious ideas from the Social Gospel movement or from evangelical beliefs. Their efforts reflected a broad range of concerns about cleanliness, from the physical (garbage removal, safe housing, immunizations, and campaigns against spitting in public and against venereal disease), to the political (opposing city bosses and their political machines, and fighting for women's suffrage), to the moral (prohibition and antiprostitution). Public-health reformers in particular engaged in awareness campaigns about the "white plague"—tuberculosis—along with typhoid and infant diarrhea, which were rampant among immigrant communities living in the nation's most crowded urban centers.

Embracing the germ theory of disease, reformers worked to end the use of shared drinking vessels on trains, in saloons, at workplaces, and in schools. Walden's water cup and slogan, which she later described in an accompanying note, a page of which is reproduced here, resonated with all of these progressive initiatives and helped insert them into Debs's campaign. The cup was intended to signal the Socialist leader's forward-thinking and informed leadership, and to symbolize his political incorruptibility, outsider status, and even his moral purity.

The May Walden Papers at the Newberry—particularly some of her socialist writings after 1900—partly document her long reform career. She began working as a social and political activist as a teenager in the early 1880s, when she joined the Woman's Christian Temperance Union over concern about her invalid father's drinking. In 1892 Walden and her husband, Charles H. Kerr, joined the Unitarian All Souls' Church. Led by Jenkins Lloyd Jones, this Chicago congregation was a community of enlightened, reform-minded people. Before 1900, disillusioned after working for Democrat and populist leader William Jennings Bryan, Walden was drawn to the Socialist movement and began contributing to Socialist magazines issued by her husband's Chicago publishing company. Although the couple divorced in 1904, Walden's commitment to the movement remained firm, and she officially joined the Socialist Party. She stumped for the party in Illinois in 1912 and 1913 and contributed her own money to fund the water-cup project for Debs's campaign. R. E. B.

1912

The Story of the drinking cup.
At the beginning of the Century people became
sanitary-conscious and decided to use
individual communion cups, individual
drinking cups, etc. Hygiene was the word.
About that time a substance was
invented called glassine. We now call it
plastic
A Chicago man by the name of Stone
patented a Life-cup — advertised as an
opposite to the Death cup that everybody
used — and made it out of glassine and
strong waxed paper, stitched together in a
small cup with an envelop suitable for
pocket or handbag. I conceived the idea
of using these cups for a campaign
novelties with the pictures of Debs and
Hanford printed on the glassine. The
matter was brought before the Executive's Campaign
Committee and Debs opposed it. Few
favored it on account of the expense.
It would cost over a hundred dollars

40

Ben Hecht

News Dispatch; Photograph Album

Berlin, June 30, 1919; April–June 1919
Manuscript; photographs
11⅜ × 9 in.; 11 × 7⅞ in.
Bequest of Rose Caylor Hecht, 1979
Midwest MS Hecht, Box 2, Folder 108;
Box 113, Folder 2981

BEFORE HE WAS NAMED the *Chicago Daily News*'s foreign correspondent in Berlin in 1918, Ben Hecht (1894–1964) had cut a colorful path across what was at the time a raucous journalism landscape. Born in New York City and raised in Racine, Wisconsin, Hecht arrived in Chicago as a teenager and began his journalism career as a picture chaser for the *Chicago Journal*. That job entailed snatching or otherwise securing photographs of the recently deceased or scandal-plagued for use in the paper. He soon became a reporter and man-about-town, diving enthusiastically into the city's literary scene. He started working for the *Daily News* in 1914.

The Hecht Papers came to the Newberry in 1979 from his second wife, Rose Caylor Hecht, fifteen years after the author's death. It is a massive collection: one hundred forty-four boxes and nineteen oversize boxes containing personal papers, correspondence, photographs, scrapbooks, sound recordings, film, and miscellaneous ephemera. As Robert Schmuhl wrote, "Studying Ben Hecht's papers at Chicago's Newberry Library for a prospective book is less an academic exercise than a mental game akin to assembling a complicated jigsaw puzzle." Representing the collection here are a photographic album and the first of two pages that Hecht dispatched from Berlin via Western Union to the *Daily News* on June 30, 1919. The album contains sixty-four numbered photographs affixed, with some care, across twelve of its twenty-four pages, with captions, many still legible, written by Marie Armstrong, Hecht's first wife. (She had her own views of Germany, of course, writing in one place of "this exhausted, feverish country.") The photos are a miscellany, including shots of clouds, a cemetery, an airfield, several of Ben and Marie ("Me," reads the caption for more than one), and many of a Scottish terrier named Tiger. Photo 59, of Marie, bears this caption: "There is a wonderful moral to this picture, which is—never be cross when someone is snapping you."

The spread shown here includes a photo of Hecht, along with three snapshots of the June 1919 funeral of famed radical reformer Rosa Luxembourg. She had been slain several months before, but her body had only just been retrieved from the river into which it had been thrown. Clearly, Luxembourg's funeral was something that any reporter

would have wanted to witness. The dispatch is, in fact, Hecht's report on the event, which he described in detail.

Two other photographs show Hecht with the artist George Grosz (1893–1959), whose name is misspelled in the caption. In photo 64, the two sit at a table; in photo 66, they are part of a musical ensemble. Grosz's 1946 memoir, *A Small Yes and a Big No*, describes a party thrown by the Hechts in Berlin that may very well be the event seen in the snapshot:

> The host, whom everyone called Benny, sat cross-legged on top of the piano playing "Everybody Shimmies Now" on a fiddle. His wife accompanied him. There was [*sic*] glasses everywhere and ashtrays filled to the brim with butts; on our table were Havanas, cigarettes, two long-necked Rhine-wine bottles on ice, a quarter-full bottle of Black & White and a bottle of Cognac. A gigantic tin near the piano was said to contain ship's biscuits . . . towards four in the morning Benny started to conduct the band, and taught the pianist to play ragtime.

Hecht's time in Berlin—the fun as described above, as well as the terror (Hecht and his wife were attacked by a mob while riding in a taxi in March 1919)—gave him material for his first novel, *Erik Dorn*, which he started in Germany and completed after returning to Chicago and which was published in 1921. Hecht by then was writing an enormously popular and influential *Daily News* column entitled "1001 Afternoons in Chicago" (the columns were gathered in a book of the same title published in 1922).

A star by the early 1920s, Hecht left Chicago for New York in 1924, which prompted *Chicago Herald-American* drama critic Ashton Stevens to suggest that the city fly its flags at half-mast. Hecht went on to great fame by writing, with his newspaper pal Charles McArthur, the play *The Front Page* (produced in 1928). Then it was off to Hollywood and one of the most successful screenwriting careers in history.

Hecht in later life did not write about Berlin, but he revisited Chicago often. "I have lived in other cities, but been inside of only one," he stated. "I once wore all the windows of Chicago and all its doorways on a key ring. Salons, mansions, alleys, courtrooms, depots, factories, hotels, police cells, the lake front, the rooftops and the sidewalks were my haberdashery." That may be his most famous paean to the city of his youth. But filled with palpable wistfulness, he also wrote this: "We were all fools to have left Chicago. It was a town to play in; a town where you could stay yourself, and where the hoots of the critics couldn't frighten your style or drain your soul." R. K.

Axel moos politiken copenhagen relay news chicago via western union

berlin june thirty the hungry gleaming eyed faces again come into streets
where they dont belong the world revolution that put on its silk hat to
bury xxxxxbxxxghxxxx rosa luxemburgs prowling about once more stop motor
lorries loaded with enemies of world revolution surge up down main highways
distributing machine guns xxx xxxxxxxxxxxxxxxxxxxxx stop all day xxxxxx
assembly halls been crowded with workingmen theres been much oratory
 tomorrow strike begins therell be no street cars subways auto busses or
railroad trains running stop noske the first noske the new iron man of
germany has made blunder stop he xxxxxxxxxxxx issued decree pronouncing
all strikes illegal ordering immediate arrest all workingmen who so much
as thought of striking quote merciless suppression all signs of labor
troubles ran decree quote government wont tolerate any more destructive
attempts on part workers unquote then there were other decrees ordering
soldiers shoot to kill commanding all gatherings cease stop gwas great
idea of noske and wonderful way to restore order to his exhausted
feverish country quote you cant drive sense into starving mans head with
machine gun unquote noske said some time ago quote but you can keep him
quiet
xxxxxx unquote another admirable idea stop as result mr noskes scintillent
notions of iron handed politics xxxxxxxx nearly everybodys going strike
tomorrow stop noskes eleventh hour effort soothe ruffled feelings of
world revolution by withdrawing his quote strike verbot unquote has
only complicated things quote noskes fumbling the militarys weakening
unquote these and similar cries have gone up xxxx cries that contain
as fars i can see great element truth in them stop newspapers are full
of startling communications from various volunteer regiments addressed
to government the regiment von horcke one noskes units answers national
assemblys appeal for xxxxxxxx loyality with following furious words quote
we men of honor regard it insolence that so called representatives of
german people who in cowardly fear have given away honor of germany whove

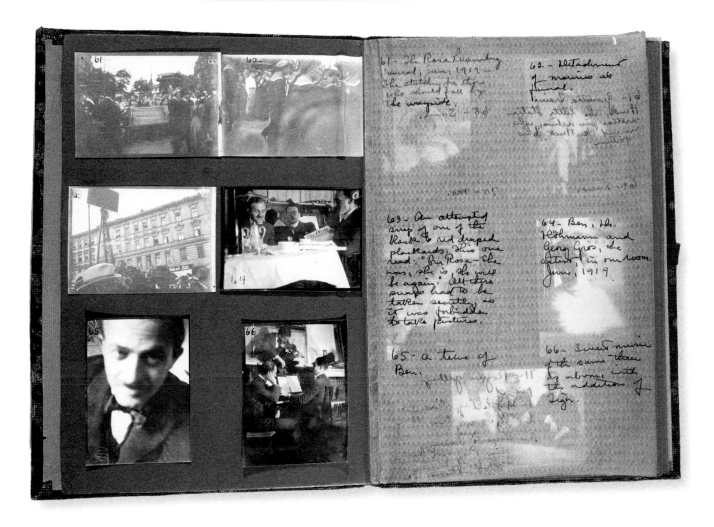

Fanny Butcher – Books Guestbook

Chicago, 1920–1927
Manuscript
7⅛ × 8⅞ in.
Gift of Fanny Butcher, 1987
Midwest MS Butcher, Box 36,
Folder 1565

FOR NEARLY FIFTY years, Fanny Butcher (1888–1987) served as a literary editor at the *Chicago Tribune*, arguably at that time the most powerful newspaper in the Midwest. Through her weekly columns, she developed a wide network of friends in the book world, many of whom she came to know intimately. Her papers, bequeathed to the Newberry, include diaries, engagement books, personal notes, photographs, clippings, and a large body of correspondence with important twentieth-century authors and notable figures in the publishing industry. The Butcher Papers constitute a major resource for scholars and a key asset of the library's Modern Manuscript Collection.

Butcher's papers also include the guestbook from a bookshop she established in 1920 in the Pullman Building on South Michigan Avenue. At that time, the retail book trade was flourishing in Chicago. In addition to big stores like Brentano's and A. Kroch, there were many small shops with specialized stock, cavernous secondhand outlets, and the rarified rooms of such eminent antiquarian dealers as Frank Morris and Walter M. Hill. Although this trade was dominated by men, women entered the business in significant numbers. Except for Marcella Burns Hahner, who built the book section at Marshall Field & Co. into the most impressive department-store book operation in the country, most of these women tended to create a domestic atmosphere in their shops, with a predictable emphasis on flower pots and chintz cushions.

Fanny Butcher – Books, however, was unique. Its distinction lay in its cosmopolitan clientele and the new note of urbanity it sounded in a city painfully conscious of its image as a provincial hinterland and crude second cousin to centers of culture in the East. This feeling of inferiority

was compounded by Chicago's growing reputation as the playground of gangsters. Indeed, Butcher reported that she could not successfully represent Chicago, the newspaper, or her shop at publishing teas in Manhattan without a good answer to the question, "Do they actually shoot people dead in the street?"

Butcher's unabashed cultivation of the brightest stars in the literary and theatrical firmament, together with the power of her popular *Tribune* columns, drew a stream of famous visitors to her store. Their endless (and often unexpected) appearances—faithfully recorded in the guestbook—were the shop's most alluring feature. This document includes the signatures of such luminaries as Sherwood Anderson, Stephen Vincent Benet, Willa Cather, Will Durant, Lynn Fontanne, Aldous Huxley, Sinclair Lewis, Maurice Maeterlinck, Edgar Lee Masters, and William Butler Yeats. H. L. Mencken and Edna Ferber traded barbs in its pages. Carl Sandburg wrote a poem. Carl Van Vechten, that ardent advocate of the Harlem Renaissance, signed in with a sketch of his cat. Local customers who chanced to wander in might have overheard what Butcher described as "a river of conversation." At the same time, the store's gracefully designed cases, secluded corners, and wobbly book ladder (artfully arranged by modernist decorator Rue Carpenter) also appealed to loners. W. Somerset Maugham preferred to browse quietly and remain anonymous. Butcher recalled that, during a fortnight in Chicago en route to Indonesia, Maugham came in often, apparently seeking to hide from the relentless attention that followed the success of his bestseller *The Moon and Sixpence* (1919).

By 1927 Butcher could no longer balance her expanding responsibilities at the *Tribune* and the store's exhausting demands. Regretfully, she sold the shop to Doubleday-Page & Co., which operated in the same location until its lease expired in 1931. Under corporate ownership, the store's singular cachet evaporated. This tattered guestbook remains—living evidence of a time when a bookshop could be an exciting destination and a vital institution in the marketplace of literature and ideas. C. H.

42

Dill Pickle Club

Tooker Alley Club Door;
Dil-Pickle Club;
A Night in Bohemia

Chicago, undated; Chicago, 1916;
Chicago, October 31, 1916
Photograph; broadsides
9⅛ × 6⅜ in.; 5⅜ × 3½ in.; 10⅞ × 6¾ in.
Gifts of Mrs. Iailah Cooper, 1973
Midwest MS Dill Pickle, Box 3, Folder 285;
Box 2, Folder 115; Box 2, Folder 188

THE DILL PICKLE CLUB, whose dramatic entry doorway is pictured here, was located just southeast of Washington Square Park and the Newberry, between Chestnut and Delaware streets. Early club documents spell "Dill" with one *l*. However, well-meaning printers of the club's broadsides probably added the second *l* in some cases, believing they had caught a misspelling. Opening in 1915, the Pickle quickly gained a national profile. It operated as a coffeehouse, theater, dance hall, lecture room, art gallery, and Prohibition speakeasy. Political radicals, nonconformists, hobos, artists, prostitutes, academics, writers, and reformers of all kinds visited the Pickle as they passed through Chicago. The club hosted weekend jazz dance parties and little theater productions of work by Henrik Ibsen, August Strindberg, Eugene O'Neill, and local playwrights. It offered serious lectures by university professors and spoof debates staged for pure entertainment. In its early years, the Pickle was a meeting place for some of Chicago's most famous authors, intellectuals, and radicals, including Sherwood Anderson, Ralph Chaplin, Clarence Darrow, Floyd Dell, Ben Hecht, Vachel Lindsay, Harriet Monroe, Lucy Parsons, Ben Reitman, and Carl Sandburg.

In significant ways, the Dill Pickle Club institutionalized the open forum and the soapbox

oratory that occurred regularly in Washington Square Park. During the first decades of the twentieth century, people had begun to use the park to air their political opinions, religious views, and grievances, and to perform or display their art. Most of the speakers were working people, many of whom were members of a new union formed in Chicago in 1905, the Industrial Workers of the World (known informally as Wobblies). Interested in fostering working-class education, Wobblies became known as well-informed, literate, and skillful extemporaneous speakers. Not surprisingly, IWW members dominated the informal competitions for audiences and donations among the "ozone orators" in the park, which was nicknamed Bughouse Square (slang facetiously referencing a mental-health facility). People listened, commented, argued, and enjoyed the spectacle of a public forum as a kind of performance art. Although no known documentary evidence supports this claim, some debaters probably settled their differences by running into the Newberry for a reference. We know that soapboxer Jack Jones (1876–1940), an IWW member and one of the founders of the Dill Pickle, was an inveterate reader who often used the Newberry's reading rooms.

A small group of Bughouse soapbox regulars (mostly IWW members) opened the club in early 1915 with the mission of giving a respectful hearing or view to any idea or work of art. Jones, a skillful impresario, managed the club and, as the advertisements pictured here reveal, offered programs that informed, entertained, and demanded public attention. Sherwood Anderson, who wrote about the Pickle in the *Chicago Daily News*, called Jones its "father, mother, and ringmaster." Jones asked every guest who entered the Pickle the same questions: "Are you a nut about anything? Don't you want to talk to

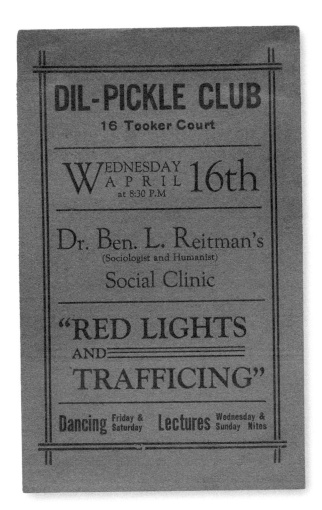

DIL-PICKLE CLUB
16 Tooker Court

WEDNESDAY
APRIL 16th
at 8:30 P.M

Dr. Ben. L. Reitman's
(Sociologist and Humanist)
Social Clinic

"RED LIGHTS
AND
TRAFFICING"

Dancing Friday & Saturday Lectures Wednesday & Sunday Nites

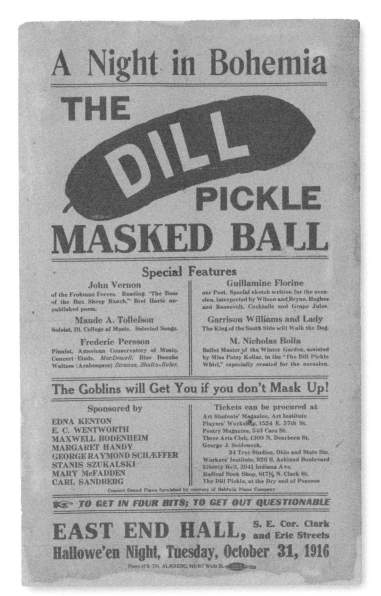

A Night in Bohemia
THE DILL PICKLE
MASKED BALL

Special Features

John Vernon
of the Frohman Forces. Reading: "The Boss
of the Box Sheep Ranch," Bret Harte un-
published poem.

Guillamine Florine
our Poet. Special sketch written for the occa-
sion, interpreted by Wilson and Bryan, Hughes
and Roosevelt. Cocktails and Grape Juice.

Maude A. Tollefson
Soloist, Ill. College of Music. Selected Songs.

Garrison Williams and Lady
The King of the South Side will Walk the Dog.

Frederic Persson
Pianist, American Conservatory of Music.
Concert-Etude. *MacDowell;* Blue Danube
Waltzes (Arabesques) *Strauss, Shultz-Evler.*

M. Nicholas Boila
Ballet Master of the Winter Garden, assisted
by Miss Patsy Kellar, in the "The Dill Pickle
Whirl," especially created for the occasion.

The Goblins will Get You if you don't Mask Up!

Sponsored by
EDNA KENTON
E. C. WENTWORTH
MAXWELL BODENHEIM
MARGARET HANDY
GEORGE RAYMOND SCHÆFFER
STANIS SZUKALSKI
MARY McFADDEN
CARL SANDBERG

Tickets can be procured at
Art Students' Magazine, Art Institute
Players' Workshop, 1554 E. 57th St.
Poetry Magazine, 543 Cass St.
Three Arts Club, 1300 N. Dearborn St.
George J. Seideneck,
34 Tree Studios, Ohio and State Sts.
Workers' Institute, 920 S. Ashland Boulevard
Elberty Hell, 2041 Indiana Ave.
Radical Book Shop, 817½ N. Clark St.
The Dill Pickle, at the Dry end of Pearson

Concert Grand Piano furnished by courtesy of Baldwin Piano Company

TO GET IN FOUR BITS; TO GET OUT QUESTIONABLE

EAST END HALL, S. E. Cor. Clark and Erie Streets
Hallowe'en Night, Tuesday, October 31, 1916

Press of S. TH. ALMBERG, 915-917 Wells St.

the Picklers?" The club declined in the late 1920s; Prohibition, corrupt public officials, bootlegging, and the Great Depression all took a toll. The Pickle closed permanently around 1934.

The bulk of the Dill Pickle Club's records came to the Newberry in the form of two scrapbooks donated by Mrs. Iailah Cooper of Chicago, who had received them from Jones. Neighborhood activists and Newberry staff revived the spirit of the Pickle with the Bughouse Square Debates in 1986, the centenary of Haymarket, which was a watershed event in the history of labor and free speech in Chicago and the United States. On May 4, 1886, during a public labor protest meeting at the West Randolph Street Haymarket in Chicago, a bomb was thrown. The political and judicial aftermath of the bombing led to one of the worst miscarriages of justice in the history of the United States: eight anarchists were convicted of the crime on the basis of their speeches and writings rather than on physical evidence. Set in Washington Square Park, the annual Bughouse Square Debates commemorate the Pickle's open forum and passion for good talk by honoring the best soapbox speaker with the Dill Pickle Award. R. E. B.

43

John T. McCutcheon

The New Yorker's Idea of the Map of the United States

New York, July 27, 1922
Drawing
17¾ × 14 in.
Gift of Mrs. John T. McCutcheon, 1958
Midwest MS McCutcheon, Box 13,
Folder 382

JOHN T. MCCUTCHEON'S inventive cartoon reflects two areas of Newberry strength: its remarkable map collection and its comprehensive archive of the work of midwestern journalists, artists, writers, and critics. McCutcheon (1870–1949), a proud Hoosier, was linked to the region and his adopted city of Chicago through an elaborate web of friendships, social clubs, and professional associations. Born near Lafayette, Indiana, and a graduate of Purdue, he moved in 1889 to Chicago, where he remained for the rest of his life. McCutcheon, who married late (his wife, Evelyn, was the daughter of Chicago architect Howard Van Doren Shaw), did not simply stay put, however. In his younger years especially, he roamed the world from China and Japan to Turkey and Iran in the interest both of curiosity and his newspaper employers. A prolific book and magazine illustrator for writers like George Ade and Irvin S. Cobb, he was best known as the *Chicago Tribune*'s editorial cartoonist. He won a Pulitzer Prize in 1932.

The cartoon differs from other types of pictures, McCutcheon wrote in his autobiography, because "the idea alone is the essential requirement." It "has little to do with beauty or grace; it has much to do with strength and uniqueness." This drawing, for a cartoon published in the *Tribune* on July 27, 1922, epitomizes McCutcheon's notion. It seems an uncanny anticipation of Saul Steinberg's celebrated 1976 *New Yorker* cover "View of the World from 9th Avenue," and it is indeed impossible to avoid the relationship. Both look west over the Rocky Mountains to the Pacific Ocean. And both focus on the "typical" New Yorker's self-obsession and lopsided sense of national geography. But McCutcheon was less sympathetic in his portrait of New York's sense of privilege and ownership. He included no skyscrapers, no city or state names, concentrating instead on Long Island and the rich at play. Washington, D.C., flies the municipal flag in homage, one of its sides attached to a laundry, where, presumably, dirty linen is being continuously washed. The vast acreage devoted to agriculture, mining, forestry, and oil wells suggests a colonial empire feeding the pleasures of the great metropolis, personified by a knickerbocker-clad playboy at its center. The New Yorker's garage is, appropriately, placed in the general vicinity of Detroit, and New England contains his school house.

Two years later, illustrating a book by Cobb, McCutcheon produced another Gotham-centric map. More conventional if more expansive, it includes several cities of interest to New Yorkers like Reno, Palm Beach, and Hollywood. At the tip of one of a "Group of Probably Fresh Lakes" sits a "Frontier Trading Post" (Chicago). All this a decade before the usually cited ancestor to Steinberg's masterpiece, Daniel Wallingford's "New Yorker's Idea of the United States of America," was published. McCutcheon's maps, still rarely invoked, document a midwesterner's response to East Coast condescension (or indifference), which, as Steinberg's image reveals, would hardly abate across the next fifty years of national life. N. H.

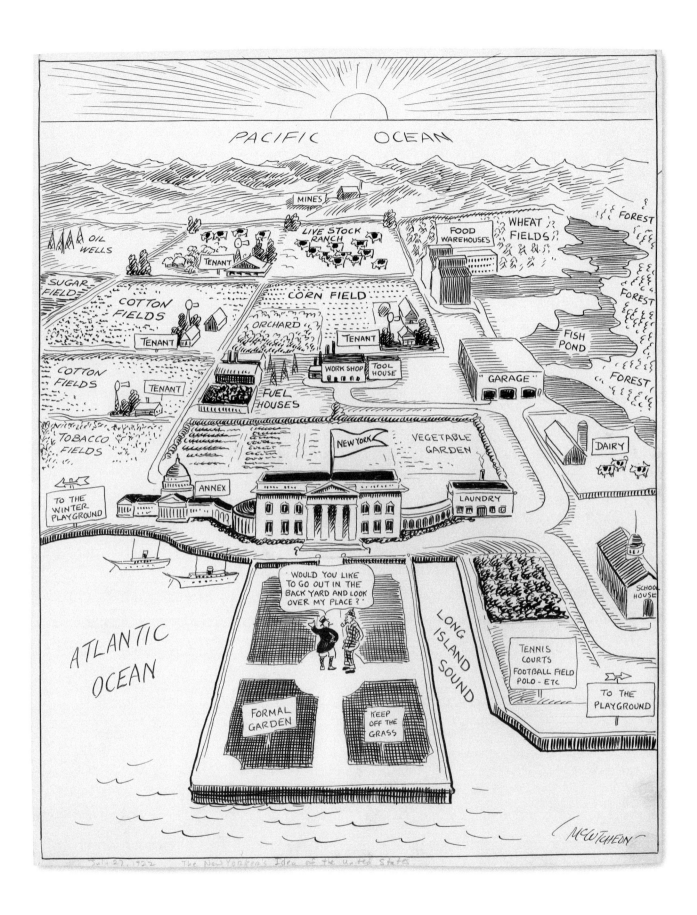

44

Jack Conroy (editor)
John Rogers (illustrator)

The Anvil

Moberly, Missouri, number 2,
September–October 1933
Periodical
10⅝ × 7⅜ in.
Gift of Jack Conroy, 1989

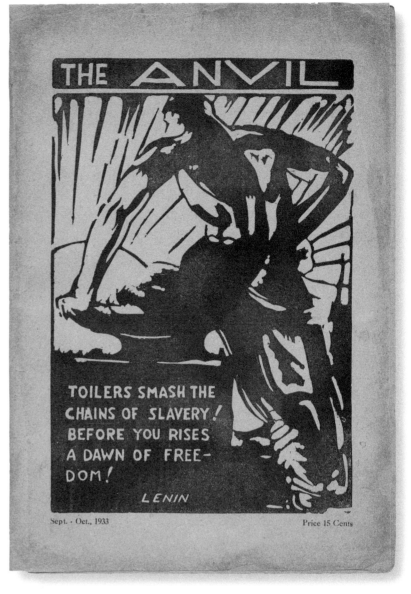

AN IMPORTANT VOICE of the Depression-era radical working class, writer Jack Conroy (1898–1990) was born and grew up in the hardscrabble mining camps of Missouri. He is the author of one of the best known and most enduring works of 1930s proletarian literature, *The Disinherited* (1933), which was published with the encouragement and support of the famous journalist H. L. Mencken.

During his lifetime, Conroy launched and edited three leftist literary magazines, *The Rebel Poet*, *The Anvil*, and *The New Anvil*. Its title borrowed from a Bulgarian publication of the same name, *The Anvil* first appeared in 1933. Under Conroy's editorship, this midwestern venture, with its volunteer contributors, quickly emerged as one of the decade's most important periodicals of its type. The magazine's slogan—"We prefer crude vigor to polished banality"—conveyed its editorial policy, which was to encourage the submission of sketches, stories, poems, and essays by young writers from "the mills, mines, forests, factories and offices of America who are forging a new literary tradition." *The Anvil* was remarkably successful in identifying new talent such as Nelson Algren. Unlike many publications of the era, it welcomed the work of African American and women writers: Langston Hughes, Meridel Le Seuer, and Sanora Babb all appeared on its pages. Sadly, the magazine's successes probably led to its early demise. In an October 1935 Communist Party power play, *The Anvil* was absorbed by the more doctrinally correct *Partisan Review*, and Conroy lost editorial control.

The second issue's proletarian-themed cover is probably the work of John Rogers (1907–1979), a writer and artist whose wood- and linoleum-block illustrations exemplify the "crude vigor" that Conroy sought from his contributors. A true worker-artist, Rogers spent his days as a tree trimmer, Civilian Conservation Corps worker, and Federal Writers' Project employee; later he served in World War II, attended the Corcoran School of Art in Washington, D.C., and worked as a government artist and illustrator-writer for the travel section of the *Washington Daily News*.

This copy of *The Anvil* is from Conroy's own collection of leftist and literary magazines, which forms part of the Jack Conroy Papers at the Newberry. Conroy's personal papers, documenting radical politics and writing of the early and middle decades of the twentieth century, are among the Midwest Manuscript Collection's most important social action/literary holdings. Together with the papers of Malcolm Cowley (see no. 16), they underscore the importance of leftist politics in the lives of many 1930s writers and intellectuals. The Newberry received the Jack Conroy Papers in 1989 as a result of the interest and solicitation of a former Special Collections staff member, Carolyn Sheehy, who in a lengthy correspondence developed a close relationship with the writer. M. B.

THIS BITING EDITORIAL cartoon was created by Pulitzer Prize-winning cartoonist John Fischetti (1916–1980). It was published while he was working for the *New York Herald Tribune* in 1964, a time when racial tensions were running high in the United States. That year the Civil Rights Act was passed, and in Mississippi three civil rights workers were lynched in an infamous murder case. The cartoon portrays three white men, a map of Mississippi with "negro targets," guns and dynamite, and faces that Fischetti rendered with expressions of anger and fear. "I got feelin's Jack. I'll bomb the church all right, but not on a Sunday night," says one of the men. Fischetti succeeded in capturing the hypocrisy and small-mindedness of this faction in one scathing sentence.

Fischetti was born in Brooklyn, New York. He attended Pratt Institute, where, during his last year, he realized that he wished to be a political cartoonist. In his memoir, *Zinga Zinga Za* (1973), he wrote, "I had found out that politics was the linchpin of most of the social ills I had seen. I'd discovered that a good politician was worth his weight in gold, and that I should therefore make the bad politicians my targets." His first political cartoons were published in the *Chicago Sun* in the 1940s. After World War II, he did freelance commercial illustration before taking a job at the Newspaper Enterprise Association. When he moved to the *Herald Tribune* in 1961, he demanded total editorial freedom and got it. He also employed a new drawing technique, transitioning from grease crayon to pen and brush on screentone paper, which allows for quick application of textures. He also adopted a wider horizontal rectangular frame, which was unusual for editorial cartooning at the time. Both practices are evident in this piece.

The John Fischetti Papers were donated to the Newberry in 1998 by his wife, Karen Fischetti. They are part of the Newberry's considerable holdings of journalism-related manuscript collections. Sitting alongside the papers of fellow cartoonists such as Morrie Brickman and John McCutcheon (see no. 43) and columnists such as Hoke Norris and Mike Royko, Fischetti endures as part of the rich Chicago tradition of social criticism steeped in humor. L. J.

45

John R. Fischetti

"I Got Feelin's Jack. I'll Bomb the Church All Right, But Not on a Sunday Night,"

New York, 1964
Drawing
11⅝ × 14⅝ in.
Gift of Karen Fischetti, 1998
Midwest MS Fischetti, Box 21, Folder 1231

46

Alexander Calder
Letter to Rue Shaw

Roxbury, Connecticut, June 18, 1945
Manuscript
11 × 8½ in.
Gift of the Arts Club of Chicago, 1972
Vault Midwest MS Arts Club

THIS 1945 LETTER from the American artist Alexander "Sandy" Calder (1898–1976) to Rue Winterbotham Shaw (1905–1979), president of the Arts Club of Chicago, illuminates Calder's playful melding of art and the everyday. Here Calder described his stovetop invention for avoiding the overflow of boiled milk: a system of weights and balances constructed from scrap metal, not unlike the much larger mobiles for which he is most famous. The artist also provided an illustration, which shows a dish of milk sitting atop a gas flame. One end of a wire is weighted down in the milk with an old aluminum cup; an empty tin sits at the other end on an adjustable platform. "When the milk rises in the pot the tin can is dumped on the floor," Calder wrote, "making a horrible noise. Thus through nervousness one's attention is held." Three years before Calder wrote this letter to Shaw, the Arts Club had commissioned his magnificent mobile *Red Petals*. Still on view at the club, it stands over eight feet tall. But like Calder's tiny stovetop contraption, *Red Petals* is constructed partly from boilerplate. Built during the metal shortages of World War II, Calder's mobile and milk pot both radiate balance and beauty, practicality and frugality.

The Arts Club was founded in 1916 by a small group of cultural philanthropists in response to the Armory Show. The Art Institute of Chicago had reluctantly exhibited the show in April 1913 after its New York City run. Mobs of Chicagoans flocked to see the extensive display of European and American avant-garde art, which mystified many and enraged others. The club committed itself to supporting and exhibiting international contemporary art, as well as to sponsoring lectures, poetry readings, and music and

dance performances. An early president of the Arts Club was Rue Winterbotham Carpenter (1876–1931), an accomplished interior decorator and the wife of musician and composer John Alden Carpenter (see no. 38). Rue Winterbotham Shaw was the club's third president; like her aunt, after whom she was named, Shaw was a cultural force in Chicago. Calder's correspondence with her—just one of the many gems in the voluminous Arts Club Papers held at the Newberry—offers insights into the everyday working practices of a major figure in modern art. The letter also illuminates the critical role Chicago played in attracting and financially supporting artistic experimentation. Along with Calder, many of the most important twentieth-century visual artists received their first solo exhibitions in the United States or the Midwest at the Arts Club, including Brancusi (his show was installed by Duchamp), Braque, Chagall, Dalí, Dubuffet, Gorky, Hartley, Lautrec, Léger, Motherwell, Noguchi, Picasso, Pollock, Rodin, and Seurat. The Arts Club Papers at the Newberry document every stage of these events, from invitations and packing receipts to critics' reviews.

As artist and patron, "Sandy" and "Rue" related to each other on an intimate, first-name basis. This letter ultimately serves as a creative thank you to Shaw for having taken care of Calder's seventy-nine-year-old mother during a five-hour train layover in Chicago en route to California. Shaw had picked up Calder's mother at the train station, taken her home to rest, and delivered her to the station in the evening. The next morning, Calder explained in his letter, "I was called to the phone and got your nice wire about putting mother on the train with all the soldiers." Between the bad phone connection and the image conjured of his mother at a Chicago train station, surrounded by soldiers, Calder nearly forgot his milk on the stove: "I got the lady to repeat it once, and turned around just in time to catch the tin can (and turn off the gas)." Like much of his work, Calder's illustrated letter reflects his wry attention to simultaneous focal points held in fragile equilibrium. L. O.

Ernest Hemingway
Letter to Sherwood Anderson

Paris, March 9, 1922
Manuscript
11 × 8½ in. (each)
Gift of Eleanor Copenhaver Anderson, 1947
Midwest MS Anderson,
Box 21, Folder 1068

IN THIS ENTERTAINING 1922 letter from Paris, the young and as-yet-unpublished Ernest Hemingway (1899–1961) regaled Sherwood Anderson (1876–1941), the critically acclaimed realist author of *Winesburg, Ohio* (1919), with tales of his friendships in the expatriate literary community. The letter reveals Hemingway to be a master namedropper: it mentions, among others, James Joyce ("Joyce has the most god-damn wonderful book [the just-published *Ulysses*]"); Ezra Pound ("I've been teaching Pound to box with little success"); and Gertrude Stein ("Gertrude and me are just like brothers").

The correspondents had met in Chicago in January 1921, and the established writer quickly took the aspirant under his wing. Anderson advised Hemingway to write about what he knew and introduced him to the modernist-realist movement in literature. He also urged Hemingway to move to Paris to grow as a writer and provided him with letters of introduction to the writers he had met during his own visit in the summer of 1921. Armed with Anderson's letters to Joyce, Pound, and Stein, as well as to bookseller Sylvia Beach and others, Hemingway quickly became acquainted with these individuals, who proved remarkably important in the development of his career. Pound helped Hemingway get published. Stein advised him on his writing and engaged him in discussions about modern art and how a writer might arrange words visually on a page.

Anderson's mentoring relationship with Hemingway soon soured. Biting the hand that fed him, Hemingway thanked Anderson for his patronage with *Torrents of Spring* (1926), a cruel parody of Anderson's less-than-stellar *Dark Laughter* (1925). Anderson was understandably wounded by the attack and ceased personal correspondence with Hemingway soon after *Torrents* was published. Still, he always felt that one of his greatest accomplishments was jumpstarting the careers of younger authors such as Hemingway and William Faulkner.

The Sherwood Anderson Papers arrived at the Newberry in 1947 as a result of a four-year courtship of Anderson's widow by librarian Stanley Pargellis. One of Pargellis's first moves at the Newberry was to begin collecting primary source materials to support scholarly research on the history and culture of Chicago and the Midwest. By the time he retired in 1962, he had assembled the nucleus of the remarkable Midwest Manuscript Collection, revealing the literary, artistic, social, economic, and political activity that occurred in the region from the late nineteenth to the middle of the twentieth century. Anderson's papers are a centerpiece of this collection, and it is fitting that they reside in Chicago, where he spent his most creative years. M. B.

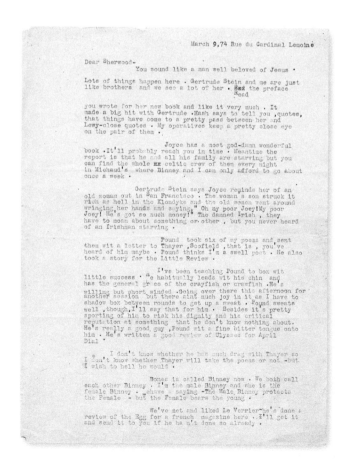

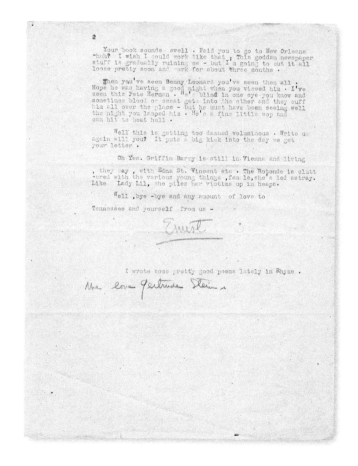

JACK MABLEY (1915–2006) was a lifelong newspaperman and an impassioned crusader who was not afraid to take a stand. After years as a popular columnist for the *Chicago Daily News,* he moved to *Chicago's American* in 1961. There he continued to write his column and became known for sensational exposés of police corruption, racketeering, and vice. His work required undercover operatives and surveillance teams.

This memorandum and photograph date from the volatile summer of 1968 in the wake of nationwide rioting over the assassinations of Martin Luther King, Jr., in April and of Robert F. Kennedy in June. The memo was written by Dwayne Oklepek, a young reporter whom Mabley assigned to go undercover and infiltrate the Students for a Democratic Society (SDS) offices at 1608 West Madison and the National Mobilization Committee to End War in Vietnam (NMC) offices on South Dearborn. Oklepek was asked to report on the activities of the organizations, including those of future Chicago Seven members Tom Hayden and Rennie Davis. Both were in Chicago to help organize antiwar demonstrations that would coincide with the 1968 Democratic National Convention.

In the summer of 1968, Mabley wrote a series of columns on the impending demonstrations based on information gathered by Oklepek. As revealed by other memos in the Mabley Papers, Oklepek observed hours of mundane office machinations but was also privy to logistical planning for several marches up and down the lakefront and military-like exercises designed to "break police lines" in case of confrontation.

The photograph shows Mabley covering the action firsthand while riding a bicycle. Once the convention was underway, he was onsite around the clock; his eyewitness accounts gave his columns the immediate and personally invested qualities for which he was known.

Mabley was not unsympathetic to the demonstrators' cause but was alarmed by the tactics of the NMC. Many, including the political and social activist Abbie Hoffman, perceived his columns as fanning the flames of unjustified paranoia over the protesters' planned actions. Reading the columns today, one finds that Mabley covered both sides in a fair-minded and balanced manner. At the time, another leading protestor, Jerry Rubin, as well as members of the Chicago Police Department, agreed.

Donated by Mabley's wife, Frances Mabley, in 2007, the Jack Mabley Papers are among the many important journalism-related manuscripts at the Newberry. Chicago has always been a celebrated newspaper town, and the Newberry's Modern Manuscript Collection holdings in journalism are extensive. Ranging from the 1800s to the present and including such pioneering newspapers as the *Chicago Daily News* and the *Chicago Reader,* as well as such larger-than-life personalities as Ben Hecht (see no. 40) and Mike Royko, these collections are a vital resource for the study of Chicago history and its illustrious contributions to journalism. L. J.

48

Dwayne Oklepek
Jack Mabley; Memorandum to Jack Mabley

Chicago, 1968
Photograph; manuscript
10⅞ × 14 in.; 11 × 8½ in.
Gifts of Frances and Patricia Mabley, 2007
Midwest MS Mabley,
Box 17, Folder 190;
Box 16, Folder 164

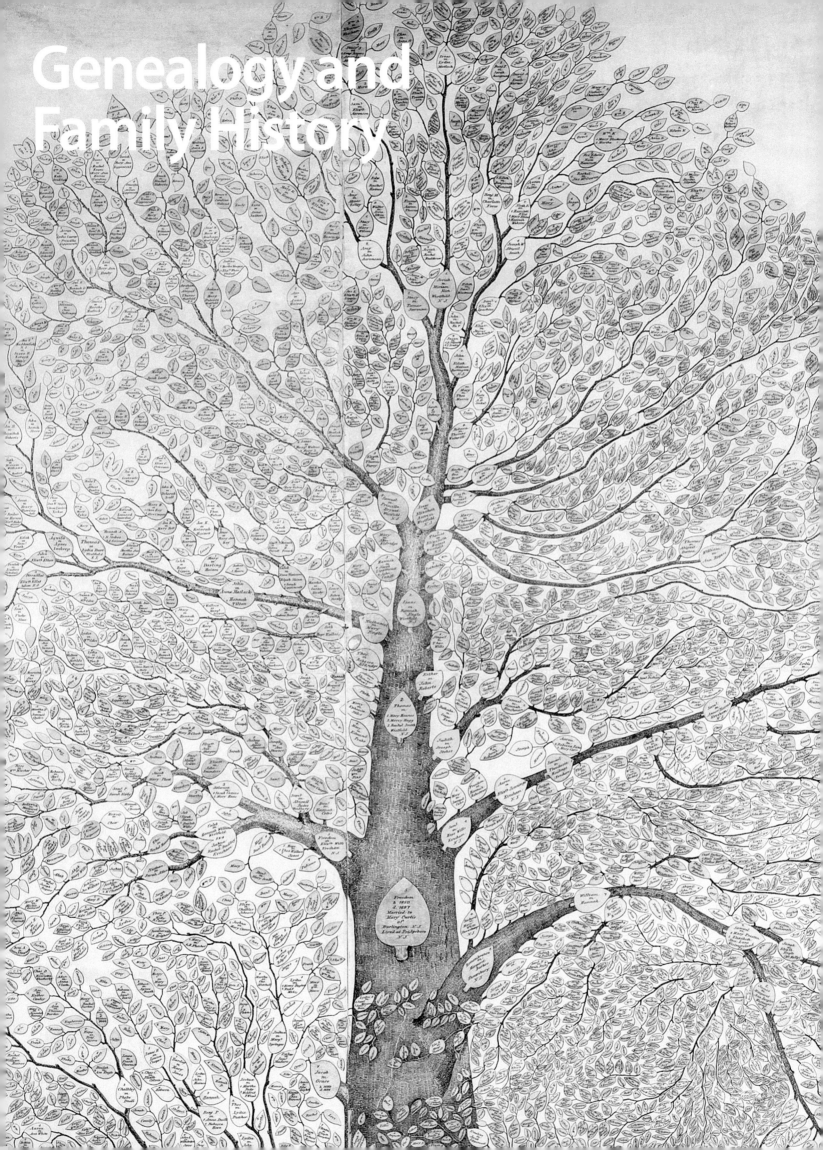

Genealogy and Family History

FAMILY ARCHIVES from the early-modern period can be highly miscellaneous. Routine accounts and correspondence are found beside elaborately formal legal records, children's notebooks, recipe collections, artworks on paper, and literary manuscripts. Such archives are most useful for recording social history, but individual documents may have considerable beauty as well as utility, while others may represent lost forms of scribal culture or document storage. When preserved in order, a family archive may even offer important evidence about information management.

This illuminated document comes from the large, nearly intact archive of the Parravicini family of Ardenno, Italy (in the Valtellina, above Milan), whose records run from the sixteenth to the middle of the nineteenth century, with a few earlier items like this one. It records a grant by Francesco Sforza (1401–1466), duke of Milan, to Giovanni Merlo (dates unknown). Merlo was a resident of Galliate on the Ticino River just west of Milan and served as a customs officer at the river port there. He would have been a subject of the duke but not a citizen of Milan. This document allowed him to do business (buying and selling goods and owning property) in the city. The grant extended this right to his descendants for all time (*usque in infinitum*).

The grant, or privilege, is an original, formal copy, written in a fine notarial hand on sheepskin parchment. At one time, it was folded into a tiny packet for storage in the family archive, perhaps so that Merlo could carry and present it as needed when doing business in Milan. The Sforza coat of arms (taken more than five years earlier from the previous ruling house of Visconti) appears in the initial F at the upper left. It shows the basilisk (or *biscione*)—a crowned blue serpent—devouring a small red man. There are several legends associated with the serpent, but none really explains what must have been a rather sinister image at the time, just as it appears today. Certainly, it represented the power of the new ruling house, founded on the feats of arms that brought Francesco from relative obscurity (as the illegitimate son of a mercenary soldier) to the powerful dukedom of Milan. The same device of the basilisk, quartered with the imperial eagle, appears on the seal at the bottom of the document; this combination was used as the arms of the duchy as a political entity. The basilisk is so strongly identified with Milan that it appears today in the logotypes of several local sports teams; the Alfa Romeo automobile company; and Fininvest, a powerful bank that is also the holding company of the media conglomerate controlled by former Italian prime minister Silvio Berlusconi. P. F. G.

49

Francesco Sforza, Duke of Milan

Grant of Commercial Rights

Milan, September 7, 1452
Manuscript
11⅜ × 16¾ in.
Newberry Library Associates Fund, 1969
Vault Oversize Case MS 145 no. 5

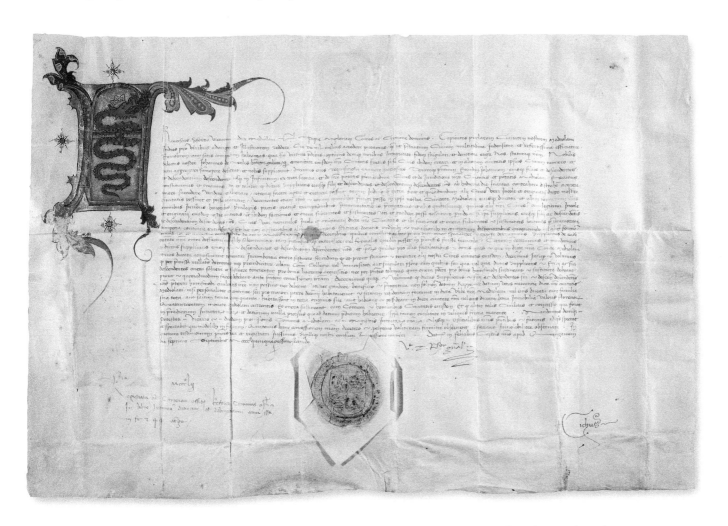

LES LIGNÉES DES ROYS de France, a roll manuscript on parchment, contains an abbreviated version of *Les Grandes chroniques de France*, the official history of the realm that was composed and regularly extended by historiographers drawn from the Benedictine monks of the royal abbey of St. Denis, north of Paris. Not only is this text a narrative of the French kings and their genealogy, but also an unusual chronogeography. It was disseminated both in codex form, which emphasized the cartographic dimension, and, as here, in roll form, which accentuated the genealogical function by virtue of the layout of the text. (The most famous roll chronicle of the Middle Ages was Peter of Poitiers's *Genealogia Christi* [Genealogy of Christ], which the French kings, never noted for humility, deemed an appropriate model for their own narrative). The Newberry's royal-history roll is nearly twenty-three feet in length and has been fully unrolled and displayed only two or three times. The roll begins with a large illumination of a city that resembles fifteenth-century Paris but was likely intended to be Troy, from whose rulers the kings of France claimed direct descent. The clear purpose of the roll was to demonstrate graphically that the Capetian and Valois kings were the sole legitimate heirs of Troy. Such a statement was important in the final years of the Hundred Years' War, when the kings of England claimed that they, and not Charles VII and his descendants, were the legitimate heirs to the French throne.

Les Lignées also pertains to the geographic frontiers of the dominion that the kings of France had conquered and administered for more than 1,000 years. The narrative of each king's reign is accompanied by a roundel containing an image of a monastery that the sovereign or his spouse founded. Although these depictions conform to contemporary archetypal standards, they can be rich in color (the façades of Romanesque and Gothic churches originally having been painted) and geographic detail; the abbey of Mont St.-Michel, in a gesture of verisimilitude, is shown surrounded by water.

This roll was one of the first acquisitions made possible by a rare book fund, which was created in the early 1990s partly by selling materials that did not fit well with the Newberry's collection. Among the items sold were some Buddhist roll manuscripts, thought to be Chinese. No staff member at the time could read these rolls, let alone shed light on their contents and significance. Only when the experts from a New York auction house had examined them did the Newberry learn for the first time that the rolls were in fact of medieval Japanese origin.

In the spring of 1993, Newberry trustee T. Kimball Brooker, then chairman of the Book Committee, visited the noted antiquarian dealer André Jammes in Paris. Jammes showed him *Les Lignées*, which he thought would be appropriate for the Newberry, and a description was quickly relayed to the staff. One month later, the library purchased it. P. S.

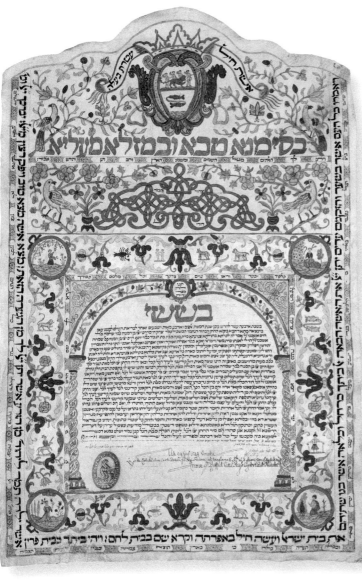

Ketubbah

Venice, 1711
Manuscript
32⅞ × 21¾ in.
Gift of Edward E. Ayer, 1911
Vault Hebrew MS 11

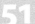

THE KETUBBAH (pl. ketubbot), or marriage contract, has been a part of Jewish weddings for more than two millennia. Essentially, a ketubbah guarantees the rights of the wife. The ketubbah featured here conveys the husband's promise of honor, support, and conjugal rights to his new spouse during the course of their marriage. It goes on to guarantee her, should the marriage end in his death or in divorce, a first claim on his estate to the amount of 200 *zuz*, or about 700 grams of pure silver. This was a minimum ordained by the Talmud, but it could be supplemented by the groom. In addition to this guarantee, many ketubbot also include stipulations about the bride's dowry. As a gift to the groom, a dowry both enhanced the value of a wife and knitted more closely the financial affairs of families that might well be (or become) partners in business. But it also served to protect the wife, since it was understood that, in case of neglect or abuse by the husband, a dowry could be rendered null.

This ketubbah records in Hebrew the marriage of "Isaac Hai Mordecai, son of the late Solomon, son of Hayyim Ashkenazi" to "Buona, daughter of Joseph, son of the late Simhah Ashkenazi." The dowry is specified as "2,500 ducats in cash: 600 ducats paid to the groom by the father of the

bride from the family fortune in which he has an equal share with the finest of gentlemen, his brothers Baruch and Mordecai Ashkenazi, and the remaining 1,900 ducats paid to the groom by Baruch who, out of his great generosity, has made the bride, his niece, a gift from his private means." As their surname indicates, the bride's family was Ashkenazi, that is, descended from Jews from Central and Eastern Europe. The Ashkenazi were the first and largest of the Jewish communities in Venice, arriving as early as the twelfth century.

The Ashkenazi brothers were businessmen, probably involved in one or more of the professions traditionally reserved to Jews such as pawnbroking or international trade. And they were quite wealthy: depending on whether the ducats being paid were silver or gold, Buona's dowry of 2,500 would come to about $150,000 or $425,000, respectively, in today's currency.

The date of the wedding, Friday, Nisan 14, 5471 (April 3, 1711), resonates with symbols of Judaism. The ceremony would have been held before the beginning of the Jewish Sabbath at nightfall. In Jewish prayer and song, the Sabbath is often referred to as a "bride." Furthermore, as the twelfth-century philosopher and Torah scholar Moses Maimonides taught, intercourse on Shabbat was considered a special mitzvah. All of the weddings recorded on Newberry ketubbot were on Fridays, but April 3, 1711, was especially holy, since it had a full moon marking the beginning of Passover.

The lettering on either side of the crown at the top of the scroll is from Proverbs 12:4: "A woman of valor is a crown to her husband." Other biblical quotations fill the various borders. The seasons and signs of the zodiac were commonly incorporated into the decorative schemes of Italian ketubbot. Both are present here: the twelve signs (each associated with one of the twelve tribes of Israel) are arrayed around the center panel, while the figures in the four corners represent the seasons.

This is one of ten ketubbot in the Newberry, all Italian. They relate to the library's strengths in religion and Italian history, as well as in Hebraica and family history. R.W. K.

52

Heinrich Otto

Baptismal Certificate of Hans Friedrich Latscha

Ephrata, Pennsylvania:
Cloister Printshop, 1788
Broadside
12¾ × 16⅜ in.
Purchased from the principal of the fund
generated by the sale of duplicate and
out-of-scope materials, 2003
Stopp 247.2

THIS CHARMING BROADSIDE is one of more than 1,200 German-American birth and baptismal certificates from the collection of Professor Klaus Stopp (d. 2006). The text and borders of this example were printed at the quasi-monastic community of Ephrata Cloister in Pennsylvania, originally founded in 1732. By the time this broadside was made, the celibate, utopian community was in decline but the associated congregation of married members was still a functioning group with a full publishing program that included books, pamphlets, broadsides, and prints. Heinrich Otto, an itinerant scribe, ordered the broadsides with text and woodcut borders that he subsequently colored and filled out to order for his clients. Because the end result is often highly calligraphic, such broadsides are sometimes called Frakturs, after the style of the types and handwriting that was used to fill in the names.

The Stopp Collection is the largest single collection of birth and baptismal Frakturs. It documents the evolution of this uniquely German-American genre from artisanal production to modern color lithography. The earliest Stopp certificates, like this one, represent an American adaptation of the European art of illuminating manuscript books and documents. In the nineteenth century, the designs more clearly imitated printed broadsides and engraved work like commemorative plaques and tombstones. By the end of the century, broadside baptismal certificates resembled lithographic posters, with color images of the life of Christ or other pious imagery. The Stopp Collection reflects these changes of taste and technology and, in so doing, represents work by almost every significant printer of German-language material in North America from Colonial times to the end of the nineteenth century.

These beautiful objects served no legal function; they were decorative and commemorative. In the way that photographs would later do, they served as mementos of births that were all too often followed by premature deaths. Sometimes, the facts of such a death are noted on the certificate, but death was not just incidental to this form of literature and art; it was an integral theme. In addition to the facts of birth and parentage, the textual matter often includes poems devoted to the subject of death understood in Christian terms as a birth into the afterlife. Similarly, the pictorial symbols, including angels, parrots and other birds, flowers and fruit, refer not to birth but to everlasting life.

Stopp was one of the twentieth century's most distinguished bibliographers and collectors of German maps and ephemera. His birth and baptismal certificate collection, carefully conserved, came to the Newberry with its own published catalog, which is widely recognized as a fundamental reference tool on the art of Germans in North America. P. F. G.

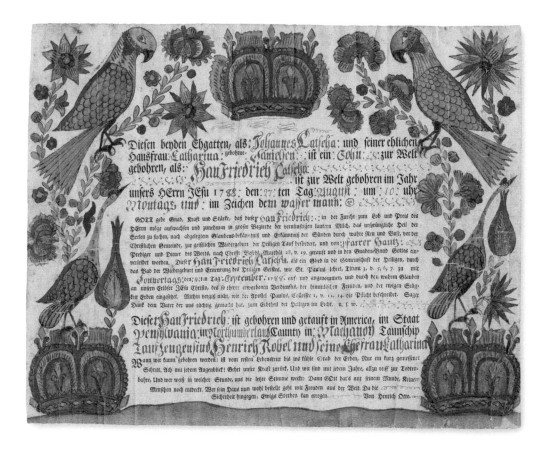

53

Charles Lippincott

A Genealogical Tree of the Lippincott Family in America, from the Ancestors of Richard and Abigail Lippincott

Philadelphia: J. L. Smith, 1880
Poster
81 × 48 in.
General Fund, 1926
E 7 .L675

Newberry's holdings in history, biography, and the rest of the humanities provide a rich context in which to situate and explore the lives of our ancestors.

The tree has long been a symbol for family structure, and a compiled family tree serves as both source and product of genealogical research. The Newberry's holdings of compiled genealogies number approximately 20,000 items, including scrolls, making it one of the largest collections in the country. The Lippincott family tree shown here represents the lineage of Quaker immigrant Richard Lippincott (d. 1683) through his children Remember, John, Restore, Freedom, Increase, Jacob, Preserve, and Israel. The hundreds of leaves on the tree are color-coded by generation, each leaf bearing the name of a Lippincott descendant. In portraying the descent of many individuals from a particular ancestral couple, this chart approximates the structure of most compiled genealogies.

Americans of Quaker origin developed strong genealogical interests in the nineteenth century. Like New Englanders, they could avail themselves of well-kept and often highly detailed records that allowed them to trace their ancestry back to the seventeenth or early eighteenth century. Descendants of Quakers, like those of Puritans, could therefore track their origins to a period of heroic settlement, the importance of which is attested to by the poetic exhortation on this chart:

Sons of our Quaker Sires
And Daughters of those worthy ones of old
Rekindle then, the pure and holy fires
That warmed your Fathers in our "Age of Gold." M. R.

FROM ITS BEGINNINGS, the Newberry has collected local and family histories, and its holdings rank it among the top institutions for genealogy research in the United States. In the library's 125 years, tens of thousands of researchers have come in search of information about their forebears, and their diligent use of collection strengths such as census materials, newspapers, passenger lists, military rosters, city directories, and church records often leads to successful outcomes. Researchers in family history at the Newberry likewise benefit from many of the library's manuscript collections, including the Family Papers Collection, the Pullman Porter employment files (see no. 35), and the insurance applications of the Polish Women's Alliance of America. Furthermore, the

History of
the Book

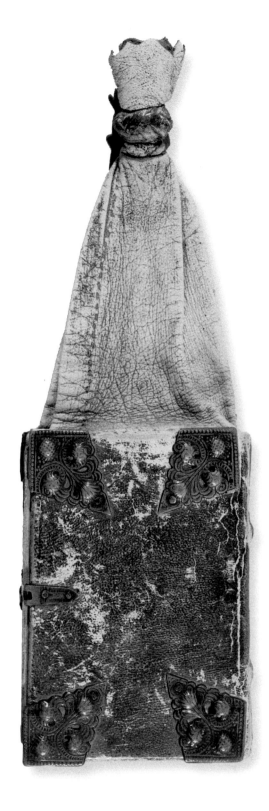

Book of Hours (Use of Rome)

Book: Bruges, c. 1450
Binding: sixteenth century
10⅜ × 3⅜ in. (binding)
Wing Fund, 1924
Case MS f38

IN RECENT YEARS, there has been an emphasis on the portability of texts: e-readers are seemingly ubiquitous, and users marvel at the ability to carry around multiple texts in a compact format. While the technology behind e-readers is certainly new, the desire to carry texts for consultation throughout the day is not. This Book of Hours, produced around 1450, is exactly the genre of book an owner may have wanted to keep at hand. Books of Hours, of which more survive than any other type of medieval manuscript, are compendiums of devotional texts meant to be read privately. They comprise a calendar of saints' days for the year and a standard series of prayers and psalms to honor the Virgin Mary at each of the canonical hours of the day; other short texts might be included as well. The owner of a Book of Hours was meant to read from it eight times a day, although it is unclear how often people actually did so.

This particular Book of Hours has a girdle binding, which allowed one to carry the book, hands free, throughout the day. The olive-green deerskin binding (thought to date from the sixteenth century) extends six inches beyond the edges of the book, forming a pouch for a rosary at the bottom. The pouch terminates in a large braided knot, which the book's owner could have attached to a girdle or belt; the book could then be lifted up and consulted whenever desired. Less than two dozen girdle bindings survive intact, mostly because the leather or cloth extensions were removed so that the books might be stored upright on bookshelves. Because so few exist, much of our information about how girdle books were used and who carried them comes from their depiction in paintings and prints.

Although the Newberry has not traditionally acquired books solely for their bindings, this volume, purchased from the Chicago bookseller Alexander Greene in 1924, is an exception. The book's contents were damaged prior to the Newberry's acquisition of it: most sections lack one or more leaves, and illuminated borders and any miniatures that the manuscript might have contained have been cut out. Still, it offers a rare chance to understand the experience of reading from a portable medieval book. J. G.

Mathaeus de Cracovia

Tractatus rationis et conscientiae

Mainz, c. 1469
Book
7⅞ × 5⅝ in.
Wing Fund, 1953
Vault Inc. 147

ONCE ATTRIBUTED to the inventor of printing, Johann Gutenberg (1398–1468), this little book (Treatise on Reason and Conscience) has been the subject of intense research by historians and bibliographers for more than fifty years. Indeed, it was acquired for the Newberry by James M. Wells (one of his first "picks" as custodian of the library's John M. Wing Foundation on the History of Printing) just in time for the scholarly debate to begin. It was, of course, the attribution to Gutenberg that attracted the attention of specialists, who were soon able to determine on the basis of the paper used that it could not have come from Gutenberg's press in Mainz, Germany. Subsequent arguments centered on the type, the smallest made in the early years of printing, which is now generally believed to have been cast for Gutenberg's press around 1460 for use in documents (legal forms, indulgences, etc.). This type was recast to print a famous Latin encyclopedia, the *Catholicon*, also once attributed to the father of printing. By the late 1460s, the punches or matrices had passed to successor firms. The version here may be a third casting, made in 1469 or somewhat later. With the kind of certainty that is typical of the history of technical processes and producers in the absence of good sources, scholars now attribute the book to "an anonymous Mainz printer."

At least as interesting as the printer, however, is the book's author, its contents, and the traces of use it bears. Mathaeus de Cracovia (Mateuz z Krakowa; c. 1330–1410) was a professor of theology at the universities of Prague, Krakow (his native city), and Heidelberg. He was a celebrated preacher, courtier, and diplomat, and was made bishop of Worms, Germany, in 1405. Although he is credited with several abstruse theological works, the two short treatises in this booklet are more pastoral in nature. His *Tract on Reason* is a dialogue in which a father explains to his son the reasonableness of divine providence. It is a clear and simple consideration of the age-old problem of the persistence of evil in a world governed by a just God. The *Tract on Conscience* is more in the manner of a manual for confession, rehearsing the major sins and the matter of repentance.

This copy was extensively annotated by someone who was particularly concerned with matters of conscience. The reader added red headings to indicate questions and answers in the dialogues, while marginal notes index points of interest to the early owner regarding sin, justification, and the efficacy of the sacraments.

In 1983 all of the Newberry's books in Gutenberg-related types, including this one, were sent to the University of California at Davis for ink analyses using their cyclotron milliprobe. The resulting data proved definitively that the book is not by Gutenberg. Thereafter, conservation staff removed a nineteenth-century binding from the present volume that was damaging the leaves and replaced it with a flexible, non-adhesive paper structure. This housing will allow future scholars to study the paper stock and type in further detail as new technologies evolve. Meanwhile, it preserves the book as a comfortable reading copy as well. P. F. G.

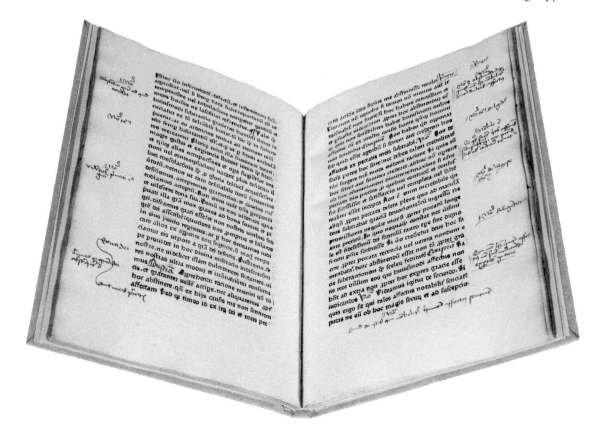

THIS COLLECTION of Latin sermons, published in Venice in 1471, is one of forty Newberry incunabula rebound in 1950 and 1951 by Hungarian-American book artist Elizabeth Kner (1897–1998). As she said of the binding campaign in a memoir, "The work was of a kind that most bookbinders dream about." It offered her the opportunity to enhance the conservation of many beautiful books from the first age of printing. We do not know how this volume was bound when it arrived at the Newberry, but Kner said she was asked to work on books "that . . . came to me in a pitiful condition."

The state of the book in 1950 may be explained by the circumstances of its purchase. In the late spring of 1930, the curator of the Newberry's printing-history collection, Pierce Butler (1886–1953), was sent to Europe on what seems to have been a buying spree. Apparently in an attempt to take advantage of reduced book prices in the first year of the Depression, he was allowed to choose more than 300 fifteenth-century books from dealers in Florence, Milan, Munich, Berlin, and elsewhere. His mission was to find works from presses and with typefaces not already in the collection; the condition of the bindings was not a consideration. He set himself the goal of getting these highly collectible books for less than $125 apiece, and in the end he spent far less than that on average. This book was part of a particularly large and modestly priced lot, 150 titles from the stock of Davis & Orioli in Florence for which the library paid only $77 per volume. By 1930 this famous antiquarian book and publishing partnership, which among other things had published D. H. Lawrence's *Lady Chatterley's Lover*, had long since transferred the bulk of its operations to London. This transaction was probably part of an attempt to further reduce its Florence inventory in the year that Giuseppe Orioli (1884–1942) was turning his attention to a bibliophile publishing project in collaboration with Lawrence.

For the new binding, Kner used a splendid red-brown Niger goatskin that had been in the stock of the Newberry bindery before World War II. She stated that she had "perfect freedom in every respect" to design the bindings, but that she preferred to make covers that would show off the natural qualities of the handsome leather. This example is more ornate than most. She created a blind-stamped pattern with ruled lines forming panels, massed flowers, and a brief author/title statement in the Newberry's all-caps bindery type font. The framed panels echo designs found on monumental fifteenth-century bindings that Kner studied at the library, but the other elements are more contemporary in inspiration. The result is essentially a modernist statement, conditioned by the binder's training at the Leipzig's Hochschule für Grafik und Buchkunst and the long association of her prominent printing family with the Arts and Crafts and Bauhaus movements. For many of her bindings, Kner used antique tools she had brought from Hungary, but the flower tool employed here was designed by her brother Albert Kner (1899–1976), who founded the Design Laboratory at Chicago-based Container Corporation of America.

The volume contains forty-two sermons, one for each day of Lent, composed by Leonardo da Utino (d. 1470), a renowned Italian Dominican preacher. Leonardo's sermons were printed frequently throughout Europe; this is one of eleven early editions of his works held by the Newberry. P. F. G.

56

Leonardo de Utino (author)
Elizabeth Kner (binder)

Quadragesimale aureum

Book: Venice: Franciscus Renner, 1471
Binding: Chicago, 1950/1951
11¼ × 8⅜ in.
Wing Fund, 1930
Folio Inc. 4153

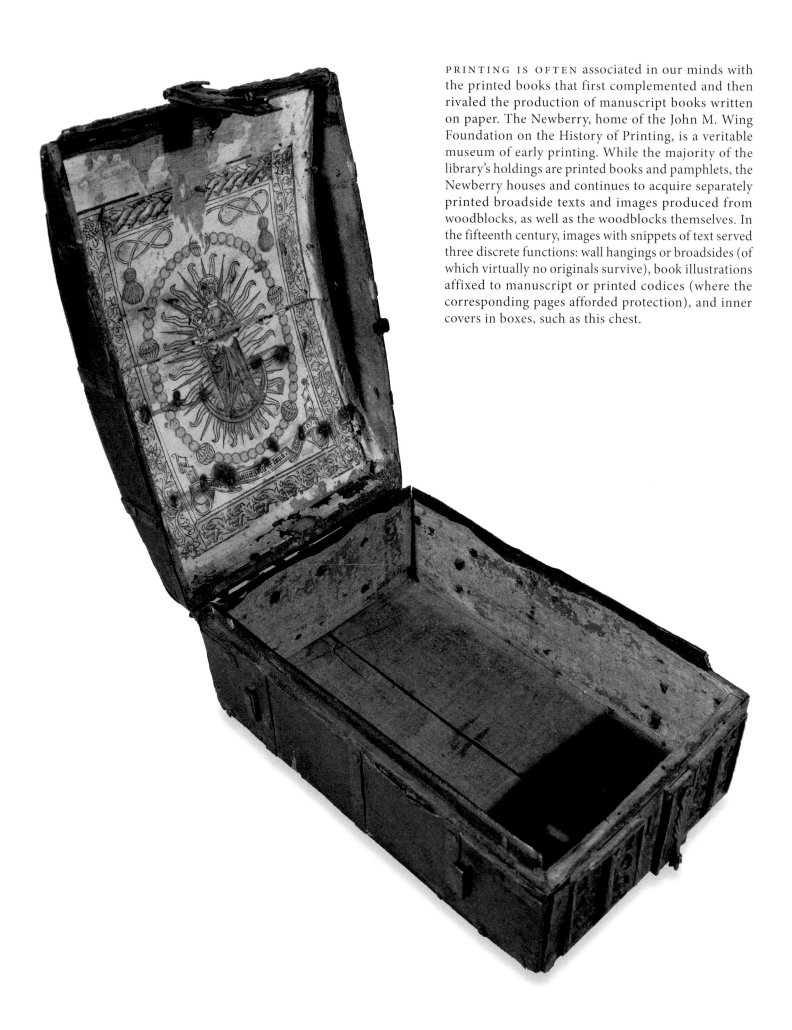

PRINTING IS OFTEN associated in our minds with the printed books that first complemented and then rivaled the production of manuscript books written on paper. The Newberry, home of the John M. Wing Foundation on the History of Printing, is a veritable museum of early printing. While the majority of the library's holdings are printed books and pamphlets, the Newberry houses and continues to acquire separately printed broadside texts and images produced from woodblocks, as well as the woodblocks themselves. In the fifteenth century, images with snippets of text served three discrete functions: wall hangings or broadsides (of which virtually no originals survive), book illustrations affixed to manuscript or printed codices (where the corresponding pages afforded protection), and inner covers in boxes, such as this chest.

What functions did these objects serve? Late medieval sources are silent. All such boxes, the Newberry's example included, were produced in Paris between about 1485 and 1510. The image that graces this box—the Virgin with her feet upon a crescent moon surrounded by rosary beads—is believed to closely resemble a woodcut in a 1493 Paris edition of Martial d'Auvergne's *Les virgilles de la mort de Charles VII*. Some boxes had secret compartments and were likely used by messengers. The Newberry's does not; it was probably intended to transport prayer books. The illuminated images contained in such volumes would have complemented the colored image of the rosary, the use of which was a defining aspect of private devotion in the second half of the fifteenth century.

The Newberry was introduced to chests with images such as the Virgin of the Rosary, and encouraged to acquire one, by the Parisian dealer André Jammes. Jammes had the largest collection of such chests in private hands, an assemblage that rivaled or exceeded in size the collections of the Bibliothèque Nationale de France, the Musée de Cluny, and the Musée du Louvre. Years passed before the box illustrated here appeared in a French antiquarian catalog. The library acquired it with the help of the Florence Gould Foundation and the Wing Fund. P. S.

57

La Vierge du Rosaire

Paris, c. 1490
Box
5¼ × 11½ × 7½ in.
Wing Fund, with the assistance of the
Florence Gould Foundation, 1990
Vault Inc. 52.5

John Philoponus

Iōannou tou Grammatikou eiz ta ysera analytika Aristotelous, hupomnēma

Book: Venice: Aldus Manutius, 1504
Binding: Milan, 1510/1516
11⅜ × 7½ in.
Louis H. Silver Collection, 1964
Case 6A 132

THE LATE FIFTEENTH and early sixteenth centuries saw great progress in the recovery and study of objects from Greek and Roman times. Inscriptions, sculptures, coins, and carved jewelry yielded important insights into the material culture of ancient society, mythology and literature, and political history. Roman cameos in particular fascinated the women and men of the Renaissance for their entrancing beauty and skill of workmanship and for the best artists' ability to tell stories in miniature form. There was nothing short of a craze for these antiques and for new cameos in the style of the ancient ones. Bookbinders in Venice and Rome in the first half of the sixteenth century picked up on this fashion and made metal plaquettes with cameo patterns in reverse that could be pressed into the leather-covered front and back panels of book bindings. This method was technically difficult, and bindings of this type were the most expensive and luxurious of the period. Only a few collectors commissioned such bindings. This book belonged to the most famous of them.

Jean Grolier (1479–1565) was a member of a family of bureaucrats of the sort that, in the fifteenth century, advanced in the service of the increasingly well-organized French state; but he is best known as the greatest book collector and bibliophile in Renaissance France. During the French occupation of the duchy of Milan (intermittently from 1499 to 1521), Grolier served in the royal administration there and took the opportunity to greatly enlarge his library with the beautiful new editions of classical texts coming from Italian presses. It seems that, between 1510 and 1516, he brought Venetian craftsmen to Milan to work on specially commissioned bindings for his growing collection of classical literature.

Among them was this folio edition of a commentary on Aristotle by the sixth-century Alexandrian grammarian John Philoponus, printed by the Venetian firm of Aldus Manutius. A handsome book to begin with, it was made nearly monumental with this binding. The plaquettes show a scene of knightly warfare on the front cover and Orpheus with his lyre (actually a fine sixteenth-century fiddle) on the back. The cameos are framed with bands of gilt ornament, as if displayed in a jewelry box or jeweler's display case, and colored with enamel paints. Grolier's ownership mark, indicating his rank in the royal administration, is on the title page of the book.

Like several other important books featured in this volume, this one comes from the collection of Louis H. Silver (1902–1963). Silver assembled a remarkable group of books, many of them first editions of major works of European literature. After Silver's death, his books were on the brink of being sold to the University of Texas when Newberry trustees, on the urging of Director Lawrence W. Towner (1921–1992), outbid the Texans. P. F. G.

THE LATE FIFTEENTH and early sixteenth centuries witnessed a mania for Roman inscriptions. Humanist scholars of the day studied them intensively in order to record classical linguistic usages, gather social and economic data, and above all recover the beautiful Roman capital scripts of the ancient world. It was just the moment when printers were beginning to create new types on ancient Roman models also, so humanists and printers pursued an urgent joint project for fifty years.

This sixteen-page volume (Fragments of Ancient Roman Inscriptions in the Diocese of Augsburg) contributed to this movement in several ways. On the informational level, it is a modest-enough achievement, presenting as it does a collection of twenty-three inscriptions found in and near Augsburg, Germany. Some are fragmentary, and they are all transcribed as found so as to provide future scholars with as much evidence as possible. More importantly, the book represents the collaboration of an original and technically advanced scholar-printer, Erhard Ratdolt (1447–1528), with one of the greatest antiquarian scholars and book collectors of the age, Konrad Peutinger (1465–1547). Both men were natives of the rich and culturally advanced imperial city of Augsburg; both had extensive personal experience of the humanist culture of Italy. Peutinger trained in Bologna and Padua, and he was a prominent politician in his hometown and an advisor to Emperor Maximilian I (r. 1486–1519). Ratdolt was a printer in Venice from 1476 to 1486 and then returned to Augsburg. An innovator in many ways, he was the first printer to illustrate scientific texts with tables and diagrams, the first to issue a printed type specimen, and one of the first to work in multiple colors for informational purposes. One innovation of this book is Ratdolt's use of an all-capital font to reproduce the inscriptional style of the ancients. He designed and cast entirely new type for the project, at an unprecedented large size and in a form that duplicates some of the characteristics of incised letters (the prominent serifs for example). The result is a highly original typographic design, not really a facsimile of the originals but a book with an air of replicating ancient lettering.

In a sense, there was a third collaborator for this book. It is dedicated to Peutinger's patron Maximilian. This copy, one of three known to have been printed on vellum, was almost surely a presentation copy for the emperor himself or for someone else at court, which explains why Ratdolt employed another important invention here—his method of printing type in gold. The soft gold sheen on mottled brown parchment lends an additional air of antiquity to the page. Maximilian was a generous supporter of scholarship and the arts, but he was also prescient in realizing the power of print for disseminating information and especially for projecting the dignity and worth of his dynasty. In presenting him with this small bit of original scholarship, elegantly printed in a novel style, Peutinger and Ratdolt were almost surely bidding for patronage for future publishing projects. P. F. G.

59

Konrad Peutinger

Romanae vetustatis fragmenta in Augusta Vindelicorum et eius dioecesi

Augsburg: Erhard Ratdolt, 1505
Book
12¼ × 8¾ in.
Wing Fund, 1940
Wing Folio ZP 547 .R11

60

Henri Estienne

Epistola qua ad multas multorum amicorum respondet de suae typographiae statu

Geneva: H. Estienne, 1569
Book
6⅞ × 4⅜ in.
Gift of Arthur Holzheimer,
the Florence Gould Foundation, and
the George Lurcy Charitable Trust, 1998
Vault Wing ZP 538 .E82

HENRI ESTIENNE the Younger (1528 [or possibly 1531] –1598) was one of several notable scholar-printers of the sixteenth century. The son and grandson of prolific Parisian printers, Estienne distinguished himself first as a classics scholar, then as a great editor of Greek and Latin texts, and eventually as a printer in the longstanding family business. The Estiennes left France in 1551 to avoid the kind of religious censorship (and personal discrimination) that Protestants often suffered during the wars of religion, and they carried on their work from Geneva. The young Henri spent a good deal of this troubled period traveling Europe in search of Greek manuscripts; he finally settled in Geneva in 1555, married, and took over the family printing house upon the death of his father, Robert, in 1559.

This volume contains two small booklets that concern the history of the business under Estienne's direction. The first, illustrated here, includes a 1569 report on the state of his press in the form of an open letter to the scholarly community, together with a catalog of Estienne imprints (Henri's and those of his father's) that were still in his stock. The second booklet is a 1574 appendix to this catalog.

Estienne's letter is a self-conscious and rather defensive reflection on the state of scholarly publishing in troubled times, couched in elegant humanist Latin. It includes, among other things, an apology to his customers for the tardiness of a projected Greek dictionary begun by his father. The 1569 catalog contains an optimistic promise that the dictionary would come out very soon. Estienne laid the blame for the delay on, among other things, the poor state of existing Greek dictionaries; other printers and editors created many false readings that had to be corrected in the course of compiling an authoritative lexicon. His *Thesaurus Linguae Graecae* did in fact appear, in four volumes, in 1572. It remained an important reference work into the nineteenth century.

Even though the 1569 booklet was written in Latin and therefore addressed to a limited audience, we can read it today as if it were a modern, direct-mail advertisement. Certainly, it contains a familiar plea for customer loyalty. By buying books from his inventory, Estienne implied, clients could help him sustain the family firm and carry forward the work on the Greek dictionary. P. F. G.

IN 1941 THE NEWBERRY acquired the bulk of the library of Chicago scribe and engrosser Coella Lindsay Ricketts (1859–1941), the largest collection of printed books on handwriting then in private hands. Ever since, the library has built upon this strength with further acquisitions of calligraphic books and manuscripts. Calligraphy was a special interest of Newberry trustee Alfred E. Hamill (1883–1943), who was involved in the 1941 purchase and who left the library his own considerable collection of books on the subject. Today the Newberry boasts more than 2,100 printed books and 600 manuscripts on calligraphy.

The writing-specimen book of the Sieur de Beaulieu (his first name and birth and death dates are unknown) is a recent acquisition, purchased in 2005 with the help of Chicago graphic designer and calligrapher Robert Williams. It is also one of the rarest printed calligraphy books, with only three copies recorded. Although far from ranking among the more influential writing manuals, Beaulieu's book certainly shows his sense of self-importance; it is ornamented with both an elaborate title page (left) and a portrait of the author at the end (right). The title page includes four classical heroes of the pen: two mythological figures (Mercury, messenger to the gods; and Palamedes, inventor of counting and measurement) and two historical figures (Cadmus, credited by the Greeks as having introduced the Phoenician alphabet; and Anaxagoras, the philosopher thought to be the first to trace such phenomena as eclipses, meteors, and rainbows). Each holds a tablet or scroll with letters. This all-embracing, mythic notion of the role of the professional scribe is echoed in two standing female allegorical figures who represent Drawing and Measure, demonstrating pen-drawn letters and geometrically constructed ones. The author portrait is more straightforward but no less pompous. Beaulieu appears in court dress above a poem that praises him for bestowing the art of the pen upon the engraver. Curiously, he is flanked by two ship's masts; above the crossbeams, an Arab and an African seem to spy on the author.

The remainder of the thirty-one engraved plates fulfill Beaulieu's title-page claim to be demonstrating the hands used in chancery and commercial work in late sixteenth-century France. Instead of displaying them in sample documents, however, the author used each different hand to inscribe a moral aphorism or proverbial saying surrounded by graceful flourished borders. At the end are six plates that demonstrate a version of an Italian cursive; these were deemed suitable for letter writing but not for documents. The volume as a whole, then, embraces both commercial and more personal acts of writing while claiming a certain philosophical prestige for the art of the scribe. Still, the book is not for beginners or amateurs. It demonstrates the very best aesthetic and technical achievement offered to scribes who were already professionals and may have wished to perfect their art. P. F. G.

Thomas Earl

Calligraphic and Computing Instruction Manual

Burlington Township, New Jersey,
1740–1741
Manuscript
8 × 12½ in.
Gift of Susan and Rudy Wunderlich, 1998
Vault Folio Wing MS 105

BEAUTIFUL, LEGIBLE handwriting was long a fundamental part of the education of European professionals, especially the clerks and accountants working for the modern states and businesses that evolved from the sixteenth to the eighteenth century. The ability to write a "good copy" was the mark of a professional man or a genteel woman. In America, even in Colonial times, handwriting education had a somewhat more egalitarian meaning, but it was not until the early nineteenth century that a significant number of American handwriting books appeared. In the eighteenth century, Americans were dependent on English or German textbooks, or, almost as often, on handwritten copies of European books that were put before students to copy out in turn. The same was true for the mathematics textbooks, which taught everything from simple arithmetic to surveying and astronomy.

The present copybook manuscript was drawn up by a schoolmaster named Thomas Earl, but we do not know which of several teachers by that name he was; all were active in the mid-eighteenth century. The most likely candidate lived in Burlington Township in western New Jersey, on the upper reaches of the Delaware River, which forms the border with Pennsylvania; he probably taught in both New Jersey and Pennsylvania. This compilation of copies was intended to demonstrate his writing skills to potential clients (parents and school committees), to show the subjects he was qualified to teach, and to offer his students models for their own copying. A typical page or opening concerns a single topic. Included are alphabets, record keeping, weights, measures, currencies, algebra and geometry problems, astronomy, cartography, tides and currents, and math puzzles.

The book is remarkable for its elaborate use of color. Although it is entirely in English, with most of its content drawn from textbooks published in London or Edinburgh, the decoration resembles other folk-art objects of the German-speaking communities along the Delaware. The manuscript is fragmentary, consisting today of about half of the nearly 600 leaves that it once comprised. The leaves were loose when they arrived at the Newberry in 1998. Because they are brittle, each leaf was de-acidified, encapsulated in mylar, and inserted into a three-volume post binding. This loose-leaf structure allows for the insertion of additional leaves from the manuscript, several of which have been given to the Newberry or acquired at auction in subsequent years. P. F. G.

IN LATE-EIGHTEENTH-CENTURY Pressburg (present-day Bratislava), any fashionable young lady on the go would have needed a calendar that she could easily keep with her throughout her busy day. This tiny "finger-calendar" for the year 1799, just under three inches long, combines form and function: in addition to a calendar printed in red and black, the book (below top) contains the weekly mail-coach schedules through Pressburg from Vienna, Hungary, and other neighboring regions. Interspersed throughout are twelve printed illustrations that follow the course of a young woman's romantic life, from courtship through marriage and family to widowhood and remarriage. While they are clearly meant to represent the passage of time, the surprisingly cheerful depictions of widowhood suggest that the book may have been a gift from one woman to another—perhaps a mother to a daughter—bestowed with a knowing smile. Contained in an enamel binding with a cosmetic mirror inside the back cover, the book even has its own paper storage case (below bottom). Although the text is essentially ephemeral, of no use after 1799, the elaborate binding and illustrations elevate it to an item of luxury. Intended to be carried—and displayed—in public, the book would have allowed its owner to check the post schedule and her appearance with equal confidence.

Miniature books were produced throughout the medieval and early-modern periods and covered many subjects, ranging from religious and literary texts, atlases, and dictionaries to children's books, political tracts, and even medical books. The earliest miniature almanac was the *Calendarium für 1475*, printed in Trent. But it was not until the beginning of the seventeenth century that production of miniature almanacs increased, and by the late eighteenth century they had become overwhelmingly popular and were readily available to all classes.

Miniature books were not generally recognized as a separate class of book to be collected until the last half of the nineteenth century, when Empress Eugénie, wife of Napoleon III, amassed 2,000 of them. Although the Newberry never specifically pursued the collecting of miniature books, it nevertheless contains hundreds of specimens. Moreover, Doris Varner Welsh, a Newberry cataloger from 1947 to 1970, was one of the great twentieth-century miniature-book scholars, producing both a history of miniature books and a bibliography of more than 7,000 entries. J. G.

*Pressburger Finger-kalenderl
auf das Jahr 1799*

Bratislava: Franz Patzko, 1798
Book
2¾ × 1⅛ in.
Wing Fund, 1990
Wing Min. ZP 958 .P28

François-Marie Arouet de Voltaire

Candide, ou l'Optimisme, Traduit de l'allemand de Mr. le Docteur Ralph

London, 1759
Book
7⅜ × 4½ in.
Louis H. Silver Collection, 1964
Case Y 762 .V8802

ENGLAND MEANT MUCH to Voltaire (1694–1778), during his lifetime and after. It provided him a haven when he had to leave France. It was home to his principal intellectual heroes, John Locke and Isaac Newton. It tutored him in the ways of deism and religious toleration. And, in one of history's little ironies, from Edmund Burke's attack on him in 1790 ("we are not the disciples of Voltaire") to John Morley's celebration in 1872 of his "stupendous power," England did much to create the concept of an Enlightenment typified by Voltaire and the *philosophes*. It seems only fitting, therefore, that London should have been the place of publication for the earliest version in print of Voltaire's enduring masterpiece, *Candide*.

The manuscript for *Candide* went to Voltaire's Geneva printer, Gabriel Cramer, at the end of 1758 and was typeset in January 1759. A London edition was planned, and therefore Cramer sent a printed proof copy to London for typesetting there. While that copy was in transit, Voltaire made some textual changes in Geneva, and these were incorporated into the final version of the type for the Geneva edition, which was printed accordingly. The same changes could not reach London in time for John Nourse, the responsible bookseller there, to include them in his edition. Consequently, the first London edition presents the story as Voltaire had originally submitted it

for publication. In particular, the London text includes a paragraph that Voltaire removed from the final Geneva text because it could have been construed as offensive to Frederick the Great. The Geneva edition is considered the "first state" of *Candide*, but the London edition preserves a previous state of Voltaire's thinking.

Copies of the first London edition are held in a dozen libraries in Great Britain and the United States. What is especially unusual about the Newberry's copy is that it is bound in its original blue-paper wrapper, which remains largely intact (except along part of the spine, where the individual signatures can be seen). Both wrapper and text are in remarkably good condition. In short, the book remains almost exactly as it was when it came from Nourse's shop in early 1759—the earliest physical state of the earliest printed version of *Candide*. No other copy is known to be in this original condition.

This volume entered the Newberry as part of the purchase of the Louis H. Silver Collection in 1964, when it was mistakenly considered, owing to the scholarship of the day, to be from a purported Amsterdam edition, which turned out not to exist. The book's provenance prior to belonging to Silver is not known with certainty. Earlier in the twentieth century, it was in the possession of Mary Hunter (1856–1933), whose bookplate is on the front endpaper. Hunter, sister of the English composer and feminist Ethel Smyth, was a close friend of novelists James and Wharton, as well as artists Monet, Rodin, and Sargent. She is reported to have said that she considered it her "sacred duty to spend every penny" of her husband's money that she could. Voltaire, who prospered so mightily from his writings, would have been pleased that an Englishwoman had spent handsomely to acquire his old book. D. S.

CANDIDE,

OU

L'OPTIMISME,

TRADUIT DE L'ALLEMAND.

DE

MR. LE DOCTEUR RALPH.

MDCC LIX.

Seaton 3ᵈ Mſſ. 5. 9

Thomas Bewick

Peacock

Newcastle upon Tyne, c. 1800
Woodblock
3⅛ × 3⅜ × ⅞ in.
Wing Fund, 1943
Case Wing Oversize ZY 845 .B572

THOMAS BEWICK (1753–1828) was undoubtedly the greatest wood engraver of the early-modern era. Except for a brief, youthful period of travel, he spent virtually his whole life in Northumberland, England, in and around the town of Newcastle-on-Tyne. Early in his career, Bewick supplied engraved woodblocks to printers on any subject they required; later he undertook a systematic series of illustrations for books in which he had some personal interest, most importantly *The General History of Quadrupeds* (1790), *The History of British Birds* (1797), and an edition of Aesop's fables (1818). Although best remembered as a technically brilliant engraver, he was also one of the most perceptive observers of nature and everyday life in rural England. The *Quadrupeds* and *Birds* volumes include not only lively and generally accurate images of the animals, but also dozens of tailpieces with vignettes of rural scenes: fishermen and hunters, tradesmen and farm folk, children at play, mills and farmsteads, and comic characters aplenty.

The Newberry owns 119 blocks by Bewick, the largest collection in America. The history of the blocks is a complicated tale and one with a Chicago connection. After Bewick's death, his blocks passed to some cousins, the Wards, a family of printers in Newcastle. The firm of R. Ward & Sons included a thorough representation of them accompanied by the original texts in the *Memorial Edition of Thomas Bewick's Works* (1885), printed for the London publisher and bibliophile bookseller Bernard Quaritch. The blocks remained in the family until 1942, when 1,350 of them were offered for auction at Sotheby's. In the midst of World War II, however, they did not garner much interest in the English book world. Thus, Ben Abramson, proprietor of the Argus Book Shop in Chicago, was able to acquire them for £300. Abramson probably hoped to resell them quickly to an American institution (he almost surely had the Newberry, among others, in mind), but when no single buyer emerged, he put them up for sale individually. Newberry curator Ernst Detterer (1888–1947) was given an early opportunity to buy and chose twenty-four of the very best subjects for the Newberry and twenty-two more for himself. One of the largest blocks, that of a peacock, was among the first purchased on behalf of the Newberry. Robert Hunter Middleton (1898–1985), a Chicago-based type designer and former student of Detterer's, acquired many blocks between 1943 and 1955; other collectors purchased smaller lots. Middleton became well known for his prints from the blocks that he owned and those that others loaned to him. The most important record of this work is a portfolio of one hundred prints published by the Newberry in 1970. Most of those blocks are now in the library.

The Chicago Bewick story continues. Between 2003 and 2008, the Newberry's blocks were conserved and given new exhibit housings created in the library's Conservation Laboratory by volunteer Fred Anderson. Former Newberry curator James M. Wells donated another block in 2012. And in 2009, Evanston printer Bill Hesterberg published a census detailing where the blocks once in Chicago are now. He was able to locate 729 of them, somewhat more than half of the total, so there is still some sleuthing to do. P. F. G.

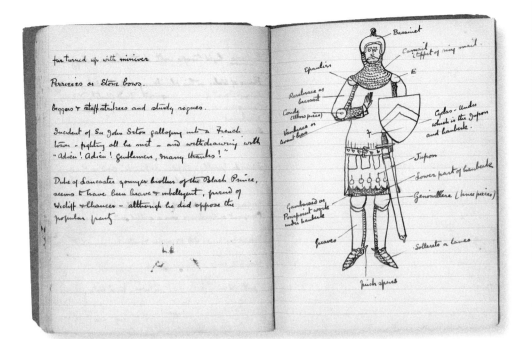

Sir Arthur Conan Doyle

Notebook for
The White Company

London, 1889–1890
Manuscript
9⅛ × 7⅛ in.
Gift of C. Frederick Kittle, 2004
Vault Folio Case MS 5116 no. 2

THE C. FREDERICK KITTLE COLLECTION of Doyleana began coming to the Newberry in 2003. A thoracic surgeon, Kittle initially collected travel books written by physicians. But well before selling that collection in 1990, he had turned his attention to materials by and about Sir Arthur Conan Doyle (1859–1930) and the Doyle family. His first acquisition was the manuscript "The Romance of Medicine," a lecture Conan Doyle gave in 1910. Today the Kittle Collection at the library consists of some 700 publications, along with manuscripts, photographs, artworks, and objects. It illuminates Conan Doyle as a doctor, a writer of Sherlock Holmes stories and much more, a member of a creative family, a key participant in the changing world of authorship and publishing, an influence on his times, and a subject of ongoing scholarship, which is abundantly represented in the collection.

Among the Kittle Collection's rich manuscript materials are both Conan Doyle's fair copy (final version intended for the printer) holograph of *The White Company* (first published serially, by *Cornhill Magazine*, in 1891) and his research notes for this Hundred Years' War novel. Conan Doyle began work on *The White Company* in 1889, conducting detailed research into late-medieval society and culture. His preparatory labors can be followed in three substantial notebooks, some separate pages, and two sheaves of what he called "gleanings" from his studies. These materials show Conan Doyle becoming familiar with the broad outlines of the later Middle Ages in Western Europe and with many details of medieval life and warfare, as well as crafting ideas for events and even turns of phrase that would find their way into the book.

Research by Conan Doyle for *The White Company* post-dated the appearance of his first Sherlock Holmes novel,

A Study in Scarlet (1887), and coincided with his brief, unsuccessful career in ophthalmology. The notebooks reveal that he consulted general works such as Paul Lacroix's *Manners, Customs, and Dress during the Middle Ages and Renaissance* (English translation, 1874). On military history and technology, he read books like the recent *Art of War in the Middle Ages* (1885) by Charles Oman and *From Crécy to Assye* (1881) by H. R. Clinton, as well as Thomas Roberts's *English Bowman* (1801). His notes show that he was at least somewhat familiar with Roger Ascham's *Toxophilus* (1545) and Francesco Patrizi's *Paralleli Militari* (1594). The title of his book may well have come from commentary by Clinton on Sir John Hawkwood: "In 1361 he led into Italy a band of 3,000 adventurers, called The White Company (La Compagnon Bianca)." Conan Doyle's reading led him also to note specific strings of words that he thought would suit the novel's purposes. For instance, he fancied the phrase "a drift of arrows," which eventually appeared in Chapter 22.

The *White Company* notebooks demonstrate Conan Doyle employing his modest artistic skills for research purposes, in this case an aide-memoire depiction of an armored knight. He illustrated several of his own stories. An artistic strain ran in his family: his grandfather John Doyle painted and drew political caricatures under the initials "H. B."; his uncle Richard "Dickie" Doyle regularly contributed illustrations to *Punch*. The Kittle Collection contains art by these family members and others.

In *The White Company*, set in the 1360s, a young Englishman's experience on the Continent with a company of archer-adventurers leads him to a knighthood and to even greater success in the French wars. Had Conan Doyle illustrated the book himself, the depiction of Sir Alleyne Edricson with which the novel ends might have looked something like the author's early notebook sketch of a knight in armor, without the annotations. D. S.

67

John Milton (author)
Sangorski & Sutcliffe
(binder)

*Paradise Lost;
Paradise Regained*

Book: Birmingham: John Baskerville for J.
and R. Tonson
1758–1760
Binding: London, 1910/1930
9⅛ × 5⅞ in.
Gift of Helen Swift Neilson, 1945
Vault Case Folio Y 185 .M6376a v. 1 and 2

THE NEWBERRY STAFF do not usually think of the library as having a major collection of book bindings, but with 1,500,000 volumes from medieval times to the present it is inevitable that there are good specimens of many styles and structures, as well as some examples of the most over-the-top ornamental bindings. This pair of bindings, adorning what is certainly among the simplest and most soberly beautiful books of all time, certainly falls into the category of bindings-for-bibliophiles. They come from the collection of Helen Swift Neilson (1869–1945), daughter of Chicago meat-packing pioneer Gustavus Swift, and herself a major patron of arts and academic organizations. Writing as Helen Swift, she authored several charming memoirs of growing up in Chicago and traveling the Midwest, which offer affectionate portraits of the city's elite in the late nineteenth century. She and her second husband, British-born politician, author, actor, and theater director Francis Neilson (1867–1961), spent their last years in New York, where they were active in Socialist causes. But Mrs. Neilson always maintained her ties to Chicago and its cultural institutions. In 1944 she made an important gift of decorated bindings to the Newberry; after her death, Mr. Neilson completed her intended gift with other valuable books, including the one featured here.

Helen Swift Neilson seems to have had a particular fondness for the work of the London luxury binder Sangorski & Sutcliffe, whose workshops produced a dozen bindings in her collection. The firm was established in 1901 and did fine binding of all sorts, though they were probably best known for extravagant jeweled bindings like these. Founder Francis Sangorski was particularly interested in and skilled at this kind of work, and it proved so popular that the firm continued to produce bindings of the sort long after his death in 1912. The designer/binder of this example seems to have given considerable thought to the choice of materials—snakeskin for *Paradise Lost* (below) and mother-of-pearl for *Paradise Regained* (opposite)—but both bindings also include more traditional materials, such as garnets, opals, colored leather inlays, and much gold tooling. These bindings are undated but were probably executed in the late 1910s or '20s. P. F. G.

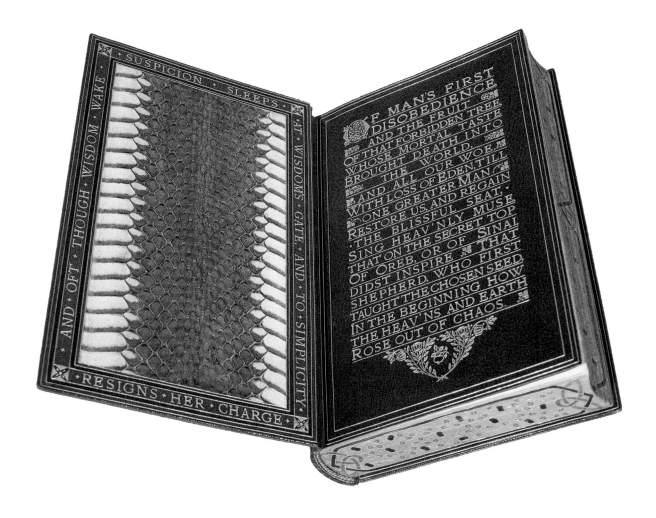

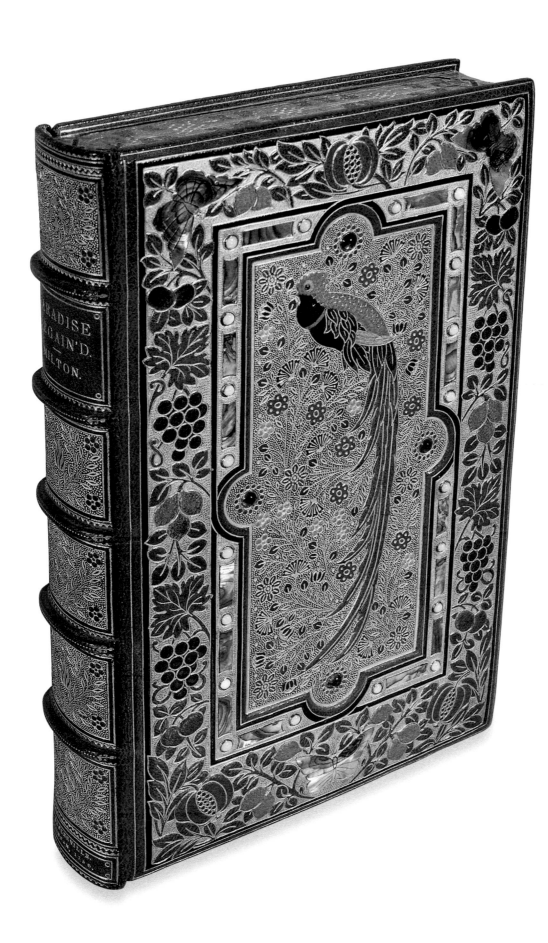

Saggio caratteri in legno

Foligno: E. Toni & C., 1888
Type specimen
19 × 26 in.
Wing Fund, 1941
Case Wing Oversize Z 40535 .884

TYPE SPECIMENS are popular collector's items because of their intrinsic beauty and visual interest, but they can also be important sources for understanding the history of printing technology, design, and popular culture. Such specimens are essentially sample books. They might have been issued by printers selling their services, that is, showing off the variety of typefaces they offer along with their skill at printing. More often they were directed by type manufacturers at printers who could actually buy the type.

This curious specimen—the only known surviving copy—belongs to the latter category. Produced in the small central Italian city of Foligno, it probably dates to the 1880s. We know that the maker's full name was Espartero Toni and that he owned and managed a café in Foligno, as well as a type foundry. Advertisements for his type business discovered by James Clough tell us that the type firm was founded in 1885; Toni died in 1897.

The specimen offers wood type to job printers—the craftsmen once found in every town who printed posters, handbills, invitations, and cards. Typically, wood type was employed for poster work because it could be made cheaply in large sizes. E. Toni & Sons displayed a variety of letter forms, borders, and pictorial images that could be used for theatrical events, religious festivals, and even bullfights. This last seems an unlikely commercial theme for Italians, but the woodblocks are sizeable and may have been intended as showpieces for an 1888 exhibition in Barcelona in which the firm participated. In any case, they appear here primarily to show what kinds of large-scale images the cutter could provide.

The title panel is a tour-de-force of printing, done in at least seven colors from blocks that range in size from under two inches to over twelve. The border includes intricate one- and two-color corner cuts, while the remainder of the border is composed of typeset names of famous figures in printing history, each in a different style. Johann Gutenberg, Daniel Elzevier, and Giambattista Bodoni are obvious choices, but the name of Castaldi in the bottom border is less familiar. Panfilo Castaldi (d. c. 1490), according to some seventeenth- and eighteenth-century local historians from his hometown of Feltre, invented printing before Gutenberg, supposedly because his wife, a granddaughter of Marco Polo, had inherited Chinese metal types that could serve as models. This legend, which promoted the primacy of an Italian over a German printing innovator, was repeated by the nineteenth-century English diplomat and travel writer Robert Curzon. He authored popularizing books on Marco Polo and printing in China that might have been the source of the patriotic spirit expressed in this type specimen. On the same title panel, we find the coats of arms of the Italian ruling house of Savoy and those of the English royal family (whose motto is misspelled). Like the bullfight cut and Castaldi reference, this is another seeming oddity until we remember that English travelers were ubiquitous in nineteenth-century Italy and that there were many established Anglo-Italian families, especially in Tuscany and Umbria. P. F. G.

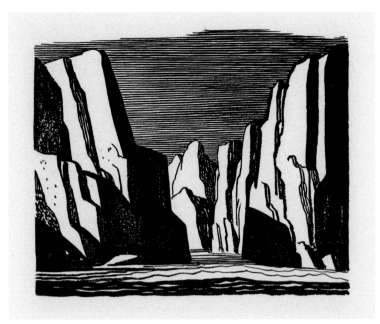

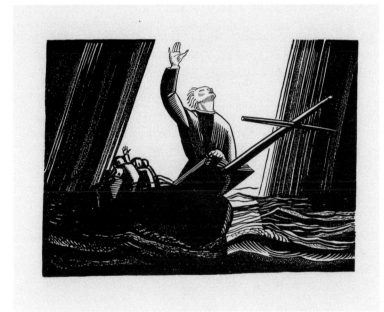

Rockwell Kent
Proof sheets for the
Lakeside Press's *Moby Dick*

Chicago: R.R. Donnelley & Sons, 1930
Prints
7⅛ × 11¼ in. (each)
Gift of Dan Burne Jones, 1977
Case Wing Oversize ZX 983 .K37

literary classics. The other three were Edgar Allen Poe's *Tales* (illustrated by W. A. Dwiggins); Richard Henry Dana, Jr.'s *Two Years Before the Mast* (Edward A. Wilson); and Henry David Thoreau's *Walden* (Rudolph Ruzicka), all published in 1930. This project attempted to demonstrate that commercial book printing in the United States could be as elegant and beautiful as anything done in Europe at the period. It was primarily a marketing concept, to showcase the quality of Donnelley's book work; as such, it was successful, for the company subsequently received orders from a number of American trade publishers. But there was a bit of American nationalism in the plan, too, vaunting as it did both American letters and American design and printing.

Since Donnelley did not impose many limits on him, Kent saw the commission as a unique opportunity to create a suite of illustrations as ambitious and expansive as Melville's great novel of the sea. Kent's ink drawings, reproduced from electrotypes, presented a particular challenge to the printer because they called for a rich, dense black; and the illustrations in turn required bold typography. The result realized Donnelley's marketing aim: it is a nearly definitive rendering of a classic text. Selected images were reproduced in later editions and came to define how Americans in the mid-twentieth century thought of Melville's tale.

The most complete surviving set of proofs for these illustrations is held by the Newberry. It was the gift of Dan Burne Jones (1908–1995), a longtime collector of Kentiana who acquired it from the estate of William A. Kittredge (1891–1945), director of design and typography at Donnelley. Kittredge had helped conceive the four-book project and worked closely with Kent on *Moby Dick*. The Newberry has a distinguished Melville collection (see no. 70), but these proofs were donated to the Newberry in consideration of its important printing- and design-history collections. P. F. G.

IN 1930 Chicago's R.R. Donnelley & Sons Company printed a magnificent edition of Herman Melville's *Moby Dick* lavishly illustrated by Rockwell Kent (1882–1971), housed in an aluminum box and published in an edition of 1,000 copies. The three-volume set was so eagerly anticipated by collectors of Kent's work that the printing plant on 23rd Street imposed extra security during the print run. Both Kent, by then a renowned illustrator and printmaker, and the publisher wanted to avoid the possibility that individual illustrations would end up on the print market. Only one set of proofs was to be made, overruns were destroyed, and absolutely no spoiled sheets were allowed to leave the plant.

R.R. Donnelley & Sons had undertaken *Moby Dick* as part of a larger project to print four illustrated American

70

Herman Melville

Moby-Dick, or, the Whale;
Moby Dick in Various
Languages

New York: Harper & Bros., 1851; various
publishers and dates
Books
7 × 4½ in.; various dimensions
Herman Melville Collection,
gift of Harrison Hayford, 1965;
gifts of H. Howard Hughes, 1984
Vault Melville PS 2384 .M6 1851g;
uncataloged

WITH MORE THAN 6,000 works, the Herman Melville Collection at the Newberry is one of the largest holdings in the world of materials related to the author (1819–1891). The nucleus of the collection is the personal library compiled by Harrison Hayford (1916–2001), a gift that arrived in 1965.

Hayford served as general editor of the Northwestern-Newberry Edition of *The Writings of Herman Melville*. A collaboration between Northwestern University, Northwestern University Press, and the Newberry, it is a fifteen-volume, definitive critical edition of Melville's works designed to "come as close as surviving evidence permits to establishing for each work the text intended by the author." Each volume in the series includes an authoritative edition of the work on which it focuses; an historical note containing information on the composition, production, and critical reception of the work; a note on its textual history that explains the variants the editors found in different editions and how they resolved them; and essays on associated works and documents the editors used in crafting the critical edition.

The Newberry's role in this effort was to amass a collection of all surviving forms of Melville's writings and as much information as possible on the manufacture of each. In 1965, after the Hayford gift, Richard Colles Johnson (1939–1998), bibliographer of American History and Literature at the Newberry and bibliographical associate for the Northwestern-Newberry project, began aggressively pursuing additional materials to meet Hayford's request for "a complete collection of every edition, issue, and printing of every work by Melville, including translations, and of every word ever printed about Melville's works or about Melville himself."

Johnson compiled a collection that comes close to meeting this ambitious goal. Nearly every edition of Melville's work printed during his lifetime is represented,

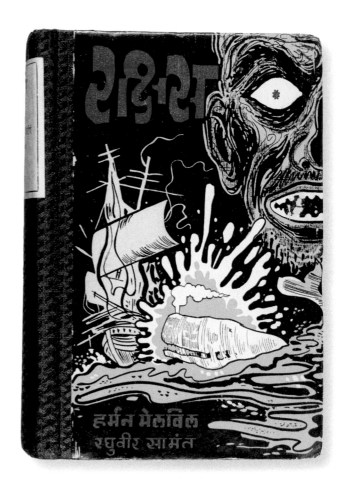

as are thousands of editions and adaptations of Melville's writings published from 1891 to the present; more than 1,000 books of criticism; a nearly comprehensive collection of English-language dissertations from 1930 to 1980; and materials related to Melville's library and personal research. Notable gifts that extended the collection include translated editions of Melville's works in more than forty languages, donated to the Newberry by Leland Phelps; the Melville collection of James A. FitzSimmons, a Chicago bibliophile, donated in 1970; and the *Moby Dick* collection of more than 700 volumes donated by H. Howard Hughes in 1984. Among the latter are three translations of *Moby Dick* illustrated here: a Marathi-language edition published in Bombay in 1962 (opposite right); a Spanish-language edition published in Barcelona in 1953 (below left); and a Russian-language edition published in Leningrad in 1968 (below right).

Many volumes in the Melville Collection contain evidence of its genesis as a working resource, including notes or markings by scholars engaged in the Northwestern-Newberry Edition. This is true even of the first editions of *The Whale* and *Moby Dick*. The Newberry holds three copies of the first edition of *The Whale*, published in three volumes by Richard Bentley in London in October 1851; and fourteen copies of the first American edition, *Moby-Dick, or, The Whale,* published in a single volume by Harper and Brothers in New York in November 1851. The editors used these to observe differences in bindings and endpapers and to explore the hundreds of differences in wording and the thousands of punctuation variants between the text of the English and American first editions. Collation notes are inscribed in the copy of the first American edition of *Moby-Dick* (opposite left). Howard P. Vincent (1904–1985) relied on this copy to prepare the Hendricks House edition of *Moby Dick*, which, when it was published in 1952, contained the most detailed description of the variations between the English and American editions. Vincent also annotated this copy in red pencil with notes for the printer of the Hendricks House edition. Hayford purchased this copy of *Moby-Dick* from Vincent and found the collation and printer notes useful in preparing the Northwestern-Newberry Edition of the novel. Such careful attention to detail established the Northwestern-Newberry Edition as the definitive compendium of Melville's writings, and it has been used as the text for the author's works in the popular Library of America series. A. M.

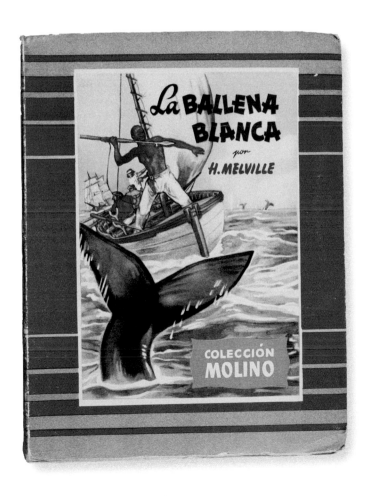

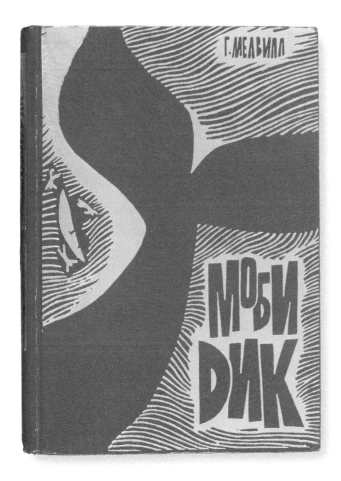

Oswald Bruce Cooper

Advertising Brochure; Drawings for Cooper Black Type

Chicago, 1919/1922
Pamphlet; drawings
11 × 7⅝ in.; 8½ × 11 in.; 11⅞ × 16⅞ in.
Gifts of Bertsch & Cooper, 1946
Wing Modern MS Cooper

ALMOST EVERY word-processing program today offers Cooper Black as a typeface option, but few people know that this font originated in Chicago. Oswald Bruce Cooper (1879–1940) was widely known in the Midwest both as an advertising designer and as a creator of types for Barnhart Brothers & Spindler, the Chicago affiliate of the American Type Founders Company. His Cooper Black was the most widely used and imitated advertising type in America for much of the first half of the twentieth century. Today it typifies the witty, punchy élan of the 1920s for those who are historically minded, while for the rest of us it is simply fun—what we happily call a "fat face."

Cooper's surviving papers consist largely of advertising layouts for Chicago clients like Henrici's Restaurant, Marshall Field's, and the Exmoor Country Club, and for national firms like Butler Paper and the Marchbanks Press. There are also hundreds of drawings for type, including sketches, finished drawings, proofs, and advertising for more than a dozen typefaces. Cooper Black was released commercially in 1922, but dates penciled on the sketches indicate that Cooper began work on it in 1919, proof that even this most informal of typefaces required long thought and careful revision. The letter forms are based on the punchy hand-lettering Cooper did for the clients of his design firm in the late 1910s. He drew and redrew some letters dozens of times in the hope of giving the type, necessarily a mechanical product, some of the fluidity and bounce of his personal lettering style. The tissue sketches that went back and forth between Cooper and Richard N. MacArthur, the Barnhart executive in charge of type design, contain many notes about the shapes and fit as Cooper experimented. Some, though pleasing to our eyes, bear a tiny note against one letter among many that says "Kill," followed by a date.

Cooper was a founding member of the Society of Typographic Arts (STA), which produced a retrospective tribute to him, *The Book of Oz Cooper*, in 1949. That substantial volume includes remembrances by colleagues and friends and many illustrations of Cooper advertisements and type designs; it is still the standard work on Cooper's career. The making of the book occasioned some disorder in the Cooper Papers at the Newberry. Most but not all of the drawings and art boards were donated to the library by the Bertsch & Cooper advertising firm in 1946. Cooper's widow, however, had meanwhile given many items to Chicago designer Raymond F. DaBoll (1892–1982), who had been charged with assembling the memorial book for the STA. These materials came to the Newberry in 2006 as a gift from DaBoll's heirs. P. F. G.

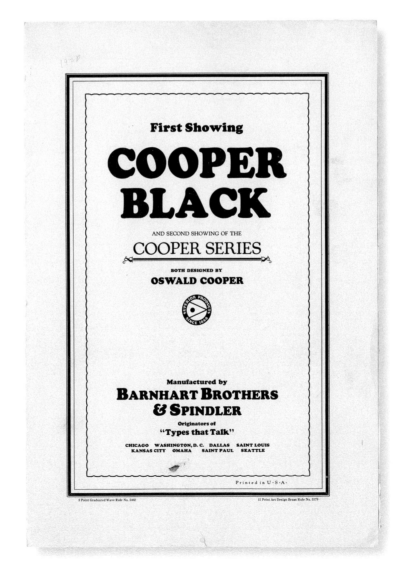

pack my box with fv
JUG e dozn lqurjgs s
sttuu u a nneen
comply HOME RRE

Josef Váchal

Váchalova ročenka na rok
1927

Ve Vršovicích, Czechoslovakia, 1926
Book
13½ × 12⅞ in.
Wing Fund, 1997
Vault Wing Folio ZP 958 .V336

JOSEF VACHAL (1884–1969) was a visionary Czech author, painter, designer, and printer whose career spanned two world wars and the repressive Communist rule of his country. He witnessed and participated in (though always with considerable ironic detachment) avant-garde movements in art and literature from the Vienna Secession through Dada, Expressionism, Constructivism, and Art Deco. At the end of his life, he was a tolerated but largely neglected elder on the design scene in Prague.

Vachal's most important graphic work appeared in small editions of books, booklets, and broadsheets printed on his own press and illustrated with his own remarkable woodcuts. Even now this body of work is less well known than it deserves to be because it is rare and thus difficult to study. Vachal gained belated critical appreciation in the 1990s as his books came onto the post-Communist collectors' market. Today his work is avidly sought after and has been shown in many exhibitions. The Newberry acquired a few small examples in the 1930s. Larger and more significant works have come into the collection in recent years.

The book that represents his oeuvre most broadly is *Váchalova ročenka na rok 1927*. The title means "yearbook" or "specimen book" for 1927. Czech artists used the term *ročenka* for an anthology of recent work in a miscellany united only by the creativity of the compiler. This volume includes both writings and woodcuts by Vachal. It displays the full range of his woodcut work, including virtuosic color images in romantic and Expressionist styles; faux folk-art decorations and lettering; calligraphy and type in many forms; charming, ironic comic strips; and bitterly satirical caricatures. There are nine self-portraits and four images of Vachal's dog, Tarzan. The book opens with a rather formal, four-color woodcut self-portrait facing an exuberant title page. It ends with a caricature of Vachal in the guise of Johnny Appleseed sowing the seeds of imagination across a sunny landscape, accompanied by a frisky Tarzan. Among the most biting of the caricatures are images of art dealers and collectors—apparently colluding in and enjoying the poverty and despair of the modern creative artist.

This copy is bound in full, bright pink leather with yet another large self-portrait of Vachal, Cubist in style this time, stamped from a woodblock onto the front cover. The coarse paper inside was made by Vachal, who also added touches of color by hand to many of the images. This volume was owned by his student and companion, Anna Macková (1887–1969); it contains the bookplate he designed for her. P. F. G.

ERIC GILL (1882–1940) is best known today as the designer of widely used typefaces like Joanna, Perpetua, and Gill Sans. In his lifetime, however, he was at least as famous as a figurative artist with a strong religious bent. His drawings, prints, and sculptures were widely exhibited in Britain and North America. The Newberry commissioned two works directly from the artist in the 1930s: an alphabet stone and a bookplate design.

Gill's collaboration with the Golden Cockerel Press started in the mid-1920s with illustrations for an edition of poems by Gill's sister Enid Clay. The proprietor of the press, Robert Gibbings, was himself a wood engraver and wanted to illustrate his books with this technique. Contemporary English engravers, however, favored strong images with heavy lines and large areas of black. The results were often too dark and too bold to match well with the types owned by Golden Cockerel. Thus, at Gibbings's urging, Gill began to design a new type in 1928 that could be employed in a variety of woodcut-illustrated books, and specifically in a projected *Four Gospels* that Gill was to illustrate. The type project consumed most of two years, and making the woodcuts and printing the Gospels required another year. The result, however, is widely admired as one of the masterpieces of English fine printing in the interwar period; the Golden Cockerel's proprietary type went on to have its own future in the company of other esteemed woodcutters. It has been available in digital form since 1996.

Gill's illustrations for the *Gospels* are notable for the playful way in which the narrative figures inhabit a space that also includes initial letters, which may act as architectural frames, vegetation, or other objects in a landscape. In the Newberry's block—one of the chapter heads in the work—three women approach an angel who seems to greet them. The three dark figures walk through a forest of uprights that form the first word in the opening line of the last chapter of the Gospel of Matthew: "IN the end of the Sabbath, as it began to dawn . . . came Mary Magdalene and the other Mary to see the sepulcher." Robed and silhouetted, the women are sinuous black forms with features and drapery picked out in white. They occupy an entirely human space along with the word *In*. But the angel, drawn in reverse with black lines, is a radiant white figure entirely outside the space and time defined by the letter forms. The result is at once simple and thoughtful, entirely typical of Gill's spirituality.

Woodblocks by Gill are treasured both as the raw material for prints and books and also as sculptural objects in themselves. After the completion of the *Four Gospels*, a number of the larger blocks such as this one were reworked with white paint to highlight the effect of the original drawing and make them easier to exhibit. P. F. G.

73

Eric Gill
Initial Block for
Four Gospels

Ditchling, Surrey: Golden Cockerel Press,
1931
Woodblock
4½ × 6¾ × 1 in.
Wing Fund, 1962
Case Wing ZY 945 .G4117

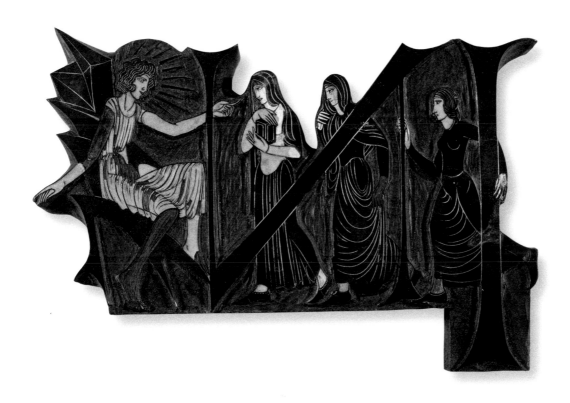

74

William Shakespeare (author)
Roger Powell (binder)

*The Tragedie of Hamlet
Prince of Denmarke*

Weimar: Cranach Press, 1930
Book
14 × 9¾ in.
Pocahontas Press Fund, 1970
Wing Folio ZP 947 .C8502

THE NEWBERRY has extensive holdings of the printed work of Count Harry Kessler (1868–1937) and his Cranach Press, one of the most adventuresome of the European fine presses between the World Wars. Kessler, an Anglo-German patron of the arts, writer, and publisher, established Cranach Press in Weimar in 1913. His *Hamlet*, issued in both German (1928) and English (1930, as here), was among the best and most famous of the press's productions. It includes contributions by three major British artists: type designed by Edward Johnston (1872–1942), and woodcuts by Eric Gill (see no. 73) and Edward Gordon Craig (1872–1966). The latter was an actor, theater designer and director, and artist; his illustrations for this book (opposite bottom) were intended to re-create in print a pioneering, abstract production of *Hamlet* that he oversaw for the Moscow Art Theater in 1911. As such, this volume is at once a masterpiece of English literary, theatrical, and artistic culture.

The Newberry's copy of the Cranach Press *Hamlet* is prized most of all for its elegant binding by another great British artist, Roger Powell (1896–1990). Powell trained in bookbinding at London's Central School of Arts and Crafts; he later taught there and at the Royal Academy of Arts. This binding was produced in 1963 at Powell's own bindery in Froxfield, Hampshire, on commission for the great English bibliophile Major J. R. Abbey (1894–1969). The binding is of black morocco leather with inlays of blue and purple leather, decorated with gilt chevrons.

The Newberry acquired the book at auction in 1970 using the Pocahontas Press Fund, which had been established by the gift of Trustee Suzette Morton Davidson (1911–1996) specifically for the purchase of contemporary artists' books and bindings. Pocahontas Press was her private imprint, founded in 1937.

This copy of the book is one of a few specially printed on vellum. It complements a second copy of the same English-language edition in the Newberry, printed on paper and bound by the Bauhaus artist Otto Dorfner, and a copy of the German edition in sheets accompanied by an extra set of the woodcuts proofed onto tissue. In all, then, the Newberry boasts four states of the illustrations, three copies of the book, and two bindings by important twentieth-century artists. The design and execution of the Cranach *Hamlet* are described in some detail in correspondence that survives in the Kessler papers concerning the Cranach Press, which were purchased by the Newberry in 1964. This beautiful volume, therefore, is just part of a complex research collection that describes in depth the creative process behind a fine-press book, and that concerns as well the creative afterlife of such a book once it passes into the hands of collectors, bookbinders, auction houses, dealers' stock, and libraries. P. F. G.

Ken Campbell

Skute Awabo

London: K. Campbell, 1992
Book
21¼ × 15⅛ in.
Bequest of Suzette Morton Davidson,
1996
Vault Wing Oversize ZP 945 .C1795

ONE OF THE GREAT pleasures of working at the Newberry is the opportunity to learn about the subject specialties of curators and other scholars on staff and occasionally collaborate with them on a purchase or gift. Sometimes this amounts to little more than eavesdropping on colleagues' expert advice to others, but it can involve substantial conversations as well. What one learns in these casual ways percolates for a while and may become a factor in a seemingly unrelated acquisition. Thus, the Newberry's broad and deep collections of American Indian history and literature, intensively used as they are, figured in the decision to acquire this major artist's book by an English printer, Ken Campbell (b. 1939). Although essentially an essay in sequencing vividly colored abstract forms representing water and fire, it is also a meditation on a short story by Scots–Swedish travel and adventure writer Harry Macfie (1879–1956) set in the lands of the Ojibwe Indians of Manitoba.

The brief narrative is paraphrased in English just once in the course of this very large book. It relates a journey into the deep forest along a river that is set afire and thereby is polluted both physically and spiritually. The long trip and the climactic event are conveyed largely through progressions of paper texture and printed color across four successive sequences of pages. Very occasionally, the reader encounters fragments of text, including single Ojibwe words and phrases, their English equivalents, and quotations from Hebrew and Christian scripture. The story of Moses, who turned the Nile to blood to prove the power of the God of the Hebrews to the pharaoh, is adduced as one parallel; passages from Revelations offer others.

Campbell created the abstract patterns that repeat through the book with pieces of type and type furniture (largely spacers and rules) turned on their sides and raised to type height. He then printed and overprinted every sheet on both sides (sometimes up to ten times) until he achieved the density of color and tone he wanted. The resulting sheets are so heavily inked that the pattern on one side is often partly visible on the reverse. A few sheets were finished with ink brushed by hand onto the printing surface, or with adhered gold tissue. The artist incorporated several different weights and types of paper in a quadruple sequence that, combined with the phenomenon of show-through, creates changing sights and sounds as the pages are turned. The physics of the book, then, heightens the sense of anticipation as one moves through the story and enhances the sensual experience of a journey through this lengthy codex. P. F. G.

JAY RYAN (b. 1972) is the best known of a large group of poster artists in Chicago who have made the city's indie-rock scene an amazingly fertile art movement as well as a musical one. While most are trained artists, many of their posters share an outsider-art ethic, with plenty of wild, edgy, and unexpected imagery. Ryan's boldly colored silkscreen posters are immediately recognizable for his fluid drawing of every conceivable kind of urban and fantasy object, often rendered in unusual perspectives, and for the entirely believable anatomy of the humans, animals, monsters, and fuzzy critters that populate the often strangely framed scenes. The appealing animals and cheerful palette of his color fields tend to make Ryan's creations seem less strident than those of his colleagues, but a close look almost always reveals some ironic inversion, or worse.

In 2003 Ryan decided to make something out of the many proofs, spoiled sheets, and overruns that inevitably accumulate in a silkscreen print shop like his, which he calls The Bird Machine. Every year since, he has assembled between twelve and thirty copies of a volume composed of posters cut down and bound up in gatherings that juxtapose a fragment of one poster with a fragment of another. Ryan calls them his "mistakes books"; the process is intended to compound the mistakes with peculiar, originally unplanned combinations. Each year's volume has its own title, typically based on the lyrics of a song

Ryan has been listening to that refers somehow to unintended consequences. The resulting artist's books, like the posters themselves, are prized by collectors of both poster art and rock-music ephemera. They can be understood as Chicago streetscapes carefully time-stamped, folded up, and resting on a shelf. The simple codex in its utilitarian case binding at first hides its contents, like an ill-lit street at night. But then the book opens out to express the gaudy randomness of urban graphics as we experience them most of the time in real life: by chance, in passing, through a window, or out of the corner of an eye.

The 2005 book, featured here, represents an interesting moment in Ryan's career. Its title refers not to a lyric, but to a period when he and Mat Daly, his fellow printer at The Bird Machine, were just beginning to earn a proper, almost regular income from their poster-making. They were not quite "living the dream," Ryan has said, but they were close and hoping it might come true. P. F. G.

Jay Ryan
Fondling the Dream. Mistakes, Misprints, and Other Debris from the Posters of Jay Ryan.

Chicago: The Bird Machine, 2005
Book
12¼ × 12⅛ in.
Gift of Diana Sudyka and Jay Ryan, 2005
Wing Folio ZPP 2083 .R82

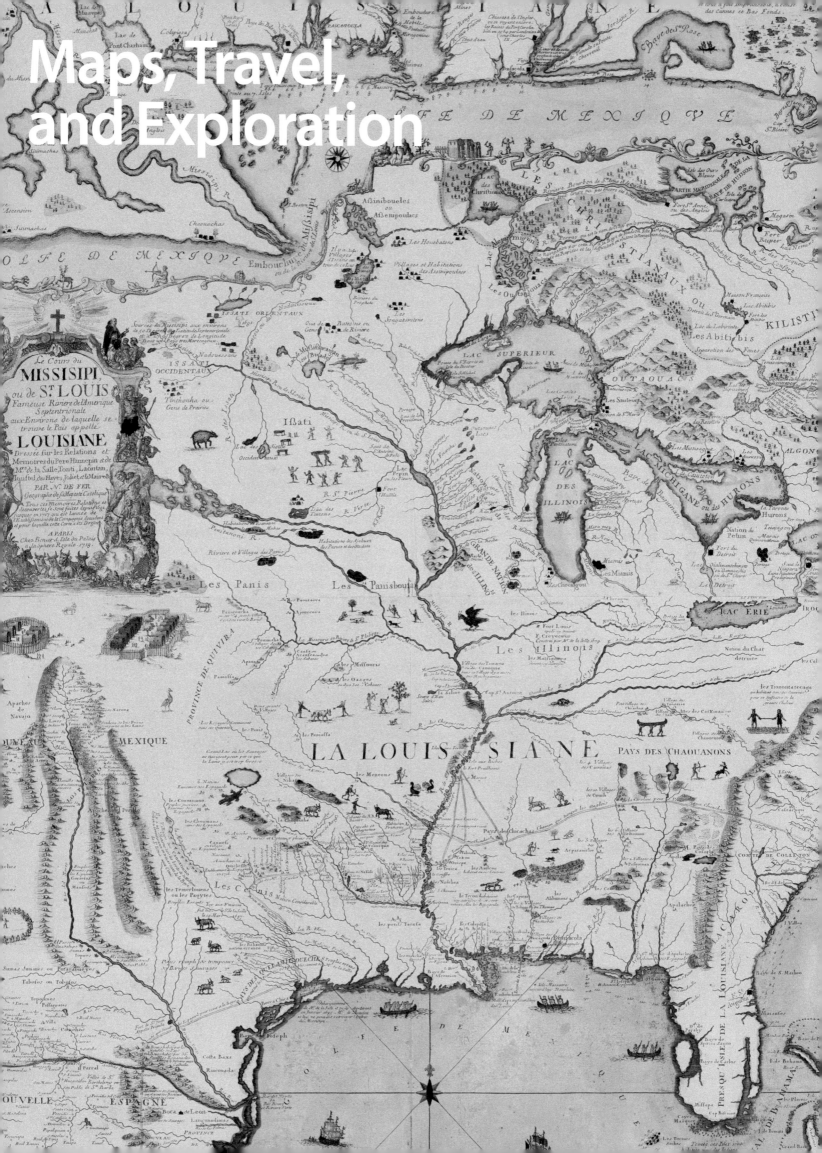

THE 1896 "cooperative agreement" to divide book collecting among the Chicago Public Library, the John Crerar Library, and the Newberry gradually transformed the latter into a humanities-oriented institution. But, as the presence in the Newberry of Athanasius Kircher's *Mundus Subterraneus* makes clear, the library's collecting interests, for good reasons, have sometimes led to the addition of items with a distinctly scientific orientation. Kircher's work and life story help to explain why.

Born in southern Germany, Kircher (1602–1680) was educated by the Jesuits and joined the Society of Jesus in 1620. His capacities as a mathematician led to an appointment in mathematics at the society's Collegio Romano in 1635. He remained in Rome until his death. Anthony Grafton described Kircher as "the central intellectual figure in baroque Rome" because of his polymathic interests and his erudition. At the heart of his work was a profound commitment to understanding the most ancient philosophy as revealed by the hieroglyphs on Egyptian obelisks. His deep theological convictions provided him with what he believed was a divine order of things (*ordo rerum*), which he employed to accommodate the findings of the new science, including those of his own undertaking. In Kircher we have the very type of the great early modern intellectual and writer who defies easy categorization: was he a scientist or a humanist, a man of numbers or of words, a natural philosopher or a theologian?

Among Kircher's forty-plus books, one of the most notable was his study of the subterranean world. The idea for it came to him during a trip to Malta, Sicily, and southern Italy in 1637–1638, where he saw the seemingly linked eruptions of Etna, Stromboli, and Vesuvius and experienced the accompanying earthquakes. He was lowered into Vesuvius, but unlike Pliny the Elder, who died during the volcano's eruption in A.D. 79, he survived and emerged with detailed observations. His research also yielded data on temperature increases in mine shafts and on the flow of lava. He combined his empirical data with theory in a manuscript written in the mid-1650s, adding his own sketches of what he had seen, including the eruption of Vesuvius. This document became the basis for the *Mundus Subterraneus*, published by Jansson and Weyerstraet, Amsterdam, in two volumes in 1664–65, with a second edition in 1668 and a third a decade later.

Amsterdam was Europe's premier center for printing in this period, which made possible the book's lavish illustration with images small and large, including fold-out plates, maps, and even a rotating dial. The illustrations are more than decorative, however: they help the reader to understand the text, in which among other things Kircher presented his concept that a central fire moves through canals to various exit points on the earth's surface—i.e., volcanoes.

Depicted here is an aspect of Kircher's generally overlooked theory of water circulation, elucidated in Books 2 and 5. In this case, too, he was especially concerned with interior channels, such as canals from the bottoms of oceans and seas to the insides of mountain peaks, where he believed vast quantities of water were stored. Complementing the interior movement of water were east-west and north-south surface currents. In this view and map, Kircher combined currents and channels. He showed ocean surface water moving between giant Arctic vortices off Norway and in the Gulf of Bothnia by means of a hypothetical interior channel, where the water is subjected to heat and siphoning action. Kircher was not only a humanist-scientist but also an imaginative cartographer; considered in this context, his superbly printed book merits its place at the Newberry. D. S.

Athanasius Kircher
Mundus Subterraneus, in XII Libros digestus

Amsterdam: J. Jansson and
E. Weyerstraet, 1668
Book
14⅛ × 9⅛ in.
Ayer Fund, 1950
Vault Folio Ayer 7K58 1668

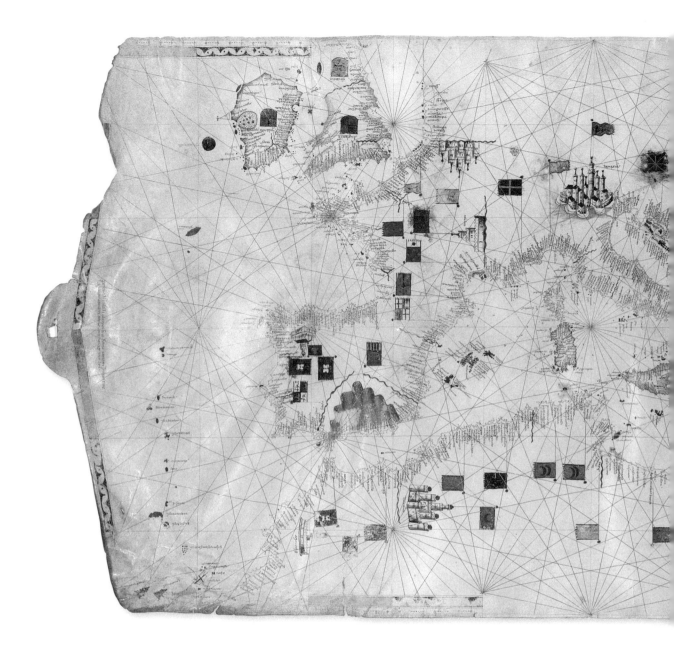

THIS KIND OF late-medieval map, called a portolan chart, seems to have been invented in the Mediterranean area in the last quarter of the thirteenth century. Unlike most medieval maps, it was a practical navigational tool with a mathematical basis. Such charts appear to have originated in books of sailing directions, called portolanos, which provided distances and directions between ports in the Mediterranean basin. This one is typical of the genre in 1) being drawn on vellum, 2) being centered on the Mediterranean, 3) showing place names written inland, whenever possible, so as not to clutter the sea, 4) exhibiting a system of rhumb lines (directions) that radiate out from compass roses, 5) including a scale bar, and 6) using flags to aid in the identification of ports. Some 200 such charts, made before 1500, are known. Their use in navigation is well documented, although many of the surviving examples are lavishly and vividly illuminated, suggesting that they were made as objets d'art for wealthy patrons. The rather worn and water-stained appearance of this map suggests that it may have been consulted at sea. It was originally attached to a dowel at the right edge, where nail holes can still be seen. In the neck area of the animal at the left edge, there is a hole where a thong would have been attached to keep the chart rolled for storage in the skipper's cupboard.

A ship captain would have used such a map to plot a course between two ports, ascertain which of the sixteen rhumb lines best fitted that course, and sail as close to that tack as possible. The scale is indicated by the dots along

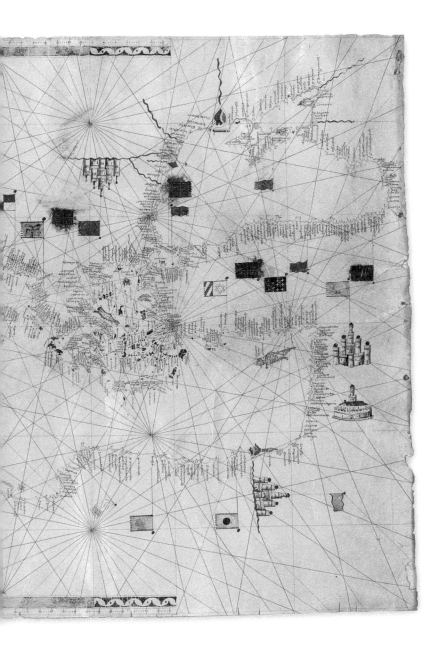

78

Petrus Roselli

Portolan Chart of the Mediterranean and Black Seas

Majorca, 1456
Manuscript
14½ × 27½ in.
Gift of Edward E. Ayer, 1911
Vault Oversize Ayer MS map 3

the bands in the upper and lower margins. Curiously, the scales on portolan charts are never numbered nor is the unit even announced. Scholars have determined that the units were Roman miles of 1,000 paces (roughly 4,850 feet).

This chart is signed at the left, "Petrus Roselli compossuit hanc cartum in ciuitate Maioricum anno domini M. cccclvi" (Petrus Roselli made this chart in the city of Maiorca [Palma] in the year of our Lord 1456). Roselli (fl. 1446–1468) was part of a thriving chart-making community in Majorca that went back to Abraham Cresques, the Jewish cartographer responsible for the famous *Catalan Atlas* (c. 1375; Bibliothèque Nationale, Paris). Roselli himself may have come from a Jewish family, but a series of pogroms (the last in 1435) forced many Jews to convert to Christianity.

The Newberry's collection of 110 portolan charts (including seven that date before 1500 and individual maps in portolan atlases) is one of the largest in North America. It was assembled, like so many of the library's cartographic treasures, by Edward E. Ayer, whose interest in discovery and exploration led him to acquire what would become the foundation of the Newberry's collections in the history of cartography. R.W.K.

79

Nicolaus Germanus

World Map in Claudius Ptolemy, *Cosmographia* [*Geographia*]

Ulm, Germany: Lienhart Hol, 1482
Book
16⅞ × 12⅞ in.
Gift of Edward E. Ayer, 1911
Ayer 6 .P9 1482a

PERHAPS NO SINGLE work has exerted a greater influence on the development of cartography in the modern world than the *Geographia* of the ancient astronomer, mathematician, and geographer Claudius Ptolemy (c. 90–168). Ptolemy lived in Alexandria during a time when the Egyptian port was the cultural, commercial, and scientific center of the eastern Mediterranean. He had access to centuries of Greek scientific and mathematical learning as well as to geographical information that world travelers brought to the great port. Ptolemy compiled this information into a catalog of more than 8,000 places throughout the ancient world, noting his estimates of their latitudes and longitudes. From these tables, he very likely made his own maps, though none directly attributed to him survives. Renaissance editions of the *Geographia* typically include twenty-six regional and world maps derived from the earliest surviving Greek manuscripts of the work dating from the thirteenth century. A Latin translation of the *Geographia* was completed by the Florentine scholar Giacomo da Scarperia (Jacobus Angelus) around 1406–1409, and dozens of copies from the fifteenth century survive, testifying to the work's influence, both as a model for mapmaking and as a compendium of geographical knowledge.

The revival during the Renaissance of Ptolemy's *Geographia* ushered in a new age in cartography, impressing upon Europeans the desirability and practicability of compiling maps by means of measurement and mathematical calculation. It is the oldest surviving work to explain the technique of map projection—how the spherical surface of the Earth can be projected usefully onto a two-dimensional surface by means of simple drawing tools and rudimentary knowledge of geometry. Ptolemy described no less than three projection methods and inspired Renaissance geographers to invent new methods.

Map projections took on added importance in the sixteenth century, as Europeans struggled to incorporate discoveries in the Americas, Asia, and Africa into a new picture of the world. Ptolemy also explained how one could use his data catalog of place names, latitudes, and longitudes to create new maps of any part of the Old World. The maps associated with him, like this one, were the first to utilize the now-familiar grid (or graticule) of latitude and longitude as the basic framework for regional maps. Just as important, through its widespread dissemination first in manuscript and then in printed form, the *Geographia* became a kind of master atlas of the world for fifteenth- and early-sixteenth-century Europeans, though not a static one. Even in the era of manuscript reproduction of the *Geographia,* nearly every editor updated or modified the atlas in some way, often incorporating new maps (*tabulae modernae*) and modern information or adding text. This process accelerated during the sixteenth century as editors responded to new discoveries beyond Europe and geographers inspired by Ptolemy began updating the map of Europe itself.

The Newberry's collection of editions of the *Geographia* is one of the most comprehensive in the world, offering a nearly complete record of this modernization of Ptolemy. Among editions from the fifteenth and sixteenth centuries, the library lacks only one, published in Bologna in 1477. Nearly all were collected by the great London bookseller Henry Stevens and sold by his son Henry Newton Stevens to Edward E. Ayer, whose collection came to the Newberry. Featured here is the elegant edition (here titled *Cosmographia*) published in Ulm, Germany, by Lienhart Hol (fl. 1482), the first edition of the *Geographia* to be published outside of Italy and the first to use woodcut maps. The edition copied in almost every detail a manuscript by Nicolaus Germanus (fl. 1460–1477), whose work was a model for several early printed editions of Ptolemy. Hol's production costs, including the elegant hand-coloring characteristic of most surviving copies, were so great that he went bankrupt about 1484.

Here we see the Ptolemaic world map, demonstrating the extent of Ptolemy's knowledge of Europe, Asia, and Africa. It is drawn on his second projection, which preserves the impression of the earth's curvature. Note that the Indian Ocean is depicted as a closed sea. Both Africa and Asia appear to continue beyond the southern and eastern edges of the map, a clear indication that Ptolemy and his editors recognized that there was more to the earth than what they knew. J. R. A.

80

Giacomo Gastaldi

Il Disegno della geografia moderna de tutta la parte dell' Africa

Venice: Fabius Licinius, 1564
Map
42⅛ × 56½ in.
Franco Novacco Collection, 1967
Novacco Map 8F 13

THE TERMS *cartography* and *cartographer* were not coined until the middle of the nineteenth century. Sixteenth-century Europeans who made maps were known as geographers or cosmographers, and their skills often embraced fields we now see as distinct, such as engineering, astronomy, mathematics, history, and art. The engineer Giacomo Gastaldi (1500–1566) was one of the few sixteenth-century mapmakers to truly specialize in the trade, mostly in the service of the ruling elites of the Republic of Venice. Gastaldi's oeuvre comprises more than one hundred maps, published between 1544 and 1568. His career, as well as those of his Italian contemporaries, is well documented in the Newberry's Franco Novacco Collection, consisting of more than 700 sixteenth- and seventeenth-century maps primarily by Italian cartographers that were purchased in 1967 from the Italian map collector Franco Novacco (1904–1998).

In the first half of the sixteenth century, Germans dominated mapmaking in Europe, mostly printing their maps from durable woodcuts. Subsequently, Italian cartographers rose to prominence by printing maps from engraved copper plates. This innovative method permitted greater aesthetic expression and flexibility and enabled cartographers to include more geographical detail than woodcuts allowed and to update their plates with new information. Gastaldi was without question the leading figure in this development, which greatly expanded the European market for printed maps.

When it appeared in 1564, Gastaldi's map of Africa was the largest of the continent ever published. The Newberry copy of this very rare map lacks one of the original eight sheets, at lower left; fortunately, the missing sheet mostly depicts a portion of the Atlantic Ocean. The idea of publishing such a map had likely gestated as early as the mid-1540s, when Gastaldi was at work on his first major cartographic project, a set of maps of ancient and modern geography for an edition of Claudius Ptolemy's *Geographia* (see no. 79) published in Venice in 1548. He produced at least three earlier maps of the continent, including a mural created for the Hall of Maps in the Doge's Palace in Venice (now obscured by an eighteenth-century renovation). The surviving maps show that Gastaldi reworked his ideas about African geography prior to the creation of this map, which was published two years before his death and serves as his final and most influential statement on African geography.

The accounts of Portuguese navigators fundamentally redrew the European picture of the coastal outline of Africa by the early sixteenth century—disproving, for example, Ptolemy's notion that the Indian Ocean was a closed body of water (see no. 79); the interior geography of virtually all maps of Africa before Gastaldi's was still largely based on the ancient Ptolemaic map. In his version, however, Gastaldi included new information based on a compilation of recent worldwide travel accounts gathered by his mentor and friend Giovanni Battista Ramusio in *Navigationi et viaggi* (1550–1559). The Nile River is the dominant interior feature of Ptolemaic maps, its headwaters rising far south of the equator from two lakes situated among the semimythical Mountains of the Moon. Gastaldi largely accepted this idea; his version of central and southern Africa is dominated by two major lakes, their names derived from Ramusio, and an unnamed mountain range. Unlike Ptolemy, however, Gastaldi posited that the westernmost lake, identified as both "Lago de Zaire" and "Lago de Zembere," was the source not only of one branch of the Nile, but also of three other great rivers of this part of Africa, known from more modern accounts: the Zaire (Congo), Cuama (Zambezi), and Spirito Sancto (Limpopo). These rivers are in fact fed by no such lake. But Gastaldi's willingness to revise an ancient authority and experiment with new geographical ideas is typical of the best cartographers of his time, and indeed one of the things that makes the cartographic record of the sixteenth century so fascinating to modern observers. J. R. A.

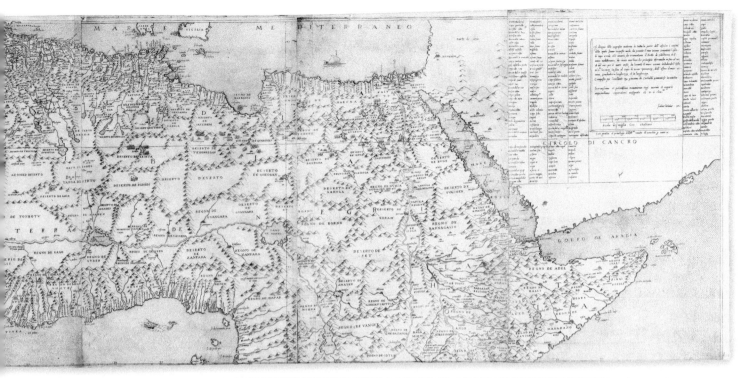

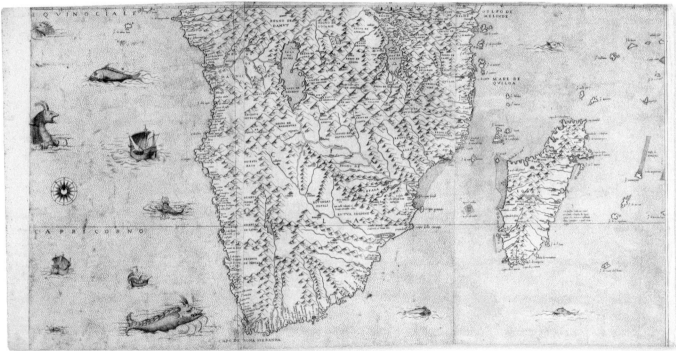

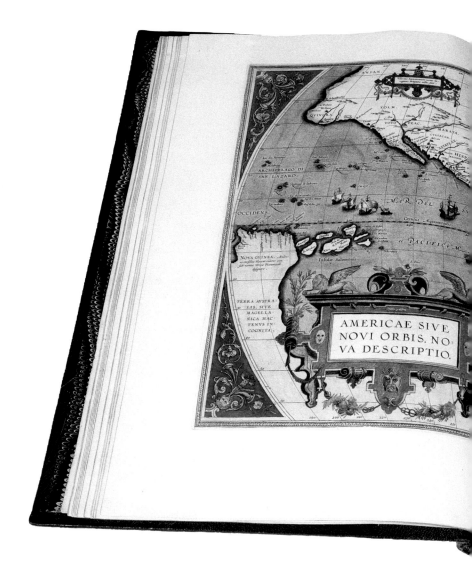

FIRST PUBLISHED IN 1570, the *Theatrum orbis terrarum* of Abraham Ortelius (1527–1598) is usually considered the first modern world atlas. It was the first printed work of global scope conceived entirely as a collection of contemporary maps prepared specifically for publication and organized according to a uniform plan. The atlas was not without its precedents, however. Many printed editions of the ancient guide to geography and mapmaking, the *Geographia* of Claudius Ptolemy (see no. 79), had been published since 1477 with a complement of twenty-seven maps based on Ptolemy's observations and instructions. Responding to the surge of new maps inspired by the *Geographia* and widespread interest in European expansion into the greater world, mid-sixteenth-century Italian map publishers served a growing European market for maps of contemporary geographical subjects suitable for display or for close private study. By the 1560s, they had begun collecting maps from their inventories and binding them together according to the specifications and whims of their customers. The content of these composite atlases varied from copy to copy; they were bound collections, rather than edited books.

Ortelius took a more direct and comprehensive role in the composition of his atlas, judiciously choosing among the best available maps and sources and supervising the engraving and printing of these maps to uniform specifications. He attached a table of contents, assuring that each copy of each edition would have uniform content and arrangement. He even acknowledged his sources in an extensive catalog of map authors. The *Theatrum* was an immediate and enduring success. To meet demand, Ortelius published three editions in 1570 alone, and bibliographers count at least thirty-three further editions in seven languages by 1612. Some thirty-seven editions of the atlas were published in reduced form by the end of the seventeenth century. Ortelius, moreover, never stopped trying to improve his product. His introductory text solicits readers for new and improved maps. These were regularly added to new editions, and owners of older editions could obtain supplements (*additamenta*) of new maps.

The map of the Americas in this 1588 Spanish edition was the third rendition of the subject that Ortelius published since 1570. The first was based substantially

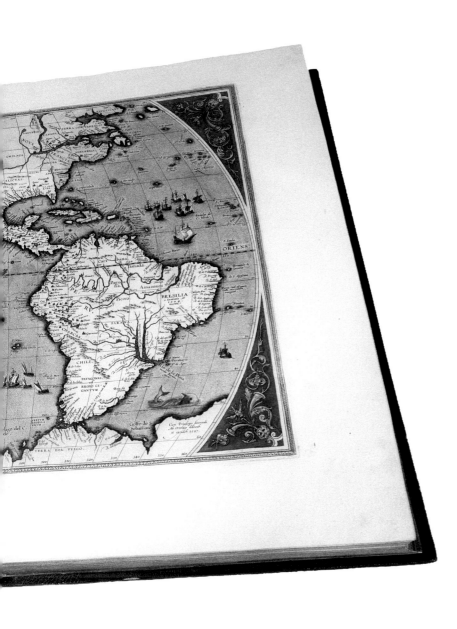

on the great 1569 world map of Ortelius's friend Gerard Mercator. Ortelius's map perpetuates one of Mercator's more colossal errors, a conjectured great polar continent incorporating Tierra del Fuego and New Guinea. This hypothetical land mass was based on the ancient Greek belief in a great antipodal continent rather than on direct evidence of Antarctica, which was not sighted until the early nineteenth century. Ortelius's rendering of South America, including the Amazon and Rio de la Plata, is quite recognizable to modern eyes. The basic geography of the North American interior and its western coast were, on the other hand, still mostly unknown to Europeans. Some features here are remarkably accurate. Baja California is shown correctly as a peninsula—a fact established by the Spanish explorer Hernando de Alarcón in 1540—even though the older idea that California was an island remained the predominant view until the eighteenth century. The St. Lawrence River begins to take shape on this map. "Wingandekoa" (Wingandacoa), on the eastern coast, was the place name that Sir Walter Raleigh thought (incorrectly) the Indians called Virginia (actually

the coast of North Carolina). But the main features of the interior of the continent—the Great Lakes, Mississippi River, and mountain ranges of the West—are nowhere to be found here. These would not appear on European maps for at least a half-century, as European colonization of the interior accelerated.

It is easy from a modern perspective to identify what sixteenth- and seventeenth-century maps of the Americas got wrong and what they got right, but this is a poor way to appraise a map's place in Western history and culture. Ortelius's atlases illustrate the undeniable progress Europeans had made in their pursuit of knowledge of the expanding world since the first editions of Ptolemy's *Geographia* were published a century earlier. But, perhaps more remarkably, they represent the colossal growth in the desire of large segments of European society to acquire and study accounts, images, and maps of the wider world for their own edification. After Ortelius, the publication and sale of printed atlases became one of the primary ways in which this desire was satisfied. J. R. A.

82

Nicolas de Fer

*Le cours du Missisipi,
ou de St. Louis, fameuse
riviere de l'Amerique . . .*

Paris: J. F. Benard, 1718
Map
40¼ × 30⅞ in.
Gift of Hermon Dunlap Smith, 1964
Map 6F G4042 .M5 1718 F4

THE MOST POWERFUL state in Europe at the turn of the eighteenth century, France also stood at the forefront of cartographic innovation. Louis XIV and his great minister Jean-Baptiste Colbert, perhaps more comprehensively than any European leaders before them, promoted mapping as a tool of administration, military operations, and colonial development. But even powerful countries like France depended heavily on private entrepreneurs like Nicolas de Fer (1646–1720) to process the geographical information flowing into the capital from the provinces and colonial outposts. De Fer enjoyed the protection and support of the crown, which gave him access to the latest accounts and reports from local administrators, colonial officials, explorers, fur traders, and missionaries. In turn, he published maps and atlases that promoted the interests of the French state, focusing especially on cities, regions, and fortifications related to Louis XIV's expansive wars in Europe.

The map seen here relates to the growing French empire in North America. It reflects the results of French explorations of the western Great Lakes and the Mississippi watershed from the 1680s on by explorers whose names are listed in the title cartouche in the left margin of the map. De Fer's maps are better known for their marketable and attractive qualities than for their geographical originality. This map's basic outlines appear to depend primarily upon earlier manuscript maps by two other royal geographers who today enjoy superior reputations, Jean-Baptiste-Louis Franquelin and Guillaume Delisle. Nevertheless, de Fer's map offers perhaps the most comprehensive European view of the North American interior at this time, including not only details of the great river system but also locations of Indian communities and overland networks.

The map was printed on two sheets joined at the line running just south of Lake Michigan ("Lac des Ilinois"). It seems complete as is, and clearly de Fer sold it as such. But the bottom (southern) sheet was originally published in 1715 as a separate map of the lower Mississippi and Gulf of Mexico coast. The Newberry's Edward E. Ayer Collection possesses a rare copy of this earlier edition, which lacks many of the decorative elements found here. De Fer's addition of the northern sheet in 1718 allowed him to present information about the upper Mississippi and its linkages to the Great Lakes. It also enabled him to include (across the top of the upper sheet) a more detailed and up-to-date inset map of the Gulf Coast stretching from Texas to western Florida. The primary source for this addition is likely a manuscript map (now in the collection of Arthur Holzheimer) based on a survey of the coast conducted in 1715–1716 by a French pilot named Soupart (or a map based on that survey). It appears that de Fer sensed a need for an enlarged map of the whole Mississippi Valley (or "Louisiana") by 1718, but did not want to waste the work put into his earlier effort. Aware of the recent remapping of the gulf's coastline, de Fer chose to update his map by simply adding the new, improved delineation of the coastline as an inset.

The pressure to publish a new map of the Mississippi Valley came from one of the more celebrated fiascos in the colonial history of North America. When Louis XIV died in 1715, he left his kingdom and empire hugely in debt. Scottish financial reformer John Law was asked to set the country's finances aright, and he proposed, among other things, encouraging private investment in a new Compagnie d'Occident designed to speed the colonization of, and wealth generated by, Louisiana. New Orleans was founded under the company's auspices, but speculation in its shares inflated their value, panic set in, the "Mississippi Bubble" burst, and Law was disgraced. De Fer's map was apparently intended to promote the company, whose coat of arms is seen in the upper-left margin. In fact, this two-sheet map was also issued as part of a still larger and extremely rare four-sheet map of the whole of western North America, incorporating all of New France, the British Atlantic colonies, and Spanish Florida; it too is dedicated to the company.

This intriguing map entered the Newberry as part of the book and map collection of Hermon Dunlap Smith, president of the Newberry's board of trustees from 1964 to 1975. His gifts also supported the establishment in 1971 of a map curatorial staff for the library and the Hermon Dunlap Smith Center for the History of Cartography. J. R. A.

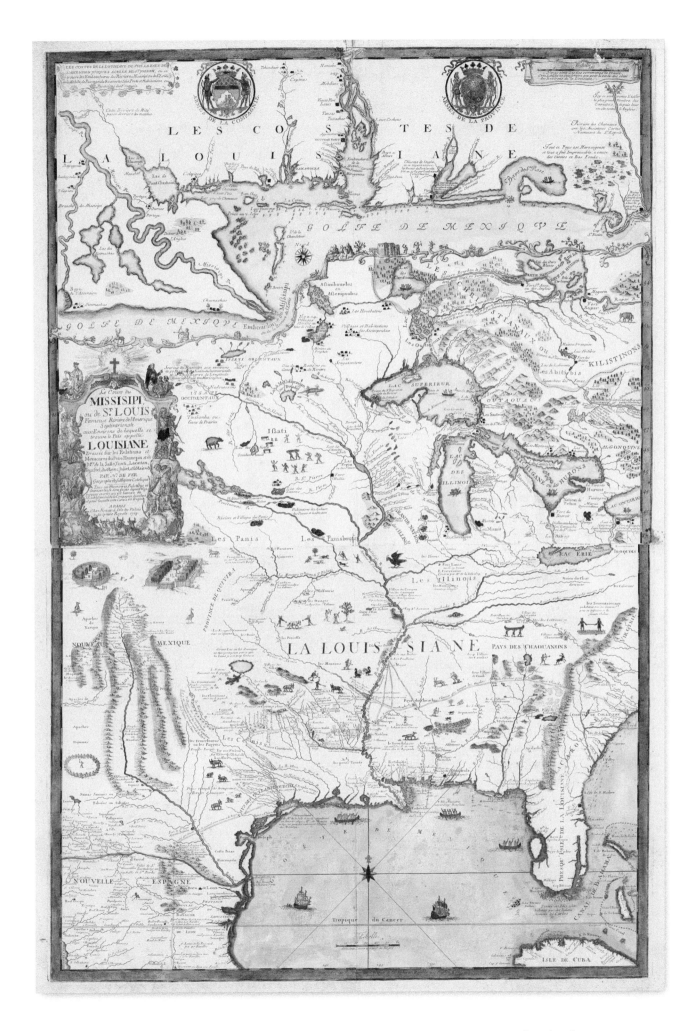

Jean-François-Benjamin Dumont de Montigny

Mémoire De Lxx Dxx officier ingenieur, contenant les evenemens qui se sont passés à la Louisiane depuis 1715 jusqu'a present

France, 1747
Manuscript
8⅞ × 13¼ in.
Bequest of Edward E. Ayer, 1911
Vault Case Ayer MS 257

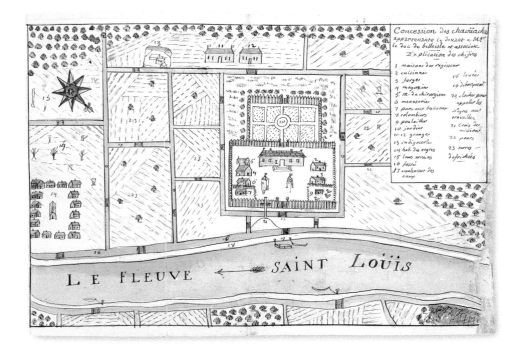

IN 1719 Jean-François-Benjamin Dumont de Montigny (1696–1760), the youngest son of a Paris lawyer, set sail for Louisiana with a commission as a lieutenant, after spending a year in the French colony of Quebec. In his peregrinations during the next eighteen years, he witnessed the turbulent early history of the Mississippi Valley, including the founding of New Orleans; battles with the Spanish colony at Pensacola, Florida; and the revolt of the Natchez Indians in 1729. Dumont did not find his fortune in America. He watched his comrades die in battle, got lost in coastal swamps, suffered from malaria and scurvy, survived quarantine on a pestilential ship, nearly drowned in the Mississippi River, and saw his home destroyed by fire. Amid it all, he started a farm, married, and raised two children. He returned with his family to France in 1737 and spent more than a decade at a garrison in the town of Port-Louis in Brittany, before shipping out with the Compagnie des Indes in the 1750s to India, where he died.

Over the years, Dumont did a lot of writing and mapmaking, including drafting legal briefs on behalf of acquaintances in Louisiana, sketching maps for the French royal cartographer Philippe Buache, and crafting a 4,000-line epic poem about battles that took place in Louisiana. In 1747, while in Port-Louis, he composed a 443-page prose memoir in which he recounted his life story. He included twenty-three watercolor maps and drawings, all in his own hand. At that time, he was struggling financially, and he dedicated the memoir to Charles-Louis-Auguste Fouquet de Belle-Isle (1684–1761), presumably in the hope of obtaining a post in the military bureaucracy or perhaps a pension, in compensation for

his many years of colonial service. A general and statesman, the duke of Belle-Isle was the most important of several patrons who had sustained Dumont's career in the military. At one point, Dumont had even worked for him in Louisiana, for the duke was one of the investors in a concession (land grant) at Chaouacha, downstream from New Orleans, the property depicted on this map. Years earlier the concession may have looked this way, but by the time Dumont created this map, the property no longer belonged to Belle-Isle. It had been sold, along with more than 150 slaves, in 1738.

Presumably, Dumont presented the memoir to Belle-Isle, although we have no way of knowing this for sure. What we do know is that someone took an interest in it, and a much-revised version was published in Paris in 1753, titled *Mémoires historiques sur la Louisiane*. The original memoir is written in a lively first-person voice that combines autobiography, colonial report, natural history, and ethnography. Although some passages of the memoir are repeated in the book, the printed version suppressed Dumont's eyewitness narrative persona and sanitized aspects that reveal his irascible character and strategizing for personal advancement. Moreover, the book treats only the years Dumont spent in Louisiana, while the manuscript also tells of his early stay in Quebec and his life in France from 1737 to 1747. The Newberry manuscript is therefore an invaluable document for the history of the French Atlantic world. The first complete English translation will soon be available, as a joint publication of the Omohundro Institute of Early American History and Culture and the University of North Carolina Press. C. Z.

FEW NATIONAL ROAD networks were as thoroughly or accurately mapped in the eighteenth century as those of France, thanks largely to the work of one farsighted administrator, Daniel-Charles Trudaine (1703–1769). In 1744 Trudaine was named director of the Assemblée des inspecteurs généraux des ponts et chausées, a title he held until his death. In 1747 he joined the École nationale des ponts et chausées, whose director was Jean-Rodolphe Perronet (1708–1794). Together they embarked on a program to map, on a large scale and in detail, all the principal roads of France. What came to be known as the Atlas de Trudaine grew to more than 3,000 manuscript pages. This particular volume, one of the few known to reside outside of France, is devoted to the road from Paris to Brittany (today's highway N12 follows virtually the same route). The map's scale is very large—almost eight inches to the mile—which enabled the draftsman to show all landscape features about a half-mile on either side of the route, including the footprints of all buildings. Some of the more rural sheets in the atlas can be difficult to rectify with a modern map, since 250 years of growth have transformed the landscape significantly. Yet, the preservation of Versailles and its surroundings is such that a modern tourist could navigate the area quite nicely using Trudaine's map. It is oriented so that south is at the top. The main route is highlighted in yellow; Paris is to the east (left), along the Avenue de Paris. To the west (right), the road follows today's rue de la Division Leclerc, past the zoo (*menagerie*), and on toward Dreux. Those who know Versailles can easily identify the parterres and the Orangerie. Most of the paths one can walk in the gardens today are identical to those mapped by Trudaine.

The French road system developed under the auspices of the École des ponts et chausées was one of the finest in the world. Along the main thoroughfares, whose paved and cambered surfaces were eighteen-to-twenty feet wide, regular stage service operated to and from Paris. As the century progressed, the introduction of better carriages and post relays greatly reduced travel times. In 1765 the trip from Paris to Alençon (some fifty-five miles) along this route took three full days; by 1780 the time had been reduced by half. R.W.K.

84

Daniel-Charles Trudaine and Jean-Rodolphe Perronet

Map of Versailles, in *Plan de la route de Paris en Bretagne par Dreux et Allençon*

Paris, c. 1770
Book
8 × 9⅜ in.
Gift of Roger Baskes, Vincent Buonanno, Arthur Holzheimer, D. Carroll Joynes, and Rudy Ruggles, Jr., 2003
Vault Case MS 5312

Richard Richardson

A Plan of Miss Hall's Estate at Hazzeldon nigh Hartlepool in the County of Durham 1758

County of Durham, England, 1758
Manuscript
16¼ × 22½ in.
McNally Fund, 1988
Vault Oversize MS
Map8C G5754 .H47 1758 R5

THIS IS A TYPICAL eighteenth-century estate plan, from County Durham, in northern England. Such maps are always hand-drawn and always detail the land held by single owners, who indeed probably commissioned them. They are also very large-scale—often using a scale of roughly twelve inches to one mile—and were generally composed with great precision using a plane table. They not only show roads and fields, but also houses and various kinds of factory buildings alongside them; sometimes they include elegant little sketches of dwellings.

The estate plan has a very specific time and place of origin, having emerged in England during the early phases of the "Agricultural Revolution," around 1600. At that time, absentee owners, like the Oxbridge colleges, felt the need to organize their estates in such a way as to profit most fully from the emerging markets. They also wanted to maximize their rents, which is why surveyors who drew these maps often encountered local hostility; indeed, some were murdered. Often the maps were drawn with great elegance and

some still hang in English houses, where they seem to say, "See what a splendid estate I have."

This particular plan shows the fields owned by a Miss Hall just outside the villages of Hazzeldon and High Hazzeldon, near Hartlepool. All the fields and their acreages are recorded, and so is the type: "close," "moor," "glebe," and so forth. At the far left is a windmill, no doubt used to grind the oats and wheat that are noted as growing in some of the fields. Documents of this kind exist for many parts of England; in time the estate plan migrated across the Atlantic, so that such maps may now be found in abundance in the West Indies and in South Carolina. In these areas, of course, we are presented with the features not of a temperate countryside, but rather with plantations growing crops like sugar, coffee, rice, and cotton. Estate plans could be very powerful tools for historians and teachers, who might employ them to understand the present countryside by analyzing its former appearance. But to date they have been little used in this way.

Estate plans lost their purpose once general large-scale mapping on a national scope was organized, like the Ordnance Survey in England (c. 1800), or the United States Geological Survey (1879). The Newberry has a fine collection of the printed manuals that instructed surveyors on how to set about making this distinctive map type. As William Leybourne put it in *The Compleat Surveyor* (1653), "These things being well performed, your plot will be a neat ornament for the lord of the mannor to hang in his study, or other private place, so that at pleasure he may see his land before him." D. B.

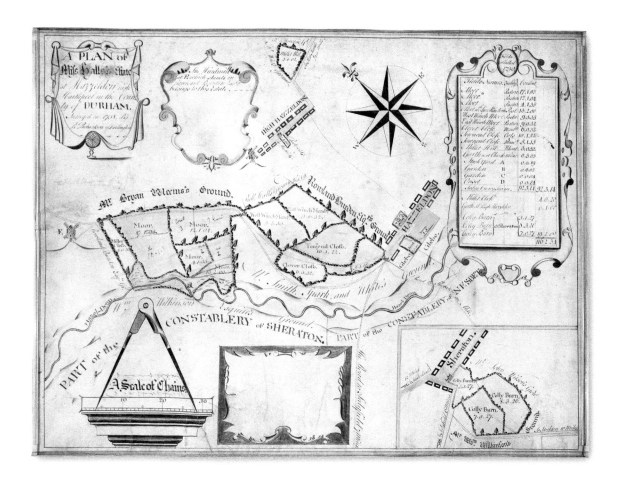

JOSÉ JOAQUIM DA ROCHA (c. 1740–1804) was a military engineer and geographer. Born in Portugal, he arrived in Minas Gerais captaincy, Brazil, sometime between 1763 and 1768. He remained in this region, celebrated for gold and silver mining, until his death. Rocha served in the cavalry and worked as engineer on several plans to fortify the captaincy. These activities required that he make a number of expeditions, which familiarized him with the area. This knowledge enabled Rocha to draw several important maps and, after his service ended in 1778, to research and write three important descriptions (Memories) of Minas Gerais.

The earliest Memory, featured here, *Geographia Histórica da Capitania de Minas Gerais,* was dedicated to the new governor, Dom Rodrigo de Meneses, appointed in 1780, when the manuscript was finished. Thus, it was probably written between 1778 and 1779. The Newberry's volume is most likely an earlier version of the final manuscript (today in the Arquivo do Itamarati, Rio de Janeiro), for it is not complete. It comprises thirty-four of the full text's

somewhat expands upon the previous texts.

Geographia Histórica da Capitania de Minas Gerais contains precious information about the local administration, such as map tables of taxes, populations, priests, officers, and so forth. The Newberry's manuscript includes fifteen of the thirty-six tables found in the complete final version. Rocha relied upon numerous sources, such as official state records, written reports from local settlers, and other Memories, the most important being the historical introduction that the famous eighteenth-century Brazilian poet Cláudio Manuel da Costa wrote to his poem "Vila Rica" (1773).

José Joaquim de Rocha
Geographia Histórica da Capitania de Minas Gerais

Minas Gerais, Brazil, 1779
Manuscript
8⅝ × 11⅞ in.
Greenlee Fund, 1989
Vault Folio Greenlee MS 425

147 leaves. The library's example is limited to historical and geographical description of the Minas Gerais settlements Mariana, Vila Rica, Sabará, Vila Nova da Rainha, Paracatu, São Romão, Papagaio and Pitangui villages, and the Serro do Frio county. That it is not a straightforward copy of the original is suggested by the fact that there are minor differences between them. Some passages in the Newberry's manuscript were suppressed in the later versions and others were corrected (mainly the settlements' geographical locations). The second Memory Rocha wrote, *Descrição geographica, topographica, histórica e política da Capitania de Minas Gerais* (1783), is, with minor additions, almost exactly the same as the first. The last one, *Memória histórica da Capitania de Minas Gerais* (1788),

Although Rocha copied older texts almost verbatim, the few differences that do exist between his texts and those that he used are significant. The most important relates to the description of the *paulistas*, native Brazilians of mixed blood who originated in the São Paulo captaincy. Rocha was the first to praise them for being the first to enter the region, showing courage and skill in penetrating the wilderness at considerable cost of life. His account was a critical revision of history, for it acknowledges the accomplishments of a native population as opposed to colonial settlers. His point of view would later serve as the basis for Brazil's national history as formulated in the aftermath of Brazilian independence. Minas Gerais and its wealth were fundamental to this process. J. F. F.

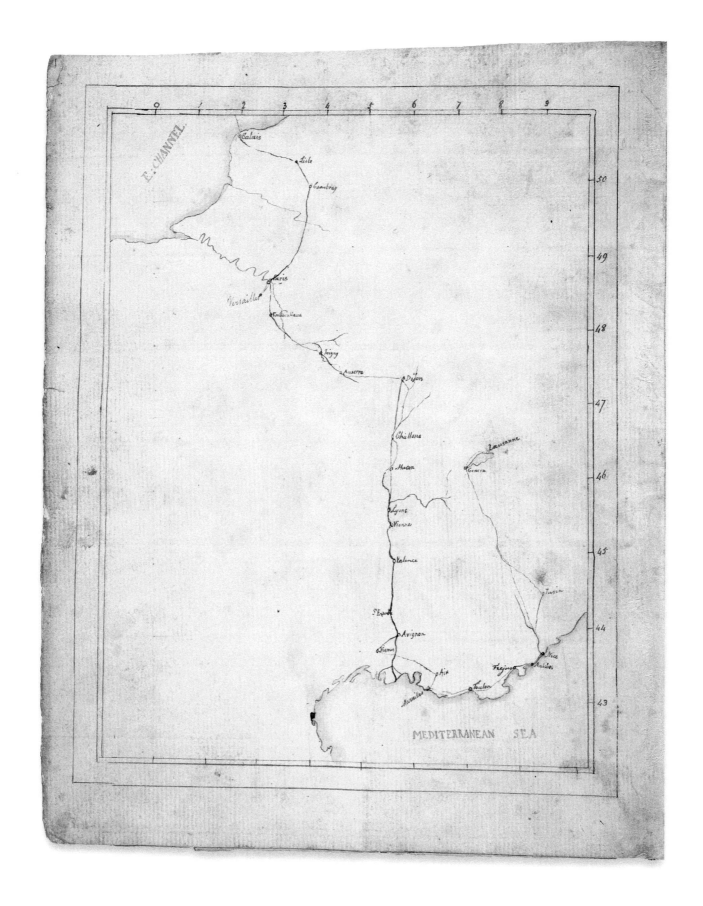

THE MORGAN-GARDNER PAPERS span more than a century of this family's life in Europe, New England, and Chicago. The earliest document, featured here, records an extensive trip George Cadogan Morgan (1754–1798) made to the Continent during the tumultuous summer of 1789. The papers also include memoirs of his grandson George C. Morgan, who lived in Chicago after the Civil War, and his great-grandson Henry A. Gardner, written during the second half of the nineteenth century. They fit several Newberry collecting strengths, including genealogy and family history, and travel and maps.

George Cadogan Morgan, born in Glamorgan, Wales, was educated at a nearby grammar school and, in 1771–1772, at Jesus College, Oxford. He completed his education at the Dissenting Academy in Hoxton Square, London, in the mid-1770s, concentrating on natural science and mathematics. He soon became a successful Nonconformist preacher in Norwich, Great Yarmouth, and ultimately the Gravel Pit, Hackney, where he assisted his mother's brother, the distinguished religious Dissenter, scientist-philosopher, and mathematician Richard Price (1723–1791). Morgan's lectures on electricity were published in two volumes in 1794. He died four years later, reportedly from the inhalation of noxious fumes during a chemical experiment.

Morgan was accompanied on his trip to the Continent by three Nonconformist friends: the Norwich physician Edward Rigby, who was a few years older than him and had been educated at Joseph Priestley's Warrington Academy; and two of Morgan's former students, Samuel Boddington, son of a London banker, and Olyett Woodhouse, later advocate-general of Bombay. During their holiday, Morgan and Rigby wrote letters to their wives. Rigby's appeared in print in 1880, and Morgan's were liberally used by Caroline E. Williams in her 1893 account of the descendants of Morgan's Welsh grandparents. The Newberry's manuscript, a notebook of laid paper with a Britannia watermark known to have been employed around 1788, is likely a copy made by Morgan

himself, after his return to England, of the letters that he had sent from abroad, with the addition of a hand-drawn map of his journey.

In these letters, Morgan reflected on matters as diverse as the travelers' repeated problems with insect-infested bedding and the great events happening in Versailles and Paris in early to mid-July. He showed considerable appreciation for the social and religious life of the French. He found his "fondest feelings" gratified by the spectacle of the "Grand Body of the Representatives assembled to establish Liberty in one of the first nations upon Earth." But Morgan also observed, "At present it is a sad calamity in France to be a Nobleman—or one of his relations." This mixture of sentiments seems somewhat out of key with the reported contents of two letters (not extant) that he told his wife he had sent to Price, expressing concern to her about whether they had arrived. One letter found its way into the *Gazetteer and New Daily Advertiser* in late summer, and selections from it were published the next year in another periodical and a pamphlet against Dissenters. Drawing on these sources, Edmund Burke gave Morgan enduring but anonymous celebrity: in *Reflections on the Revolution in France* (1790), he quoted passages from Morgan's letter to Price as evidence that Price's republican, pro-Revolution, and allegedly anti-English bias was typical of Nonconformity generally. Burke might have made even more of Morgan's final comment in a letter to his wife from Vevey dated August 17: "My journey is shortening daily. It has cost me a deal of trouble, but it has rewarded me with a world of new ideas." D. S.

87

George Cadogan Morgan
Record of Travel to the European Continent

Hackney, England, 1789
Manuscript
9 × 7¼ in.
Gift of Henry A. Gardner, 1980
Midwest MS Morgan-Gardner,
Box 1, Folder 2

Norfolk

Map: London: J. Cary, 1793
Puzzle and box: London:
William Darton, Jr., 1804/1812
8⅞ × 11 in. (assembled);
6½ × 4¾ × 1¾ in. (box)
Holzheimer Fund, 2006
Vault Case G5753.N4 1793 .C37

ON JULY 3, 1763, Thomas Grimstone, a pupil at William Gilpin's school at Cheam in south London, wrote to his father in Yorkshire explaining that he had "lost one of the countis [*sic*] of my wooden map the name of it is Flintshire" and asking, "Do you think I can get another?" The county that young Thomas had lost was a piece of a jigsaw puzzle in the form of a map, similar to the Newberry's map puzzle of Norfolk. Cartographic jigsaw puzzles—originally called "dissected maps"—were probably the most popular didactic map toys in the eighteenth and nineteenth centuries. John Spilsbury produced the first example in 1759, mounting a printed map on thin sheets of mahogany and then cutting it into pieces along national borders. Map puzzles conjoined several dimensions of English culture during this period: the waxing importance of geography and mapping, stoked by the nation's global commercial and imperial ambitions; the explosion in consumption, stimulating a new abundance of cartographic goods and items for children; and the emergence of progressive theories of education.

The map in the Norfolk puzzle is from a popular, large-quarto atlas of English counties, *Cary's New and Correct English Atlas*, published in 1793 by John Cary (1754–1835) and also in the Newberry's collection. The puzzle itself was probably made and marketed by William Darton, Jr. (1781–1854), who added his signature to the label on the box next to the phrase "Warranted Perfect." A publisher, engraver, bookseller, and stationer, Darton had established a shop in Holborn Hill in 1804 and soon issued a variety of goods for children, from dissected maps and playing cards to books and battledores (rackets used in a game similar to

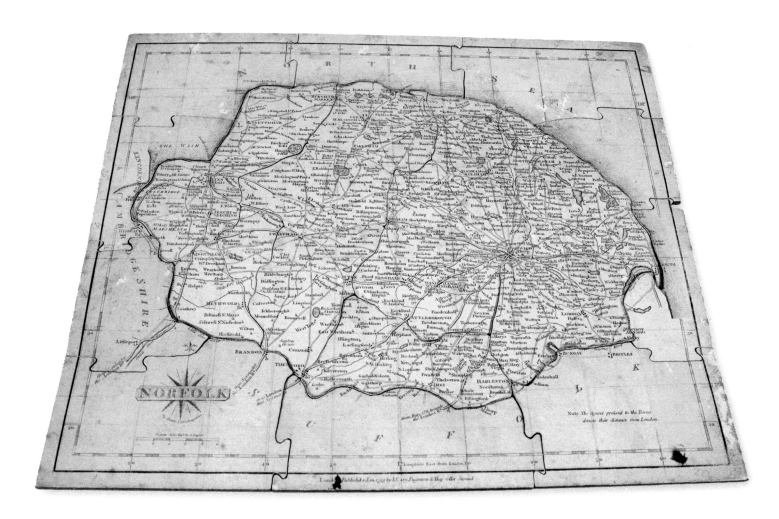

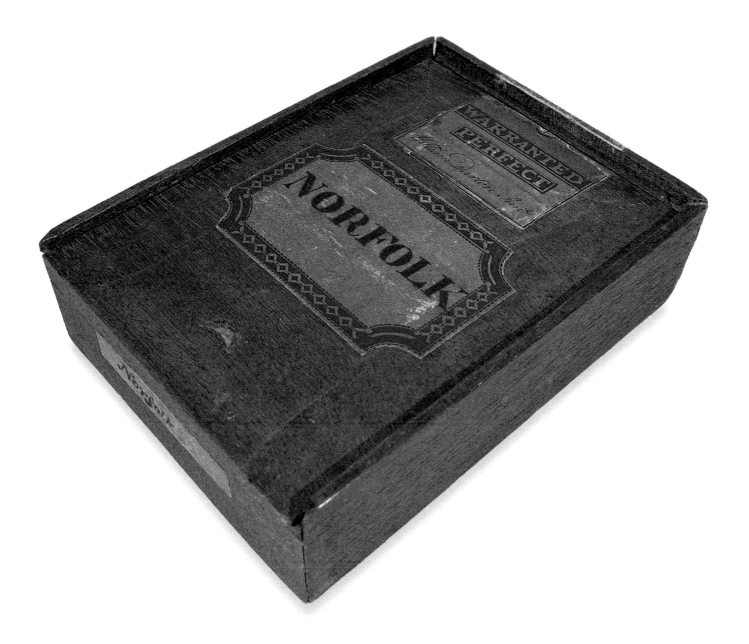

badminton). The Newberry has a wide range of geographic juvenilia, including globe and atlas puzzles, board games, school atlases, and geography textbooks featuring instructions on how to draw maps. The exact date of the Norfolk toy is itself a puzzle; it was likely produced after Darton opened his shop and before Cary issued the next edition of his atlas in 1812. It is also possible that Darton made the dissection later, as a way of using up outdated maps. The Norfolk puzzle differs from the majority of dissected maps, in which the pieces are cut along actual geographic borders. Instead, Darton focused on creating puzzle pieces that were roughly the same size, but in a variety of shapes.

Progressive educators, who stressed learning through play, were quick to promote map puzzles as a way to enliven the study of a subject long dulled by emphasis on rote memorization. These toys not only helped children learn the names and locations of towns and rivers, but they also aided development of fine motor skills and three-dimensional spatial perception. In a children's story published in *Early Lessons* in 1801, Maria Edgeworth described the challenge young Frank faced not only in fitting together his map puzzle, but also in stowing the pieces: "It was not easy to get them into the box, which was but just large enough to hold them when they were well packed. The lid of the box would not slide into its place, when the pieces of the map were not put in so as to lie quite flat." Moreover, for the status-conscious, mastering dissected maps could symbolize civilized attainment. In Jane Austen's *Mansfield Park* (1814), Fanny's cousins find her stupid because she "cannot put the map of Europe together." D. D.

ALTHOUGH THE Roger Baskes Collection at the Newberry includes such items as a tenth-century manuscript fragment and the library's earliest vernacular incunable, it largely comprises atlases, travel guides, and books with maps. As the approximately 20,000 items in the Baskes Collection are gradually cataloged and added to the Newberry's existing materials, the library's cartographic holdings (including more than 75,000 items in its cartographic catalog) will continue to rank among the world's most comprehensive and important.

At least since the beginning of printed history, maps have been a typical accompaniment of historical treatises, particularly those related to military history. The earliest editions of Caesar's *De bellogallico,* for example, usually included maps of Gaul and Italy (the Newberry has almost one hundred different editions of Caesar). Military histories of World War I were written from the beginning of that war, in 1914, and they almost always contained maps.

In 1888 Pneu Michelin began manufacturing tires in Clermont-Ferrand, France. In 1900 Michelin first published a guide to help motorists maintain their cars and locate good food and lodging in France; today the company publishes more than twenty million maps and travel guides annually. But in 1919, just after the end of World War I, Michelin began to issue a series of books different than all the others they had published before or since. The series, in French and English, comprised guidebooks to the still-destroyed battlefields on the Western Front of

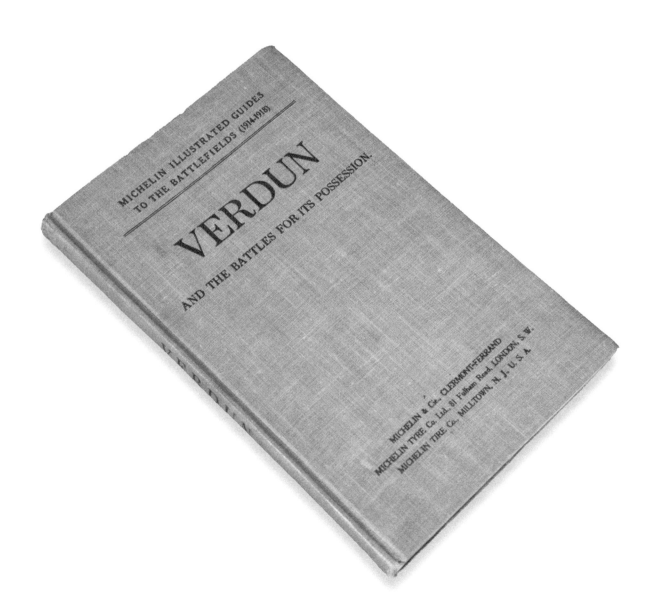

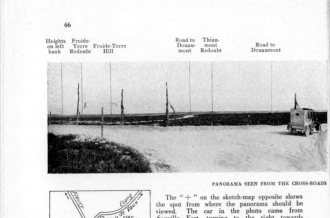

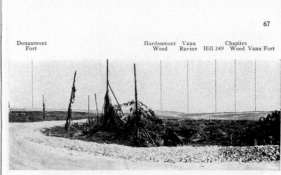

66

Heights on left bank · Froide-Terre Redoubt · Froide-Terre Hill · Road to Douaumont · Thiau-mont Redoubt · Road to Douaumont

PANORAMA SEEN FROM THE CROSS-ROADS

The " + " on the sketch-map opposite shows the spot from where the panorama should be viewed. The car in the photo came from Souville Fort, turning to the right towards Vaux Village.

After visiting the village return to the cross-roads and take the road on the right to Douaumont, seen on the left half of the above panorama (p. 66). The bombardments have left no trace of St. Fine Chapel.

IV.—From Souville Fort to Vaux Village and Pond

After visiting Souville Fort return to the cross-ways at St. Fine Chapel, seen in the above photo.

ATTACKING WAVES OF INFANTRY CROSSING FUMIN WOOD (Oct. 1916).

67

Douaumont Fort · Hardaumont Wood · Vaux Ravine · Hill 349 · Chapitre Wood · Vaux Fort

AT THE CHAPEL OF ST. FINE (*entirely destroyed*).

It was the ruins of this chapel that the enemy reached on July 12th, 1916, and that the 2nd regiment of Zouaves, at the order of General Mangin, recaptured in order to relieve Souville Fort.

At the cross-roads, take the I. C. 12 on the right to Vaux village. The road dips down into a gorge between the woods of Le Châpitre and Fumin.

Chapitre and Fumin Woods.—To the west and east of the road leading to Vaux village, these two woods cover the flanks of the plateau which dominates Vaux Ravine and supports Vaux Fort. It was there that the Germans sought to outflank the fort on the west to reach Souville, but they were held in check during May. From June, 1916, these woods were subjected to bombardments of incredible intensity. A powerful German attack on June 23rd failed, but another on July 12th enabled the Germans to get a footing in Fumin Wood. In August and September frequent enemy attacks gave them temporary local gains. On October 24th and 25th, and again at the end of the month, French counter-attacks captured the enemy strongholds and cleared the woods completely.

The defence of the " R " outworks by the 101st line regiment was intimately connected with the attacks on Fumin Wood and Vaux Fort. These outworks were at the foot of the slopes of Fumin Wood, about half-way between the village and fort of Vaux. Bombarded by heavy guns on June 1st and 2nd, it was unsuccessfully attacked by the enemy at 8 p.m. on the evening of the 2nd. Twice on the 3rd and once on the 4th the French, reinforced by a few units, although deprived of water and subjected to machine-gun fire on the flank, repulsed new German attacks. A company of the 298th which, on the night of the 5th, relieved that of the 101st (reduced to 39 men), held out three days more under increasingly difficult conditions, and was only overpowered on the night of the 8th after the capture of the fort of Vaux. These positions were recaptured during the French offensive of October 2nd, 1916. The works known as the " Petit Dépôt," " Fulda Boyau," and " Sablière," bristling with machine-guns and scarcely touched by the French artillery preparation, offered a stubborn resistance, and were only captured by the 74th Division in the evening after a whole day of exceedingly hard fighting.

Vaux-les-Damloup.—From March 8th the Germans sought to enter this village from the Woevre. The 1st battalion of their XIXth regiment of Reserves, believing it to be empty, was well-nigh exterminated. On the 10th

that war. The initiative can be understood as resulting from the enormity of destruction and loss brought about by the conflict: the death and maiming of millions of soldiers changed forever the history, demography, and self-image of the great European empires that had theretofore ruled much of the world.

Featured here is the volume that focuses on the Battle of Verdun. Lasting from February to December 1916, it constituted the longest and bloodiest battle of the Western Front of what was until that time Europe's bloodiest war. The fighting at Verdun was largely between the French and German armies, each of which sustained more than 300,000 casualties in 1916 alone. American troops entered the war in September 1918 and were very decisive in ending the fighting between the exhausted armies.

Though bearing a Clermont-Ferrand imprint, the 1920 *Battle of Verdun* was printed in the United States and was part of the English-language series *Michelin Illustrated Guides to the Battlefields (1914–1918)*. Seven of the Newberry's eight guides in the series are in the Baskes Collection. The *Verdun* guide has twenty-eight maps and 148 photographic plates. It begins with a thirty-page history of the battle; the remaining eighty pages provide a tour of the ruined city and surrounding battlefields. The publishers assumed that British and American tourists, perhaps many veterans or their families, would travel to Verdun and explore it by car and on foot, with the detailed aid of the English-language guide. Some American veterans must indeed have returned to see the battlefields, bearing their Michelin guides. In all events, their great-grandchildren now find Michelin guides indispensable for locating and describing beautiful cathedrals, medieval villages, charming hotels, and great cuisine throughout the world. R. B.

90

*Rand McNally Official 1919
Auto Trails Map
District No. 1*

Chicago: Rand McNally & Co., 1919
Map
22⅛ × 28 in.
Gift of Rand McNally and Co., 1989
RMcN Auto Trails 6F 004

FOR MORE THAN A century, the name Rand McNally has been synonymous with mapmaking for many Americans. When the Chicago-based company donated a massive historical archive of its map and book publications to the Newberry in 1989, the library instantly became one of the world's leading repositories of travel cartography and of American automobile road maps in particular.

At the turn of the last century, intercity travel in the United States was dominated by railroads. Public investment in the construction and maintenance of roads and highways was minimal and mostly handled by local governments—major federal funding was not available until the passage of the Federal Aid Road Act of 1916. Consequently, early motorists rarely traveled more than a few dozen miles from home. Early automobile road maps were, in turn, mostly large in scale and used for local travel. For longer journeys, motorists were left to their own devices, or they followed published itineraries that guided them turn-by-turn, rather like today's in-car navigational systems.

In the 1910s, motoring industries, motor clubs, national civic groups, local businesses, and some highway officials formed associations designating and promoting the development of specific regional and transcontinental highways. These organizations gave their routes colorful names that evoked regional and historical sentiments or identified, in the manner of railroads, the cities and regions they served. Most did little to actually improve their routes, confining their activities to promoting and marketing them. Highways proliferated into an uncoordinated mess, leaving the average motorist befuddled with few tools to sort out and choose among the routes, let alone follow them.

In 1917 John Garrett Brink (1883–1972), a contract draftsman for Rand McNally, developed an experimental road map of northern Illinois and southern Wisconsin that he thought effectively addressed the highway-association chaos. Brink's Auto Trails map design includes all of the named association highways in the area, but to save room he assigned a number to each road that referred to a marginal key to the different highway names and signs. This 1919 edition of "District 1" centers on Illinois. The Egyptian Trail, an itinerary linking Chicago with the town of Cairo at the southern tip of the state (not on the map), is assigned the number 27. Its route from the city's South Side through Kankakee, Champaign, Mattoon, Effingham, and Centralia is a tortuous one, making many right-angle turns as the route-makers struggled to find the best course among a host of unimproved local roads. (Readers will recognize this as the rough equivalent of modern Interstate 57.) The clarity and comprehensiveness of Brink's map, however, marked a great advance over previous designs.

By 1922 Rand McNally's Auto Trails series had grown to cover the entire nation in twenty-one districts. To ensure the maps' usefulness, the firm often sold route-marking signs to local motor clubs and highway officials and even invented and blazed many new routes on its own. Company salesmen sold bulk quantities of the maps to roadside businesses at discounts for resale. Garages, hotels, and restaurants paid subscription fees or filed advance orders for maps; in return the businesses were identified in red on the map and in accompanying booklets. Despite its success, the series lasted only a few years. By 1925 the state and federal governments had fully committed to constructing an integrated system of trunk highways identified by numbers instead of names. Although this development rendered Brink's ingenious design obsolete, the distribution model and graphic-design innovations used for the Auto Trails series enabled Rand McNally to secure a dominant position in the rapidly growing market for cheap and reliable road maps and atlases. J. R. A.

RAND McNALLY
OFFICIAL 1919
AUTO TRAILS MAP
DISTRICT No. 1.

ILLINOIS
WESTERN INDIANA

S. E. IOWA
N. E. MISSOURI

91

Pullman Company

Plan and Interior View of Pullman Private Railroad Car Ferdinand Magellan

Chicago, 1942
Drawing; photograph
8⅞ × 43½ in.; 10 × 8¼ in.
Gift of the Pullman Company, 1969
Pullman 05/02/03, Folder 18;
Pullman 13/01/01, Box 6, Folder 443

ORIGINALLY constructed in 1927 as one of the Pullman Company's fleet of private cars available for lease, the Ferdinand Magellan was the only twentieth-century railroad car custom-built for a United States president. In early 1942, in the aftermath of the Japanese attack on Pearl Harbor, White House Press Secretary Steven Early and Secret Service Agent Mike Reilly proposed that President Franklin D. Roosevelt travel in his own specially armored railcar. The Ferdinand Magellan was selected and sent to the Pullman Company's Calumet Shops for a complete rebuilding. There, the car's bedrooms were reduced from five to four, the dining/conference and observation rooms were enlarged, and five-eighths-inch nickel armor plate and inches-thick bullet-proof windows were added. Further protection was afforded by the customary Pullman dark-green exterior color and signage: from the outside, the Ferdinand Magellan looked no different than any other Pullman equipment operating on the nation's rails.

During their presidencies, Harry S. Truman and Dwight D. Eisenhower also used the Ferdinand Magellan before it was retired from service. Roosevelt logged approximately 50,000 miles aboard the car. On his first trip, he traveled to Miami en route to the Casablanca summit; his last was to Warm Springs, Georgia, where he died just two weeks later. Truman logged almost 30,000 miles during his 1948 whistle-stop campaign, speaking hundreds of times from the rear platform, where he was famously photographed holding the issue of the *Chicago Tribune* that was headlined "Dewey Defeats Truman." Preferring the increased convenience and speed of air travel, Eisenhower used the car infrequently, and the Ferdinand Magellan's last official duty was to convey Mamie Eisenhower to a ship christening in 1954. The car was declared surplus in 1958 and was acquired by the Gold Coast Railroad Museum in Miami.

In 1942 Pullman engineers recorded the details of the Ferdinand Magellan's redesign in a linen floor plan, and documented the completed interior and exterior in a series of photographs. These, together with other records detailing car construction and remodeling, are among the most heavily consulted materials in the Pullman Company Archives housed at the Newberry. Thanks to a digitization project funded by the Library Services and Technology Act through the Illinois State Library, car restorers, model-car builders, rail-car fans, railroad-history buffs, and design historians may view this and more than 1,200 additional Pullman car plans online. M. B.

...émontre par le Procureur du
...nnance de Sa Majesté, du 29
...
avril 1756, Sa Majesté auroit
...
à l'impression, distribution &
à troubler la tranquillité publique,
...galères:
...nt, du 24 septembre 1768,
...tion a été ordonné, & que des
...nés au fouet, à la marque &
...concerne Versailles & le séjour
...police de cette Cour, du 20
...portage des Livres, Brochures
...eine, contre les contrevenans,
...s extraordinairement suivant la
Qu'au mépris de ces sages pré-
...intentionnées font imprimer à
...seulement des gens sans aveu,
...pour répandre, distribuer &
...ersailles, que dans les cours
...Imprimés & Libelles séditieux,
...inquiétude dans les esprits, de
...s & d'intervertir l'ordre public:
...porteurs soudoyés, sous prétexte
...font introduits dans les maisons
...les larcins & de surprendre la
...étant de son devoir de faire
...nels, & de mettre le Public à
...leurs propriétés, il nous requiert
...s Ordonnances du Roi, des
...Ordonnances de Police, sur le
...ortage des Écrits & Imprimés
...on. A quoi voulant pourvoir:
...le Réquisitoire du Procureur

PREMIER.

...donnances du Roi, les Arrêts
...ens de Police, concernant les
...ributeurs d'Écrits & Imprimés,

...ans permissions & autorisat...
forme & teneur.

EN conséquence, enjoign...
dront l'État de colporter, ...
dans la ville de Versailles &
enregistrer au greffe de la ...
leurs noms, surnoms, âge, ...
naissance; de laquelle décla...
Certificat par le Greffier ...
contre les contrevans, de p...
dinairement, suivant la rigu...

FAISONS défenses à tous
fait inscrire au greffe de la
colporter, ni crier dans cette
Écrit ou Imprimé, sous pei...
extraordinairement.

DÉFENDONS aux Colpor...
de vendre, distribuer & crie...
suite de la Cour, dans les
endroit que ce puisse être, san...
par écrit, sous les peines p...
ci-dessus.

DÉFENDONS aux Colp...
qui seront autorisés, confor...
de distribuer, vendre & crier a...
dans l'intérieur du château ...
d'icelui, sous peine de pri...
selon l'exigence des cas.

MANDONS aux Officie...
à l'exécution de notre présente
lûe, publiée & affichée par-t...
comme Règlement de Polic...

FAIT & donné par nous ...
Chevalier, Conseiller d'Ét...
Criminel & de Police, de la ...
& grande Prévôté de France...
sept cent quatre-vingt-neuf.

PEPO DEGLI ALBIZZI (d. c. 1406), a Florentine wool merchant, opened this ledger book in January 1340. It is a good example of a then-new literary genre, the family diary or *ricordanze*, which may be considered the ancestor of both personal diaries and modern business ledgers. The book consists mostly of business transactions and contracts related to the family's interest in wool-cloth finishing and export, one of the most important industries in Florence at the time. Pepo characterized this as his own book (*libro proprio*), by which he meant that it contains his personal record of dealings, which would also have been listed in more formal account books kept in his place of business. When a transaction was complete, a merchant like Pepo would simply cancel it with a diagonal stroke, a practice that can be seen throughout this book. In various points, he referred to his "yellow" and "green" books, calling them by the colors of their bindings. In this scheme, this ledger would have been his "red book."

The last section of the book, which the author entitled "All my other memoranda," concerns business relations with his family and also includes some more personal matters. Most poignantly, there is an entry for ten members of his immediate family who died in June and July of 1348, when the Black Death struck Florence as it swept across Europe. The final name on this list is that of Pepo's father, Antonio, who seems to have been a force for family unity. After this date, the compiler recorded a radical redistribution of the family's wealth among feuding brothers, who nevertheless made careful provision for the maintenance of widows and orphans of the plague, for a brother in a religious order, and for an invalid relative who had to be boarded in turn with various family members. The strategy of redistribution represented by this ledger appears to have been a success, allowing the family to move into the political elite. Pepo himself became a member of the ruling council of priors during the 1360s, and when in 1372 his faction lost power, he was important enough to be proscribed by name from holding any further political office.

The ledger was written on fine blank parchment leaves, using a careful version of the typical *mercantesca* hand that merchants employed for all kinds of texts in Italian. Pepo's precise script is probably less an indication of his personality than an expression of the widespread notion in this period that well-kept records were an indication of honesty and probity. The portfolio binding, of sturdy red calf lined in soft, white glove leather, appears to be original, representing the kind of luxury item that could be bought from Florentine stationers (then as now). The ledger was designed to be highly portable, again emphasizing its use as a personal record book. It may have been a gift to Pepo, who was married the same month the ledger begins. His monogram, *PA*, extended to form the Latin word "Pax," is stamped on the front cover, and the original buckle clasp also survives. P. F. G.

Pepo d'Antonio di Lando degli Albizzi

Secret Ledger and Memorial Book

Florence, 1340/1360
Manuscript
12½ × 9 in.
Ryerson Fund, 1952
Case MS +27

93

Pseudo-Ludolf of Saxony

Le Miroir de Humaine Saluation

Bruges, c. 1455
Manuscript
15¼ × 11⅝ in.
Louis H. Silver Collection, 1964
Vault Folio Case MS 40

IN THE STANDARD high-school world-history curriculum, the point is frequently made that the Protestant Reformation was responsible for the translation of the Bible into the vernacular and that, in reaction to the vernacular Bibles of Luther, Tyndale, Coverdale, and the French Huguenots, the Counter Reformation defiantly defended the exclusive use of the Latin Vulgate. The Newberry's collection constitutes the perfect pedagogical instrument to adjust such oversimplification of history. The *Speculum Humanae Salvationis* (The Mirror of Human Salvation) in its various French translations, such as the codex featured here, exemplifies how the essence of the Bible and the corpus of scholarship interpreting its contents were available before 1500 to those who were not literate in Latin. In Germany a vernacular version of the Vulgate was widely available before Martin Luther emerged (more than fifteen editions were printed before 1501); the same was true in Italy. Only in England, where vernacular Bibles were linked to the Lollard heretics (popular reformers who in the fourteenth and fifteenth centuries endorsed many of the ideas later embraced by the Protestant Reformation), were they entirely banned. In France the Bible was translated in the fourteenth century for King Charles V, but the principal mode of its dissemination was in abridged and glossed versions of Latin scholastic origin, the most celebrated of which were the *Bible Historiale* and the *Miroir*.

In the *Miroir*, the narrative of the New Testament is juxtaposed with that of the Hebrew Bible. This is reflected by the mise-en-page of the Newberry's manuscript: the first column follows in historical sequence the story of the New Testament; the three adjacent columns contain narratives taken out of historical sequence from the Old Testament, which Christian commentators interpreted allegorically as a precursor to the full revelation of the Gospels.

This beautiful codex was copied in Bruges for the library of Philip the Good (1396–1467), duke of Burgundy. In the twentieth century, it belonged to Louis H. Silver, from whose estate it was purchased in 1964. P. S.

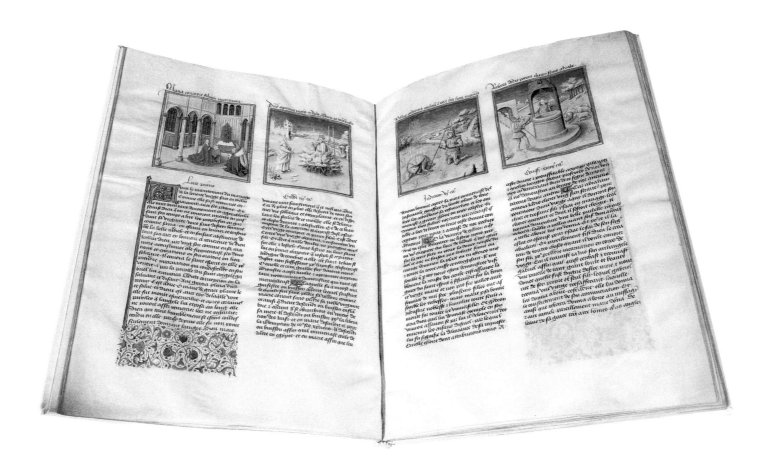

94

Francisco de Diodati
da Lucca

*Coniunctiones, oppositiones
& quadraturae luminum . . .*

Bologna, 1510
Broadside
16⅞ × 12⅜ in.
Wing Fund, 1956
Wing Oversize ZP 5351 .11

that read (in Latin): "Phases of the Moon," "Moveable Feast Days," "Lucky Days," and "Unlucky Days." The caption at the upper right, in gothic type, claims that "Venus is Mistress of the Year," but the woodcut below actually depicts Jupiter. This was surely a stock cut; the printer either used it in error or did not have the corresponding image of Venus. Illogical illustrations of this sort are common in ephemeral pieces in the early-modern period.

The text and calendrical information was assembled by Francesco Diodati da Lucca (dates unknown), a

THE LAST HALF CENTURY has seen a flourish of interest among social historians in ephemera—those insubstantial printed pieces that had momentary utility but were not substantial enough to merit careful cataloging by bibliographers. Collectors, however, have always been attracted to such things as handbills, ballad sheets, invitations, tickets, almanacs, and advertisements because of their inherent visual appeal and the often charming way their contents reflect their era.

This example, printed in Bologna, is an astrological wall calendar for the year 1511. It is a good instance of vernacular, catch-as-catch-can design; no doubt, the calendar was assembled in a hurry to meet the end-of-year market for seasonal products. The printer simply arranged material given him by the compiler into columns under headings

medical doctor active in Bologna, who is known almost exclusively as the author of popular astrological texts. Most of his publications seem to have been speculative projects for which he paid the printer directly and which he then sold for his own profit. On one title page, he claimed to have been a disciple of Luca Gaurico (1476–1558), one of the most prominent mathematicians and astrologers of the sixteenth century. The claim may have been pure advertising; certainly, it was an attempt by an obscure figure to link himself to a celebrity. Like every other known work of Diodati, this calendar survives in just one copy. Judging from the folds and pattern of wear, the broadside was preserved only because it was used as the wrapper for some other book or pamphlet, or perhaps as wastepaper filler in the covers of a binding. P. F. G.

95

Georgette de Montenay

Emblemes, ou devises chrestiennes

Lyons: Jean Marcorelle, 1571
Book
8¼ × 5¾ in.
Henry Probasco Collection, 1890
Case W 1025 .59

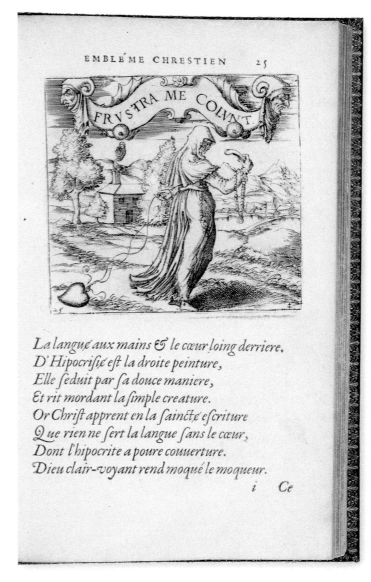

GEORGETTE DE MONTENAY'S *Emblemes, ou devises chrestiennes* (Emblems or Christian Devices) was the first emblem book by a woman writer, the first emblem book devoted entirely to Christian imagery, and the first French emblem book to use copperplate instead of woodcut illustrations. Montenay (1540–c. 1581) was a lady-in-waiting to Jeanne d'Albret, the Protestant queen of the kingdom of Navarre, whose son famously abjured Protestantism in order to become King Henri IV of France. Montenay married a Catholic nobleman and, when she wrote her emblems in the fairly open religious climate of France of 1560–1561, she probably did not expect them to be perceived as strongly partisan. But the book was not published until 1567, for production of the engravings was delayed as France became embroiled in its first War of Religion and then while the bubonic plague ravaged Lyons, where the volume was being prepared and printed. By 1567, following a brief, unsatisfactory truce between the Catholic and Protestant factions, the French realm was on the brink of a second civil war, again over religion. Because of Montenay's association with the court at Navarre, the Huguenots embraced her book as their own, and it became popular throughout Protestant Europe. Only one copy of the original 1567 printing has survived (Konelige Bibliotek, Copenhagen); the Newberry's copy represents the second printing, of 1571.

An emblem is a one- or two-page unit consisting of a title or motto, an image, and a short, satirical or moralizing poem (epigram). Sometimes there is also accompanying prose to explain the emblem's moral. In the introduction to her book, Montenay referred to the emblems as "portraits" and recommended their use, as other emblem writers had done before her, for such purposes as household decoration.

Collections of emblems were bestsellers during the Renaissance. Some were produced cheaply, in pocket-size formats, using simple woodblock images. Others, like Montenay's, were of high quality, with the illustrations designed by leading artists. In Montenay's book, the emblems are printed on only one side of the page. The visual effect of this layout is that the reader views only one emblem at a time (along with a hint of the ones placed before and after). The blank pages make the book look more like a personal album, and they would have allowed for handwritten additions by readers.

Although Montenay wrote her epigrams in French, she used Latin mottos, many of which come from the Bible. She must have supplied the mottos to the artist, Pierre Woeiriot (1532–1599), either directly or through the printer in Lyons, for Woeiriot incorporated them into his engravings, usually in cartouches. In earlier emblem books, the mottos were commonly printed above the images. In emblem 25, shown here, the image depicts Hypocrisy in the form of a nun. She carries her tongue before her, while trailing her heart behind.

The Newberry's collection of emblem books is very thorough, representing every major author in the genre, from its sixteenth-century inventor, Andrea Alciati, to Rudyard Kipling. It was largely assembled in the 1950s and '60s by distinguished historian and Newberry curator Hans Baron (1900–1988). C. Z.

IN 1887, the year in which the Newberry was established, Oscar Benjamin Cintas y Rodriguez was born in the Cuban port of Sagua la Grande. He died seventy years later in Havana after a long and distinguished career as an industrialist, philanthropist, and collector of books and art. The wealth of Cintas's highly educated family waxed and waned over the generations. Cintas overcame these vagaries of fortune to become one of Cuba's most prosperous men. He initially acquired considerable means in the railroad business, married the daughter of one of Cuba's most affluent sugar-cane producers, and served as Cuban ambassador to the United States between 1932 and 1934.

Possessing intelligence, charm, excellent taste, and good business acumen, Cintas befriended some of the twentieth century's wealthiest men, such as J. Pierpont Morgan, Jr., and David Rockefeller. They and others helped him gain access to art and book collecting. Cintas accumulated one of the world's most important private holdings of Old Master paintings, objets d'art, and furniture. But it was as a distinguished bibliophile that he had an impact on the Newberry.

Cintas tried to donate his entire estate to the Cuban nation. But he, the residents of the area where he wished to build a museum to contain his collection, and the government could not agree on terms. Consequently, he abandoned the idea. In the early 1950s, Rockefeller persuaded Cintas to establish a foundation to promote the literary and artistic work of Cubans living outside their native land. To achieve this goal, Cintas sold a large part of his estate. To this day, the Cintas Foundation supports a wide range of cultural initiatives and artists.

Partly as a result of perspicacity and awareness, and some luck, the Newberry was able to acquire Cintas's most important literary possession: the first edition of one of the greatest and most influential works of world literature, *Don Quixote de la Mancha* (published in two volumes in 1605 and 1615, respectively) by Miguel de Cervantes (1547–1616). The text blocks of the Newberry's two volumes of the first edition are trimmed so that they differ by about a half-inch. This is evidence that they circulated separately from each other until being brought together in the present, early Victorian binding, which was probably made for the prominent English politician Henry Labouchère, first baron Taunton (1798–1869), whose bookplate is found in them. It is also possible that a bookseller, speculating on their interest to a literary firsts collector like Labouchère, acquired the two volumes separately and bound them.

Cintas had acquired his copy in 1942 from the renowned collection of A. S. W. Rosenbach through Rosenbach's representative, John Francis Fleming. In 1961 Fleming purchased the book back from Cintas. In all probability, Fleming then sold it to Louis H. Silver, whose collection the Newberry acquired in 1964. The first edition of *Don Quixote* comprised some 1,500 copies, which, at the time, was a large number. Scholars believe that only twenty-eight exist today (two in private hands). In addition to the first edition, many of the earliest editions of the novel that Cintas owned are also at the Newberry. Very few libraries have such a collection. J. W.

Michel de Montaigne

Essais de messire Michel seigneur de Montaigne... Livre premier & second

Bordeaux: Simon Millanges, 1580
Book
6¼ × 4⅜ in.
Louis H. Silver Collection, 1964
Vault Case 3A 584

IN 1580 Michel de Montaigne (1533–1592) published in Bordeaux a book, *Essais* (Essays), which established a new literary genre. The first edition, featured here, comprises two volumes, one of fifty-seven chapters and the other of thirty-seven. Montaigne added a third book in 1588 and copiously expanded his thoughts until his death. The *Essais*'s contents resemble a patchwork of personal reflections all ultimately concerned with two goals: to live better in the present and to prepare for death. These considerations offer a point of departure for the reader, who is invited to produce his or her own assessments and judgments. One does not read Montaigne, one practices Montaigne. The reader levels with the author.

The very form of the essay presupposes its inevitable failure, for otherwise it would no longer be an *essai* (literally, an attempt). Philosophers create systems, not essays. Yet Montaigne elaborated a philosophy without precepts, mottos, or systems. His thought claims to be amorphous, or better, multifaceted. As one of the founding texts of modernity, the *Essais* analyze what can be broadly defined as human nature, the endless process by which we try to impose ourselves and our opinions upon others through the production of laws, policies, or philosophies. Montaigne needed to set this recurring interpretation of the world into a historical perspective, because, as he put it, "Our truth of nowadays is not what is, but what others can be convinced of." This is why his motto is no more than a question: "What do I know?" One could argue that reading Montaigne today teaches us that the angle defines the world we see, or, as Montaigne wrote, "What matters is not merely that we see the thing, but how we see it."

Montaigne postulated that "each man bears the entire form of man's estate." He strove to identify difference and preferred to conceive of the human condition in terms of its diversity, from which he developed the principle of *distingo*: to understand oneself is also to understand the other. Starting from a materialist assumption, Montaigne realized that the body is the foundation for all knowledge and that the mind is inseparable from the body. Knowledge thus depends on both the experiences of the body and the conceptualizations of the mind. Similar to the oscillations of the world and the universe, the "body and mind are in perpetual motion and action." A philosophic skeptic, Montaigne demonstrated that knowledge is often relative insofar as it depends on corporeal experiences that will sometimes adapt to the mind and at other times dominate it. The *Essais* would profoundly influence such authors and philosophers as Shakespeare, Descartes, Emerson, and Nietzsche.

Only thirty-nine copies of the first edition of the *Essais* have been located to date in public collections and about fifty are in private hands. The rarity of this edition tells us that it comprised 300 or 400 copies. The Newberry's example was in the Louis H. Silver Collection, which the library purchased in 1964; it is one of only four with an original vellum binding. P. D.

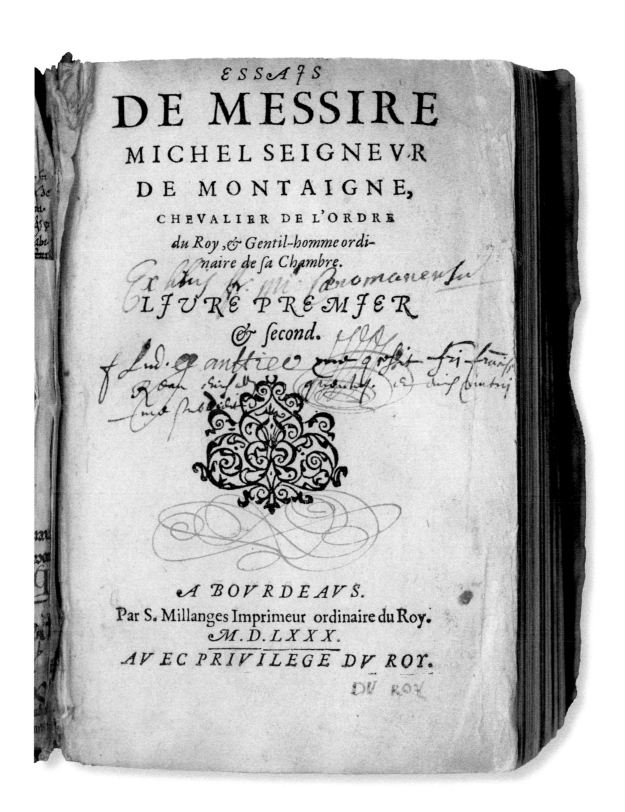

ESSAIS
DE MESSIRE
MICHEL SEIGNEVR
DE MONTAIGNE,

CHEVALIER DE L'ORDRE

du Roy, & Gentil-homme ordi-
naire de sa Chambre.

LIVRE PREMIER
& second.

A BOVRDEAVS.
Par S. Millanges Imprimeur ordinaire du Roy.
M.D.LXXX.
AVEC PRIVILEGE DV ROY.

98

Esther Inglis

A New Yeeres Gvift for . . . Lady Arskene of Dirltovn . . .

England, 1606
Manuscript
3¼ × 4⅜ in.
Bequest of Alfred E. Hamill, 1953
Wing MSZW 645 .K29

THE NEWBERRY'S John M. Wing Foundation on the History of Printing and the Book Arts is one of the world's leading resources in the field, with strengths that include calligraphy, design, the history of book collecting, and the history of libraries. Esther Inglis's 1606 miniature calligraphic manuscript, *A New Yeeres Gvift*, which never fails to amaze readers, is relevant to all of these categories.

Inglis (1570/71–1624) is the best-known English calligrapher of the Elizabethan and Jacobean periods, in part because fifty-nine of her manuscripts—including two at the Newberry—survive, the greatest number of extant works of any calligrapher of the period. Born to French Huguenot parents who emigrated to Edinburgh, she was taught calligraphy by her mother, Marie Presot, herself a skilled scribe. Only one specimen of Presot's work survives, also at the Newberry. In 1596 Inglis married Bartholomew Kello, a minor government official, and in 1604 the family moved to London, where they remained until returning to Edinburgh in 1615. Inglis helped support her family through her writing and was accomplished in a wide variety of scripts, including secretary hand, chancery, and mirror writing. Although other calligraphers of the period surpassed her in beauty of form and decoration, she excelled at writing in minuscule—indeed, hers is the most minuscule of minuscules.

A New Yeeres Gvift, a collection of proverbs, is dedicated to Lady Erskine of Dirleton. The manuscript includes nineteen different (and progressively tinier) scripts. Each page features a decoration of a flower or a bird, with a verse beneath it. The title page is more elaborate, with a border of flowers, strawberries, and butterflies on a gold ground. In her dedication, Inglis wrote of "presenting this smal work of my pen and pensil to a Lady with whom I have had no familiarity, for altho yea have perchance neither seen nor hard of me, yit your noble and wordy Lord hes both, and can best report of me. . . ." While it is somewhat surprising to think that Inglis created such an elaborate little manuscript for someone she did not know, she dedicated much of her work to nobility or other people of rank, suggesting that she was courting wealthy patrons and looking for work as a writing mistress, a necessity since she and her husband remained in difficult financial circumstances throughout their lives. She signed and dated all but two of her manuscripts and even included small self-portraits in twenty-four of them. This self-representation suggests that she fully expected her work to be passed around and shown to family and friends of the dedicatees.

Inglis's work has long been sought after by collectors, even during her lifetime. In 1620 the Bodleian Library, Oxford, acquired an example, which the diarist John Evelyn noted seeing there in 1654. This institutional acquisition is significant because it bolsters the notion that there was a thriving scribal culture in seventeenth-century England that coexisted with print culture; in fact, the Bodleian was interested in such manuscripts at the same time that it resisted collecting popular printed works such as almanacs and plays.

A New Yeeres Gvift, along with another Inglis manuscript, came to the Newberry as part of the bequest of Alfred E. Hamill, president of the library's board of trustees from 1929 to his death in 1953. He left his calligraphy collection and gypsy-lore materials to the Newberry and established the Alfred E. Hamill Fund for the purchase of books and manuscripts. J. G.

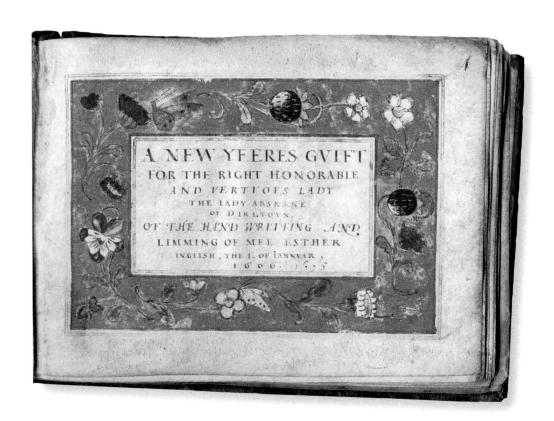

*The Compleat Servant-Maid;
or, The Young Maiden's and
Family's Daily Companion*

London: Edw. Midwinter, 1729
Book
6 × 3½ in.
General Fund, 1958
Case H 5248 .188

the *Compleat Servant-Maid*
is obviously aimed at an
entirely different audience
than Peacham's volume,
and the book's contents, as
well as reader reactions re-
corded in the Newberry's
copy, help to illuminate the
social changes underway in
the eighteenth century.

This slim, densely
printed volume would easily fit in a maid's pocket and serve
her—or, for that matter, her middle-class mistress or the
matron of a substantial farm-family household—as a source
of immediate, valuable reference. It defines the roles of and
offers guidance to housekeepers and wet and dry nurses, as
well as lady's, cook, chamber, house, scullery, laundry, and
dairy maids. It presents many recipes and recommends many
menus, with advice on doing the marketing and coping with
vendors; one section is wittily titled "The Mystery of the
Fishmongers laid open." Along the way, the book suggests
medical remedies for common complaints and even explains
how to make hair grow thick. The reader is also offered
technical guidance on handwriting, simple instruction in
arithmetic, and tables for purchasing yard goods.

Annotations in the book indicate that this volume had
multiple owners, or at least multiple users, one of them a
man with limited writing ability. At least one reader prac-
ticed her writing in the margins, including the incomplete
phrase, "I wish you a merry Cr." Grissel Smyth of Perth,
Scotland, signed her name in the book on November 23,
1743, and added a rhyme, apparently of her contriving, that
ends, "I would also make good my name." The impulse for
accomplishment, and even for upward mobility, is evident
here and undergirds the book itself. Its text and marginalia
contribute to our understanding of eighteenth-century
British literacy and readership, the spreading capacity to
write, and the quest for personal advancement then ap-
parent at all levels of society. D. S.

The Compleat Servant-Maid, which originally appeared
in 1677, is based on the work of Hannah Woolley (1622–c.
1675), who had written about household management and
medicine since the early 1660s. The book went through
several editions during the late seventeenth and early
eighteenth centuries, culminating in this ninth edition, of
1729. Using the same initial title words, a Mrs. Wilkinson
authored a different household management book in 1757.

The ninth edition was produced by Edward Midwinter
(fl. 1703–1733), a bookseller and publisher located in Pye
Corner, Smithfield, London. Although he specialized in
broadsides, ballads, and chapbooks, he had become well
known for printing an abridgement of *Robinson Crusoe*;
he also had come under suspicion for printing some se-
ditious libels. Advertising reveals that related book titles
from Midwinter were priced at between one shilling and
two shillings sixpence. Five copies of the ninth edition are
recorded, of which only the Newberry's, acquired in 1958,
is located outside the United Kingdom.

The book's title echoes the famous English exemplar
of courtesy literature, the *Compleat Gentleman* (1622), by
Henry Peacham. The *Compleat Servant-Maid* does fit into
the courtesy-literature tradition, in the sense that it gives
advice and seeks to help its readers conform their behavior
to a set of standards. Courtesy literature, traceable from
the thirteenth century and a mainstay of publishing into
the nineteenth, can be studied through the Newberry's
exceptionally strong collection in European languages. But

100

Lady Mary Wroth

The [first and] secound booke of the secound part of the Countess of Montgomery's Urania

England, after 1621
Manuscript
12⅛ × 8⅜ in.
Frederic Ives Carpenter Fund, 1936
Vault Case MS Folio Y 1565 .W95

IN JULY 1621, Lady Mary Wroth's prose romance *Urania* appeared in print. The book's publication is notable because, unlike other female writers of her time who focused mainly on translation and epitaph, Wroth (1587–1651/53) wrote secular love poetry and romances. She was the first English woman to author a complete sonnet sequence and the first to compose an original work of prose fiction.

The title character of *Urania* is a shepherdess who learns that the couple who raised her are not her real parents, and the story focuses on her quest for her true identity. Wroth interwove autobiography and fantasy into the narrative, emphasizing lack of freedom in marriage and loss of royal favor, among many themes. *Urania*'s thinly veiled accounts of scandals in the court of James I prompted an immediate uproar. Within months Wroth wrote to the duke of Buckingham, claiming that the book had been published without her authorization or assistance and that she "had caused the sale of them to bee forbidden." Nevertheless,

that same year Wroth probably began writing the second part of *Urania*, which remained unpublished until 1999. Wroth's text is the Newberry's most important English literary manuscript.

Born Mary Sidney, Wroth was the niece of Sir Philip Sidney, an Elizabethan courtier and poet. She was educated by tutors under the guidance of her mother, and her family home was a center of literary and cultural activity during the Elizabethan and Jacobean periods. As a young woman, she was an intimate of Queen Anne, and she participated in masques at court, including her friend Ben Jonson's *Masque of Blackness*. In 1604 she married Sir Robert Wroth; the marriage was not a happy one, with most accounts alleging that Wroth was a drunk and a philanderer. After his death in 1614, Lady Mary allegedly bore two children by her first cousin William Herbert, the third earl of Pembroke (and the man to whom the Shakespeare First Folio [see no. 101] is dedicated).

The Newberry manuscript takes up immediately after the end of the first book and places a special emphasis on children born out of wedlock, again suggesting that Wroth was drawing inspiration from her own life. It was acquired by the Newberry in 1936 using a fund created by Trustee Frederic Ives Carpenter, a University of Chicago professor, specifically for the purchase of English prose fiction.

Originally, the manuscript was thought to be the work of two hands. Ernst Detterer (1888–1947), custodian of the John M. Wing Foundation on the History of Printing when the manuscript came to the Newberry, concluded that it was by one hand, arguing that variations in the handwriting were due to different pens, paper, and ink, as well as to Wroth's care and speed in writing at certain times. The manuscript is not a fair copy (a clean copy that incorporates final corrections), but rather a draft. Wroth left blank spaces in the text for the insertion of poetry within the prose. She estimated how much space she would need and occasionally found that she had either left too much space or too little; on at least one occasion, she had to squeeze a poem into double columns, again signaling a work in draft form.

The editing of *Urania* for a print edition was begun in 1991 by Josephine Roberts; after her death in 1996, Suzanne Gossett and Janel Mueller completed the project. The finished edition is an important piece of Wroth scholarship that provides insight into how an extraordinary seventeenth-century writer developed her texts. J.G.

William Shakespeare

Mr. William Shakespeares Comedies, Histories, & Tragedies

London: Isaac Iaggard and Ed. Blount, 1623
Book
12⅜ × 8½ in.
Louis H. Silver Collection, 1964
Vault Case Oversize YS 01

PERHAPS THE MOST discussed, studied, and fetishized book in English literature is the First Folio, the common name for the first printed collection of William Shakespeare's plays, published in 1623 as *Mr. William Shakespeares Comedies, Histories, & Tragedies*. It was the first folio book ever published in England consisting entirely of plays, half of which had never before been printed. Without the First Folio, eighteen of Shakespeare's plays, including *Macbeth* and *The Tempest*, would not have survived.

Two groups—players and publishers—cooperated to produce the First Folio. The players, headed by John Heminges (1566–1630) and Henry Condell (1576?–1627),

were members of Shakespeare's company, the King's Men (formerly the Lord Chamberlain's Men). The publishers were Edward Blount (1562–1632 or before) and Isaac Jaggard (d. 1627). A variety of sources, including manuscripts, prompt books, and previously printed copies of the plays, was used to compose the text. The book was proofread and corrected while it was being printed, and hundreds of corrections were made, resulting in numerous variants in individual copies. Approximately 750 copies of the book were printed; 228 are extant.

The Newberry has owned a First Folio for nearly its entire existence, although the copy it now holds is not the one acquired in 1890 as part of the collection of Henry Probasco. The present copy belonged to Louis H. Silver, a Chicago businessman whose collection of more than 800 books was acquired by the Newberry in 1964 (see no. 58). His library was especially rich in Elizabethan literature and included Shakespeare quartos as well as folio editions. To help raise the funds needed to purchase Silver's collection, the Newberry decided to include the Probasco First Folio among the "duplicate" books that were to be sold at auction

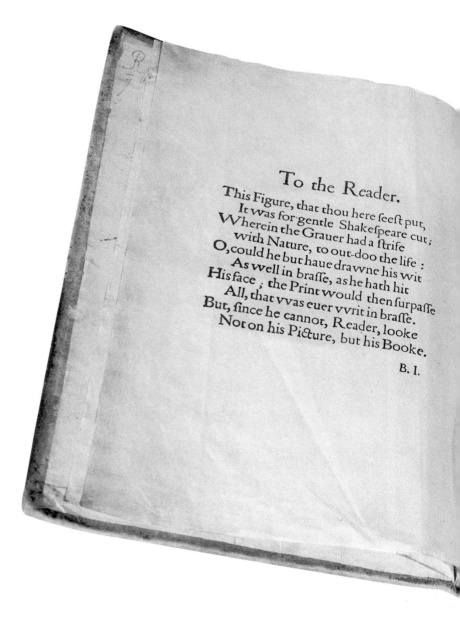

at Sotheby's in London in November 1965; it was purchased by the New York book dealer John Fleming, who sold it to Caroline Newton the following year. Newton gave the book to Bryn Mawr College in 1974.

The Newberry's copy has several manuscript annotations, beginning with an ownership signature on the title page that reads, "Robert: Wynn: bodescalian"; perhaps this owner was responsible for other marks in the book. The title *Troilus and Cressida* was added in manuscript to the catalog of plays (i.e., table of contents). Because the publishers were still negotiating at the eleventh hour for the rights to *Troilus*, they did not list it in the catalog. At the very last moment, they succeeded and included the play in the book; an owner of the Newberry's volume added its name to the catalog to reflect where it was bound into the copy, directly before the *Tragedy of Coriolanus*. Another reader was moved by a passage in *Two Gentlemen of Verona*. On page 27 of the play, the phrase "Ann Park is" has been added to the top of the first column. The reader is meant to add this to the beginning of the text below: "That I did love, for now my love is thaw'd / which like a waxen Image 'gainst a fire / Bears no impression of the thing it was," so that it reads: "Ann Park is / That I did love. . . ." Alas, Ann Park, breaker of at least one seventeenth-century heart, remains an enigma. The marginalia in the Newberry's First Folio, while not extensive, nevertheless serve as a reminder that for nearly 400 years, readers have heeded the dedicatory lines by Ben Jonson that sit opposite the portrait of Shakespeare on the title page: "Reader, looke / Not on his Picture, but his Booke." J. G.

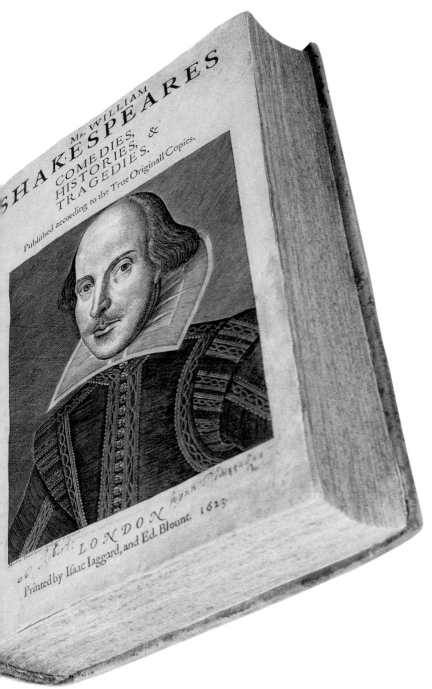

General Assembly of the
Church of Scotland, and
Charles I, King of England,
Scotland, and Ireland

*To the King's Most
Excellent Maiesty.
The Humble Petition of
the Commissionerrs of the
Generall Assembly . . .
met at Edenborough . . .
With His Maiesties Gratious
Answer thereunto*

Oxford (?): Leonard Lichfield,
Printer to the University, 1642
Pamphlet
8⅜ × 7 in.
General Fund, 1949;
purchased from Ralph T. Howey, 1959
Case J 5453 .789

THESE PAMPHLETS ex-
emplify the Newberry's
rich collection of English-
language materials on the
history of British politics in the early-modern period.
They help to explain why a research library keeps, and
even seeks, near-duplicates. The differences between the
two pamphlets highlight a real turning point in British
history, important enough for Edward Hyde, first earl of
Clarendon, to have reprinted a version of the pamphlet in
full in his *History of the Rebellion and Civil Wars* (1720).

In relations with the Church of Scotland, King Charles I
(r. 1625–1649) fared much less successfully than had his
father. Both monarchs aimed at royal supremacy over the
Kirk, but James was more cunning and patient. Charles
made the Scots deeply suspicious of his plans for religion as
early as 1627. A decade later, his insistence on implement-
ing a new liturgy without review by a General Assembly
provoked a battle royal. After the resulting Scottish National
Covenant came a strong turn toward Presbyterianism,
followed by two brief "Bishops' Wars."

With the start of the English Civil War itself, the Scots
believed that they could help Charles devise a common
antipapist, antiepiscopalian religion for his three domains
and find a way to mend relations with the English Parlia-
ment. To this end, they sent a representative of the Scots
Council and commissioners from the General Assembly
to meet with him, knowing that he wanted and needed
the Scots' support to shore up his weakened position in
England and Ireland.

The commission's leading figure, Alexander Henderson
(c. 1583–1646), had served as royal chaplain during Charles's
1641 visit to Edinburgh, and he later had amicable dealings
with the king in London. Henderson and the others arrived
in Oxford in February 1643, presented the petition (dated
January 4, 1643, Scots' style) and waited three weeks for an
audience, during which they had their petition published
by Henry Overton in London. When the desired meeting
finally occurred, the monarch adamantly rejected the idea of
abandoning episcopacy and ordered the petitioners to stay
out of English affairs. He also expressed great displeasure
that the petition had been made widely known by printing,
and he prohibited the commission members from returning
to London. When Charles's response was printed officially
in Oxford, together with the petition itself, his ire was still
visible in the sharply worded statement that the petition-
ers had "not the least Authority or Power to intermeddle
or interpose in the Affaires of this Kingdome or Church."

The title pages of the Newberry's two versions of this
pamphlet state that they were printed at the king's com-
mand in Oxford by Leonard Lichfield, the royalist printer
of the university. Both came to the library during the
time it was directed by Stanley Pargellis, when English
political materials were arriving in abundance. The earlier

acquisition (opposite), occurred at Sotheby's on June 20, 1949. The document was part of a *Sammelband* (a group of separately printed texts that have been bound together) of pamphlets from the 1640s, and therefore the purchase was probably not made to obtain this particular work. Ten years later, the second version (below), from the inventory of Philadelphia book dealer Ralph T. Howey, to whom the Newberry sometimes sold duplicates, was acquired.* It seems clear that this second purchase was intended to bring another state of the document to the collection.

Several versions of this pamphlet exist, most with title pages indicating that they were printed at Oxford by Lichfield. During the English Civil War era, it was not uncommon for a pamphlet to appear in half a dozen or more different editions. An historian of early-modern printing at Oxford long ago asserted that the version the Newberry acquired in 1959 was a counterfeit, printed in London. The involvement of the Scots in English affairs was a highly contentious matter in England, as of course was the royal rejection of antiepiscopacy, so it is understandable that London printers might have wanted to hide behind the facade of a royalist printer in Oxford.

In fact, the Newberry's two pamphlets differ from each other as well as from the version considered to be the official royal printing, but not in an easily explained way. The 1949 acquisition shares with the official version every nuance of content and printing, from the title page (and its decoration) to the end of the petition, so part of it must have been printed by Lichfield. But the response from King Charles (opposite) differs from the official version in font, decoration, some spelling, and even a marginal reference to an earlier royal pronouncement. Beyond these typographical differences, in some cases the content is subtly altered. For instance, the response insults Henderson by omitting the honorific "Mr." in the heading for this section and carefully leaves out the words "and payed" from its description of the army that Parliament "has raised." The London counterfeit (below), despite its different typesetting, avoids such adjustments. Who were the individuals responsible for changing some things and not others? What was their intention? Did they have profit or politics in their sights? Answering such questions, as scholarship advances, is why the Newberry collects near-duplicates. The devil, perhaps the printer's devil, is in the details. D. S.

* *To the King's Most Excellent Maiesty. The Hvmble Petition of the Commissioners of the General Assembly . . . met at Edinbourgh . . . With His Maiesties Gratious Answer thereto*, Oxford [London?], 1642, 8⅜ × 6¼ in., General Fund, Case J 5453 .2669 1643–1644.

DE PAR LE ROI.

Monsieur le PRÉVÔT *de son Hôtel & grande Prévôté de France :*
Et M. le Lieutenant général, Civil, Criminel & de Police en ladite Prévôté.

ORDONNANCE
DE POLICE,

Concernant les Colporteurs & Distributeurs d'Imprimés & d'Écrits, tendans à soulever les esprits,
à troubler l'ordre & la tranquillité de l'État, & à donner atteinte à l'autorité du Roi.

Du 11 Juillet 1789.

SUR ce qui nous a été remontré par le Procureur du Roi, que par une Ordonnance de Sa Majesté, du 29 octobre 1732, il a été défendu à tous Colporteurs de crier, vendre ni débiter aucun Imprimé, sans en avoir obtenu la permission de la Police, sous peine d'emprisonnement & de *Cinquante livres* d'amende : Que par une Déclaration du Roi, du 16 avril 1756, Sa Majesté auroit renouvelé les peines portées par ses précédentes Ordonnances, contre ceux qui auroit part à l'impression, distribution & colportage d'Imprimés tendans à troubler la tranquillité publique, & à donner atteinte à son autorité, sous peine des galères : Que par Arrêt du Parlement, du 24 septembre 1768, l'exécution de cette Déclaration a été ordonné, & que des contrevenans ont été condamnés au fouet, à la marque & aux galères : Quand ce qui concerne Versailles & le séjour du Roi, une Ordonnance de police de cette Cour, du 20 août 1766, a défendu le colportage des Livres, Brochures & Imprimés prohibés, sous peine, contre les contrevenans, de prison & d'être poursuivis extraordinairement suivant la rigueur des Ordonnances : Qu'au mépris de ces sages précautions, des personnes mal-intentionnées font imprimer à leurs frais & soudoient, non-seulement des gens sans aveu, mais aussi des mal-faiteurs, pour répandre, distribuer & crier, tant dans la ville de Versailles, que dans les cours & château de Sa Majesté, des Imprimés & Libelles séditieux, dans l'intention de jeter de l'inquiétude dans les esprits, de troubler la liberté des Citoyens & d'intervertir l'ordre public : Que même aucuns de ces Colporteurs soudoyés, sous prétexte de la licence du moment, se sont introduits dans les maisons pour tenter d'y commettre des larcins & de surprendre la confiance des habitans : Qu'étant de son devoir de faire réprimer des abus aussi criminels, & de mettre le Public à l'abri de projets qui attaquent leurs propriétés, il nous requiert de maintenir l'exécution des Ordonnances du Roi, des Arrêts du Parlement & des Ordonnances de Police, sur le fait de la distribution & colportage des Écrits & Imprimés qui se débitent sans permission. A quoi voulant pourvoir :

NOUS faisant droit sur le Réquisitoire du Procureur du Roi :

ARTICLE PREMIER.

ORDONNONS que les Ordonnances du Roi, les Arrêts du Parlement & les Règlemens de Police, concernant les Colporteurs, Crieurs & Distributeurs d'Écrits & Imprimés, sans permissions & autorisations, seront exécutés selon leur forme & teneur.

II.

EN conséquence, enjoignons à tous Particuliers qui prendront l'État de colporter, crier & distribuer des Imprimés dans la ville de Versailles & suite de la Cour, de se faire enregistrer au greffe de la Prévôté de l'Hôtel, d'y déclarer leurs noms, surnoms, âge, qualités, demeure & lieu de leur naissance ; de laquelle déclaration leur sera donné *gratis* un Certificat par le Greffier de ladite Prévôté, sous peine, contre les contrevans, de prison & d'être poursuivis extraordinairement, suivant la rigueur des Ordonnances.

III.

FAISONS défenses à tous Particuliers qui ne se seront pas fait inscrire au greffe de la Prévôté à Versailles, de débiter, colporter, ni crier dans cette ville & suite de la Cour, aucun Écrit ou Imprimé, sous peine de prison, & d'être poursuivis extraordinairement.

IV.

DÉFENDONS aux Colporteurs qui se seront fait enregistrer, de vendre, distribuer & crier aucun Imprimé à Versailles & suite de la Cour, dans les rues, cafés, maisons, & en tel endroit que ce puisse être, sans en avoir obtenu une permission, par écrit, sous les peines portés dans les articles II & III ci-dessus.

V.

DÉFENDONS aux Colporteurs qui seront enregistrés & qui seront autorisés, conformément à l'article IV ci-dessus, de distribuer, vendre & crier aucuns Imprimés, même autorisés, dans l'intérieur du château, jardins, cours & dépendances d'icelui, sous peine de prison, & de plus grande peine, selon l'exigence des cas.

VI.

MANDONS aux Officiers de Police de tenir la main à l'exécution de notre présente Ordonnance, qui sera imprimée, lûe, publiée & affichée par-tout où besoin sera, & exécutée comme Règlement de Police.

FAIT & donné par nous CLAUDE-JOSEPH CLOS, Chevalier, Conseiller d'État, Lieutenant général, Civil, Criminel & de Police, de la Prévôté de l'Hôtel de Sa Majesté, & grande Prévôté de France. A Versailles le onze juillet mil sept cent quatre-vingt-neuf. *Signé* CLOS.

TERTRE, *Greffier en chef.*

A VERSAILLES, DE L'IMPRIMERIE ROYALE. 1789.

THIS BROADSIDE, a Versailles police ordinance dated July 11, 1789, illustrates well the value of ephemera in the Newberry's history of the book and printing collections. It came to the library in 1977 as part of a purchase of a large group of French ordinances, edicts, and judicial decisions about printing, bookselling, and censorship. Such materials, although not books themselves, reveal important aspects of the history of the book, as well as the larger story about the production, distribution, and regulation of printed matter since the 1450s.

Ephemeral materials complement the unique manuscripts and rare printed books in the Newberry's collection. Ephemera of various kinds, including commercial and legal documents, have always constituted a large share of printed matter, and often, as with this broadside, illustrate what early-modern printing technology could accomplish, even for material not expected to endure. As the name suggests, ephemera can be vanishingly rare, either because their intensive or outdoor use led to disintegration or because their purpose made it unlikely that people would save them. In the case of this broadside, no other copy is known to have survived.

Recent scholarship has revealed much about the book trade in *ancien régime* France. Among other things, we understand that the market for "bad books," "philosophical books," and *livres bleus* (inexpensive books) was not noticeably harmed by the French government's efforts to regulate it. A royal ordinance of October 20, 1721, sought to prevent the unlicensed sale of books about religion or the government or contrary to the "purity of morals," with special focus on limiting the work of the *colporteurs*, those peddlers who sold such books door-to-door and by public display in plazas or along waterfronts. The July 11 ordinance lists a series of other legal actions dating from 1732 to 1768 that specified narrow legal limits for *colportage* and threatened penalties for violations. By the summer of 1789, it was clear that, despite many kinds of police action across the decades, the government had failed miserably in its efforts to control the hawking of printed matter in Paris and the provinces. There is good reason to think that in fact *colportage* actually enlarged the reading public in France.

With the July 11 ordinance, Claude-Joseph Clos (c. 1736–1812), head of the French police and an important member of the court at Versailles, was desperately trying to put a halt to *colportage* in Versailles, even within the palace itself. Here we see the *ancien régime* at its wits' end. The court seemed riveted on the sale of print as a fundamental cause of what the ordinance calls the disquieted public spirit, with the potential to overturn public order. Ironically, the ordinance could say that print sold by *colporteurs* would "trouble the liberty of citizens" (note that it does not say "subjects"). And how did Clos propose to cure this problem at Versailles itself? Why, by posting large, printed legal notices bearing the royal house's emblem—the *fleur de lis*—which would prohibit the sale of print in the area.

As the English historian Thomas Carlyle later pointed out, the government took a similar approach in Paris the next day, posting broadsides urging citizens to stay indoors. It was July 12, 1789. Soon there would be no Bastille and, despite renewed regulation of *colportage* by the city of Paris later in 1789, a flood of pamphlets and political ephemera would cover the nation—tens of thousands of them ending up at the Newberry. D. S.

Prévôté de France
[Claude-Joseph Clos]

*De Par le Roi . . .
Ordonnance de Police,
Concernant les Colporteurs
& Distributeurs d'Imprimés
& d'Écrits*

Versailles: Imprimerie royale, 1789
Broadside
21¼ × 16¾ in.
Wing Fund, 1977
Case Wing Folio Z144 .A1 v. 10 no. 87

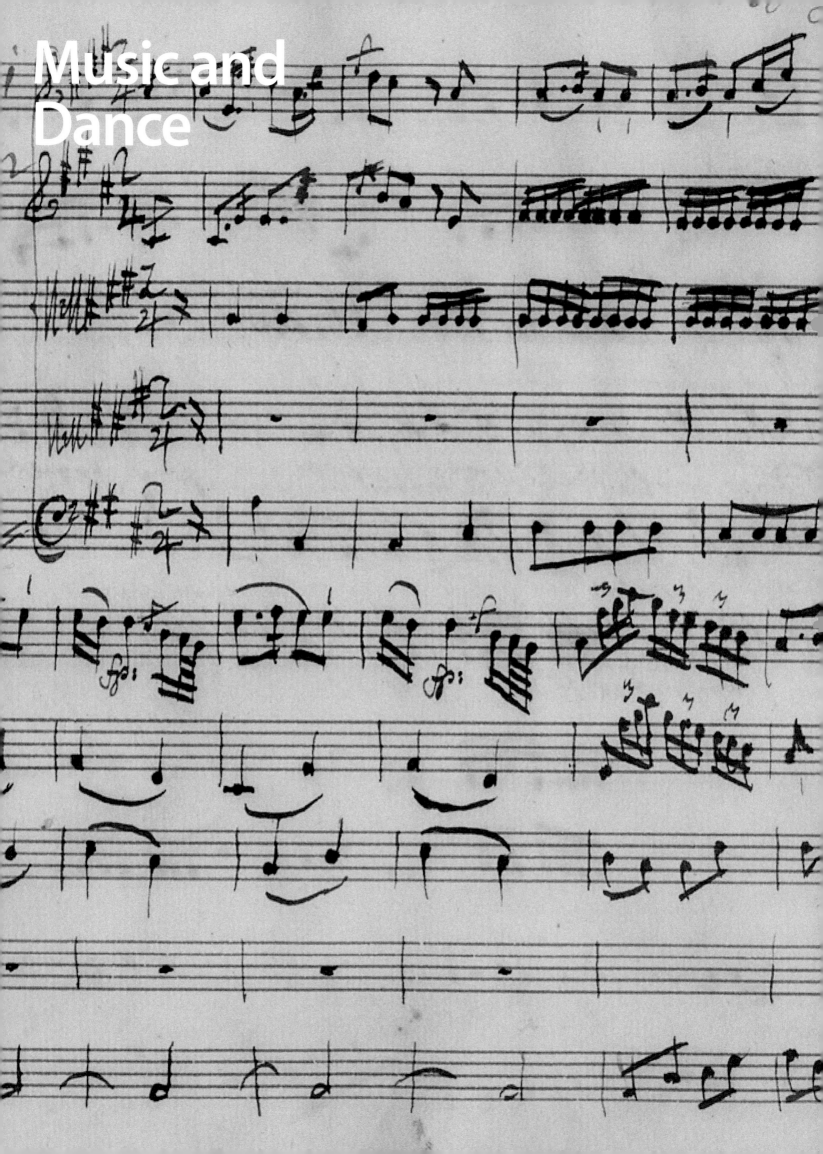

Friar G. de Anglia
Musical Treatise

Pavia, c. 1391
Manuscript
10¼ × 7⅝ in.
Ryerson Fund, 1955
Case MS 54.1

AN ENGLISH SCRIBE who signed his name as Friar G. de Anglia created this manuscript in late-fourteenth-century Pavia, copying into it a selection of mathematical and practical works relating to music. The duke of Milan had conquered Pavia in 1359 and then set out to make it a cultural capital. He built a castle there and established a university. Musicologist Lucia Marchi recently studied the cultural context surrounding de Anglia's creation of this manuscript, and she noted that the mix of works it includes reflects the two musical institutions of the city: the court, where music was played; and the university, where speculative music (music theory) was taught. Music, as one of the seven liberal arts—and allied especially with arithmetic, geometry, and astronomy—was an area of academic study considered as a prerequisite to entering the more advanced domains of law, medicine, and theology.

The harpist Jaquemin de Senleches (fl. 1378–1395) composed a piece entitled *La harpe de melodie*, which is the most visually spectacular image found in the manuscript. A Frenchman who spent at least part of his career in Spain, Senleches is known to have served Eleanor of Aragon, queen of Castile, and Pedro de Luna, cardinal of Aragon, who later became Pope Benedict XIII. Senleches wrote in the highly refined, late-fourteenth-century musical style known as *ars subtilior*, which was centered at secular courts in southern France, Aragon, and Cyprus.

La harpe de melodie might be viewed as a cross-over work, one that primarily addresses the intellectual concerns of the university but also reflects cultural fashions of the court. It is a three-voice composition in which the bottom voice (the tenor) performs a relatively simple line, probably intended to be played by the harp, while the two upper voices sing more complex lines, in canon—that is, in imitation of each other, with the second voice chasing the first. The piece is written in the shape of a harp, with the pitches arranged on the strings, as if they were musical staves. As Marchi wrote, the "purpose of the piece is pure pleasure; the perfection of its harmony can be enjoyed by playing, listening or by looking at the song." The song text praises the enjoyment of music-making as a noble entertainment, while the presence of a hand holding a key to tune the harp serves as a reminder that only a well-tuned instrument will produce a sweet sound. Facing the harp is a table of mathematical proportions that offers yet another take on harmony, reminding us that music and measurement have always gone hand in hand. C. Z.

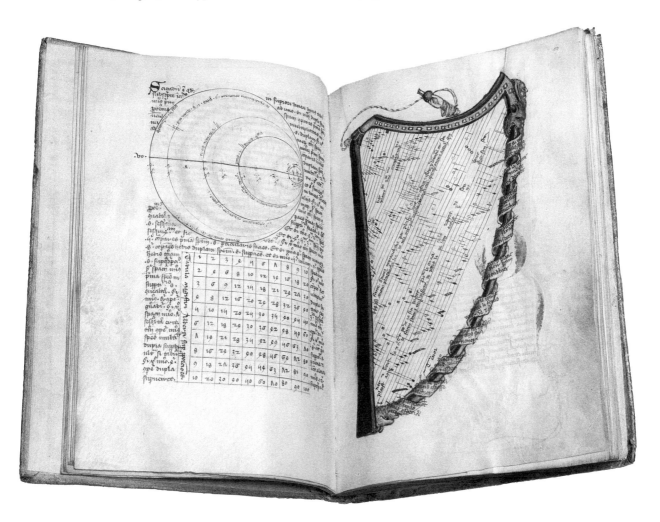

105

Antiphonarium Basiliense

Basel: Michael Wennsler, c. 1488
Book
16 × 12 in.
Gift of Dr. Emil Massa, 1996
Vault oversize Inc 7517.5

MUSIC BOOKS have a printing history that, although roughly parallel to that of other books, is distinct in both aesthetic and practical ways. Music has always been expensive to print, so there is constant technical experimentation in the field, evident in books of many periods. Whether for performance or for instruction, moreover, musicians have demanded a high degree of legibility. Perhaps inevitably then, the earliest fully realized printed music appeared in large and expensive liturgical books, a luxury genre for which clarity and beauty were important and cost was not a major consideration.

Both before and after the invention of printing, churches and monasteries needed books large enough for whole choirs to read from at once. Antiphonals, like this one printed in Basel about 1488, contain the chants sung at mass and at the canonical hours of prayer. Significant differences of both text and chant had developed in many localities during the Middle Ages, so the chants included in any given choir book vary from place to place according to the liturgical usage of the city, region, or monastic order. The contents of this book were determined by the needs of churches in the diocese of Basel. Printers did not have to identify a market for a choir book of this sort; typically, a local church official would bring the contents to the printer and subsidize the printing.

The *Antiphonarium Basiliense* (Basel Antiphonal) is a regional product in yet another way, namely its notation.

Most late-medieval and early-modern chant was written with square notes on a four-line staff, with a variety of additional forms to represent common sequences of notes. In German-speaking lands from the thirteenth century forward, however, the local scribal tradition was different. Scribes in this region employed notes in a different style, called *Hufnagel* notation because the single note resembles the shape of a horseshoe nail. This scribal tradition was strong enough to last into the eighteenth century. The commissioners of the Basel antiphonal apparently insisted on reproducing it very accurately, so that choirs already familiar with it would not have to master an unfamiliar notation.

This copy is bound in sturdy tawed pigskin, elaborately blind-stamped and furnished with brass bosses and the remnants of matching clasps. We can be sure that it saw long use because it contains marginal notes and additional chants in hands dating from the sixteenth to the nineteenth century. The book was presented to the Newberry by Dr. Emil Massa (1927–2003), who made several other gifts and established a book fund by bequest. To celebrate the bequest, the library commissioned Chicago designer and calligrapher Tom Greensfelder to create a bookplate in Dr. Massa's honor. The design of the plate is based on the distinctive red-and-black gothic initials in this book. P. F. G.

IN SIXTEENTH-CENTURY Europe, the lute was highly regarded among musical instruments. Although its ancestor was the Arabian *al 'ûd*, Renaissance humanists fancied the lute to be descended from the classical lyre. With its mellow-sounding gut strings, the lute is well suited to the musical needs of amateurs. One can produce acceptable tones on it without a highly skilled touch, and it works well as an accompaniment for the voice. The lute was a common accessory of a gentleman's study and was also appropriate for women, since it was cradled gently in the arms and its playing did not require ungainly gestures. This was also the period when a small number of virtuoso lutenists began to distinguish themselves from the ordinary run of itinerant minstrels by securing salaried appointments with aristocratic families. These literate musicians mingled freely with kings and courtiers and provided instruction to them.

Vincenzo Capirola (1474–after 1548) was one of the first in this emerging cohort of highly skilled lutenists. An Italian composer and nobleman, he may have traveled as far as the court of King Henry VIII of England, although he lived most of his life in Brescia and taught in Venice. In about 1517, one of Capirola's pupils in Venice, a painter we know only as "Vidal," prepared this manuscript of his teacher's lute music. It contains a preface that provides practical information on how to play the lute and some forty pieces, ranging from simple examples manageable for beginners, to extremely difficult ones intended for advanced players. Intabulations (arrangements) of Italian and French vocal pieces are included, as are some dances and *ricercari* (preludes in an imitative style).

Lute tablature is a chart-like notation that shows players exactly where to position their fingers on the instrument. The earliest surviving tablatures for lute date from the late fifteenth century. The first printed sources came from the press in Venice of Ottaviano Petrucci, beginning in 1507. In the Newberry's example, Vidal introduced the use of different colors to indicate different aspects of the notation. Despite the very beautiful and fanciful illustrations included on some of the pages, the small size of the volume suggests that it was not made for public show, but rather for personal use, as a method book and score for lute playing at various levels of skill. The drawings may have been intended to ensure that the pages would be preserved and kept together.

The Newberry purchased the Capirola manuscript in 1904 from the Florentine dealer Leo S. Olschki. The entire manuscript was recently digitized as part of the "Corpus des luthistes," which is one of the projects sponsored by "Ricercar," a program in musicological research located at the Centre d'Études Supérieures de la Renaissance in Tours, France. C. Z.

106

Vincenzo Capirola
Compositione di meser Vincenzo Capirola, gentil homo bresano

Venice, c. 1517
Manuscript
5⅞ × 8⅝ in.
General Fund, 1904
Case MS minus VM 140 .C25

Jacopo Peri

Le mvsiche di Iacopo Peri Nobil Fiorentino Sopra L'Euridice del Sig. Ottavio Rinvccini

Florence: Giorgio Marescotti, 1600
Printed score
13½ × 9⅝ in.
Pio Resse Collection, 1889
Vault Case VM 1500 .P44e

WILLIAM FREDERICK POOLE (1821–1894), the Newberry's founding librarian, made the institution's first major purchase in 1889 by obtaining the library of Count Pio Resse (dates unknown) of Florence, Italy. With this acquisition, the Newberry became a leading American resource for the history and theory of music. At the time of the sale, Resse was married to the American suffragist Elizabeth Woodbridge Phelps Pearsall (1834–1924), who was active in many philanthropic social movements in Rome and Florence. She had a strong interest in music and was a friend of Amy Beach, Franz Liszt, Arthur Rubinstein, and other notable composers and performers.

The Pio Resse Collection includes 751 items, mostly printed scores and books, of early Italian music and music theory. The jewel in the crown is this rare, pristine first edition of the opera *Euridice,* composed in 1600 by Jacopo Peri (1561–1633). Most historians consider *Euridice* to be the first extant opera score (that of an earlier opera, *Daphne,* by the same composer and dating to 1597, did not survive). What makes this score particularly special is the presence in the Resse Collection as well of the matching libretto, by Ottavio Rinuccini, *L'Evridice d'Ottavio Rinvccini, rappresentata nello sponsalitio della christianiss. Regina di Francia, e di Navarra* (1600).

Based on books 10 and 11 of Ovid's *Metamorphosis,* this first operatic version of the Orpheus legend premiered on October 6, 1600, as part of the celebration of the wedding of Marie de' Medici to Henri IV of France. The performance took place in the apartments of Marie's half-brother Don Antonio de' Medici in Palazzo Pitti, Florence, before 200 guests. The opera was composed for fourteen singers and an unknown number of instrumentalists. The skeletal score that Peri printed includes the vocal lines and figured bass but not much of the instrumental music (one brief dance is found in the finale) or instrumentation, except for two vocal pieces with one and three instrumental parts, respectively. Peri's preface provides a list of four instrumentalists and their instruments for the first performance: harpsichord, lira da gamba, lute, and chitarrone. It is likely that other instruments, particularly winds, were also used. The opera employs the new theatrical expressiveness of the nascent Italian Baroque style. *Euridice* exerted a considerable influence on Claudio Monteverdi, whose *Orfeo* (1607) exhibits a greater musical depth than does Peri's pioneering work.

Howard Mayer Brown (1930–1993), longtime professor of musicology at the University of Chicago and a Newberry researcher, edited a modern performing score of *Euridice* in 1981. D. J. B.

François Picquet Prayer Book

New York, c. 1750
Manuscript
9⅛ × 7⅜ in.
Ruggles Fund, 1991
Vault Ruggles 393

THIS MANUSCRIPT is the prayer book—more properly, the service book—of Father François Picquet (d. 1781) of the Sulpician order. In many ways the Sulpicians, as missionaries, educators, and preachers, assumed a niche in the French religious ecology similar to that of the Jesuits. Picquet was a missionary among the Mohawk Indians in a region that today lies within upstate New York and southern Ontario; he achieved renown as the priest who fought the English in the French and Indian wars. Containing prayers, litanies, and hymns with musical notation, his prayer book is precious witness to the Sulpician espousal of the vernacular in the French-speaking New World at a time when, within Catholic Europe in the centuries following the Counter Reformation, the vernacular was often treated with suspicion.

When first presented to the Newberry in 1990, the well-worn manuscript was accompanied by Picquet family correspondence, although the language in which it was written and its authorship were both ambiguous. One theory at the time posited Mandarin Chinese as the mystery language. Eventually, however, linguists determined that the language of the codex, transliterated into Latin characters, is Mohawk. Research into the question of authorship uncovered documents from the archives of the Sulpician order in Montreal identifying the script of the prayer book as that of one of the hands in the Picquet papers, and thus confirming the author of the Newberry's codex as Picquet himself or one of his secretaries.

In September 2007, the disinterment of the prayer book, which began with its arrival and proper cataloging at the Newberry, was completed when one of its Gregorian chants was performed, in the library's Ruggles Hall, by the Schola Antiqua of Chicago in a concert forming part of the post-Congress festivities of the Association Internationale de Bibliophilie. P. S.

109

Alessandro Stradella

Cantate

Italy, c. 1750
Manuscript
8 ½ × 11 ¼ in.
Brown-Weiss Book Fund, 1995
Case MS 5067

ALESSANDRO STRADELLA (1639–1682), like the painter Caravaggio, was one of the bad-boy artists of seventeenth-century Italy. A brilliant composer, he was somehow often in trouble. Born into a noble Tuscan family, he grew up in Rome, where he had his first successes as a composer of sacred oratorios. His spendthrift ways and propensity for fraud and sexual intrigue meant that he was on the run for much of his brief career. In 1678 he was nearly killed in Turin by ruffians hired by a romantic rival. Four years later, he was stabbed to death,

Perhaps helped along by his notoriety but certainly also because of the brilliant virtuosity of his music, Stradella's music was actively, even obsessively, collected in manuscript throughout the eighteenth century. This album, elegantly bound for a French collector, is testament to that popularity. Like many such collections, it includes genuine and doubtful works. The songs were copied onto sheets preprinted for music—the usual practice for music manuscripts intended for performance. In this case, decorative initials, some including mythological scenes, were pasted in. Similar mythological etchings appear on music papers used for manuscripts of Stradella's works. These manuscripts were prepared in the late seventeenth century and now reside in the national libraries of Turin and Vienna. Here, however, they have been reused in a book probably assembled in its present form in the mid-eighteenth century.

apparently again the victim of professional assassins. He was forty-two and had spent only fifteen years as an active composer. Still, the *New Grove Dictionary* concludes that he was the "leading composer in Italy in his day." He left an impressive body of work in many musical forms: instrumental pieces for solo players and ensembles, sacred and secular cantatas and oratorios, madrigals, theatrical prologues and intermezzi, pageants, and at least seven operas. His vocal settings, like those in the collection featured here, are often highly emotional and notoriously difficult to sing, but the right artist can achieve breathtaking effects.

In the nineteenth century, Stradella's troubled life became the stuff of much-embroidered legend; it was the subject of songs, novels, plays, and five *bel canto* operas. In 1979 the composer was the focus of an essay by University of Chicago musicologist Howard Mayer Brown. When Brown's library came to the Newberry in 1993, it included several Stradella editions. This manuscript was acquired with funds from the Brown bequest, and it was the basis for a concert presentation by the Newberry Consort in 1997. Consort Director Mary Springfels recorded these settings with soprano Christine Brandes for Harmonia Mundi in 1998. P. F. G.

THIS MANUSCRIPT is perhaps the most important of the three Mozart autograph scores in the Newberry. Written in October 1765, when the composer was just nine years old, it is one of his earliest arias. The child prodigy composed the piece when he was in The Hague, a stop on the Mozart family's first European tour, between 1763 and 1766. He might have composed the aria for a concert performance before Princess Carolina of Orange.

Conservati fedele (Stay Faithful) is a da capo aria (a tripartite form, with an obligatory repeat of the first part, ornamented by the singer). Written in the *galant* style—a clear, elegant, and direct approach to composition that dominated this era— it is arguably equal in quality to that of any adult composer active at the time. After hearing this and another aria by the young composer (*Va, dal furor portata*, K. 21/19c), the writer Friedrich Melchior, Baron von Grimm, predicted that "the boy would have an opera performed in an Italian theatre before he was twelve." Grimm was slightly off, but not by much: Mozart's first opera for an Italian theater, *Mitridate, re di Ponte*, received its first performance, in Milan, on December 26, 1770, when the composer was fourteen.

In Leopold Mozart's list of his son's works, this aria appears as No. 2 of "15 Italian Arias, composed in London and The Hague." The text, from act 1, scene 1, of Pietro Metastasio's libretto *Artaserse* (1730), is the farewell that Artaserse's sister, Mandane, addresses to her lover, Arbace:

> Conservati fedele;
> Pensa ch'io resto, e peno,
> E qualche volta almeno
> Ricordati di me.
>
> Ch'io per virtù d'amore,
> Parlando col mio core,
> Ragionerò con te.

Stay faithful;
Think how I remain here,
 and grieve,
And sometimes at least
Remember me.

While I, by virtue of love,
Talk to my own heart
And converse with thee.

The manuscript comprises six sheets and eleven written pages. Based on comparisons with contemporary examples of the composer's handwriting, Raphael Georg Kiesewetter (in 1815), and Aloys Fuchs and Abbot Maximilian Stadler (both on December 7, 1832), authenticated the score on the title page and its verso. The composer signed the first page of the score ("di Wolfgango Mozart") but did not inscribe the title page. Scholars believe that Mozart wrote everything here except for the initial instrument indications, the clefs, and the accidentals, which were penned by his father. Another autograph of the aria, thought to be somewhat earlier, is in the Bibliothèque Nationale, Paris. A copy of the aria in Leopold Mozart's hand is found in the Bayerisches Staatsbibliothek, Munich. Ludwig Ritter von Köchel gave the aria the number K. 23 in his chronological thematic catalog of Mozart's oeuvre.

This manuscript was bequeathed to the Newberry by Claire Dux Swift (1885–1967), an internationally renowned soprano who sang with the Chicago Civic Opera beginning in 1921. Related to Clara Schumann, she was the wife of Charles H. Swift, son of the founder of the meatpacking company. D. J. B.

110

Wolfgang Amadeus Mozart
Conservati fedele

The Hague, 1765
Manuscript
9¾ × 12⅞ in.
Bequest of Claire Dux Swift, 1967
Case MS 6A 48

111

Giuseppe Valisi

Chicago Day Waltz
October 9th, 1893

Chicago: Valisi Bros., 1893
Sheet music
14 × 11 in.
J. Francis Driscoll Collection
of American Sheet Music, 1968
Case Sheet Music M32. V35 C55

OCTOBER 9, 1893, was Chicago Day at the World's Columbian Exposition. Huge crowds converged on Jackson Park to honor and celebrate the city's proudest achievement on the anniversary of its greatest calamity, for only twenty-two years earlier it had burned in the devastating fire of 1871. Now, however, Chicago rejoiced in its recovery as host to the wondrous Dream City. At a noontime ceremony Mayor Carter Harrison, Sr., was presented with the original deed to the site of Chicago. This was followed by parades and celebrations lasting into the night. With a documented attendance of more than 700,000, Chicago Day set a new record, with more than twice as many visitors as on July 4, the fair's busiest day until then.

Chicagoan Giuseppe Valisi (dates unknown) composed *Chicago Day Waltz*, sheet music for solo piano, in honor of Chicago Day's tremendous success. The sheet music's cover, a lithograph by the Orcutt Company of Chicago, depicts a bird's-eye view of the Court of Honor, looking west over the Grand Basin toward the gold-domed Administration Building. The Electricity Building, Mines and Mining Building, and Machinery Hall extend past the Administration Building and fade into a hazy pink horizon, perhaps indicating the onset of evening. In the foreground, uniformed groups parade in neat rows around the Great Basin, while throngs of fairgoers crowd the paths extending westward into the distance. Inside, printed above the music, is a caption: "Attendance 716,881."

Valisi dedicated his composition to Lena Burton Clarke, chairman of the Committee on Music in the Woman's Building, who developed for the fair a well-received series of afternoon concerts featuring women and girls. Designed to promote amateurs, the concerts excluded professional performers and required an extensive try-out process, which included final approval by a jury consisting of musicians chosen by Theodore Thomas, musical director of the exposition (see no. 112). Clarke worked closely with Bertha Honoré Palmer, president of the Board of Lady Managers of the Fair. For Palmer, Valisi composed another work, *Columbus Day Waltz*.

Following the World's Columbian Exposition, the California Midwinter International Exposition opened in San Francisco during the winter of 1894, featuring many exhibits and attractions transferred from the Chicago Fair. For this event, Valisi composed *The Tower Waltz*, commemorating the Electric Tower, a dominant structure at the Midwinter exposition.

Chicago Day Waltz is one of the Newberry's many fair-related musical holdings, including *Song of the Ferris Wheel*, *Chicago World's Exposition Grand March*, and *Afternoon at Midway Plaisance: Fantasie for Piano*. Most of these compositions are marches or waltzes, reflecting popular musical trends of the time, and the sheet music often includes an image of the fair. *Chicago Day Waltz* is part of a large collection of sheet music that came to the library in 1968 from the heirs of J. Francis Driscoll (1875–1959). It was given a separate catalog entry to highlight its uniqueness. The Newberry's sheet-music collection adds another dimension to World's Columbian Exposition research and complements correspondence (see no. 34), diaries, souvenirs, photographs, and pictorial works also found in the library. K. K.

THEODORE THOMAS (1835–1905) was famous well before coming to Chicago in 1891 to become the first conductor and music director of the Chicago Orchestra. After his death, the orchestra was renamed the Theodore Thomas Orchestra in his memory. Its name changed once again, in 1913, when it became the Chicago Symphony Orchestra. Thomas helped to shape classical music in Chicago and in the United States with his superior orchestras' excellent concerts and regular national touring. In addition, he befriended many famous European composers, including Berlioz, Grieg, Liszt, and Saint-Saëns. The conductor had met Antonín Dvořák (1841–1904) in Berlin in 1867 during a two-month holiday in Europe, and he was a vigorous proponent of the Czech composer's work. When Thomas became musical director of the 1893 World's Columbian Exposition, he invited Dvořák to Chicago to conduct his Eighth Symphony (opus 88) at the fair, which he did on August 12, 1893.

This letter dates from four months earlier, when Thomas led the Chicago Orchestra and the Apollo Musical Club in Dvořák's *Requiem* (opus 89) at the city's Auditorium Theatre. Thomas had conducted the work at the Cincinnati May Festival on May 28, 1892, and again at the Auditorium Theatre on April 10 and 11, 1893. News traveled fast to Dvořák, who wrote on April 14, "You have taken much pains and trouble in preparing and performing my work, and therefore I feel it my duty to extend to you my heartfelt thanks."

Along with letters to Thomas and some personal materials, the Newberry also houses scrapbooks of all of the programs Thomas conducted from 1864 through 1903. His personal classical-music library—once considered to be the largest of its type in the world—comprised first editions, rare full scores, and monographs, most of which Thomas's widow and children gave to the Newberry in 1908. A. H.

112

Antonín Dvořák
Letter to Theodore Thomas; Calling Card

New York, July 17, 1897;
Prague, April 14, 1893
Manuscript; Calling card
6⅞ × 9 in.; 2¾ × 4½ in.
Oakley Fund, 1952
Midwest MS Thomas, Box 1, Folder 30

113

Scott Joplin

Euphonic Sounds:
A Syncopated Novelty

New York: Seminary Music Co., 1909
Sheet music
13⅝ × 10⅝ in.
J. Francis Driscoll Collection of
American Sheet Music, 1968
Driscoll Box 273

THE "KING OF RAGTIME WRITERS," Scott Joplin (1867 or 1868–1917) had already made his mark on American music history by the time he wrote *Euphonic Sounds*. Ten years earlier, his *Maple Leaf Rag* had been published by a small firm in Sedalia, Missouri, and had rapidly gained in popularity, igniting the nationwide ragtime craze.

Joplin, the son of a former slave and a free woman, came from a musical family and studied piano as a young boy with a German-born classical pianist in his hometown of Texarkana, Texas. Through the 1880s and '90s, he eked out a living as an itinerant musician. It has been said that he performed in Chicago during the World's Columbian Exposition of 1893, working in cafés as well as seedier establishments on and off the Midway. The music he played was later called ragtime, and while the origins of the term are in dispute, ragtime music is an unmistakable and irresistible hybrid of European classical dance forms (such as the waltz and the march) and African American melodies and syncopated rhythms. Joplin utilized what he learned as a boy studying classical music and his experiences as a traveling musician to compose the most enduring and beloved ragtime pieces ever written.

From the late 1890s through the 1910s, ragtime was the style of music played and sung in parlors across the United States, and was the reason Tin Pan Alley, the sheet-music publishing district in New York City, was so financially successful. By 1909 Joplin had published more than four dozen rags and other piano tunes and at this point was stretching the boundaries of what were considered traditional ragtime pieces. He worked hard to rid the music of its reputation as a type suited only for bars and brothels; his exceptional compositional skills helped to give ragtime a more respectable air. *Euphonic Sounds* (notably, the title does not include the word "rag") is an unconventional work filled with unusual harmonies and technically difficult passages that was considered a challenge for any pianist. The cover illustration—showing a well-dressed, white audience at an orchestral performance presumably of this composition—further suggests the desire to present Joplin's music as suitable for sophisticated and elegant listeners. The cover includes a medallion portrait of the composer so that potential sheet-music buyers knew it was an authentic Joplin piece.

The Newberry acquired the J. Francis Driscoll Collection of American Sheet Music from Driscoll's children in 1968. Driscoll (1875–1959) was a Boston-based civil engineer, organist, and choral director with a passion for sheet music. His children recalled spending many Saturdays trailing after their father as he made the rounds of book dealers, pawn shops, junkyards, and auction houses. The Driscoll Collection consists of well more than 80,000 pieces of sheet music, divided into twenty sections by the collector, with many further subdivisions under each main section. He filed this piece under "Dancing and Ballet," subdivision "Ragtime." A.H.

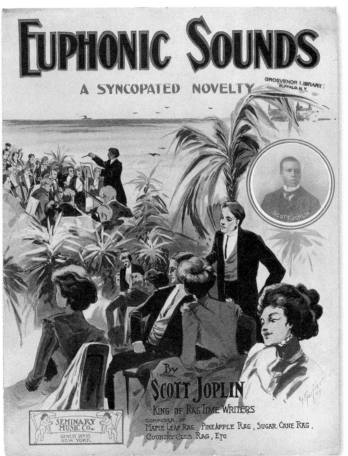

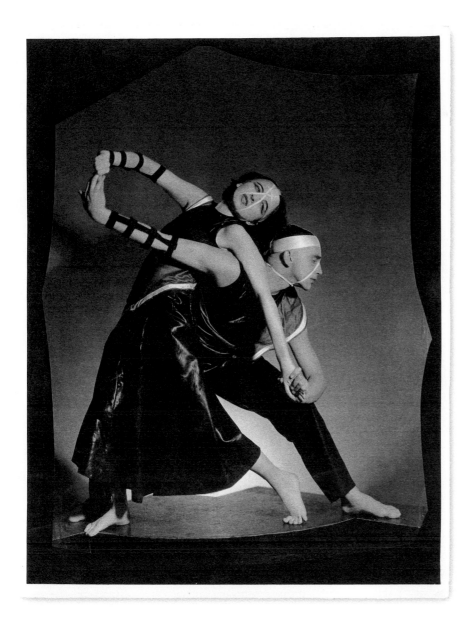

Maurice Seymour

Ruth Page and Harald
Kreutzberg in *Bacchanale*

Chicago, c. 1934
Photograph
10¼ × 8 in.
Gift of Ann Barzel, 1982/2005
Dance MS Barzel Research,
Photographs, Box 54

Here the two are shown in *Bacchanale*, a piece they choreographed to music by Gian Francesco Malipiero (1882–1973), which debuted at Orchestra Hall in Chicago in 1934. In direct contrast to its title, the piece was angular and exacting, suggesting modern functional architecture. Artist, critic, and dancer Mark Turbyfill, whose papers are at the Newberry, remarked that *Bacchanale*'s "sections fit together with the precision of ingenious gadgets in a prefabricated house."

This photograph is one of many prints in the Newberry by the Chicago-based photographic

WHEN EUROPEAN-BORN dancer and performance artist Harald Kreutzberg (1902–1968) and American-born ballerina and choreographer Ruth Page (1899–1991) joined forces, the result was a perfect synthesis in dance of old and new, grotesque and sublime, earthy and surreal. A native of Bohemia, Kreutzberg studied with Mary Wigman, the leader of modern dance in Germany. Page was born in Indianapolis and studied with Adolph Bolm in New York. She later danced in Anna Pavlova's company (see no. 115) and Sergei Diaghilev's Ballets Russes before making her artistic home in Chicago for the remainder of her long career. Kreutzberg and Page, both visionaries, combined their considerable talents to create works whose bold combinations of traditional ballet and modern dance captivated audiences. Their four-year collaboration (1932–1936) is an understudied chapter in the history of dance.

firm Maurice Seymour. According to their donor, Ann Barzel (see no. 115), the photo studio was founded by brothers Maurice and Seymour Zeldman; combining their first names into a trade name, "Maurice Seymour," they created quite a bit of confusion over the years, since no such individual actually existed. The brothers were renowned for the stunning photographs of dancers, actors, and entertainers they made from the 1930s through the 1970s. Barzel confided to her friends that her holdings of Maurice Seymour photographs were headed to a dumpster and would have been lost forever had she not intervened. Regardless of how she obtained them, thanks to her generosity the Newberry has a multitude of priceless Maurice Seymour photographs of the Ballets Russes, the Littlefield Ballet, José Greco, the American Ballet Theater, the Sadler's Wells Ballet, Kreutzberg, Page, and numerous other soloists and dancing duos. A. H.

115

Anna Pavlova: Program,
Toe Shoes, Photograph

Program: Chicago: Midway Gardens,
week commencing June 19, 1915;
toe shoes, before 1917;
photograph: London: Lafayette, undated
7 ¾ × 5 ¼ in.; 8 ½ × 2 ¾ × 2⅞ in.;
8⅜ × 6½ in.
Gifts of Ann Barzel, 1982/2005
Dance MS Barzel Research, Subject Files,
Box 341; Artifacts, unnumbered box;
Photographs, Box 35

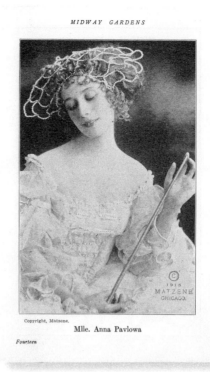

FROM 1910 ON, Anna Pavlova (1881–1931), the world's most famous ballerina, toured the United States, making several appearances in Chicago with the Imperial Russian Ballet and Sergei Diaghilev's Ballets Russes. Pavlova established her own touring company in 1913 and performed constantly, especially throughout North and South America, in the years during and following World War I. For many, Pavlova was the first ballet dancer they had ever seen, and her grace and artistry inspired hopeful young dancers worldwide. The "Divinity of the Dance," as she was sometimes called, performed at the Frank Lloyd Wright-designed Midway Gardens in the summer of 1915. The European-style concert garden, located at 60th Street and Cottage Grove Avenue in Chicago's Hyde Park neighborhood, had opened the previous year (it struggled financially and was torn down in 1929). A critic at the time remarked on the beauty of the building and its landscaping, and the comparable beauty of Pavlova's dancing, calling the former a "miracle of architecture" and the latter "mingled light and air and grace and harmony. . . ."

Pavlova's impact on Chicago would have far-reaching consequences. Two members of her troupe, Andreas Pavley and Serge Oukrainsky, relocated permanently to the city in 1917 to become ballet masters at the Chicago Grand Opera Company; later they founded their own influential touring company. Midwesterner Ruth Page, who would establish herself as a major force in Chicago dance (see no. 114), was in Pavlova's touring company from 1918 to 1919.

This lineage continued with Chicago-based dance critic and teacher Ann Barzel (1905–2007), who enjoyed an enduring friendship with Page. The core of the Ann Barzel Dance Research Collection, which Barzel hand-carried to the Newberry weekly between 1982 and 2005, is a vast personal archive relating to dance of all types, all time periods, and many parts of the world. Barzel collected brochures, press clippings, flyers, programs, souvenir books, and other ephemera related to dance performances (see no. 114); it is thanks to her ninety years of collecting that the library has such rare items as this program and photograph. The toe shoes worn by Pavlova, which the ballerina presented to Page in 1917, subsequently passed from Page to Barzel. A. H.

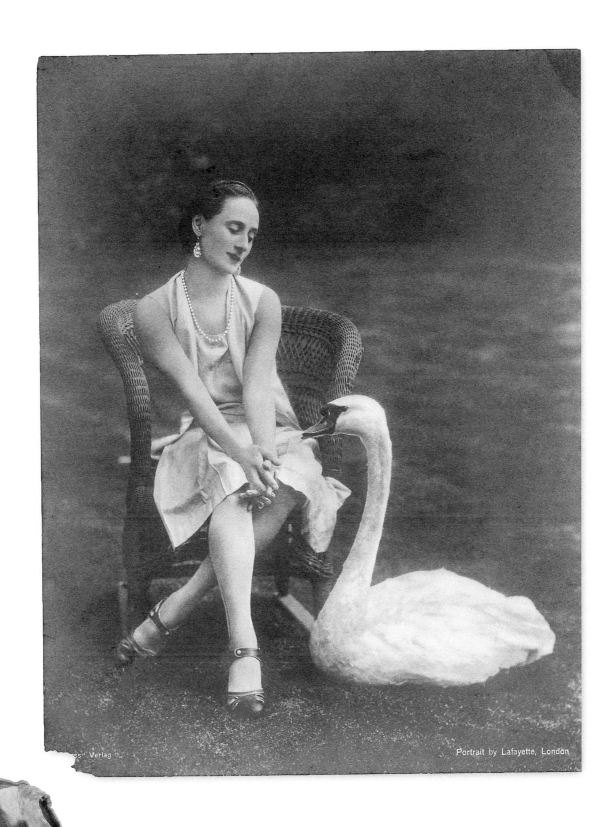

Portrait by Lafayette, London

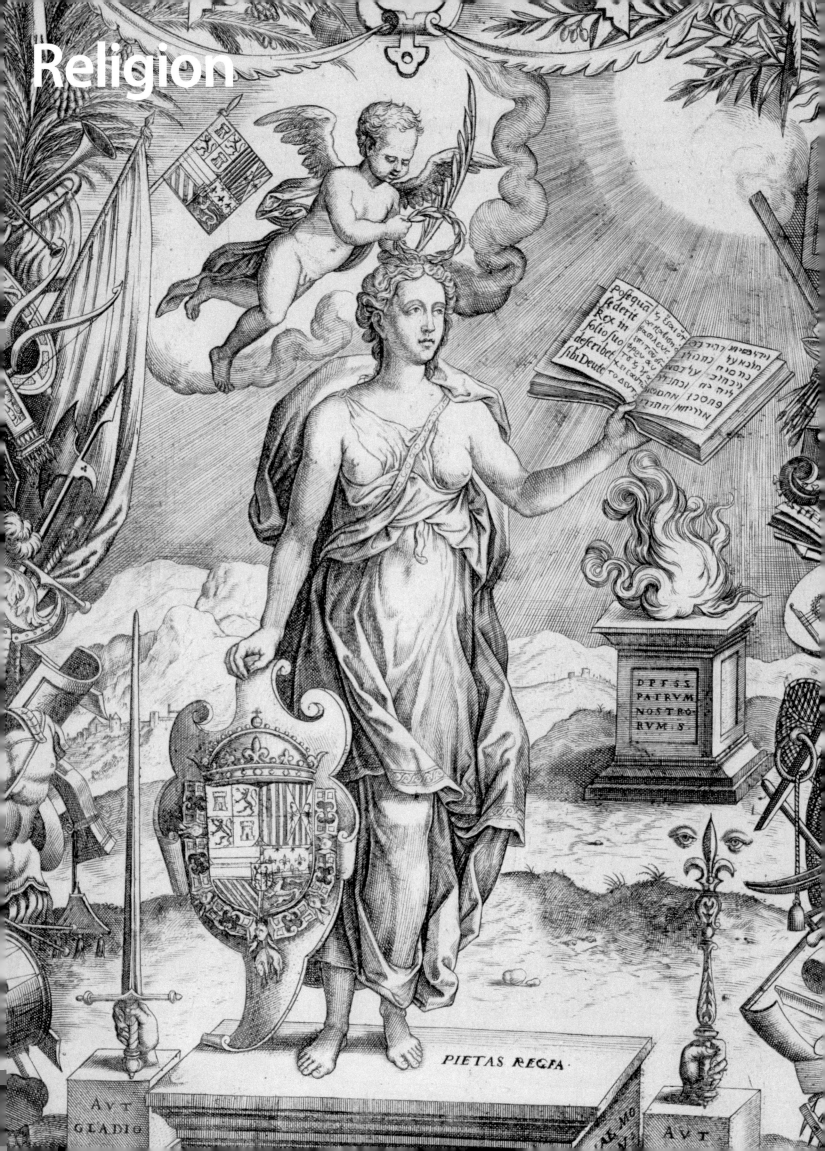

Religion

PIETAS REGIA

AVT GLADIO

AVT ... AVT

Pseudo-Augustine
Fragments of Sermons Attributed to Saint Augustine

Bern, Switzerland, late tenth century
Manuscript
14 × 20⅞ in.
Gift of Roger Baskes, 2003
Pre-1500 MS 200

THE NEWBERRY's acquisition of this manuscript is the result of the sharp eye of Roger Baskes, local bibliophile, devoted Newberry patron, and a former chairman of the Newberry's board of trustees. One day in 2003, Baskes telephoned the Newberry to say that he had spotted on eBay a copy of *Itinerarium filiorum Israel ex Aegypto in terra remissiones* (1621) by Sebastiao Barradas (d. 1615). In itself, this book was a worthy candidate for acquisition, as no American library at the time held a copy. However, it was not the printed book but the hint of a manuscript visible through the front cover on the exterior of the binding that caught Baskes's attention. It looked as though a manuscript fragment had been used as covering material. Was it perhaps a Hebrew fragment of the book of Exodus, the subject of Barradas's printed tome? Or was it in Latin? Were there spaces between the words that would help date it? Nothing was certain, but Baskes's bid for the item was successful, and he presented it to the Newberry.

The Newberry's conservation staff dissected the volume's seventeenth-century binding by removing the covers and spine linings. The manuscript's text turned out to be in Latin, and the script Caroline. The conservators also found scraps of paper wrappers bearing the coat of arms of Bern, Switzerland. In light of this evidence, it was likely that the printed sheets of Barradas's text had been shipped from Antwerp up the Rhine by boat and then on to Bern, where they were bound. The manuscript fragments used for the binding's covers probably came from a dismembered codex that had once formed part of the library of one of the numerous Benedictine abbeys near Bern. Because the script was aerated—i.e., the individual words were not fully separated—the volume it came from surely dated from before the end of the tenth century, after which spaces between words were introduced into the practice of manuscript writing.

The text then had to be identified. Using digital reference tools, colleagues at the University of Notre Dame ascertained that it was actually made up of two fragments of sermons attributed falsely in the Middle Ages to Saint Augustine; both had been printed in the eighteenth century, but neither had been parsed by more current scholarship.

Thus, the assiduous efforts of a generous trustee; the skill of the Newberry's conservators; the expertise offered by a collaborating institution; and subsequent consultation with Armando Petrucci, a distinguished visiting Italian paleographer all contributed to our understanding of two early texts to which future scholars of early Christian writing must attend. P. S.

Pierre-Jean Olivi

Principia in sacram Scripturam

Southern France, c. 1325
Manuscript
11¼ × 8⅞ in.
Purchased jointly with the
University of Notre Dame;
gifts of William and Joan Brodsky and the
B. H. Breslauer Foundation, 2011
Vault Folio Case MS 217

THE UNLIKELY acquisition of this early fourteenth-century codex containing at least two short texts by Pierre-Jean Olivi (1248–1298) can be attributed to the author's heretical career: Olivi was a Franciscan friar who, in the late thirteenth century, taught at the University of Montpellier, where he became leader of the Spiritual Franciscans. The Orthodox Franciscan order condemned his writings in 1299 and decreed that they be burned. As a result, only a few manuscripts containing Olivi's texts survive. *Principia in Sacrum Scripturam* (Foundations of Holy Scripture) is likely the oldest of these. Since it was transcribed in Provence, its origin is the closest geographically to the author, whose name, for understandable reasons, it does not bear. The contents include Olivi's explication of the Book of Revelation, a subject dear to medieval heretics and sixteenth-century radical Protestants. Other still-unidentified texts in the volume may well be Olivi's compositions, making this recent acquisition critical to the study of radical medieval theologians who were precursors to the Protestant Reformation. (Olivi was among the heretical authors cited in Umberto Eco's celebrated 1980 novel *The Name of the Rose*.)

The *Principia* was purchased through the Newberry's Joint Acquisition Program, which began in autumn 1995, when Kent Emery, professor of medieval history at the University of Notre Dame, spotted in a German antiquarian catalog a medieval manuscript containing the Carthusian Rule, the philosophical statement of the Carthusian order of monks founded in 1084. Professor Emery wondered whether or not the Newberry would be interested in purchasing the manuscript with the aid of the Medieval Institute of Notre Dame. While that item was sold before the Newberry and Notre Dame were ready to buy it, a highly useful concept had been created, and the Joint Acquisition Program born. The program, which fosters collaboration between the Newberry and universities across the country, has led to the purchase of thirty-eight rare books and manuscripts that the Newberry might not otherwise have been able to bring to Chicago and the Midwest. In spring 2011, Professor Emery called the Newberry again—to bring to the library's attention this codex including Olivi's texts. P. S.

IN MARCH 2002, the Newberry learned of the National Trust for Historic Preservation's decision to sell the little-known rare-book collection of the railroad tycoon Jay Gould (1836–1892), long stored in the library of Gould's former home, Lyndhurst, in Tarrytown, New York. Many titles were beyond the Newberry's scope, but at least a dozen items seemed of sufficient potential interest to warrant further investigation. Especially exquisite was a Book of Hours, which stood out because of an orange color used in the margins (rare in fifteenth-century illuminated manuscripts) and ten large illuminations of a peculiar beauty. By December 1, 2002, fourteen friends of the library had volunteered to raise the requisite funds to purchase eight items from Gould's collection: the Book of Hours, another manuscript, and six incunables.

The books arrived in early spring 2003. A brief article in the Newberry's newsletter announcing their purchase, illustrated by a fuzzy black-and-white illustration of the Gould Hours, appeared just before Christmas 2003 and attracted the attention of James Marrow, professor

118

Marc Coussin
The Gould Hours

Valenciennes, France, c. 1460
Manuscript
8⅝ × 6⅜ in.
Joint gift of fourteen donors, 2003
Vault Case MS 188

emeritus of art history at Princeton University. Since the volume observes the Use of Rome (i.e., the liturgical customs sanctioned by the pope), its provenance was not easily identifiable; but Marrow believed that the book had been copied and illuminated in Valenciennes by Marc Coussin, a little-known master illuminator (active in the mid-fifteenth century) about whom the professor and a colleague were preparing a monograph. Marrow's hunch, however uncertainly supported by the blurry image in the newsletter, was vindicated when he came to the Newberry in autumn 2004 to examine the codex. Marrow identified the illuminations as the work of Coussin, and declared it a lost masterpiece. P. S.

Missale Fratrum minorum secondum consuetudinem Romanae Curiae

Central Italy, c. 1472
Book and manuscript
13½ × 9¾ in.
Henry Probasco Collection, 1890
Folio Inc. 7428.5

THE MOTIVATIONS for choosing the printing press over the scriptorium for the dissemination of texts were varied. In the initial period of incunable production, the ability of the press to rapidly print a large number of copies was not always the main reason to use the technology. This was especially true for liturgical books such as missals and breviaries, of which only a limited number of copies were required for use in a particular diocese or province. For such books, uniformity of content was the primary concern. It was essential that each feast day be observed in the same way in each church of a single jurisdiction, and this could happen only when liturgical books were textually identical. During the Middle Ages, much labor was expended in a continual effort to update and make uniform the contents of missals, breviaries, and other service books. Printing solved this problem. In order to appear like manuscripts, these new volumes were printed on vellum and decorated by hand. The rigor with which these early printed liturgical books were made to resemble manuscripts makes distinguishing printed pages from written ones a near-impossible task.

Since this missal's calendar of religious events to be observed does not include the Feast of Saint Bernardino of Siena (established in 1472), it would appear that it is the earliest missal ever printed using movable type. Moreover, as a hybrid of manuscript and print, it is almost certainly a unique example of the very first printed missal.

This volume, whose assigned title translates as "Franciscan Missal according to the Use of the Roman Court," was purchased in 1890 as part of the vast collection of Henry Probasco. Following the United States Civil War, Probasco roamed Europe and bought an enormous quantity of beautiful books at moderate prices—sometimes, as in this instance, because they were mutilated by the excisions of some illuminations. The catalog of what he purchased on his shopping sprees reveals that, in many instances, he knew not what he bought. Rather, he was guided by good fortune and, often without knowing it, acquired manuscript and early printed volumes of monumental importance in terms of both their content and the mode of their production. William Frederick Poole, the Newberry's first librarian, had become familiar with Probasco's collection during his earlier tenure as librarian of the Cincinnati Public Library; he knew how good the collection actually was and negotiated the purchase. P. S.

Abraham ben Meir de Balmes

Mikneh Abram, Peculium Abrae: Grammatica Hebraea

Venice: Daniel Bomberg, 1523
Book
8⅜ × 6⅝ in.
Gift of McCormick Theological Seminary, 2008
Wing ZP 535 .B633

enjoyed the patronage of Pope Leo X. Bomberg was well versed in both the Christian and Jewish traditions of book-making. Like a Hebrew book (and unlike numerous other contemporary Gentile Latin/Hebrew grammars), this volume is to be read from back to front and right to left; thus, the title page is found at what we would usually term the end of the volume. However, following certain standards of medieval Christian codices, Bomberg used Arabic line numbers to guide the reader's eye fluidly from the unfamiliar characters of the Hebrew text on the left to the Latin version on the right of each opening.

MIKNEH ABRAM (Heritage of Abraham; in Latin, *Peculium Abrae*) represents a major thrust of the Newberry's collection development over the last two decades: the acquisition of Renaissance Hebraica to augment the library's great strength in this historical period, an awareness of which was kindled by the 1997 exhibition "The Hebrew Renaissance." Abraham ben Meir de Balmes (d. 1523), a native of southern Italy and a Jew, was steeped in the ethos of Italian humanism. He translated a number of Arabic works on logic and geography into Latin from their Hebrew versions, and he was the principal author of *Mikneh Abram*, which integrates Jewish grammatical learning into a humanist paradigm for the study of language based on Greek and Latin. Balmes composed this Hebrew/Latin volume at the request of Daniel Bomberg (c. 1483–1553), a Christian printer of Hebrew texts who

Christian seminaries and colleges, especially in the nineteenth century, had a keen interest in collecting Hebrew Bibles, concordances, and grammars, whether the authors were Jews or Gentiles. This grammar is one of several rare Hebraica volumes in the Newberry that were owned by Lane Theological Seminary in Cincinnati, which was absorbed by the McCormick Theological Seminary during the Great Depression. Lyman Beecher (the father of Harriet Beecher Stowe) taught theology at Lane, served as its first president, and doubtless helped to build the seminary's collection. In 2008 McCormick donated to the Newberry its entire rare-book collection, including twenty-one Hebraica titles from the seventeenth century and earlier. The collection has been fully cataloged thanks to a generous grant from the Bernard H. Breslauer Foundation. P. S.

121

Morys Clynnog

*Athravaeth Gristnogavl,
Le cair ụedi cynnụys yn
grynnoʻr hoḷ briſbynciau
syḍ i gyfârụyḍo dyn ar
y phorḍ i baradụys*

Milan: Vincenzo Girardone, 1568
Book
6⅛ × 4 in.
Prince Louis-Lucien Bonaparte Collection,
1901
Bonaparte 7924

LOUIS-LUCIEN BONAPARTE (1813–1891), nephew of Napoleon I, was raised in Italy, where he briefly attended the Jesuit college at Urbino before becoming interested in science. By the 1840s, Bonaparte had turned his attention to the study of languages; his book *Specimen lexici comparativi* (1847) was a pioneering work on comparative linguistics. After a brief political career in France, Bonaparte settled permanently in London in the 1850s, amassing an enormous library that was well known in his lifetime. The catalog of his collection, which appeared in 1894, three years after his death, reveals that, while Bonaparte was broadly interested in comparative linguistics, he was most attracted to minority languages and linguistic isolates, notably Basque, as well as the Celtic languages, particularly Welsh. Moreover, the catalog shows that, while Bonaparte amassed thousands of modern books about language, he also acquired rare early volumes, as well as specimens of popular printed works representing languages as they were spoken in the nineteenth century. In 1901 the Newberry acquired Bonaparte's library, numbering more than 18,000 items. The collection continues to serve scholars not just of linguistics, but of popular culture, religion, music, and printing history, among other subjects.

One book that has tantalized scholars is perhaps the most important Welsh book in Bonaparte's collection. *Athravaeth Gristnogavl* (Christian Doctrine), a Counter-Reformation catechism, was compiled by Morys Clynnog (c. 1525–1580), with an introduction by Gruffydd Robert (before 1532–after 1598). Both were ardent Roman Catholics: Clynnog was chaplain to Cardinal Reginald Pole, bishop-elect of Bangor and the first rector of the English College in Rome, while Robert was a humanist scholar who in 1567 wrote the first Welsh grammar (the Newberry owns one of six extant copies).

Clynnog and Robert produced the book while living in Milan as recusant exiles, owing to the change of the state religion under Elizabeth I. There is no indication of publisher, presumably because the volume was subsidized by its authors, but scholars have speculated that it was printed at the Milanese press of Vincenzo Girardone.

Athravaeth Gristnogavl was compiled from several sources, including a catechism composed by the Jesuit theologian Diego de Ledesma (1519–1575). Ledesma's work was translated into various languages, one of the first being Clynnog's 1568 edition. While the print run is uncertain, and a number of copies were evidently in circulation in the 1570s, the Newberry now holds the sole surviving example. The book is of particular significance to scholars of Counter-Reformation church history and Recusant printing on the Continent, as well as to philologists; moreover, when considered with other Welsh books in the library's collection, it provides insight into Bonaparte's collecting habits as a student of minority languages. J. G.

THE FIRST BIBLE printed in North America, in 1663, was not in English but rather in the Algonquian language known as Massachusett (also called Wampanoag). Its translator, John Eliot (c. 1604–1690), was born in Widford, England, but made his mark as a missionary to the Algonquian-speaking communities of the Massachusetts Bay Colony, where he earned the epithet "The Apostle to the Indians." After graduating from Cambridge University, Eliot, like many dissenting English Protestants, emigrated to New England in 1631 during a period known as the Great Migration. For those Protestants imbued with belief in the universality of the Gospels, it was imperative that the Bible be rendered in the vernacular for the nations indigenous to the Americas and beyond, just as it had at the beginning of the Reformation in England when people began to demand the Bible in their own language (not to mention the partial translations of John Wycliff and William Tyndale, medieval English theologians who at different moments attempted to translate portions of the Bible but were persecuted for doing so).

It is perhaps easy to overlook just how daunting Eliot's task was when today we see Bibles translated into any variety of American Indian languages. They seem at first glance to be translations like any other, though ones that remain hermetically sealed to all but a handful of specialists and native speakers of those languages. Eliot had to master far more than an extensive vocabulary in an Indian language; he first had to invent an orthography, discern the inherent grammar of a language that had hitherto never been written, understand its idioms, and identify those non-cognate elements that would prove recurring impediments. The project required nearly ten years to complete.

Eliot went on to produce both a grammar (1666) and a logic primer (1673) in Massachusett to help missionaries become familiar with the language. He also established several so-called Praying Towns in the Bay Colony, where converted Indians lived under self-rule. In 1675 the bloody conflict we have come to know as King Philip's War broke out between an alliance of indigenous nations, led by Metacom, and the New England Colonies and their Indian supporters (see also no. 21). Even though the Indians of the Praying Towns were allied with the English, the colonists distrusted their loyalty and incarcerated many of them on Deer Island in Boston Harbor. There the majority of them died from disease, starvation, and exposure.

While Eliot's mission seemed a failure, the majority of surviving Indians in New England eventually became Christians. Another paradoxical aspect of Eliot's Bible is that it now serves as a linguistic archive of sorts for the contemporary Wampanoag language reclamation project. Other indigenous-language Bibles in the Newberry might someday serve the same purpose. S. M. S.

122

The Holy Bible: Containing the Old Testament and the New. Translated into the Indian Language

Cambridge, Massachusetts: Samuel Green and Marmaduke Johnson, 1663
Book
7⅜ × 6¼ in.
Gift of Edward E. Ayer, 1911
Vault Ayer 421 M435 B5 1663

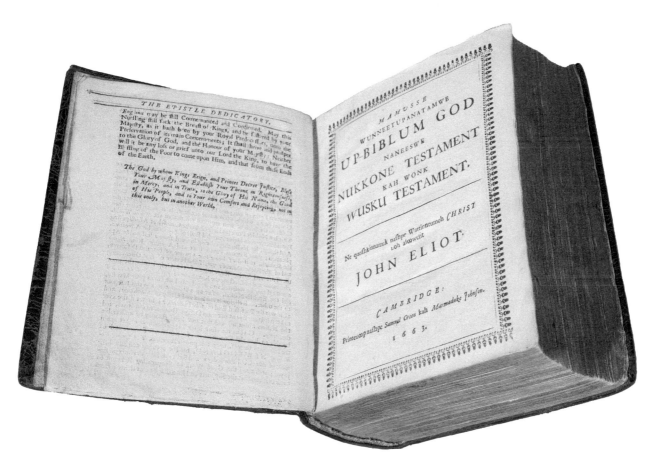

Biblia sacra, Hebraicae, Chaldaice, Graece et Latine . . .

Antwerp: Christophe Plantin, 1569
Book
17 × 11¾ in.
Wing Fund, 1945
Wing Oversize ZP 5465 .P7013

IT IS NO ACCIDENT that the first successful attempts to create a complete Bible in all the sacred languages of the ancient Near East that attest to the original texts (Aramaic, Greek, Hebrew, and Syriac) were made with the support of the kings of Spain. Charles I (r. 1516–1556), patron of the first such "polyglot Bible," was also the first monarch to be styled "His Catholic Majesty, King of Spain and the Indies," a title that implied defense of the faith as well as dominion in the Americas. This moniker was added to Charles's other titles, most importantly Holy Roman Emperor and duke of Burgundy, not to mention disputed claims to several kingdoms and duchies in Italy. So broad and complex a notion of monarchy accorded well with the ambitious goals of the compilers of a multilingual Bible, who wanted to use philology in the service of Christianity because it was understood as a universal and missionary faith.

Printing so long a text in multiple languages and scripts was complex and expensive. The first polyglot, in six large folio volumes, was produced in Spain in the 1510s under the direct supervision of Francisco Jimenez de Cisneros, archbishop of Toledo and regent for the young Charles I. It was a major achievement, and it both helped the next generation of scholars and stimulated a great deal of additional textual work. By the time advances in text criticism made a

new multilingual Bible a desideratum, the project was even larger and more costly. The new polyglot was conceived by Christophe Plantin (1520–1589), the leading printer of Antwerp in the Spanish Netherlands, who proposed to King Philip II (1527–1598) that he subsidize the project. Plantin had several motives. He had already published single-language Bibles in Latin, Greek, French, and Dutch, so he knew the technical challenges and understood the market for well-made critical texts. He was about to dissolve a successful long-term commercial partnership because his old backers were supporters of the Protestant cause. Plantin wanted to maintain his orthodox Catholic credentials in the part of the Low Countries under Spanish rule. He hoped as well to secure Philip's patronage for future publishing endeavors.

King Philip appointed his personal chaplain, Benito Arias Montano (1527–1598), as theological advisor to the Bible project. Montano and Plantin decided to illustrate the book with engravings, "lest anything be omitted that is pertinent to the beauty of so regal a work." Their concept of this splendidly royal book is perhaps best presented in the second frontispiece to the first volume, where Philip's *Pietas regia* (Royal Piety) is personified. A beautiful woman stands on a pedestal; she leans upon a shield with the king's arms and holds a book open to show the four languages on one page. The inscription identifies Philip with the warrior Joshua (who led the Hebrews into the promised land and conquered it) and says that the modern leader has erected this monument (his own piety and presumably also this Bible) to purify the faith and reestablish one true religion. P. F. G.

Institutio Christianæ religionis (*Institutes of the Christian Religion*), originally published in 1536 as a work of apology and instruction, grew longer as its author, John Calvin (1509–1564), augmented it across the several Latin editions that appeared before his death. By then it focused more squarely on preparing theology students to read the divine word. The Newberry's collection includes copies of the second Latin edition (1539), printed in Strasbourg by Wendelin Rihel, and Robert Estienne's revision of Calvin's fourth Latin version (1553), printed in Geneva. Calvin himself translated the text into French as early as 1541, and the Newberry has copies of several early translations into modern European languages. These Latin and vernacular editions make it possible to follow the development of Calvin's thinking about the *Institutes* over his lifetime. As a result of the gift of rare books by the McCormick Theological Seminary in 2008, the Newberry acquired a volume that provides unique insight into how scholars in the post-Calvin "early-orthodox era" were handling and reacting to the text.

This 1576 Latin edition was printed in Blackfriars, at the center of London, by the French émigré printer, binder, and bookseller Thomas Vautrollier (d. 1587). The project was a good fit for this Huguenot. He arrived in England in 1564 and quickly became a "brother" of the Stationers Company, printing some 150 books before his death in 1587. Most were religious and educational in nature, including many by Martin Luther and New Testaments in the Latin of Theodore Beza, a follower of and successor to Calvin. Vautrollier also served as an agent for Protestant literature coming from the Plantin press of Antwerp. In the case of Calvin, the printer produced five volumes, and perhaps 10,000 copies of the *Institutes* alone were in circulation from his presses.

Calvin had begun numbering the book's paragraphs with the fourth Latin edition, but he did not develop his own system of headings or summaries for a book that by 1559 had grown from six to eighty chapters. The 1576 London edition, featured here, provided the most extensive apparatus to date for the *Institutes*. Vautrollier himself aided serious students of the *Institutes* by creating cross-references within the text as well as a system of references for the two indexes that had been created earlier by Nicolas Colladon (*loci communes*; 1559) and Augustine Marlorat (biblical passages; 1562). Meanwhile, as Vautrollier's letter to the reader makes clear, Edmund Bunny (1540–1619), a Yorkshire Church of England clergyman and scholar, provided summary "arguments" for each of the four books into which the *Institutes* is divided, plus short, marginal subheadings for each of the chapters. Bunny's apparatus became the basis for the major editions that followed between 1590 and 1667; it was still influencing the presentation of Latin and translated editions into the twentieth century. Countless readers since 1576 therefore have had their understanding of the *Institutes* at least partially formed by Bunny's sense of a text that he himself said he found extremely dense. Vautrollier and Bunny collaborated on an abridged version in 1584, also in the McCormick Collection at the Newberry.

Twenty copies of the 1576 Latin edition are known. Of its 920 pages, 742 constitute Calvin's text itself and 178 are front matter and apparatus. Although the Newberry copy is missing its title page, it is heavily annotated throughout, including the indexes, in a small, difficult, late-sixteenth-century Latin hand. The margins of many pages are completely covered, although some annotation has been lost to trimming. At the end of Calvin's text, the annotator included a general critical note, dated November 7, 1584. Calvin could not have had a more careful reader or more influential editors. D. S.

124

John Calvin

Institutio Christianæ religionis

London: Thomas Vautrollier, 1576
Book
7½ × 4⅝ in.
Gift of McCormick Theological Seminary, 2008
Case BX 9420 .I58 1576

Francisco Ximénez

Las Historias del Origen de los Indios de Esta Provinçia de Guatemala ...

Santo Tomás Chichicastenango,
Guatemala, c. 1700/1715
Manuscript
12⅛ × 8⅝ in.
Gift of Edward E. Ayer, 1911
Vault Ayer MS 1515

THE POPOL VUH, variously translated as Book of the Council, Book of the Community, Book of the People, and the Sacred Book, is the creation account of the Mayan people. "Popol" is also defined as "woven mat," and "Vuh" (Vuj) as "book." The text weaves together Mayan stories concerning cosmologies, origins, traditions, and spiritual histories.

The Newberry's copy of the Popol Vuh was transcribed between 1700 and 1715 in Chichicastenango, Guatemala, by the Dominican priest Francisco Ximénez (1666–1729). A linguist, Ximénez was interested in the native Quiché (K'echi') language. Some scholars believe that Ximénez's copy was derived from an earlier version, probably prepared in the sixteenth century by a native speaker who had been taught Latin characters. The earlier forms of the text were codices or screenfolds with glyphs as aides-memoires. Ximénez's transcription uses Latin script to present the Quiché original and gives a side-by-side translation into Spanish; Quiché syntax, including word play, is far different from that of Spanish. The text, which almost appears to be free verse, was clearly designed to be presented orally. Ximénez's transcription of the Quiché is studded with corrections. It is possible that the text was recited, possibly by as many as three people, which would account for some of the repetition and strike-outs.

The Newberry's copy left Guatemala sometime after 1853, and ended up in France. It was acquired by Abbe Charles-Étienne Brasseur de Bourbourg (1814–1874), who used it to produce an edition of the Popol Vuh. At the sale of Bourbourg's collection in 1871, the manuscript was purchased by Alphonse Pinart (1852–1911). Portions of Pinart's distinguished collection, which was sold in 1883, found their way to a number of important libraries in the United States, including that of Princeton University and the University of California, Berkeley. At the sale, Edward E. Ayer acquired this copy of the Ximénez manuscript and

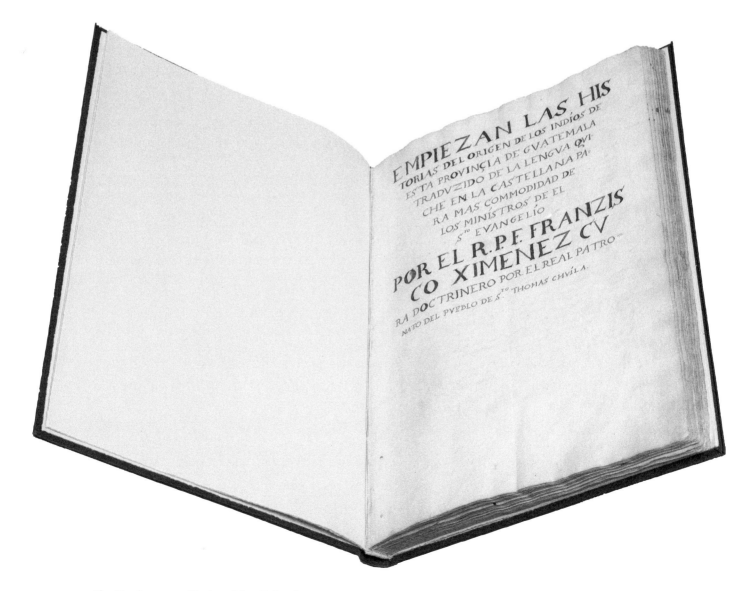

brought it to Chicago. It has been in the Newberry since 1911, soon after Ayer began donating items from his collection to the library.

To preserve the Popol Vuh and make it more widely available, the Newberry produced a digital facsimile of the manuscript and conserved all of the manuscripts by Ximénez that had been bound together with it. A multidisciplinary group of curators, librarians, conservators, and other experts began a dynamic collaboration that resulted in a deep understanding of the copy. The group reviewed the Popol Vuh's condition, formulated a treatment proposal that would provide appropriate conservation of the document and make high-quality scans. The plan included removing the existing binding and sewing, stabilizing the inks, cleaning and repairing the paper, and rebinding in a stable and flexible manner.

There was no documentation concerning the condition or appearance of the binding or text when it arrived at the Newberry, and the existing binding covers were not original, but rather added by Newberry binders in the 1930s or '40s. This binding restricted movement of the pages, putting undue stress on the paper, and obstructed areas of marginalia. Conservators felt confident about its removal, which would allow scholars to study the composition of all the manuscripts made available through the digital preservation copy. The handmade, laid paper, dating to the eighteenth century, was in good condition. Its flexibility made it a worthy candidate for rebinding. But there was still the difficult question as to whether or not the Popol Vuh should be rebound separately from Ximénez's other manuscripts. To more responsibly facilitate handling by both researchers and devotional users, conservators decided to bind the Popol Vuh and Ximénez's manuscripts separately.

In 2011 a delegation of Mayan people traveled from the mountains of Santo Tomás Chichicastenango to the Newberry for a two-day viewing and celebration of the Popol Vuh. During a special ceremony, the group blessed Newberry staff. José Luis Tigilá, spokesperson for the delegation, touched on the power of this sacred book to create a sublime moment of reflection for the Mayan people. "My heart is filled with emotion, and I've been disarmed by the forces that are present," he said. "Here are my ancestors, here in spirit; here are the past and present united through the physical form of this book." J. S. A. AND G. S.

About the Authors

All authors are on the staff of the Newberry Library, Chicago, unless otherwise specified.

Author Key

A. H.	Alison Hinderliter
A. M.	Autumn Mather
A. T.	Alex Teller
C. H.	Celia Hilliard
C. T. C.	Charles T. Cullen
C. Z.	Carla Zecher
D. B.	David Buisseret
D. D.	Diane Dillon
D. G.	Daniel Greene
D. J. B.	David J. Buch
D. S.	David Spadafora
E. C. H.	Edward C. Hirschland
F. E. H.	Frederick E. Hoxie
G. S.	Giselle Simon
J. B.	John Brady
J. C.	Jade Cabagnot
J. F. F.	Junia F. Furtado
J. G.	Jill Gage
J. M. D.	Jo Ellen McKillop Dickie
J. N. L.	John N. Low
J. R. A.	James R. Akerman
J. S. A.	John S. Aubrey
J. W.	Jack Weiner
K. K.	Kelly Kress
L. F.	Loretta Fowler
L. J.	Lisa Janssen
L. O.	Liesl Olson
M. B.	Martha Briggs
M. R.	Matthew Rutherford
N. H.	Neil Harris
P. D.	Philippe Desan
P. F. G.	Paul F. Gehl
P. J. P.	Father Peter J. Powell
P. S.	Paul Saenger
R. B.	Roger Baskes
R. E. B.	Rachel E. Bohlmann
R. K.	Rick Kogan
R. W. K.	Robert W. Karrow, Jr.
S. M. S.	Scott Manning Stevens

James R. Akerman
Director of the Hermon Dunlap Smith Center for the History of Cartography and Curator of Maps
Nos. 79–82, 90

James Akerman is the editor or coeditor of four collections of essays in the history of cartography, including *Cartographies of Travel and Navigation* (2006), *Maps: Finding Our Place in the World* (with Robert W. Karrow, Jr.) (2007), and *The Imperial Map: Cartography and the Mastery of Empire* (2009). He is editor for the series *Kenneth Nebenzahl, Jr., Lectures in the History of Cartography*, and he directed the creation of "Historic Maps in K-12 Classrooms," an online teaching resource that won a National Council for Geographic Education Geography Excellence in Media Award in 2004.

John S. Aubrey
Ayer Librarian
No. 125

John Aubrey has been with the Newberry since the early 1970s. His interests include Classical history, "people without books," early American texts, the *Geisteswissenschaften*, early Netherlandish painting, Friedrich Hölderlin, Rainer Maria Rilke, and Gottfried Benn.

Roger Baskes
Trustee, Former Chairman of the Newberry Library Board of Trustees
No. 89

An avid collector of atlases, travel guides and other books with maps, Roger Baskes is actively engaged in giving his collection to the Newberry. He and his wife, Julie, endowed the provision of services to readers in what has been named the Roger and Julie Baskes Department of Special Collections at the library. Baskes, a former president of the London-based International Map Collectors' Society, is currently a trustee of the Newberry and the American Trust for the British Library; he is a member of the Library of Congress's James Madison Council, Association Internationale de Bibliophilie, Caxton Club of Chicago, and Grolier Club of New York.

Rachel E. Bohlmann
Director of Public Programs
Nos. 36, 39, 42

Rachel Bohlmann is Director of Public Programs, a position she has held since 2004. She is an historian whose research focuses on United States social history during the late nineteenth and early twentieth centuries. She leads the Newberry's adult-education seminars, exhibitions, and public programs, including a committee of staff and programming colleagues that organizes the library's Bughouse Square Debates, an annual free-speech event held in Washington Square Park.

John Brady
Director of Reader Services and Bibliographer of Americana
Nos. 2–3, 7–9, 14–15, 32

John Brady manages the Department of Reader Services, which assists researchers at the reference desks, in the reading rooms, and beyond the Newberry's walls via e-mail, while also managing the collections in the library's stack building. As a bibliographer, he collects current monographs, antiquarian books, and manuscript Americana for the Newberry. Prior to arriving at the library, Brady worked in publishing and was an instructor at the City Colleges of Chicago, where he taught early-American history via fully interactive satellite technology, for members of the United States military stationed abroad (primarily in the Sinai Desert, Egypt).

Martha Briggs
Lloyd Lewis Curator of Modern Manuscripts
Nos. 10–11, 13, 16, 35, 37, 44, 47, 91

Martha Briggs oversees more than 800 manuscript and archival collections (including the Midwest Manuscript Collection, railroad and dance collections, Ayer Modern Manuscript Collection, and Newberry Library Archives). Her research specialty is United States social history, a focus that informed "'Everywhere West': Daily Life along the Chicago, Burlington and Quincy Railroad," the Newberry Spotlight Exhibition she cocurated in 2011. Briggs's most recent grant from the National Endowment for the Humanities is underwriting the arrangement, description, and preservation of the Newberry's CB&Q archives, materials that had spent sixty years in relative obscurity before being brought to light as part of "'Everywhere West."

David J. Buch
Professor Emeritus, University of Northern Iowa
Nos. 107, 110

David Buch has authored scholarly studies on a wide range of topics in music. His most recent book is *Magic Flutes and Enchanted Forests: The Supernatural in the Eighteenth-Century Musical Theater* (2008). His edition of the opera *Der Stein der Weisen*, with newly discovered music attributed to Wolfgang Amadeus Mozart, appeared as one of a series in 2007, and he is working on editions of four more operas for the series. Buch's next monograph is *Representations of Jews in the Musical Theater of the Habsburg Empire 1788–1807* (2012).

David Buisseret
Senior Research Fellow
No. 85

David Buisseret was a Research Fellow of Corpus Christi College at Cambridge University, where he specialized in sixteenth-century French history. In 1964 he went to teach at the University of the West Indies, Jamaica campus, where he researched and wrote about Caribbean history. In 1980 he came to the Newberry to direct the Hermon Dunlap Smith Center for the History of Cartography, leaving in 1996 to become the first Garrett Professor in the History of Cartography and Southwestern Studies at the University of Texas at Arlington. In addition to his continuing research activity at the Newberry, Buisseret is book-review editor for *Terrae Incognitae*, the journal of the Society for the History of Discoveries.

Jade Cabagnot
Program Coordinator,
D'Arcy McNickle Center for American Indian and Indigenous Studies
No. 29

Jade Cabagnot was born and raised in the Philippines. At the Newberry, she organizes scholarly and public programs for the McNickle Center, including the Newberry Consortium for American Indian Studies. In addition, she serves as a reference librarian at Indiana University Northwest.

Charles T. Cullen
President and Librarian Emeritus
No. 6

Charles T. Cullen is president and librarian emeritus of the Newberry, having retired in 2005. He joined the history department at the College of William and Mary and then at Princeton University in 1979. At William and Mary, he became editor of the papers of John Marshall, and at Princeton of the papers of Thomas Jefferson. For both projects, he pioneered the application of computers in historical editing. Cullen came to the Newberry in 1986, where he continued to pursue Jefferson research and the use of computers in the humanities. He currently serves as a member of the board of the Thomas Jefferson Foundation, which owns our third president's home, Monticello.

Philippe Desan
Howard L. Willett Professor, Department of Romance Languages
& Literatures and the Committee on the History of Culture,
University of Chicago
No. 97

Philippe Desan specializes in historical and sociological approaches to the French Renaissance. He is the author of *Les Commerces de Montaigne* (1992), *L'Imaginaire économique de la Renaissance* (2002), *Montaigne. Les formes du monde et de l'esprit* (2008), and *Bibliotheca Desaniana. Montaigne* (2011), among other books,. He has edited the *Dictionnaire de Michel de Montaigne* (2004, 2007), work rewarded by the Académie Française, and edits the journal *Montaigne Studies*.

Jo Ellen McKillop Dickie
Special Collections Services Librarian
No. 38

Jo Ellen McKillop Dickie has been in the library and museum fields for more than twenty years, sixteen of which she has spent in Special Collections at the Newberry. In addition to overseeing the daily operations of the Newberry's reading room, Dickie serves both the main reference and genealogy desks. She works closely with the railroad and modern manuscript collections, with a particular interest in collections related to popular culture. She has been a member of the Security Committee of the Association of College and Research Libraries' Rare Books and Manuscripts Section and is currently secretary of the Caxton Club of Chicago.

Diane Dillon
Director of Scholarly and Undergraduate Programs
Nos. 12, 88

The research fields of Diane Dillon include American art, architecture, and visual culture; world's fairs; the history of cartography; and Chicago's history and culture. Among her recent publications are "Indians and 'Indianicity' at the 1893 World's Fair," in *George De Forest Brush: The Indian Paintings,* ed. Nancy K. Anderson (2008); *Mapping Manifest Destiny: Chicago and the American West*, with Michael Conzen (2007); and "Consuming Maps," in *Maps: Finding Our Place in the World*, ed. James R. Akerman and Robert W. Karrow, Jr. (2007).

Loretta Fowler
Professor Emeritus of Anthropology, University of Oklahoma
Nos. 20, 24

Loretta Fowler is a cultural anthropologist and ethnohistorian who has studied politics, ritual, gender, and regional comparisons among Native Plains people. She has written six books and coedited one and is a past president of the American Society for Ethnohistory. Since 2006 she has been the ethnohistorian and editor of "Indians of the Midwest, Past and Present," a multimedia educational website produced by the Newberry and funded by the National Endowment for the Humanities. Fowler's work combines archival research, field studies, and oral history, and makes native peoples' perspectives central to her analysis.

Junia F. Furtado
Professor of Modern History,
Universidade Federal de Minas Gerais/Brazil
No. 86

Junia Furtado was named to the Joaquim Nabuco Chair at Stanford University in 2012. She has published several books and articles about Colonial Brazil and slavery, including *Chica da Silva: A Brazilian Slave of the Eighteenth Century* (2009; the Brazilian edition was *Honnor, Casa de las Américas* [2004]). Furtado was a visiting professor in the History Department at Princeton University in spring 2001 and at the École des Hautes Études en Sciences Sociales, Paris, in 2008.

Jill Gage
Reference Librarian
Nos. 54, 63, 98, 100–101, 121

In addition to providing reference services at the Newberry, Jill Gage is the library's specialist in British and American literature and book history. She has published work on various Newberry materials, most notably the library's large collection of extra-illustrated books. Gage has taught classes in the history of the book at Columbia College, Chicago. She is currently completing her Ph.D. dissertation on eighteenth-century English schoolboy authors.

Paul F. Gehl
Custodian of the John M. Wing Foundation on the History of Printing
Nos. 49, 52, 55–56, 58–62, 65–69, 71–76, 92, 94, 105, 109, 123

Paul Gehl is responsible for one of the largest collections on printing history, calligraphy, and design in North America. He is also an historian of education. He has published extensively on manuscript and printed textbooks of the Renaissance, the book trade, and modern fine printing and artists' books. Gehl's interactive online monograph, *Humanism for Sale: Making and Marketing Schoolbooks in Renaissance Italy*, has been hosted by the Newberry's Center for Renaissance Studies since 2008.

Daniel Greene
Vice President for Research and Academic Programs
No. 5

Daniel Greene is an historian who specializes in ethnicity, pluralism, and American identity. His book, *The Jewish Origins of Cultural Pluralism: The Menorah Association and American Diversity,* appeared in 2011. Before coming to the Newberry, he was an historian at the United States Holocaust Memorial Museum in Washington, D.C. Greene is an affiliated faculty member of the History Department at the University of Illinois at Chicago.

Neil Harris
Preston and Sterling Morton Professor Emeritus of History and Art History, University of Chicago
No. 43

Neil Harris's recent books include *Chicago Apartment Houses* (2004) and *The Chicagoan: A Lost Magazine of the Jazz Age* (2008). A life trustee of the Newberry, Harris has served on the boards of the American Council of Learned Societies, Terra Foundation for American Art, and Phi Beta Kappa Senate, and has chaired the Smithsonian Council. He is a Fellow of the American Academy of Arts and Sciences and received a Mellon Emeritus Fellowship in support of his latest book project, a study of J. Carter Brown and the National Gallery of Art (forthcoming).

Celia Hilliard
Independent scholar, Chicago
No. 41

A specialist in Chicago history, Celia Hilliard has an abiding interest in the city's cultural institutions and the luminaries who founded and nurtured them. Her study *The Prime Mover: Charles L. Hutchinson and the Making of the Art Institute of Chicago* appeared as an issue of *The Art Institute of Chicago Museum Studies* in 2010. She has contributed to several Chicago-history readers and compendia, including *Women Building Chicago: A Biographical Dictionary* (2001), for which she wrote the entries on the opera singer and impresario Mary Garden and the literary editor and bookseller Fanny Butcher.

Alison Hinderliter
Manuscripts and Archives Librarian
Nos. 112–15

Prior to serving as manuscripts and archives librarian, Hinderliter was a library assistant in Special Collections and a project archivist, working a variety of grant-funded archival initiatives, including the Newberry Library Archives, Pullman Railroad Company Records, Illinois Central Railroad Company Records, Ann Barzel Dance Collection, "Voices of the Prairie" (social-action-related collections), and "Headlines from the Heartland" (journalism-related collections). She has been in the archival field for more than twenty years, working for the Chicago History Museum, Chicago Public Library, Chicago Symphony Orchestra, and the city's Old Town School of Folk Music.

Edward C. Hirschland
Collector, Chicago
No. 31

Edward C. Hirschland has been collecting in the entire range of Chicago history since the mid-1970s. His focus is on nonfiction: books, maps, posters, autograph materials and ephemera. His collection was featured in *CityTalk*, a publication of WTTW, Chicago's educational TV network, in December 2002. A management consultant, Hirschland is president of The Landhart Corporation. He is on the boards of the Chicago Map Society, the College of Architecture at the Illinois Institute of Technology, and the local chapter of the American Statistical Association, as well as a former board member of the Adler Planetarium, Field Museum, and the Society of Architectural Historians. Hirschland is a member of the Caxton Club of Chicago and the Grolier Club of New York.

Frederick E. Hoxie
*Swanlund Professor of History, Law and American Indian Studies,
University of Illinois, Urbana/Champaign*
No. 30

Frederick Hoxie is the author or editor of more than a dozen books, including *A Final Promise: The Campaign to Assimilate the Indians 1880–1920* (1984, rev. edn. 2001), *The Encyclopedia of North American Indians* (1996), and most recently *This Indian Country* (2012). Hoxie first served the Newberry as director of the D'Arcy McNickle Center for American Indian History and then as vice president for research and education. He is also a professor in the Center for Advanced Study at the University of Illinois, Urbana/Champaign.

Lisa Janssen
Archivist
Nos. 33, 45, 48

Lisa Janssen has been an archivist at the Newberry for more than five years. She has worked with dozens of manuscript collections, ranging from personal papers to corporate records and from famous authors to rural families. She directed the reissue and the audio recording of Rudolph Wurlitzer's classic 1984 Hollywood novel *Slow Fade* (2011) and edited filmmaker Curtis Harrington's memoir, *Nice Guys Don't Work in Hollywood* (forthcoming). Her writing has appeared in *Women's Studies Quarterly,* Minneapolis *City Pages,* and *MAKE: A Chicago Literary Magazine*, among others.

Robert W. Karrow, Jr.
Senior Research Fellow
Nos. 1, 51, 78, 84

Robert Karrow worked at the Newberry Library for forty years, twenty-two of them as curator of Special Collections and curator of maps. He is the author of *Mapmakers of the Sixteenth Century and Their Maps* (1993) and of numerous articles, reviews, and exhibition catalogs. He coedited, with James R. Akerman, *Maps: Finding Our Place in the World* (2007). Karrow retired in 2011 but continues to work in cataloging and bibliography and serves as an associate editor for the fourth volume of the *History of Cartography* (forthcoming).

Rick Kogan
Writer, Chicago
No. 40

Rick Kogan has worked for the *Chicago Daily News*, *Chicago Sun-Times*, and the *Chicago Tribune*, where he is currently a senior writer and columnist. Named Chicago's Best Reporter in 1999 and inducted into the Chicago Journalism Hall of Fame in 2003, he is the creator and host of WGN Radio's "Sunday Papers with Rick Kogan." Among his many books are *Everybody Pays: Two Men, One Murder and the Price of Truth* (with Maurice Possley, 2001); *America's Mom: The Life, Lesson and Legacy of Ann Landers* (2003); *A Chicago Tavern*, the history of the Billy Goat (2006); and *Sidewalks I* (2006) and *Sidewalks II* (2009), collections of his columns illustrated with photographs by Charles Osgood.

Kelly Kress
Project Archivist
Nos. 34, 111

As part of the Modern Manuscripts staff, Kelly Kress has worked on three major National Endowment for the Humanities archival-processing projects, including the Chicago, Burlington & Quincy Railroad Company archives. Before arriving at the Newberry, she worked with music and folklore collections at the Southern Folklife Collection at the University of North Carolina, Chapel Hill.

John N. Low
*Assistant Professor, Department of Comparative Studies,
Ohio State University–Newark*
No. 26

John Low is an enrolled citizen of the Pokagon Band of Potawatomi Indians. He has authored several articles; most recently his essay "The Architecture of Simon Pokagon—In Text and on Display" was included in the 2011 reprint of Simon Pokagon's *Ogimawkwe Mitigwaki: Queen of the Woods*. Low served as executive director of the Mitchell Museum of the American Indian in Evanston, Illinois, and is a member of the advisory committee for the "Indians of the Midwest: Past, Present, and Future" project at the Newberry's D'Arcy McNickle Center for American Indian and Indigenous Studies.

Autumn Mather
Reference Services Librarian
No. 70

Autumn Mather manages the activities of the Newberry's Reference Services section, providing reference assistance and supervising reader registration; answering reference correspondence regarding Newberry collections; and conducting bibliographic instruction, tours, and orientations for visiting groups, classes, and Newberry Fellows. She is responsible for building and maintaining the reference collection and for describing reference resources and services on the Newberry's website.

Liesl Olson
Director of the Dr. William M. Scholl Center
for American History and Culture
No. 46

Liesl Olson's first book, *Modernism and the Ordinary* (2009), examines a broad range of twentieth-century writers and how their work presents the habitual and unself-conscious actions of everyday life. She is currently writing a book about Chicago's literary and cultural centrality during the early twentieth century.

Father Peter J. Powell
Research Associate
No. 25

For more than forty years, Father Peter Powell has studied the ethnography, history, and art of the Cheyenne Indians. His two two-volume works, *Sweet Medicine* (1969) and *People of the Sacred Mountain: A History of the Northern Cheyenne Chiefs and Warrior Societies 1830–1879* (1981), were written at the Newberry. The latter won the National Book Award in History in 1982. A third two-volume work, *In Sun's Likeness and Power*, is scheduled for publication in 2014. Father Powell is founder and spiritual director of St. Augustine's Center for American Indians, a social-service agency that has served Chicago's Native American community for more than fifty years.

Matthew Rutherford
Curator of Genealogy and Local History
No. 53

Matthew Rutherford manages the Newberry's renowned genealogy collection. He has spoken at the Illinois State Genealogical Society and the Conference on Illinois History, as well as several local genealogy societies, including the North Suburban Genealogical Society, Genealogical Forum of Elmhurst, and Illinois St. Andrew Society. Rutherford also teaches seminars on a variety of genealogy topics, including beginning genealogy, researching at the Newberry, researching pre-Fire Chicago, adoption searches, non-population census schedules, the history of the federal census, and the Social Security Death Index. He is coauthor, with Jack Simpson, of *A Bibliography of African American Family History at the Newberry Library* (2005).

Paul Saenger
George A. Poole III Curator of Rare Books
and Director of Collection Development
Nos. 50, 57, 93, 108, 116–20

Trained as a medieval historian, Paul Saenger wrote his doctoral dissertation on illuminated manuscripts in the libraries of the kings of France and dukes of Burgundy. He is the author of the Newberry's *Catalogue of the Pre-1500 Western Manuscripts* (1989) and the frequently cited *Space Between Words: The Origins of Silent Reading* (1997). He has occupied his current position at the Newberry since 1985.

Giselle Simon
Director of Conservation Services
No. 125

Giselle Simon began as collections conservator at the Newberry in 2001. From 2003 until 2012 she was director of Conservation Services. She is currently the conservator for the University of Iowa Libraries. Simon has taught bookbinding and conservation classes at Columbia College Chicago Center for the Book and Paper Arts and a collections-care course at the University of Chicago's Graham School.

David Spadafora
President and Librarian
Introduction and nos. 4, 64, 66, 77, 87, 99, 102–103, 124

A specialist in European intellectual history, David Spadafora joined the staff of the Newberry in October 2005. His scholarship focuses on English, Scottish, and French thought from the late seventeenth to the mid-nineteenth century. He is adjunct professor of history at Lake Forest College, where he previously served as dean of the faculty (1990–1993), president (1993–2001), and professor of history (1990–2007). Before going to Lake Forest, he was associate dean of the Graduate School and a member of the History Department at Yale University.

Scott Manning Stevens
Director of the D'Arcy McNickle Center for American Indian and Indigenous Studies
Nos. 17–19, 21–23, 27–28, 122

An enrolled member of the Akwesasne Mohawk Nation, Scott Manning Stevens regularly contributes essays to books about early-modern European colonialism, while participating in and delivering papers at American Indian Studies conferences. Stevens's research interests have revolved around the diplomatic and cultural strategies of resistance among North American Indians in the face of European and American settler colonialism, as well as the political and aesthetic issues that surround museums and the indigenous cultures whose artifacts they display. He is currently at work on a research project entitled "Indian Collectibles: Encounters, Appropriations, and Resistance in Native North America."

Alex Teller
Communications Specialist
No. 16

With an advanced degree in English, Alex Teller brings a hyper-literary voice to his work for the Department of Communications of the Newberry, which includes the promotion of library events, developments, and milestones, and the occasional lecture in provenance research.

Jack Weiner
Scholar-in-Residence
No. 97

Jack Weiner began his career as a Spanish interpreter for the United States Department of State. He used his skills in Russian and German when he was stationed in Berlin while serving in the United States Army. He later taught Spanish at the University of Kansas, Northern Illinois University, and the University of Illinois at Chicago. His areas of research are Hispano-Russian literary and cultural relations, with special focus on Spanish Renaissance and Baroque literature and culture. Weiner is author of *Mantillas in Moscovy: The Spanish Golden Age Theater in Tsarist Russia (1672–1917)* (1970), *El libro de los Proverbios Glosados de Sebastián de Horozco* (1994), and *Democracia y autocracia en Cervantes* (2009). He currently is working on a book about the Spanish Baroque poet Francisco de Quevedo.

Carla Zecher
Director of the Center for Renaissance Studies and Curator of Music
Nos. 83, 95, 104, 106

Carla Zecher specializes in French Renaissance poetry and music and early-modern French travel writing. Prior to coming to the Newberry, she taught at Bates and Coe colleges. At the Newberry, she served as project director for the major 2003 exhibition "Elizabeth I: Ruler and Legend." She is the author of *Sounding Objects: Musical Instruments, Poetry, and Art in Renaissance France* (2007) and a coeditor, with Gordon M. Sayre and Shannon Lee Dawdy, of *Dumont de Montigny, Regards sur le monde atlantique, 1715–1747* (2008). Zecher recently completed a National Endowment for the Humanities Fellowship at the Huntington Library in Pasadena, California.

Acknowledgments

Across the past 125 years, thousands of people have contributed, directly and indirectly, to the making of this book. Donors of library materials and financial resources, other friends of the institution, Newberry staff from every department: all have had their parts. Among them, some merit special recognition.

The members of the quasquicentennial selection committee, Rachel E. Bohlmann, John Brady, Martha Briggs, Paul F. Gehl, Daniel Greene, and Kelly McGrath, spent many hours closeted in the library's Wade Conference Room, deliberating about which items to include. Their informed and thoughtful discussion led to the superb choices highlighted in this book, and each authored at least one essay. Additional thanks go to John, Rachel, Paul, and Martha for getting the "tombstone" right for each item, a Herculean task. Paul, Martha, and Kelly devoted extraordinary effort to the entire yearlong process, with valuable assistance throughout from Kelly's Communications and Marketing team of Alex Teller, Andrea Villasenor, and Claire Spadafora. Paul T. Ruxin gave the entire set of essays an insightful and tough-minded reading that improved both the whole and individual pieces. As the project's end approached, Paul Gehl, who had already written so many essays, labored mightily on many crucial details, and took responsibility for defining and then redefining our approach to the index. Thanks go as well to Carolyn Spadafora for her multiple proofreadings of the text.

The revealing and often stunning images in this book are the result of the fine work of Newberry Photographer Catherine Gass, whose artistry has already graced countless projects over the years, photographer Jamie Stukenberg, and Pat Goley of Prographics. They owe much as well to the expertise and subtle touch of Director of Conservation Giselle Simon and her department. Indeed, without the involvement of Conservation many items showcased here could not have been photographed at all.

At the core of this book, of course, are the 125 essays and therefore those essays' authors. Being already or seizing the opportunity to become experts on the objects featured in these pages, our writers embraced their assignments with energy and eagerness and brought their special set of perspectives to bear on these important and often unique materials. That they could do so quickly while still shouldering the other demands of their busy lives makes their contribution all the more notable. We heartily thank each of them.

It takes first-rate objects, authors, and photographs to produce first-rate, illustrated essays. But it takes something more to turn them into an integrated and handsome volume. This critical additive ingredient was supplied by the exceptional skills, talents, and dedication of The Coventry Group, led by managing editor Kim Coventry, and Kim's team: designer Hal Kugeler, editor Susan F. Rossen, and James Fuhr of Fleur de Lys Indexing & Editing. We are fortunate indeed to have had them involved so instrumentally in this project.

The author of the introduction benefited mightily from the assistance of John Brady, Martha Briggs, and Paul Gehl in finding materials and avoiding errors. He owes an even greater debt to Richard H. Brown, author of what will soon become the standard work on the Newberry's foundation and its historical context; Dick's careful and perceptive readings were extremely helpful, as they have been to two generations of Newberry Fellows. A timely, thoughtful reading by Paul Ruxin improved the introduction in important ways. The errors that might remain are, of course, exclusively the author's responsibility.

This book was made possible through the generous support of Newberry Trustee Richard Gray and his wife, Mary. We are grateful to them for their commitment to this project, and to the Newberry.

Index

Page numbers in bold italics refer to illustrations.

The text in this book was set in Minion and Myriad.
The book was printed on 150 gsm GardaMatt Art
in an edition of 4,000.